bamboo in japan

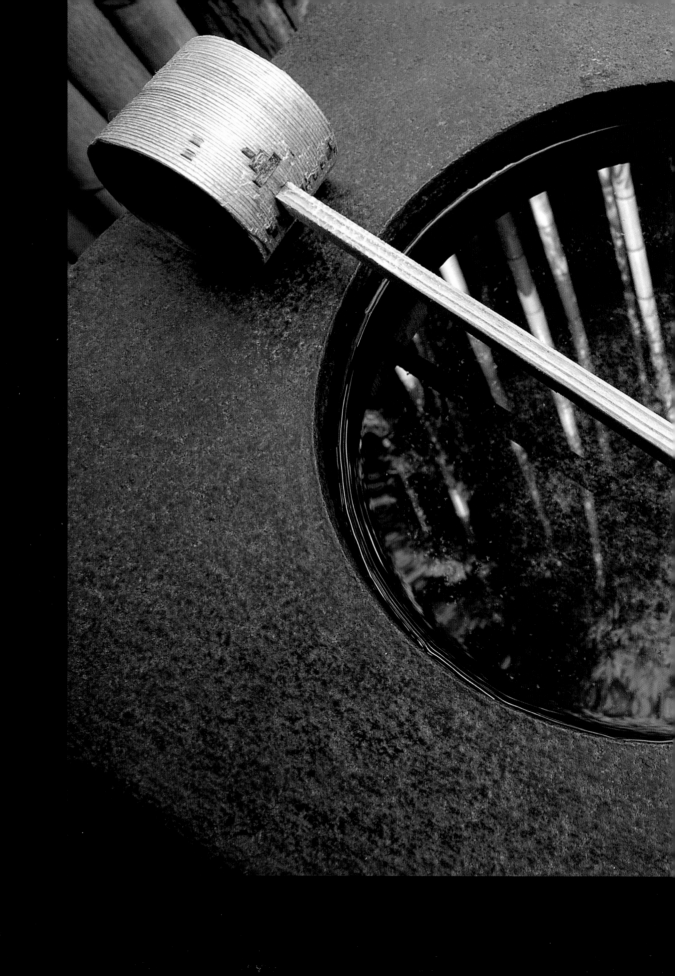

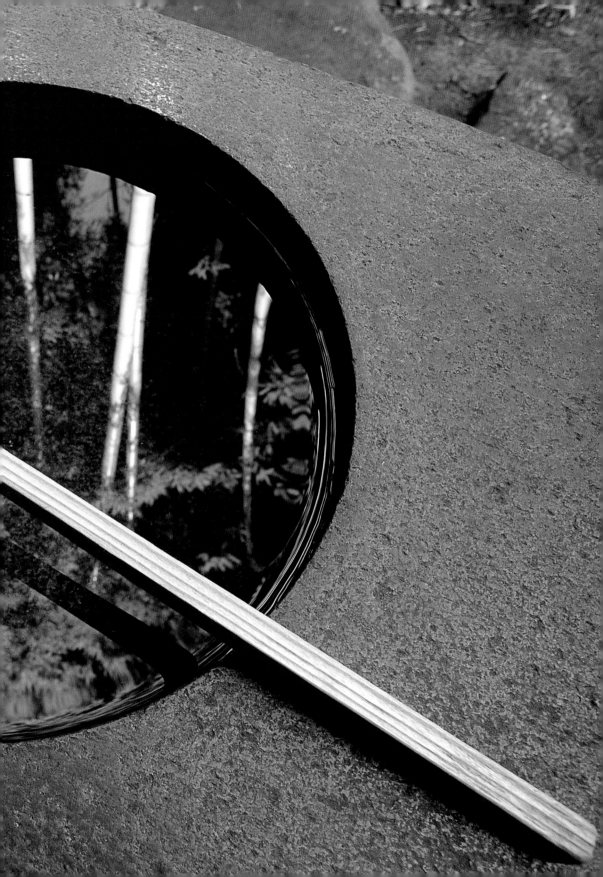

KODANSHA INTERNATIONAL
Tokyo · New York · London

bamboo in japan

Nancy Moore Bess

with Bibi Wein

CONTENTS

I dedicate this volume, in gratitude, to the great libraries and museums—large and small—that keep and protect the cultural treasures of the world, and to their staff, who make these treasures available to the public.

The author and publisher are indebted to several groups and individuals whose special contributions have enriched this volume. Throughout this project, the continued support of the American Bamboo Society and many of its regional chapters helped sustain our momentum. The Honolulu Academy of Arts, with the encouragement of the Curator of Asian Art, Ms. Julia White, opened its library and facilities to the author and provided photographs from their exceptional collection. Unique photographs of Japanese bamboo basketry and basket makers came from Robert Coffland and Mary Kahlenberg of Tai Gallery (formerly Textile Arts Gallery) in Santa Fe, New Mexico. A traveling exhibition, parallel to the book topic, was curated and organized by Benji Bennington of the East/West Center in Honolulu. There is a worldwide audience for the photography of Takama Shinji, whose shots of bamboo in its many guises grace these pages. His contribution helped us celebrate the life of bamboo, as did photographs from D. James Dee and Monty H. Levenson of Tai Hei Shakuhachi.

Note to the Reader
The names of Japanese appear in the customary Japanese order, family name preceding given name. No comma has been used in this case, except in the bibliography. In the Source section, Japanese names appear in the Western order, given name before surname.

In the Japanese language, the second part of a compound word is sometimes modified to facilitate pronunciation. For example, when the word *take* (bamboo) is used in a compound, it may be pronounced as *dake*.

Published by Kodansha International Ltd., 17-14 Otowa 1-chome, Bunkyo-ku, Tokyo 112-8652, and Kodansha America, Inc.

Distributed in the United States by Kodansha America, Inc., 575 Lexington Avenue, New York, New York 10022, and in the United Kingdom and continental Europe by Kodansha Europe Ltd., 95 Aldwych, London WC2B 4JF.

First edition, 2001

CIP data available. 1 2 3 4 5 6 7 8 9 05 04 03 02 01
ISBN 4-7700-2510-6

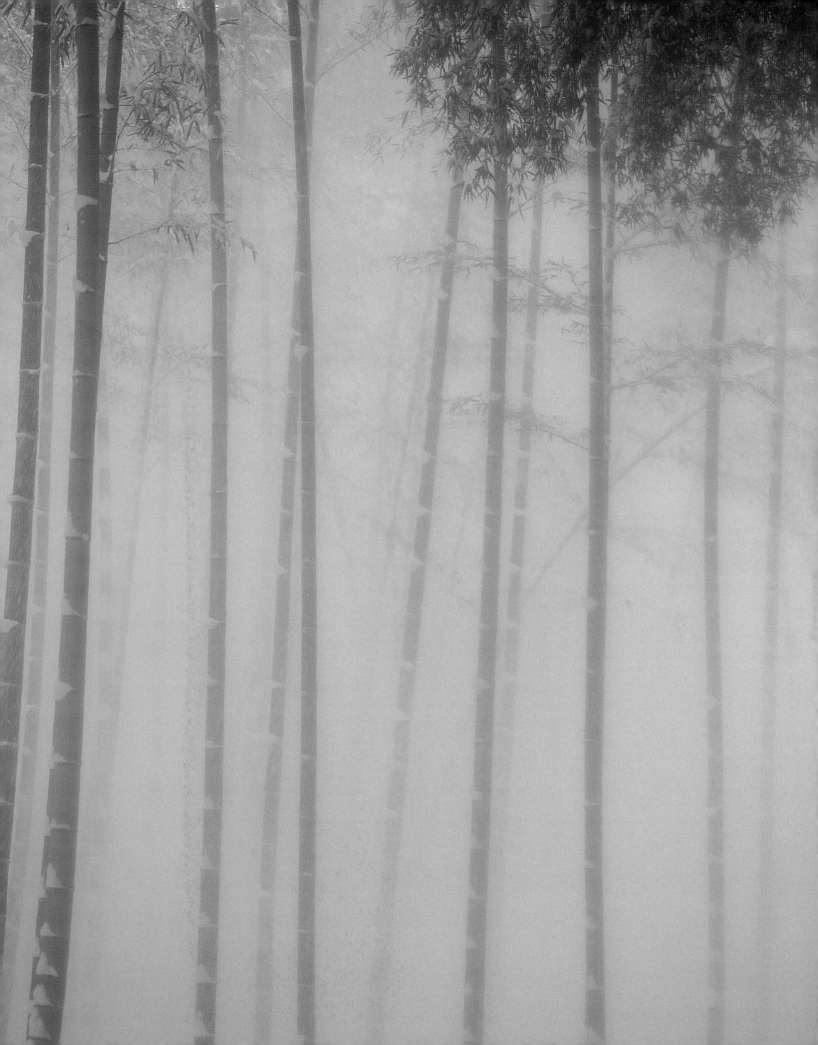

PREFACE
A View from the Outside

Basket makers are obsessed with materials, from roots gathered in the towering cedar forests of the Pacific Northwest to hand-spun linen. And I am no exception. On my first trip to Japan in 1986, I planned to explore new materials and immerse myself in a different culture. Several years earlier, the book *How to Wrap Five More Eggs*[1] had become a strong influence on my basketry work, and I expected to find this influence reinforced by contact with Japanese materials—specifically, bamboo, rice straw, and paper. I had prepared for the trip by spending long hours in libraries and in museum exhibits devoted to Asia. As I reread Morse's *Japan Day by Day*[2] and Statler's *Japanese Inn*, I made lists of places and planned daily activities. I joined the American Bamboo Society (ABS) in order to learn about the horticulture of bamboo. As a result, I came to realize the potential of bamboo more fully, and it became the focal point of my time in Japan.

As my plane circled over Narita airport, my agenda was simply to learn about bamboo as a craft material. I expected to find bamboo baskets, but I had no idea how wide the range, how beautiful the patina, how practical the form would be. In Mary Kahlenberg's *A Book about Grass*, I had already read about Japanese bamboo fences and analyzed their function. But when I finally saw them for myself, it was their beauty—from the simplest to the most complex—that took my breath away. I had also read about the majestic thatched farmhouses with their towering rooflines, but I hadn't realized how intrinsic a contribution bamboo made, and how beautiful in its massive scale the supporting bamboo grid would be. I didn't know I would love the smooth touch of a bamboo brush handle and smile as I made ink tracings across paper. I hadn't expected to walk down winding roads to a small country train station, enveloped in the shadows of the rustling bamboo that lined the path. I was startled by the beauty of bamboo shoots breaking the ground at a Kamakura temple, their covering sheaths alive with a purplish glow and minute surface fibers. Nor had I realized that bamboo, in all its incantations, was everywhere in Japan.

One of my fondest memories took place during this first trip. Sekijima Hisako, the renowned Japanese basket maker, met me at the small train station near the Fuji Bamboo Garden in Shizuoka. During the course of our walk through the grounds, we stopped between the tall rows of bamboo to eat the rice balls she had brought. The garden was not crowded, so we lay back on the grass in the hot sun, looked up at the clouds, and watched the tips of the tall bamboo sway in the breeze. Mount Fuji was visible in the background. Sekijima, I, and bamboo had become part of a Hokusai *ukiyo-e* print. Eleven months later, as I stood quietly weeping at the bus stop in front of the airport, I knew bamboo was a passion for life, a passion that required some complicated changes in my goals.

Over the years, my initial response to bamboo has been enriched by personal experiences, new acquaintances, and a wealth of scholarly information. What began as naive fascination

became a thorough study of bamboo's complexity. Every conversation, every email from Japan, every ABS meeting, and every book moved me forward in this learning process. I accumulated thousands of slides, hundreds of books, and a collection of bamboo artifacts. Eventually, requests to teach and lecture began to include bamboo as well as basketry, and these offered opportunities to expand my knowledge further. The more I taught, the more information others provided. When I showed slides of the basket collection in the National Museum of Ethnology in Osaka, students mentioned a basket maker in Kyushu. When I spoke of the Minka-en in Kawasaki City and the Farmhouse Museum of Osaka (both sites that feature traditional Japanese buildings), an architect stepped forward to explain the significance of bamboo in these structures. By 1996, with an opportunity for a seven-month stay in the countryside near Tokyo, the idea of a book began to take shape. From the initial focus on bamboo baskets, the final topic—bamboo itself—evolved, and this expansion led me to new resources: the Ukiyo-e Society of America, bamboo wholesalers, Japanese media, and the museums and research libraries of Honolulu. I have learned about bamboo's part in the Japanese language, the design world, the building industry, and national cuisine. I began the process by wondering about bamboo in basketry; now I see its influence everywhere.

Sometimes, I think I have gone a bit too far. American friends say I talk about bamboo incessantly. Japanese friends still look askance on occasion when I introduce the topic, but more often they now admit they see bamboo with new clarity.

As an observer and a craftsperson, I offer this book to those who have yet to experience the wonder of bamboo, as well as to those who have bamboo in their garden, bamboo shoots in their wok, and lovingly fashioned bamboo objects in their home. Bamboo's contribution to Japanese culture goes far beyond a mountainside grove or a simple basket. Its presence touches every aspect of daily life—art, literature, design, food, and crafts. Its warm golden glow can be found in a pair of chopsticks and a garden fence. It is this very warmth and abundance that I hope will catch your attention as it has mine.

Nancy Moore Bess
Amherst, Massachusetts

A traditional pairing of bamboo and sparrows decorates this sliding door from Daikakuji temple in Kyoto.

Chapter **1**

BAMBOO IN JAPANESE CULTURE

So extensive is the part played by bamboo in Japanese domestic economy that the question is rather, what does it *not* do?[1]

Basil Hall Chamberlain
Japanese Things

Without exaggeration, one can say that bamboo's presence in Japan is so pervasive that hardly a day goes by, anywhere in the country, without some interaction with bamboo. As a symbol of strength coupled with flexibility, uprightness, and purity, bamboo represents what one aspires to; as a material, bamboo is used for everything from disposable goods to family treasure; bamboo is at the roadside and on hallowed grounds. Phone cards with a background design of green bamboo groves are used at the busy Kyoto Station. A bamboo ladle is dipped into clear water for washing hands—an act of purification—at temple entries in Kamakura. In the ikebana *school, flowers are arranged in a delicately woven bamboo basket. A new bamboo rice scoop is purchased at a Chiba department store. Onions are hung from a bamboo pole under the eaves of a farm house in Hiroshima. Even in Tokyo, a snack is eaten from a bamboo skewer. Bamboo, simple in appearance, varied in use, is at once common and elegant, rugged and refined.*

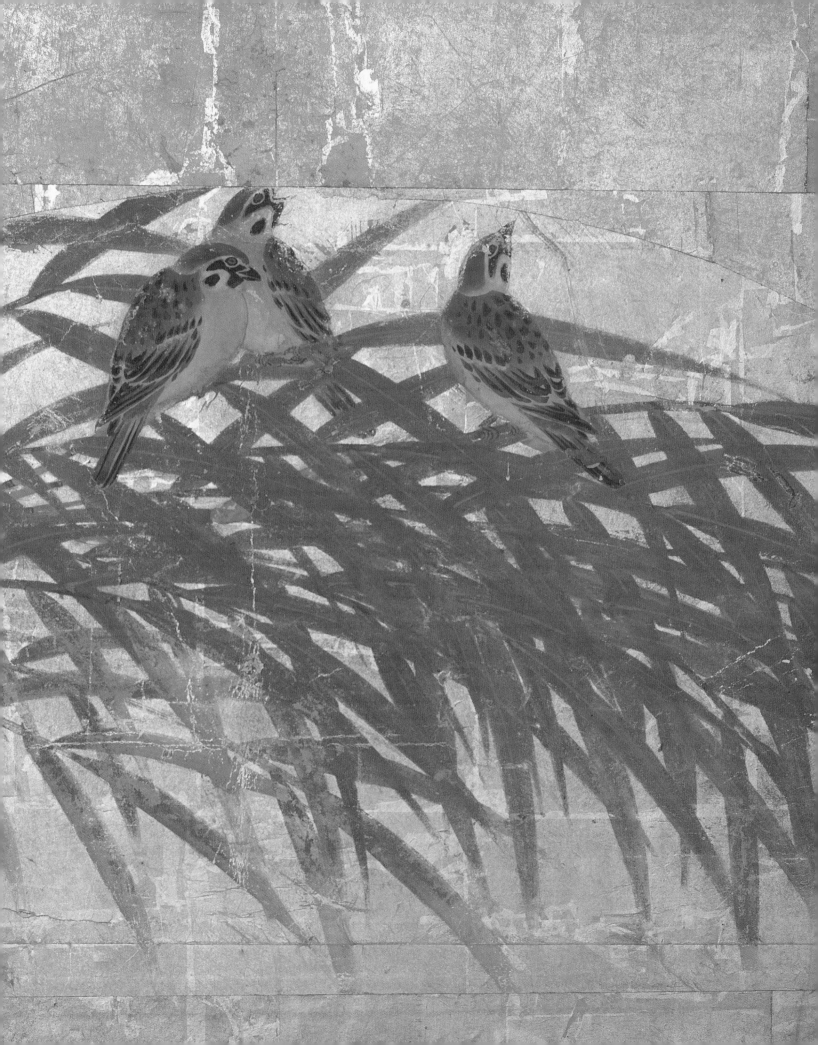

竺　竿　筑　笄　笆　筏　笊　笋　笏　笑　筈
笛　答　笠　筍　符　笨　第　笳　范　笑　笹
笙　筅　筆　筈　等　筋　筌　筍　筏　筐　筑
筒　答　策　筬　筝　筥　筧　筮　筰　筱　筴
筵　節　筐　筺　箇　竹　箋　箍　箏　箒　箔
箕　算　箘　箆　箙　箚　箜　箝　管　箸　箭
箱　箴　篁　範　篆　篇　篋　篌　箪　箾　篝
篤　篥　篦　篩　篭　築　篡　篳　篤　篷　簀
簇　簍　簑　篠　篊　簗　篹　簞　簡　簣　簧
簷　簸　簽　簾　簿　簫　簹　籌　籍　簪　簇
籐　籔　籃　籤　籐　籟　籠　籤　籥　籬　纂

LANGUAGE, LITERATURE, AND BAMBOO

WHEN SPEAKING ABOUT BAMBOO, the Japanese use the terms *take*, *chiku*, and *sasa*, and these words have been assimilated into the culture's idioms and figurative language: *chikuba no tomo* describes a "bosom friend from childhood," and *takeo wattayona-hito* is a "sincere, straightforward person." Bamboo is also integrated into the pictograph language of *kanji* characters, the written characters of the Japanese language, and its extensive inclusion supports bamboo's importance in the language.

籠　kago (baskets)

笊　zaru (tray-basket)

筆　fude (writing brush)

笑　warau (laugh)

答　kotae (to answer)

筋　kin (muscle, tendon)

箱　hako (box)

範　han (example, pattern)

Kanji was adopted from the Chinese system, which dates back to the sixteenth century B.C. As the system was adapted, most *kanji* took on two readings: *on*, Chinese derived, and *kun*, reflecting the Japanese phonetic system. Most *kanji* used today are a combination of pictographs and abstract forms, and *kanji* themselves are often combined with *kana*, Japanese syllabaries. Each *kanji* has, at its core, one or more radicals which indicate the root of its meaning, and within the Japanese written language there are a disproportionate number of *kanji* that uses one of the numerous radicals based on bamboo. There is a logic to its inclusion in some characters. For example, *take* is part of the *kanji* for baskets (*kago*) and the little woven bamboo tray-basket (*zaru*), two household items always associated with bamboo. The radical for "bamboo" is also part of *fude*, painting brushes, and all of its derivatives: *mannenhitsu* (fountain pen), *jihitsu* (handwriting), and *fudesaki* (tip of the brush). Since bamboo is the most common material for *fude* handles, the logic is quite clear. But the radical also appears in the verbs "to laugh" (*warau*) and "to answer" (*kotae*), plus the noun "muscle" (*kin*), and each of their derivatives. The radical is incorporated in *hako* (box) and *han* (example). In all these cases, and others, the logic is not always obvious.

15

At every level, Japan's literature reveals much about its culture, values, and mores. Poetry, proverbs, ghost stories, legends, and novels old and new reflect themes from Japanese life, the Japanese connection with nature, Japan's ingenious use of natural materials, and a love of bamboo, in particular. For centuries, occupants of the small hamlets and valleys of Japan remained relatively isolated from one another. In *Folk Legends of Japan*,[2] Richard Dorson cites this isolation as a primary force in the development of regional religious beliefs and folk-tales passed on by oral tradition, legends that were perhaps originally based on historical events and were widely believed. In agrarian settings, the Shinto ties to nature were powerful, and plants (including bamboo) had spirits (*kami*) and a place in the regional lore.

Repeatedly, bamboo appears in writings short and long, historic and humorous. "Grafting a bamboo onto a tree" is equated with "an unbecoming match."[3] Stories about the good son Moso who searches for food for his mother include illustrations of bamboo shoots (one variety of bamboo is commonly called *moso*). In *Road to the North*, Basho wrote, with characteristic reflectiveness:

Many sad junctures—
in the end, everyone turns into
a bamboo shoot[4]

A much beloved folk-tale known variously as "The Bamboo-Cutter's Daughter" or "The Shining Princess" revolves around an impoverished old bamboo-cutter's discovery of a beautiful miniature princess in a bamboo culm. Another favorite, "The Luck of the Sea and the Luck of the Mountains,"[5] includes the character Shihotsuchi, whose antics involve bamboo in various ways. First he flings a bamboo comb down to the ground and is rewarded with a bamboo grove; this he cuts down and weaves into a basket—bamboo three times over. In some stories, bamboo appears as it does in real life—as a pole to dry clothes, a fence to divide property, a basket, a backpack, or as young shoots. In others, a bamboo grove is used in the illustration as a backdrop for the action.

Bamboo even appears in some of Japan's great war epics, known collectively as *gunki mono*.[6] These lively tales are great fun to read—full of intrigue, hostile monks, honor, and pride. As is appropriate to stories set in war, bamboo arrows and quivers play a part in the action. But bamboo also edges the path and appears in others ways, such as in bamboo ornaments described in festival scenes.[7] Bamboo's characteristics of strength and flexibility are called upon to add to the drama of another tale in which Master Kumawaka seeks to be reunited with his father, who is sequestered on Sado Island in a place surrounded by a bamboo thicket. When his father is beheaded before Kumawaka can reach him, Kumawaka claims revenge and escapes across the moat by making a bridge of the black bamboo that grows above the water.[8] Elsewhere, the intensity of a storm is "violent enough to pierce bamboo."[9] Sometimes, the references are very subtle. In "The Dream of Lady Minbukyo," within three paragraphs there are separate references to each member of the auspicious trio, *Sho-Chiku-Bai*—Pine, Bamboo, and Plum. Because these "Three Friends of Winter" are so well known, the reader is expected to take them in as one.

Year round, bamboo ladles await the observant at shrines in Japan. In an act of purification, water will be used to cleanse the hands and mouth before visitors enter sacred grounds.

BAMBOO IN RITUAL

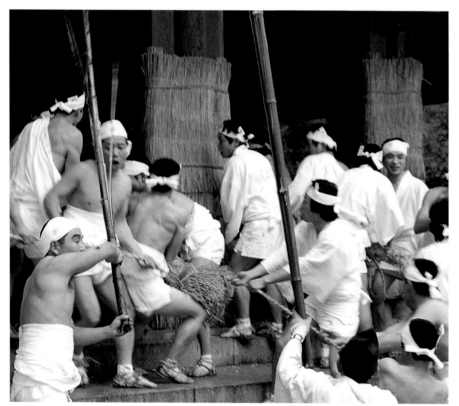

Bamboo is used in many festivals throughout Japan. Sometimes its inclusion has great significance. At other times, such as during the Takewari Matsuri held every year on February 10 in Ishikawa Prefecture, bamboo is pole, spear, or ramming rod.

AS A SYMBOL OF PURITY, flexibility, resilience, and uprightness, bamboo plays an essential role in many religious rites and festivals. In present-day Japan, as it was in ancient times, bamboo is chosen for the important rituals around birth and death. Ancient documents chronicle the use of a small bamboo knife that was thought to have magic powers and, consequently, was used to cut the umbilical cord after birth, a practice exercised in southern Japan as recently as the late twentieth century.[10] Long ago bamboo was part of the funeral procession, and bamboo poles were stuck into the ground over the grave, perhaps to repel evil spirits.[11] Even now, a container made from bamboo holds the flowers, not only at the funeral site, but once more each year during *obon*, when the spirits of the dead are welcomed back to earth.

Very fresh, green bamboo is used in festivals and rituals to emphasize purity. *Sake* is poured from long green bamboo poles at the *Fudoin* temples at New Year's as part of a purification rite to ensure safety and success in the coming year. In front of shrines and temples, supplicants dip water with green bamboo ladles to purify hands and mouth before entering the grounds. On other occasions, bamboo is chosen as a symbol of strength combined with flexibility, or because its rapid growth signifies powerful progress and ascendancy. Bamboo shoots that break through the earth's crust each spring are seen as a symbol of fertility and strength. In the Bamboo Cutting Festival of Kyoto, green bamboo poles represent snakes, an evil omen. It is high drama when they are noisily hacked to pieces by sword-wielding priests in traditional costumes. Cut at an angle, bamboo can impale devils. Thrown into a fire, a whole culm explodes and frightens away ghosts.

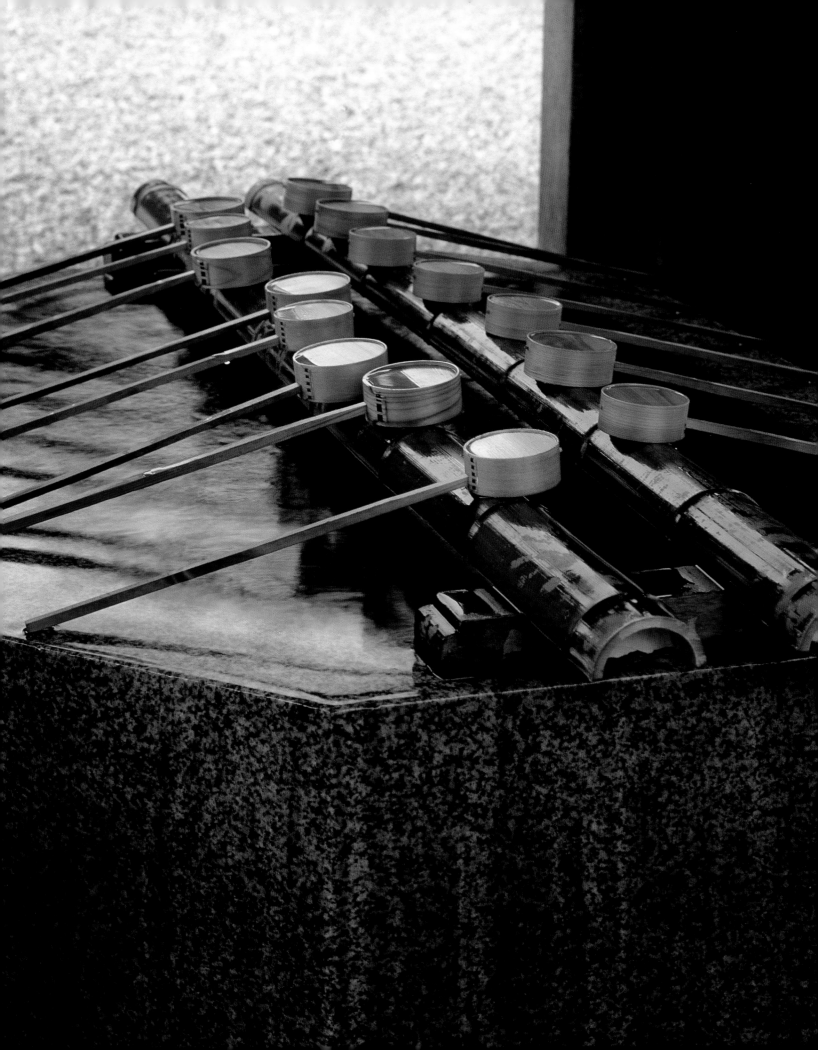

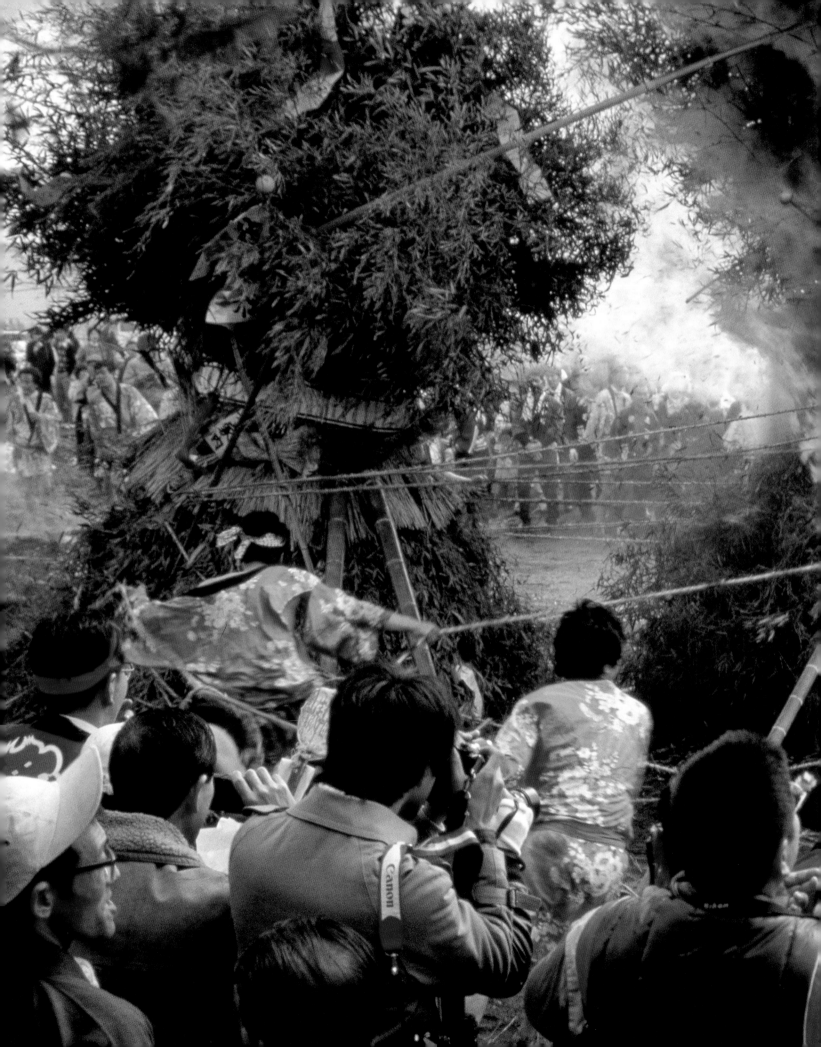

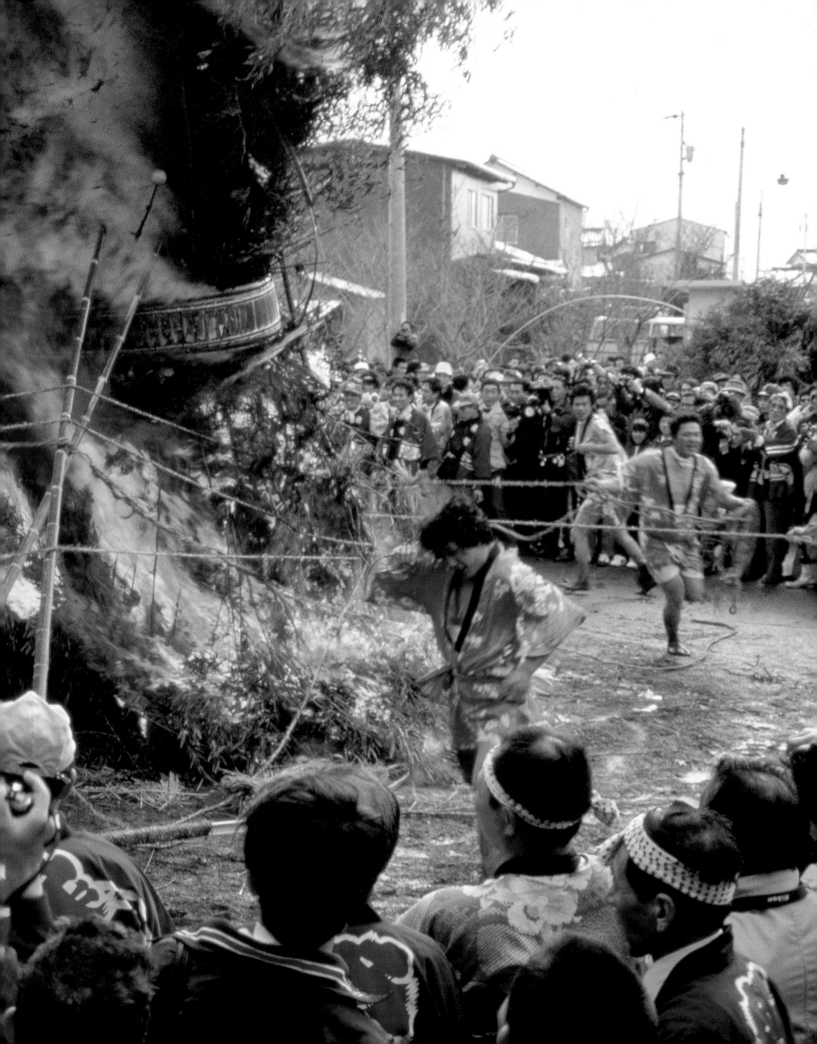

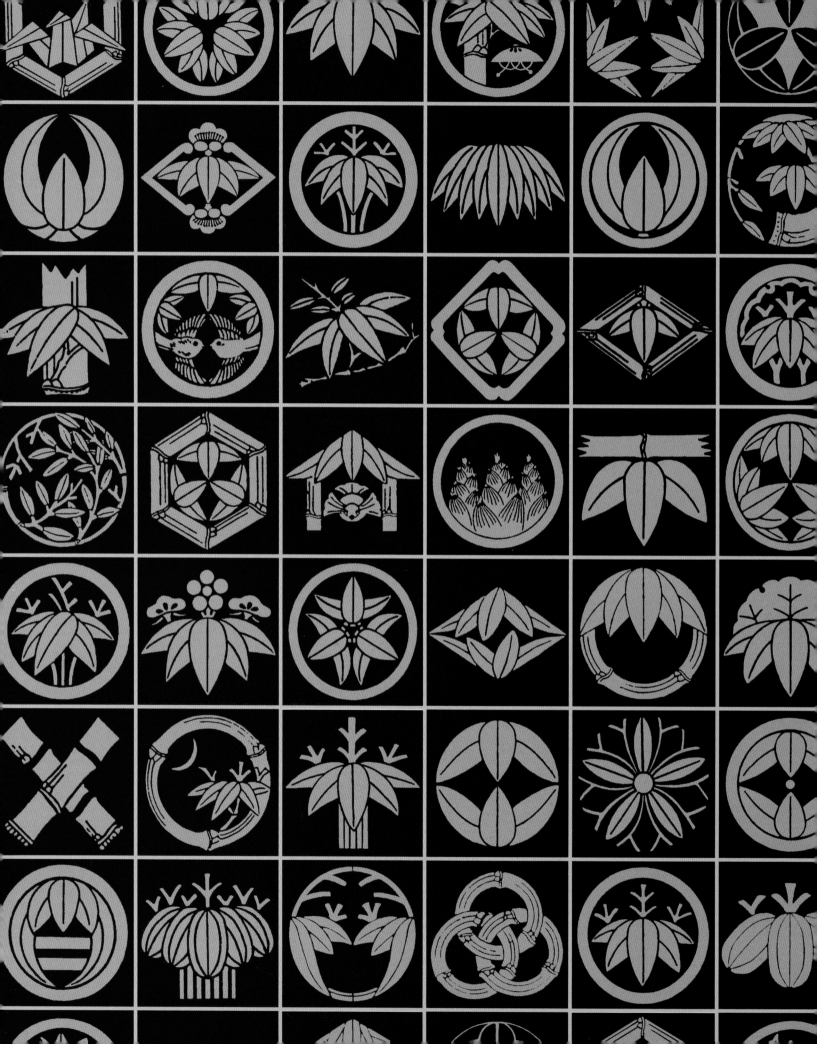

BAMBOO AS A DESIGN MOTIF

BAMBOO DESIGNS APPEAR EVERYWHERE, sometimes as a symbol of strength, flexibility, and purity, sometimes representing beauty in nature. Anything that can be decorated with a design has been embellished at one time or another with a bamboo pattern—stationery, shop curtains, theatrical sets, traditional sweets, print ads, T-shirts, postage stamps, food packaging, and matchbox covers. The list is endless. Outside Japan, bamboo as a design motif is taken for granted as part of the Japanese design vocabulary and rarely discussed. Within Japan itself, bamboo elements in design have received little recognition.

Bamboo's contribution to design is enriched by the wide variety of ways in which it can be depicted—as grove; whole culm; cross section; new shoot; leaf; snow-capped leaf; or combined with pine and plum, or tortoise, tiger, or sparrow. Red bamboo, a symbol of luck woven into textiles and printed on both paper and fabrics, is seen in many stores displaying traditional prints, paintings, and ceramics for home interiors. A sweeping grove of bamboo is a favorite image in *maki-e* lacquer patterns, in which the gold leaf brings the bamboo to life. A similar grove is carved into inkstones and wooden transoms, painted on elaborate screens and simple fans. Designs featuring bamboo shoots are favorites in advertising and contemporary fabric collage. A single stalk of bamboo in a book illustration instantly conveys a sense of serenity. Japanese family crests (*kamon*) incorporate bamboo in many ways—a single culm may form the outer border of the crest, a bit of culm and leaf or a stylized bamboo shoot can be the focal point, or bamboo leaves may be arranged in a distinctive fashion.

On year-end cards, gift-money envelopes, summer greeting cards, kimono, postage stamps, and advertisements, images of bamboo and bamboo crafts, such as fans, arrows, and umbrellas, play prominent roles. Designs beget new designs—bamboo shoots are painted on a fan, which

A familiar dish in Japan, the covered soup bowl is transformed by lacquer and a design in gold depicting a bamboo grove motif.

23

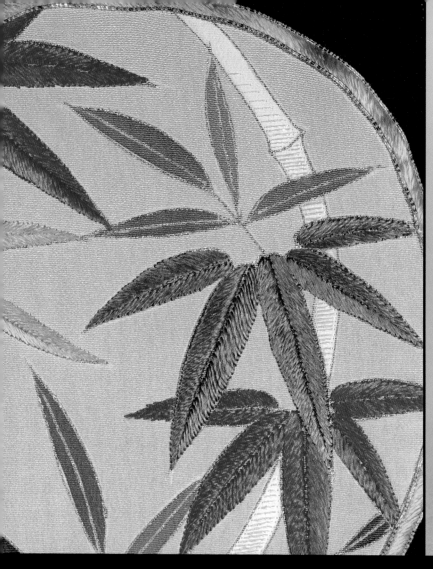

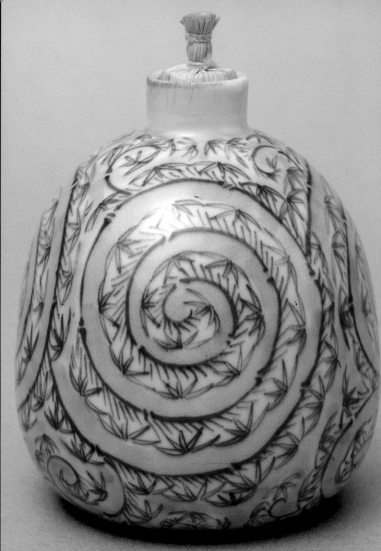

TOP LEFT Elegant in shimmering silk, bamboo leaves and culm are embroidered on this kimono fabric.

TOP RIGHT The unusual spiraling bamboo pattern on this ceramic jar covers the entire surface. The tied stopper is a folk art touch.

RIGHT Even as this fan ages, the bamboo will remain graceful, the painted plum blossoms delicate.

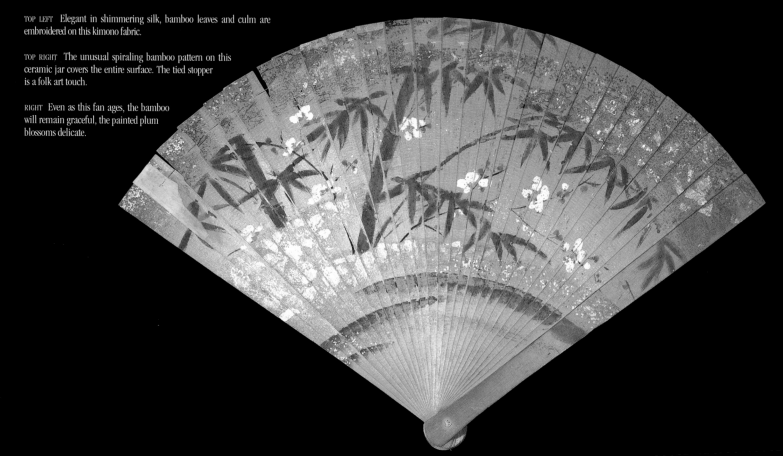

later becomes a motif for fabric. A travel advertisement features three golden fans made of bamboo and paper, with pine on one, bamboo on the second, and plum on the third, offering an unwritten message—visit home at New Year's. The publisher of a popular food magazine uses a photograph of a *zaru* tray filled with sliced bamboo shoots to advertise its spring issue. The text need not mention bamboo shoots. The image is synonymous with spring.

Paradoxically, the same contemporary Japanese who dismiss bamboo as unimportant revere the fine work of renowned bamboo craftsmen such as Shono, Tanabe, and Maeda. Bamboo is as much a part of Japanese life as the mountains and the sea; it is taken for granted that new bamboo ornaments will be purchased to mark the beginning of each new year, bamboo kitchenware will appear in stores each spring, and that, each summer, fans will be taken out of storage and bamboo blinds hung to block the sun. In every season, bamboo patterns will be purchased, worn, mailed, and admired. The depth of bamboo's importance in Japan emerges in rituals, music, folk-tales, legends, designs, prints, and artifacts.[12] As imagery on fabric and in art, in everyday possessions and family treasures, in the rustic and the finely crafted, bamboo, in all its myriad forms, is an intrinsic part of Japanese culture.

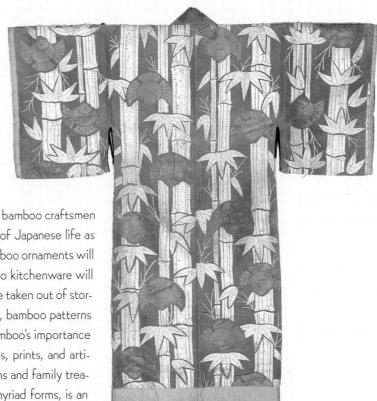

Bamboo patterns can be delicate and subtle, figure or background. In this *kabuki* kimono the bamboo is bold and fills the eye.

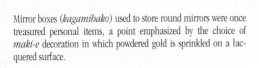

Mirror boxes (*kagamibako*) used to store round mirrors were once treasured personal items, a point emphasized by the choice of *maki-e* decoration in which powdered gold is sprinkled on a lacquered surface.

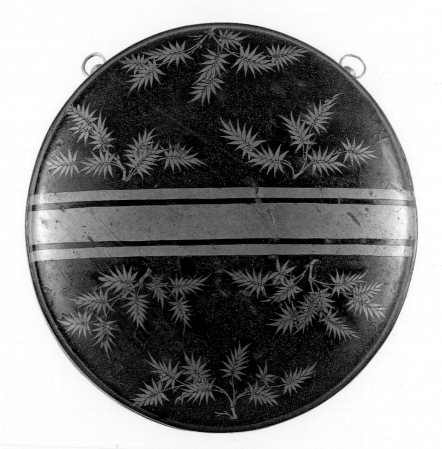

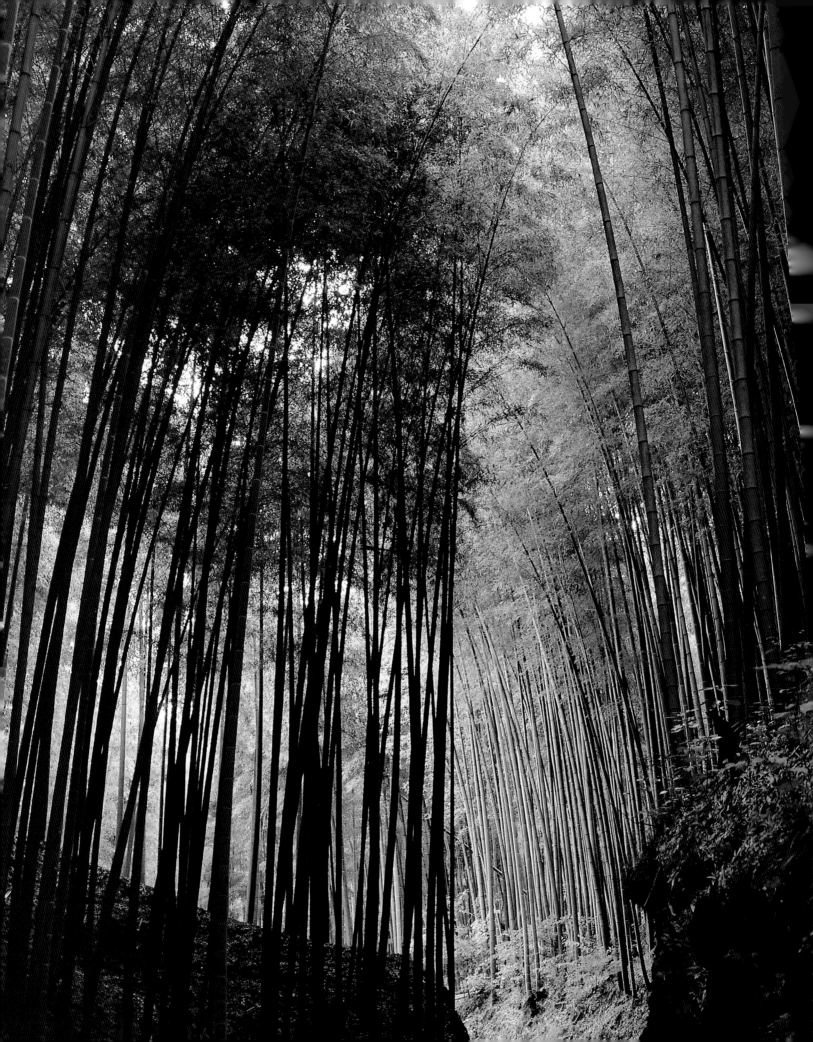

Chapter 2

BAMBOO ITSELF
A Living Resource

"The horticulture of bamboo in Japan is an art."

Susanne Lucas
American Bamboo Society

Bamboo is a fascinating plant. Although it is a primitive grass, it grows in forests that cover millions of acres. Within one year, it reaches its full height; some varieties grow so quickly, one can actually witness the growth! When a new shoot emerges from the ground, it is already the diameter of the mature plant, and all the nodes and membranes are compactly in place. The shoot is delicious to eat, and the adult plant strong enough to support traditional scaffolding tens of stories high, yet delicate enough to be cut into fibers scarcely wider than a hair.

There is also a grace and beauty associated with bamboo. The word evokes images of tall, green, treelike plants, swaying in a tropical breeze. While some bamboos conform to this picture, bamboos actually range from towering, impenetrable groves to lush ground-cover, with a coloring from bright yellow with dramatic green stripes to a beautiful purplish black. Some thrive on snow-covered mountain tops, others fulfill the stereotype of the tropics. Bamboo, versatile in use and distinctive in size and color, is also adaptable to a wide variety of growing environments.

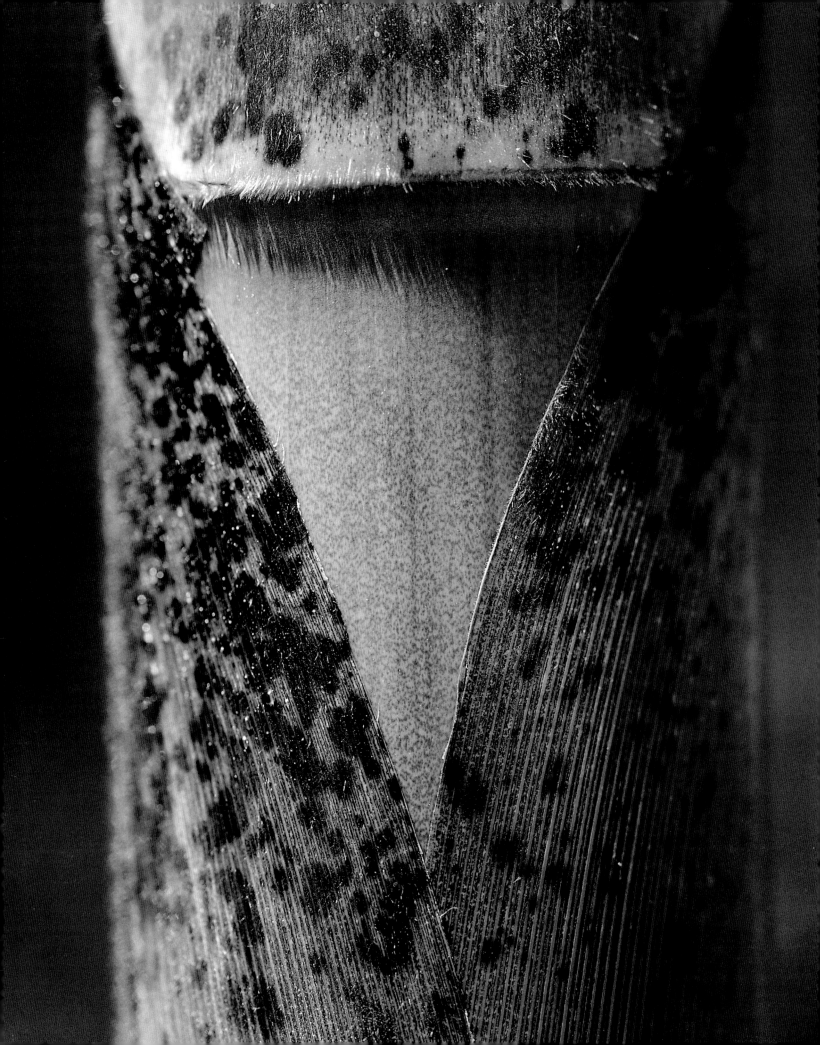

A brown sheath opens to reveal a shimmering green internode.

H O R T I C U L T U R E

THE TAXONOMY OF BAMBOO can be off-putting and confusing to the casual inquirer. Latin names do not roll easily from most tongues, and in discussing bamboo, many people (including bamboo craftspeople) succumb to using the common names. Bamboo classifications are complicated by continuing changes in terminology, additions, and discoveries of new information that often provoke fresh debates, even among professional bamboo horticulturists. Furthermore, as bamboo species bloom, which may occur as infrequently as every fifty years, new categorization information is learned, and regroupings are suggested. When distinct bamboo forms are cultivated, the resulting cultivar ("cultivated variety," sometimes referred to as "forma") names are incorporated into the botanical classifications, and more confusion results.

It is sufficient here, however, to classify what is commonly referred to as bamboo as a member of the grass family, *Gramineae*' (synonym, *Poaceae*). Within this larger classification, bamboo is further divided into genus (plural: genera), species, and cultivar, terms repeatedly seen in bamboo literature, popular and scholarly. Cultivars are specific forms or individuals within a species. The species, in turn, is a subgroup within the larger genus. It is at the species level that the typical form of the plant is defined. There are further distinctions among bamboos in the horticultural literature that play a role in the terminology used by bamboo aficionados. Some of this terminology is accepted in scientific circles, while some remains controversial. Because all of these terms—"monopodial" versus "sympodial," "hardy" versus "tropical," "temperate" versus "tropical," and "clumping" versus "running"—appear in bamboo nursery catalogues and much of the popular literature on bamboo, it is important to include them here. The common terms help describe the growing style of each bamboo and its survival capacity or growth potential in different geographic regions—all of which is useful in understanding where a particular type might be available for commercial and craft production.

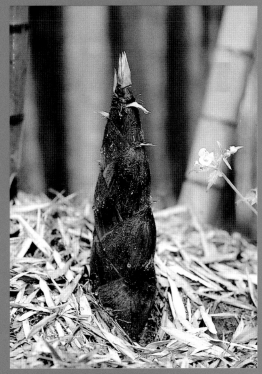

As the bamboo shoot breaks through the earth's surface and reaches for the sun, it is covered and protected by a set of distinctive sheaths.

THE CULTIVATION OF BAMBOO
RHIZOME SYSTEMS: Monopodial versus Sympodial

It might be expected that a plant reaching a height of one hundred feet in a year would resemble a typical tree with a single trunk and root structure, but it does not. Instead, bamboo's underground system of rhizome roots is no different from turfgrass, and the rhizomes' characteristics are a primary factor in identifying bamboo genera.

Bamboos are divided into two major categories: monopodial and sympodial. Some of the most useful bamboos for crafts in Japan are monopods. Each year the rhizomes of this category, popularly referred to as "running bamboos," send out underground runners, with new shoots often emerging far from the parent plant. The perimeter of the resulting grove expands quickly. Because monopodial bamboos thrive primarily in climates that include winter temperatures, they are also referred to as "hardy" or "temperate." Local growing conditions, however, have profound effects on bamboo, modifying exactly where and how any species will grow. Thus, the term "hardy" may be slightly misleading and the more scientific term, "temperate runners," is more accurate.

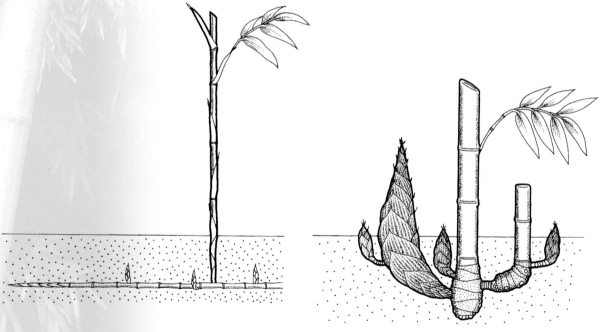

Monopodial rhizome system Sympodial rhizome system

Groves of sympodial bamboos are much denser because new growth from the underground rhizome is nearer the parent plant, resulting in a slower expansion of the grove. Because of the resultant density, sympodial bamboos are popularly referred to as "clumpers." And, as many thrive in the tropics, they are frequently and incorrectly referred to as "tropical bamboos." In Japan, sympodial bamboos can be found as far north as Hokkaido. Some of the most widely used landscape plants in Japan are sympodial bamboos.

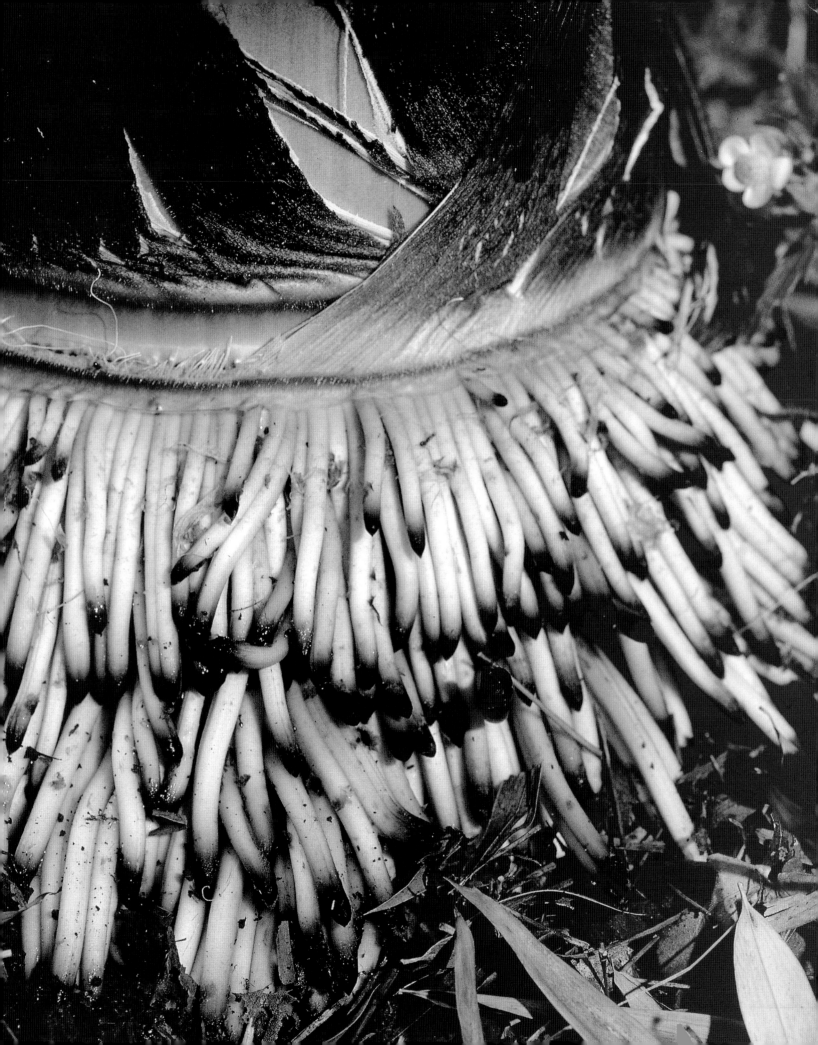

Understanding the vocabulary of bamboo allows one to better appreciate and utilize its great potential. However, accurate identification of bamboo is complicated by the fact that in botanical research, bamboo can be identified by a number of different characteristics, not all of which are observable at any one point in the plant's growth cycle. Among the particulars that can be observed only periodically or sometimes sporadically in the life of the plant are rhizome type; culm growth patterns; measurements and characteristics of nodes, internodes, and leaf and culm sheaths; and type and frequency of flowering. Other botanical factors, such as modifications in the plant morphology due to growing conditions and infrequency of flowering, further complicate identification. Inconsistencies in documentation procedures and cross-cultural miscommunications add to the difficulty. For example, a cultivar newly named in a European greenhouse may already have been identified and named in Japan. Or, alleged variations may be due to temporary, isolated environmental stress. Since acceptance of a universal vocabulary is essential for accurate communication in an academically validated field, bamboo societies around the world consider the development of common terminology and taxonomy a high priority.[2] A comparison of Fairchild's 1903 *Japanese Bamboos* and recent ABS Source Lists reveal many changes in the terminology. Even the groundbreaking work of the late Dr. Ueda Koichiro, a leading contributor to the field, has seen some modification. Bamboo is an evolving field of study.

VOCABULARY LIST

BRANCHES—the side extensions emerging from the main vertical element (culm) at the node, with characteristics particular to each genus. The type and placement of branching are factors in bamboo identification. Bamboo branches are used for brooms and in Japanese fencing, both rustic and formal.

BRANCH SHEATHS—miniature versions of the more dramatic culm sheath. Some stay in place for the life of the culm, others drop off when the branch achieves full length.

CHIKU—one of several Japanese terms for bamboo; used in compound words, such as *moso-chiku*.

CLUMPERS—term applied to sympodial bamboo. Because the new growth emerges near the parent plant, the resulting grove is dense and slow to expand, a pattern that makes it ideal for landscape use. Example: *Bambusa*.

CULM OR CANE—the primary vertical stem of bamboo. The culm emerges from the ground as a shoot, and its base is the full diameter of the mature bamboo. Though full height is attained in one year of growth, the woody tissue structure changes with maturity. Most culms are hollow inside except for the diaphragm (membrane) across the interior at each node. The culm tapers slightly from the ground level to the top. The culm is the part of the plant most often used in crafts. Once cut, it is often referred to as a pole.

CULM SHEATH/*TAKEKAWA*—the leaflike covering that protects bamboo shoots as they emerge from the ground. There is one at each node. These are used in food packaging, footwear, hats, baskets, and in an important woodblock tool, *barren*.[3]

CULTIVAR—"cultivated variety." These are natural variations of species that have been cultivated. Sometimes abbreviated as *c.v.* or *c.v.s.* In some documents, referred to as "forma" and abbreviated as "form" or "f."

CUTICLE—outer skin (cortex) or rind of the bamboo culm. Some bamboos are known for distinctive coloration, patterning, or other characteristics, such as a powdery surface.

DIAPHRAGM OR MEMBRANE/*FUSHI*—the undulating tissue crossing the interior of the otherwise hollow bamboo culm at the point of each node. When a bamboo shoot breaks the ground, every layer of diaphragm that will appear in the mature culm is already present, much like a stack of papers. Craftspeople always consider the placement of the node and diaphragm when cutting bamboo for their work. The diaphragm acts as a natural base in a vessel made of a single section of culm. Flower vessels and carved bamboo often begin with such a piece of bamboo.

FIBER LENGTH—the length of the verticle fibers between nodes. Fiber length varies according to the type of bamboo and the location of the fiber in the bamboo. It is shorter near the base and interior, and has a direct impact on bamboo's suitability for crafts and other usages.

FLOWERING—patterns of flowering are complicated and differ from species to species. Some bamboos flower sporadically, some gregariously (i.e., every plant in the species blooms at the same time).[4] When flowering gregariously, all plants within the species might either die back, exhausted, or might regenerate. Such a flowering of *madake* in 1966[5] resulted in the loss of most *madake* plants in Japan. It has survived, of course, to become Japan's most important bamboo.

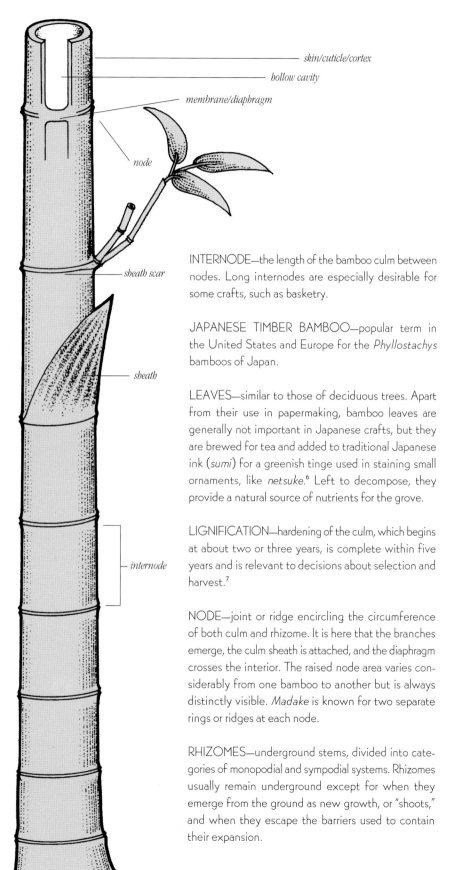

skin/cuticle/cortex
hollow cavity
membrane/diaphragm
node
sheath scar
sheath
internode

ROOTS/*TAKENE*—fine extensions of the underground rhizome. Some bamboos (especially sympodial) also have aerial roots at the nodes just above ground that stabilize the culm. *Takene* are incorporated into some sculptures and carvings and offer surface interest when fashioned into cane, purse, and umbrella handles.[8]

RUNNING BAMBOO—common term for monopodial bamboos. The quickly expanding network of underground rhizomes is considered invasive and a potential problem in the garden (though there are simple remedies); however, the same system provides excellent erosion control as well. The rate of grove expansion and density will be highly dependent on species, location, and soil conditions. Example: *Phyllostachys* species.

SASA—a distinct genus indigenous to Japan and Korea comprised mainly of shrublike or ground-cover species. Used in Japan frequently as a nonhorticultural term. When mentioned in the food industry, *sasa* leaves is simply a generic phrase for bamboo leaves.

SHOOT/*TAKENOKO*—new growth breaking the surface of the ground. Used symbolically in literature and illustrations to convey power and fertility. A favored food throughout Asia. In Japan, a special rice dish, *takenoko gohan*, served only when the shoots appear, marks the arrival of spring.

INTERNODE—the length of the bamboo culm between nodes. Long internodes are especially desirable for some crafts, such as basketry.

JAPANESE TIMBER BAMBOO—popular term in the United States and Europe for the *Phyllostachys* bamboos of Japan.

LEAVES—similar to those of deciduous trees. Apart from their use in papermaking, bamboo leaves are generally not important in Japanese crafts, but they are brewed for tea and added to traditional Japanese ink (*sumi*) for a greenish tinge used in staining small ornaments, like *netsuke*.[6] Left to decompose, they provide a natural source of nutrients for the grove.

LIGNIFICATION—hardening of the culm, which begins at about two or three years, is complete within five years and is relevant to decisions about selection and harvest.[7]

NODE—joint or ridge encircling the circumference of both culm and rhizome. It is here that the branches emerge, the culm sheath is attached, and the diaphragm crosses the interior. The raised node area varies considerably from one bamboo to another but is always distinctly visible. *Madake* is known for two separate rings or ridges at each node.

RHIZOMES—underground stems, divided into categories of monopodial and sympodial systems. Rhizomes usually remain underground except for when they emerge from the ground as new growth, or "shoots," and when they escape the barriers used to contain their expansion.

TAKE—generic Japanese term for bamboo. Many older craftsmen apply this word only to Japanese timber bamboo, rather than to all bamboos.

33

BAMBOO AS CRAFT MATERIAL

Bamboo's most heralded characteristics—strength, lightness, flexibility—have secured it a place in many Japanese crafts. Sometimes bamboo is the only material used in a craft, such as finely woven flower baskets. At other times, bamboo's role seems minor: it becomes a handle or a pole. The characteristic differences among the varieties of bamboo are what determine exactly which bamboo is chosen for each task.

However, it is important to remember that when Japanese craftspeople select their bamboo, experience leads them beyond the nomenclature to more subtle differences. For a fine tea scoop, they may look for a more elegant bamboo. For a fishing pole, they may combine three or four bamboos of varying weight and flexi-bility. For a tea ceremony flower holder, they may look for a culm with surface damage to reflect the *wabi* aesthetic.

Of the thousands of varieties of bamboo, those in the genus *Phyllostachys*, a temperate bamboo, contribute the most to the Japanese economy. Used for the finest of crafts, such as flower baskets, as well as for the heaviest of work assignments in construction, *Phyllostachys* is without parallel in its versatility.

The accompanying chart presents the essential characteristics of those species of *Phyllostachys* used extensively for crafts in Japan as well as those of two other species that play a small, but significant role.

BAMBOOS MOST FREQUENTLY USED IN JAPANESE CRAFTS

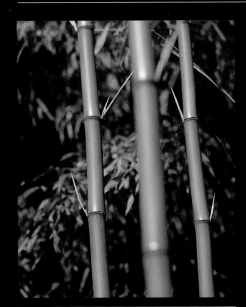

PHYLLOSTACHYS BAMBUSOIDES

COMMON NAME: *madake*, Japanese timber bamboo

APPROXIMATE SIZE: height—60 feet, culm diameter—4 inches

IDENTIFYING CHARACTERISTICS: thin-walled culm that thickens with maturity; long internodes; two distinctive rings at node; lustrous skin without powder; leans toward sun.

SUITABLE PROPERTIES FOR CRAFTS: thin skin, long fibers, easy to split lengthwise, very flexible, tough texture.

CRAFT PRODUCTS: most crafts, but especially suitable for weaving, architectural elements, fans, and musical instruments, including *shakuhachi*. This species and *moso* are commonly used when decorative techniques are desired (see Decorative Techniques). The strong, hairless sheath is a favorite for food wrapping, hats, and the woodblock tool *barren*.

COMMENTS: *Madake* is the quintessential Japanese bamboo—extremely strong, but flexible. Used for almost every craft, its long internodes and ease of cutting make it ideal for basketry.

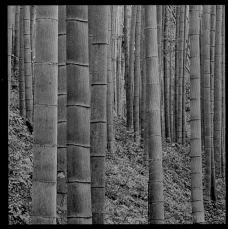

PHYLLOSTACHYS PUBESCENS

(syn. *Phyllostachys edulis, Phyllostachys heterocycla f. pubescens*)

COMMON NAME: *moso, moso-chiku*

APPROXIMATE SIZE: height—72 feet, culm diameter—7 to 9 inches

IDENTIFYING CHARACTERISTICS: the largest bamboo in Japan; thick-walled culm; single ring at nodes on lower culm; short internodes near base, plumelike appearance from afar.

SUITABLE PROPERTIES FOR CRAFTS: large diameter, thick-walled, strong, shoots sweet for eating; deformed versions (e.g., "tortoise-shell") desired as decorative craft element..

CRAFT PRODUCTS: fences, architectural elements, chopsticks, woven blinds.

COMMENTS: *moso's* size dictates its contribution. It is the handle, rim, and support system for most large work baskets and is used whole and cut for fences and architectural elements. Because it cannot be as easily and neatly cut as *madake*, it is not used for fine work.

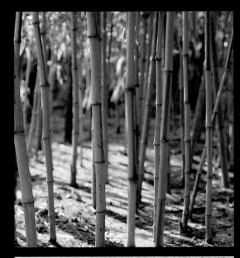

PHYLLOSTACHYS NIGRA F. HENONIS

(or *henon*)

COMMON NAME: *hachiku*

APPROXIMATE SIZE: height—24 to 36 feet, culm diameter—3 to 4 inches

IDENTIFYING CHARACTERISTICS: culm is thin-walled but durable; short internodes; prominent nodes; withstands cold weather; appears as far north as southern Hokkaido in Japan.

SUITABLE PROPERTIES FOR CRAFTS: desirable skin is sometimes patterned; easy to split into thin strips.

CRAFT PRODUCTS: *chasen* (tea whisks), baskets, fan and lantern ribs, decorative elements.

COMMENTS: *hachiku* is cut very easily, making it particularly suitable for tea whisks, the ribs in fans and lanterns, and other crafts that require finely split bamboo. See also comments for *Phyllostachys nigra*.

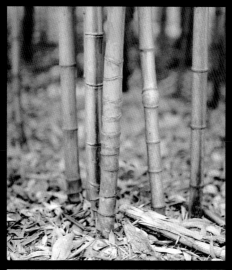

PHYLLOSTACHYS AUREA

COMMON NAME: *hotei-chiku*, "fish-pole" bamboo

APPROXIMATE SIZE: height—24 to 30 feet, culm diameter—1 to 1 1/2 inches

IDENTIFYING CHARACTERISTICS: deeply grooved; internodes known to become distorted (compressed) a few feet above ground.

SUITABLE PROPERTIES FOR CRAFTS: smaller size; very erect and hard, but still flexible; distorted poles are highly desired for ornamental use.

CRAFT PRODUCTS: canes, fishing rods, pipe stems, umbrella and bag handles.

COMMENTS: the distinctively distorted culm, varying widely from one example to another, makes this bamboo suitable for decorative handles and grips.

IDENTIFYING CHARACTERISTICS: branching from middle of trunk; one twig at each node; long 10-inch internodes; very smooth surface.

SUITABLE PROPERTIES FOR CRAFTS: small size; very straight; warm color.

CRAFT PRODUCTS: bows and arrows, fishing rods, decorative items (e.g., *kakejiku* for hanging pictures), fans, umbrellas, smoking pipes.

COMMENTS: *yadake*'s size and relatively even nodes make it ideal for use as arrows, its primary contribution to Japanese crafts.

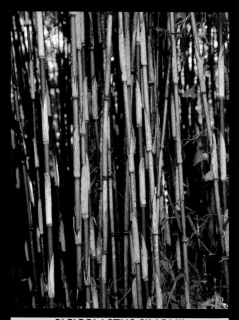

PLEIOBLASTUS SIMONII

COMMON NAME: *medake*, sometimes called *kawatake*

APPROXIMATE SIZE: height—9 to 12 feet, culm diameter—1 inch

IDENTIFYING CHARACTERISTICS: robust; attractive sheaths.

SUITABLE PROPERTIES FOR CRAFTS: small size; availability.

CRAFT PRODUCTS: baskets, all small crafts.

COMMENTS: *medake* grows throughout much of Japan, making it easily accessible for use in small crafts and, given its strong resistance to wind, as garden supports.

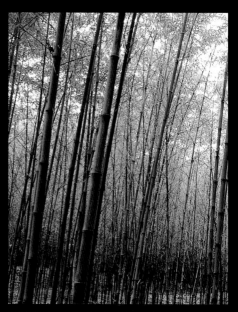

PHYLLOSTACHYS NIGRA

COMMON NAME: *kuro-chiku*, black bamboo

APPROXIMATE SIZE: height—8 to 15 feet, culm diameter—1 to 2 1/2 inches

IDENTIFYING CHARACTERISTICS: smaller and thinner walled than *hachiku*; green surface of first year changes to distinctive blackish tones later; two ridges at nodes.

SUITABLE PROPERTIES FOR CRAFTS: dark pigmentation makes this bamboo highly desirable.

CRAFT PRODUCTS: interior design elements, canes, umbrella handles, fishing rods, fan ribs, bonsai.

COMMENTS: several *nigra* varieties have distinctive markings, making them especially appealing for decorative elements, *Boryana* being the most frequently mentioned. *Tosa torafudake* (Tosa tiger bamboo), when grown in Kochi Prefecture, produces very distinctive brown cloudlike markings. *Tanba-hanchiku* exhibits similar patterning.

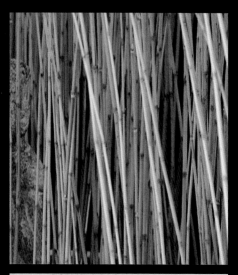

PSEUDOSASA JAPONICA

COMMON NAME: *yadake*, "arrow" bamboo

APPROXIMATE SIZE: height—6 to 15 feet, culm diameter—less than 1 inch

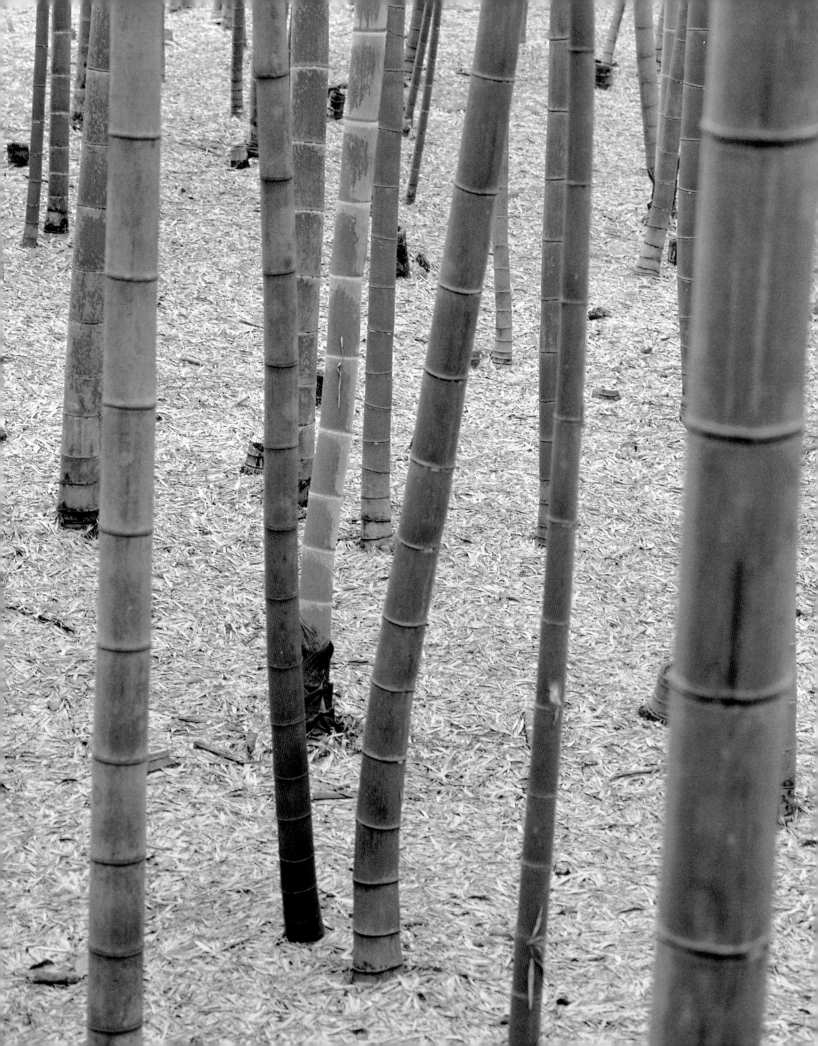

PROCESSING AND PREPARATION

PRODUCTS MADE OF BAMBOO often retain the feel and look of nature. Hence, the words *processing* and *curing*[9] applied to bamboo may seem inconsistent with its character and appearance. However, as strong and resilient as this material is in its natural form, it is highly susceptible to insect infestation, mold, and other debilitating complications. Those knowledgeable about fine bamboo crafts realize that the processing techniques are an essential step, almost as critical as the initial careful selection of the bamboo. To make it suitable for some craft and commercial use, bamboo must be specially treated.

The processing and curing of bamboo has itself become a craft. And, as with any craft, the methods used vary. Training, regional differences, bamboo varietal differences, products to be fabricated, and personal style all influence the choices made in handling the material.[10] Some craftspeople execute all the procedures themselves, aiming for maximum control over the quality of the final product. In a small workshop, this allows the craftsperson to control the work flow, coordinating the procedure with the overall routine of the business. Others act as overseers, choosing to designate one or more workers as specialists in certain aspects of processing. Still others purchase processed bamboo from dealers who specialize in processing techniques and offer the results of their unique trade secrets. Years of working with the same dealer provides the security of guaranteed quality.

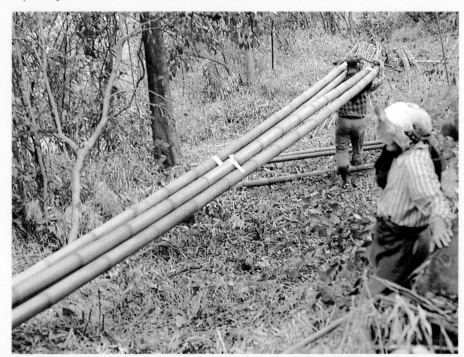

During harvest, poles destined for fine crafts are carefully handled and not allowed to sit on the ground.

Regardless of who executes the processing procedure, the user and collector can be sure that when processing decisions were made, the quality of the final craft product was always in mind. What would be desirable for an *ikebana* basket would be unnecessary for a harvest basket or a fence. The procedures used for a tea whisk would not be used for a rake.

HARVESTING

Traditionally, harvesting is completed in the late fall—November and December—when the sugar level in the bamboo is low. A hatchetlike tool is usually used, and at least three blows are needed to bisect all but the smallest bamboos. Recently, power saws have been introduced as well. Near the ground level, a cut is made just above a node to prevent the creation of a natural hollow that would collect rain water and cause rot to penetrate down to the rhizome. Harvested bamboo is left in the grove for as short a period as possible. Contact with the ground and lack of air circulation is conducive to insect infestation and rot, and is avoided whenever possible.

Although late fall may be the ideal time to harvest, individual craftspeople who harvest bamboo for their own use may have to collect specimens as and when the need arises. For example, if a temporary fence is to be erected, a farmer might cut bamboo without concern about optimum quality. If a craftsperson is making *miki-no-kuchi* for New Year's ornaments or small fence units, bamboo will be harvested as needed.

DRYING AND STORAGE

Prior to cleaning and processing, bamboo is stored, usually for as long as one year. For some crafts, such as field baskets, it is preferable to work the bamboo in its green state. For rituals in which the bright green of bamboo is symbolically significant (see chapter 10), it is harvested just before use. Nevertheless, the vast majority of fine crafts utilize bamboo that has been "aged" with storing and has had the oil removed. After cleaning, another period of storage may follow, the poles carefully placed to allow adequate air circulation around them. The practice varies from workshop to workshop and from product to product.

CLEANING

Most surface dirt is removed with fresh water, a duty often performed in a nearby stream. For most practical, everyday bamboo products, such as work baskets and rakes, the cleaning is cursory, removing, at most, the obvious surface dirt. Higher-quality products require a more gentle polishing technique using rice grain and polishing powders to avoid scratching the surface. Different varieties of bamboo require different cleaning techniques. For example, fine sand and rice straw are used for added friction to remove the white powder on the surface of some varieties of bamboo. *Gomadake* ("sesame-seed" bamboo) has small indentations on the surface and is often used in table-top items and display stands. The distinctive surface must be cleaned with soft electric brushes.[11]

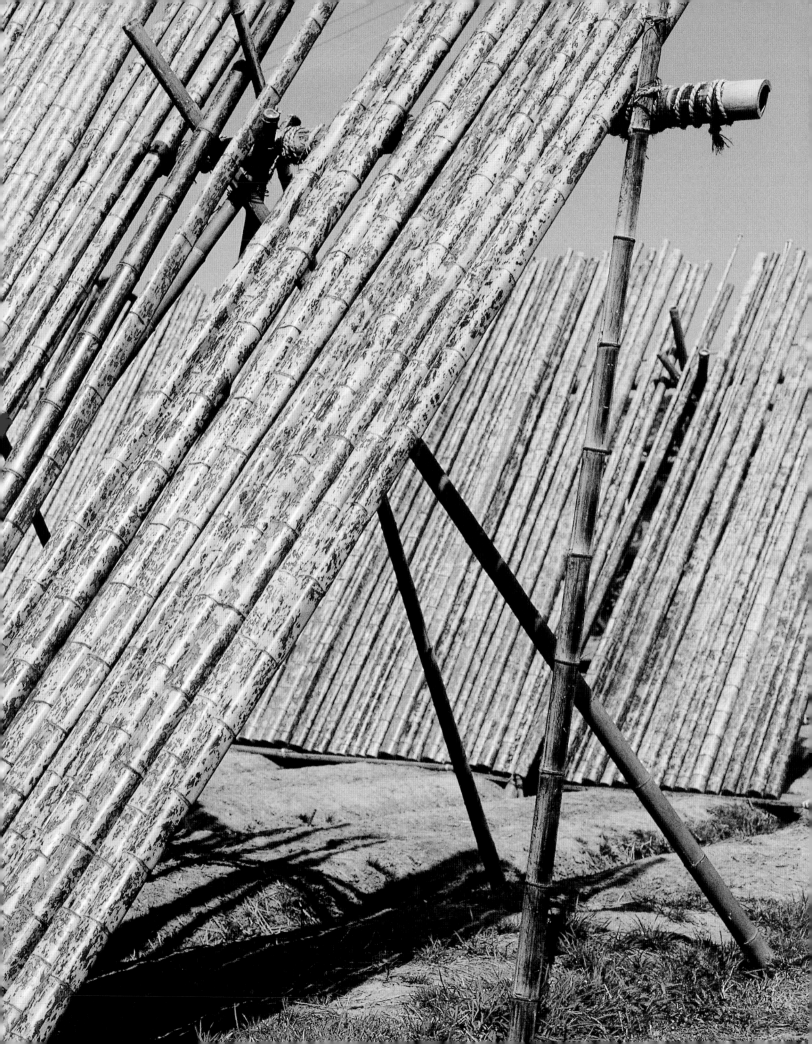

Older texts as well as contemporary craftsmen today often use the term *sarashi* to include the entire process of curing bamboo—drying, cleaning, oil removal, and any additional storage. Some Japanese craftsmen will use the term *abura nuki* (literally, "removing oil") for whatever procedure is used to bring the oil up to the outer surface of the bamboo. Regardless of the phrasing, the process reduces the starch (sugar) level, making the bamboo a less hospitable host for insects (boring beetles are a major problem) while hardening it at the same time. When *sarashi* is executed correctly, the resulting bamboo has a warm, evenly golden surface.

There are presently three basic types of *sarashi* procedures: immersion in water, dry heating, and chemical baths. Current experiments with chemical products, lasers, and microwaves may yield new techniques in the relatively near future. What is suitable for preparing bamboo for one product may be impractical or inappropriate for another. A large export business, for example, will use equipment that is different from an individual basket maker, but the process will accomplish the same goal, a higher-quality bamboo product.

Sarashi, regardless of which technique is preferred, can be done at any time of the year. However, most craftspeople avoid the summer rainy season. For many crafts, the storage period that follows the removal of oil is an essential part of the processing. It is not unusual for craftsmen to store their poles for several years prior to beginning their baskets, fans, or other fine crafts.

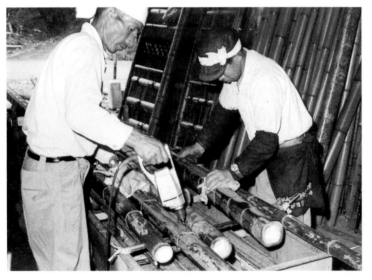

Removing the oil from bamboo poles is a time-consuming process. Here, one workman wipes oil from the surface while another drills small holes near the nodes.

WATER-IMMERSION METHOD

Submerging bamboo in water, either in pole form or cut roughly into quarters, allows the natural starch to be leeched out. It is the earliest technique known, and requires no equipment, only access to a body of water, natural or manmade. Because the bamboo may be submerged for a period of months, this method is not practical for all craftspeople. Some crafts, such as umbrellas, require the use of water immersion only at specific stages of construction rather than on the entire bamboo pole during the initial curing. The individual craftsperson has much more control with limited soaking.

DRY-HEAT METHOD

Hizarashi, as this method is known in Japanese, is a popular means of oil removal that requires only a reliable heat source and a skilled craftsperson. The heat source can vary from a small hibachi to a gas or charcoal-fired kiln that can accommodate multiple poles at once. Workers keep the poles moving constantly to prevent burning. As the oil—which some books refer to as wax—comes to the surface, clean cloths are used immediately to wipe the surface free of all residue. When no more oil emerges, the process is complete. The length of time varies considerably, depending on the variety of bamboo and its age, size, and conditions of prior storage.

Commercial equipment can be set to the specific temperature needed (220° to 240° F/120° to 130° C). Even today, individual craftsmen may prefer a small hibachi, and they know when the temperature is right and at what point their own process is complete. If yellow splotches of color appear on the surface, the bamboo skin has been permanently damaged, and this desirable outer layer as well as valuable time have been wasted.

Because the bamboo pole is completely penetrated by heat in this process, it becomes more pliable, and craftspeople often take this opportunity to straighten it. The still-warm bamboo is quickly placed in the open loop of a specialized tool, called a *tamegi*, and torque is applied until the pole has been straightened. Arrow makers use a hand-held *tamegi* (which may be only a foot long), but those working on large poles mount the tool (which may measure two by ten feet) to the floor and manipulate the bamboo itself. When the pole is straight, the end is weighted to maintain its position for a thirty-minute cooling period, after which the change in the pole's form becomes permanent. The newly processed bamboo can then be placed in storage. As always, care is taken to store it with proper air circulation.

The *hizarashi* method of oil removal is favored by many craftspeople who use whole uncut bamboo culms for their products. Because the process is slow and the penetration of the heat complete, they feel they have better control over each step in the removal process.[12] Whole culm units are prone to vertical breaks unless processed properly. To create special tea ceremony flower vessels from whole culms, slow aging of the bamboo means that the entire process, from harvest to finished product, could take as long as eight to ten years.[13]

WET-CHEMICAL METHOD

For the wet-chemical process (*yuzarashi*), poles are submerged in a boiling solution of caustic soda or sodium carbonate for approximately ten minutes and then wiped clean. This is repeated until the surface is completely clear of all foreign substances. If the procedure is stopped too early it often results in unattractive mottling later. During the process, the poles are watched carefully for any change in color, an indication that the solution is too strong.

The chemical solutions vary in strength depending on the personal preference of the craftsperson and on the type and age of bamboo being processed. Author Sato Shogoro, in his 1974 text *Zusetsu Take Kogei*,[14] suggests a 0.05 to 0.1 percent solution. Young bamboo may require an even lighter solution, while *moso* may need a stronger one. This wet-chemical treatment, an approach favored by the famous Nagai Chikusai processing plant in Beppu, is followed by open-air drying of the poles, at which point their color lightens. The resulting pole is easier to split and weighs much less than green bamboo.

A gas heater produces an even heat source for oil removal. Bamboo poles are moved in and out as a worker uses a clean cloth to remove the oil that has come to the surface.

DECORATIVE TECHNIQUES

In the heat of midsummer, selected bamboo culms are "painted" with a chemical-and-clay solution in order to produce the cloudlike patterning associated with *zumen-chiku*.

BAMBOO IS A BEAUTIFUL NATURAL MATERIAL for crafts, its original bright green turning a golden tan with processing or natural aging. Sometimes, if a decorative surface is desired for an architectural element or for use in furniture, one of several naturally patterned bamboos may be selected. Some varieties of *Phyllostachys nigra*,[15] for example, have darkened cloudlike markings that are often used in making basketry and other products. *Tosa torafudake*, called *torafudake* or "tiger bamboo" locally, has contributed to the development of bamboo craft companies in the Kochi area, where considerable acreage is devoted to the cultivation of bamboo. In the Tanba region of Japan, similarly patterned bamboo has been found and labeled *Tanba-hanchiku*.[16] Patterned bamboos are in great demand and are used extensively both for architectural elements and for craft items.

ZUMEN-CHIKU

In the Kyoto region, a technique has been developed to approximate the cloudlike patterns that occur naturally.[17] The resulting bamboo is often referred to as *zumen-chiku*. In July, an area within a grove of *moso* (or sometimes *madake*) is selected. Mature culms are "painted" as they stand with a dense solution of sulfuric or nitric acid, water, and a clay body that includes sand. This "chemical mud"[18] is applied with a long-handled brush made of rubber tire strips—each strip about four inches wide. The balance of ingredients is crucial, and skilled workers within the bamboo wholesale industry specialize in this technique. Since the solution is quite dangerous, protective clothing is usually worn.

The solution weakens the cell structure of the bamboo's surface and allows the formation of bacteria, which cause the darkening effect. During the following season, if it rains heavily enough to wash away the solution, the process must be redone. In the fall, harvesting proceeds as usual and is followed by careful cleaning and storage. If these culms were left in the ground another year, they would be so damaged that they would be virtually useless.

GOMADAKE

Gomadake is another patterned bamboo highly valued for crafts. The small dark lines on the surface of *gomadake* resemble nothing so much as roasted sesame seeds, called *goma*. Tradesmen sometimes refer to this pattern as *sabidake* as well, *sabi* meaning "rust." Ueda[19] identified a natural occurrence of this pattern in *megurochiku* bamboo, a variant of *hachiku*. Large quantities of *gomadake* are used in the production of table-top crafts—one-off small boxes, dining utensils, desk accessories, and so on. To accommodate this demand, a technique has been developed to produce this distinctive pattern artificially.[20]

Older *moso*, in particular, are selected for this process. In the spring, sometime between February and May, the branching top of the bamboo is cut off, and the remaining culm is left in place. During the June rainy season, the accumulating water at the top of the culm causes an outbreak of bacteria resulting in the desired discoloration. The summer months must be hot and sunny for the process to continue successfully. Harvest is at the end of the usual harvest season, going into December and January. If the weather doesn't cooperate—for example, if there is not enough rain in June, or the rainy season runs too long—then the pattern is not distinctive, and all the effort is wasted. When successful, harvest, cleaning (with added care), and processing proceed as usual.

SQUARED BAMBOO

Although there is a slightly quadrilateral bamboo[21] that occurs naturally, most bamboo that is distinctly squared was produced by a technique developed in the Kyoto region during the 1920s.[22] Larger bamboo is used most often in this process, in part because a frequent end use of the bamboo is for architectural elements that require such size. As the bamboo shoot emerges from the ground in spring, a four-sided wooden frame is placed over it. The diameter of the shoot, several inches above the ground, is the same as the final diameter of the resulting culm, so the frame must be carefully sized: if too small, the sides of the bamboo collapse inward; if too large, the squaring will not be distinct. The frame height is about eight feet, and every week or ten days the frame is refitted, moving it higher up to incorporate the fast-growing culm. The process is quite labor-intensive. Repositioning the frame must be done slowly so as not to mar the surface of the bamboo. Because the frames make the bamboo top-heavy, the individual culms within the grove must be tied one to another to keep them vertical. The resulting squared bamboos are especially striking and most effective for use in the *tokonoma* alcove in Japanese homes or tea ceremony rooms. Occasionally, the culms are framed into specific angles and, after harvest, are constructed into downspouts and gutters for special tea houses and gazebos.

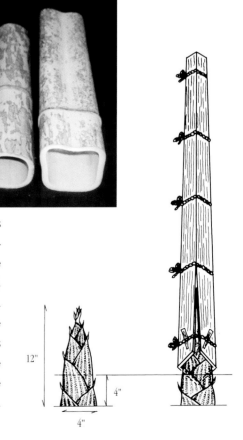

The chemical mud technique (see the discussion in *zumen-chiku*) is often applied to these squared bamboos to enhance the richness of the surface. When this combination of techniques is employed, the squaring process takes place first. When the desired shape is achieved, the frame is removed and the chemical mud applied. Both processes can be completed within one season and the results are dramatic. Longer pieces will be reserved for architectural elements. But even small pieces with only one node will be sold as containers.

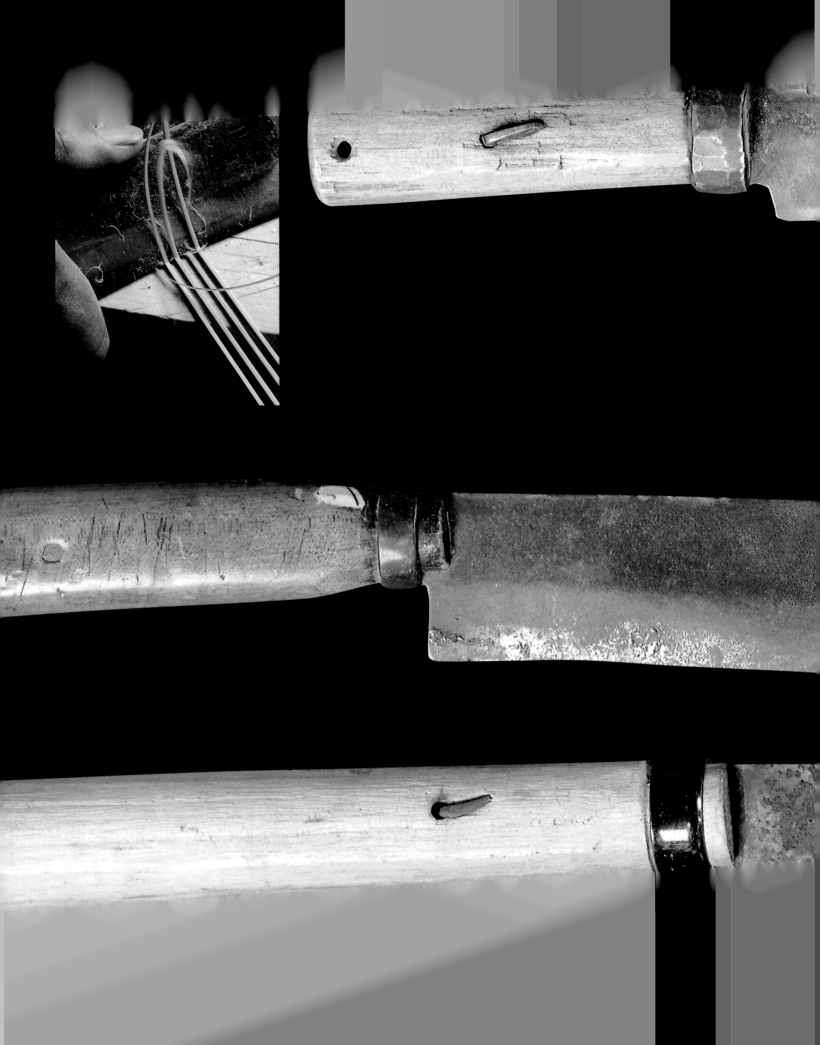

Chapter *3*

CRAFTS IN JAPAN

Higashi-san would like to retire, but if he did, who would make the tools for farmers in his area? He works in his blacksmith shop with the garagelike door open to the street, a magazine article about him pinned near the entrance. He writes the orders in chalk on the black metal hood over the fire, to be erased when each job has been completed. A teacher from the bamboo school in Beppu comes to pick up tools for his students. They chat about the quality of the metal, examine the edge of a knife together, and laugh while eating mikan oranges. . . .

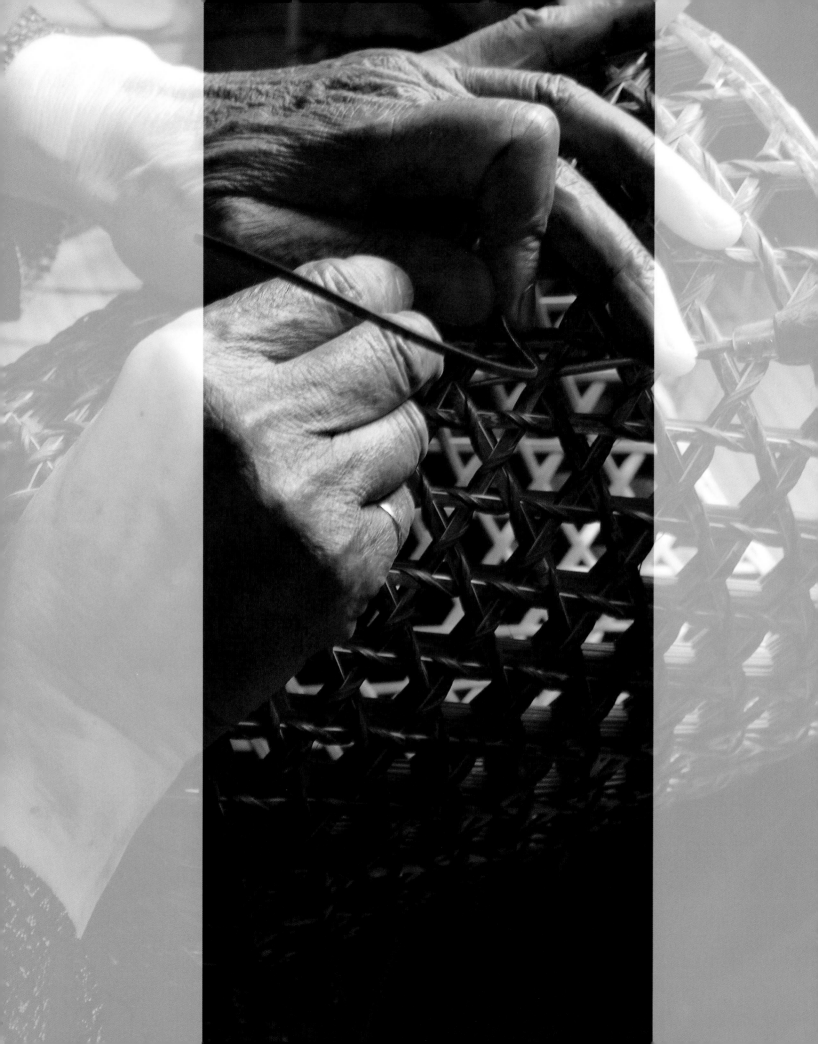

The road is steep as it winds up the hillside to the Onta pottery site, near Hita, on the southern island of Kyushu. The rivers rush swiftly to the valley below, and the power of the water activates the old-style mortar-and-pestle system—each pestle made from a tree trunk—that pounds the clay year round for these famous kilns. After about two weeks of pounding, the yellow clay is finally ready, and the craftspeople begin their work just as they have for three hundred years. . . .[1]

The basket maker sits near his teacher on a low platform in a department store in Tokyo. Under a banner praising the regional foods and crafts, historic landmarks, and natural wonders of their home prefecture, the two men demonstrate their considerable skill as they weave fine strands of bamboo into elegant flower baskets. A loud tape recording plays local music, and the air is filled with the aroma of baking senbei crackers and other local foods. After long hours of being questioned by many and ignored by some, they will pack up any unsold baskets and return to work once again in Shizuoka, Kawagoe, or Omiya—small towns never advertised abroad, never written up in American or European newspapers.

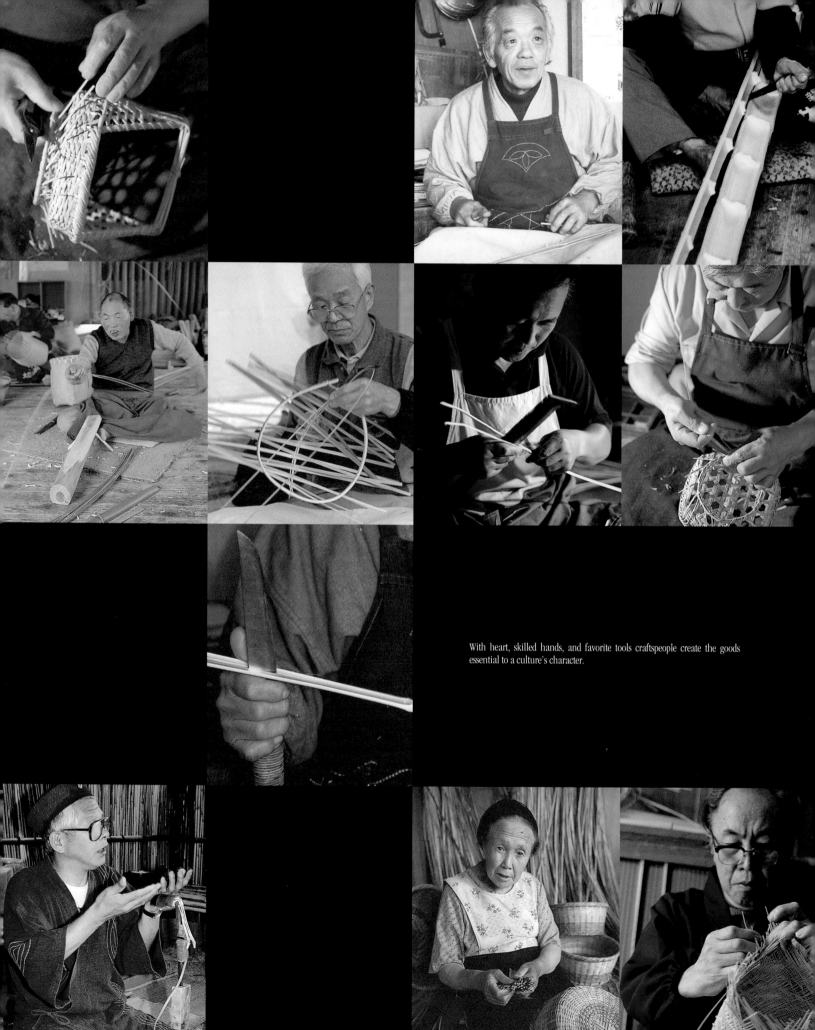

With heart, skilled hands, and favorite tools craftspeople create the goods essential to a culture's character.

Bamboo and cord—simple materials transformed into a form both beautiful and functional.

THE IMPACT OF *MINGEI*

Until the twentieth century, the Japanese vocabulary did not distinguish between art and craft. Unlike the Western world, the Japanese did not see a hierarchy in the art field, with fine arts considered superior to fine crafts. After the Meiji revolution of 1867, Japan found itself increasingly influenced by new exposure to Western ideas and industrial technology, and distinctions between art and craft began to emerge. Words like *bijutsu*, with its root of *bi* for "beauty," came to be applied to fine arts, and art museums took the name of *bijutsu-kan*. Craftwork was referred to as *kogei*, which had a slightly industrial/mechanical connotation, or as *getemono*,[8] "ordinary things made by hand." Everyday craft items were displayed in ethnological collections in natural history museums (*hakubutsu-kan*).

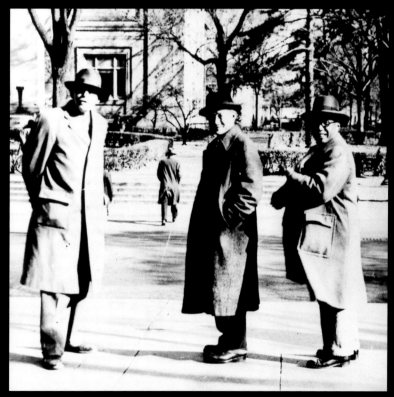

From left to right, Leach, Yanagi, and Hamada—three names forever associated with the *mingei* movement.

In the 1920s, a small group led by Yanagi Soetsu, a man who felt that "the quality of the life of a people can best be judged by its folk crafts,"[9] coined the word *mingei*, meaning "art of the people,"[10] to describe folk crafts. Yanagi himself is thought of as the savior of folk crafts by many; others consider him disingenuous. Regardless, his *mingei* concept continues to play a profound role in the Western perception of Japan's craft life. A spiritual, philosophical man, Yanagi was strongly influenced by rustic Korean crafts and felt the finest of crafts were made unselfconsciously by local craftspeople, using regional materials to create unsigned work that was to be used by everyone. He saw great beauty in these objects. His circle of friends included the noted British potter, Bernard Leach; Japanese potters Hamada Shoji and Kawai Kanjiro; screen printer Serizawa Keisuke; as well as philosophers and thinkers, few of whom remained anonymous in their work or writings. The Japan Folk Crafts Museum (Mingei-kan) opened in 1936 in Tokyo and continues to exhibit the Yanagi collection as well as international folk art. Even today, an exhibit of *mingei* anywhere in the Western world ensures a high attendance and provokes thoughtful, sometimes controversial, comments and reviews.

A PARTNERSHIP: Government and the Arts

The classic form of this basket is enlivened with a stylized Japanese wave pattern, a weave created by twining two narrow strips of bamboo simultaneously—a difficult technique to execute with flat materials.

BY THE END OF THE NINETEENTH CENTURY, the government was registering important religious landmarks under the Law for Preservation of Old Shrines and Temples.[11] This legislation was later expanded to include the fine and applied arts, such as statuary, textiles, and scrolls housed within these religious sites. Over time, the scope of the preservation widened. When the Law for Protection of Cultural Properties was enacted in 1950, performing arts and traditional crafts were included in the list of treasures designated worthy. These Cultural Properties were an accessible, living tradition the government hoped to save, support, and preserve, rather than merely catalogue. Not only were important individuals identified as "Bearers of Intangible Cultural Properties" (popularly referred to as Living National Treasures), but an emphasis was placed on regionality. In addition, art was moved out of museum storerooms into major exhibits of government-designated works, regularly mounted nationwide to ensure that the Japanese people see, enjoy, and honor the creativity of their countrymen. Individual grantees were responsible for providing training services and for making their own work available for public view.

When much of the world, in part led by Japan, rushed into computers and industrial technology, the Japanese government had the foresight to take further steps to support the crafts most in danger of disappearing behind a façade of plastic and silicon chips. As in Yanagi's time, the belief was that the tradition, warmth, beauty, and intimacy implicit in fine craftsmanship offered balance in a fast-changing culture. In 1974 The Law for the Promotion of Traditional Craft Industries outlined far-reaching provisions not only to preserve resources, but also to protect craftspeople themselves. The law was designed to give status and prestige to specified traditional crafts in the expectation that such recognition would result in consistent high standards and increased visibility, ultimately preserving and perpetuating these great national resources. By identifying categories of objects to be protected, a new, officially sanctioned definition of what constitutes fine Japanese crafts was initiated. The law is quite specific as to how designated crafts are to be selected. Under the direction of the Minister of International Trade and Industry, local and municipal governments are empowered to process the initial application. To qualify for designation, a craft must be (1) used in daily life, (2) made primarily by hand, (3) manufactured by traditional techniques dating back at least to the mid-1800s, (4) made primarily with traditional materials, and (5) involve a substantial number of people—ten businesses or thirty individuals.

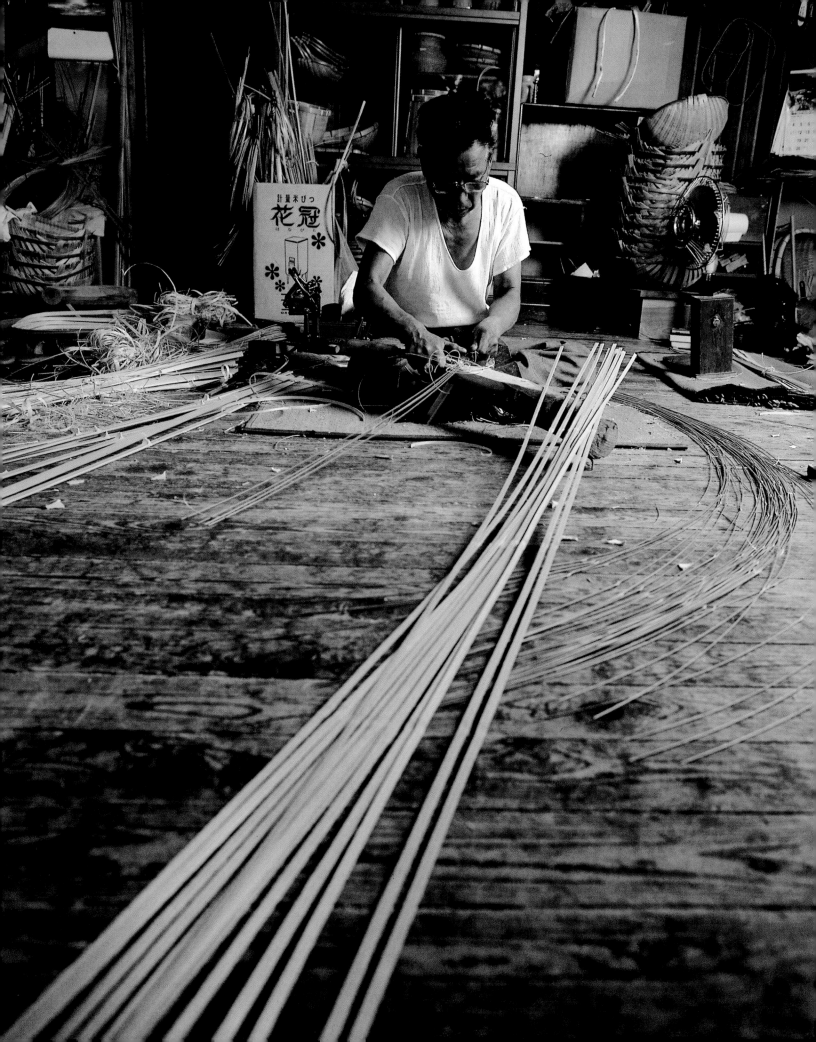

The question of regionality is especially significant as it supports the continuance of diversity in fine crafts and discourages homogeneity. For example, the Suruga basketry of Shizuoka (see chapter 4), a region near Mount Fuji, is distinctive in its use of round-cut bamboo elements carefully fitted into a framework that results in baskets, mirror frames, and cages for insects and birds. While this technique is practiced in other areas of Japan to a limited degree, in Shizuoka, Suruga *zaiku* began in the first half of the seventeenth century, and a large number of businesses and families have been involved in the work for generations. Thus, a craftsperson in Chiba Prefecture, who makes cricket cages utilizing similar techniques and with the same skills, would not be eligible for this particular designation. If he were truly dedicated and skilled, he might be eligible for a local title as a valued *shokunin*. The traditional basketry of Oita Prefecture is the direct result of both the abundance of quality bamboo groves in this subtropical area of Kyushu and the fact that basketry was a by-product of the flow of tourists to natural hot springs in the town of Beppu. Had there not been bamboo, the baskets might have been made of bark. Had there been the bamboo but not the hot springs, the bamboo might have become archery bows as it did in nearby Miyazaki Prefecture.

The Japan Traditional Craft Center was founded in 1975 and opened its doors in the heart of Tokyo a few years later. The facility continues the tradition of displaying fine workmanship begun in the early 1900s with its large exhibitions, sponsored by the Department of Education, although the center's main objective is selling. With support from the national government and local associations, all 184 designated traditional crafts are displayed to emphasize regionality. Crafts so designated, whether shown here or in local workshops and stores, bear the Mark of Tradition label, a distinctive design that includes both the red sun symbol of Japan (seen on the national flag) and part of the Chinese character meaning "tradition." The Center, with the Mark of Tradition logo prominently displayed, offers a full-immersion craft experience. Here, one can purchase a traditional diagonal-weave storage basket woven in Beppu, see a detailed map of the region surrounding Beppu and the bamboo workshops located there, watch a video about Shono Shounsai (the Beppu basket maker designated a Living National Treasure), and read a book about the history of bamboo crafts in the area.

The result of this system of merit designation is multifaceted. Designated craft businesses thrive with the increased visibility and status that come with the Mark of Tradition. Well-publicized exhibits in major department stores, small museums, and regional craft facilities advertise and help to draw a wider audience for crafts far from the site where they are painstakingly created. During regional product fairs, often staged in large urban department stores, the local bamboo crafts are sold side-by-side with famous food items and other regional specialties. The economic benefits to any region with a designated craft are substantial. The area becomes more appealing as a tourist destination. The craftspeople flourish, as do the farmers, innkeepers, restaurants, and craft shop workers.

Prefectural governments have followed the national government's lead and have designated their own regional craftspeople. Prefectural museums exhibit their crafts, television stations visit the workshops, and department stores feature local craft demonstrations. In 1996, when a major craft event at the huge Tokyo Dome exhibit space was mounted, one could hardly move through the crowds. Craftspeople ran out of brochures, knife makers sold out on several styles of knives, and Miyazaki bow makers grew exhausted from demonstrating their techniques nonstop to a demanding audience. It could not have been more clear that fine crafts were alive and well in Japan.

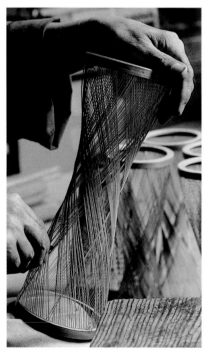

Round-cut bamboo elements are characteristic of the Suruga bamboo ware associated with the Shizuoka region of Japan.

CRAFTS REPRESENTED IN ART AND DESIGN

JAPANESE CRAFTS HAVE many incarnations. First, there is the craft itself, useful and beautiful, serving the function for which it was designed. The fan cools, the comb untangles, the iron pot heats water, the toy entertains, the hat protects, the basket holds flowers and vegetables, the religious ornament evokes the sacred. It was this very connection between use and beauty that Yanagi found so appealing. But crafts in Japan have a significance beyond their use because of their importance as design motifs that embellish and adorn the implements of daily life.[12] Toys and masks are stenciled on summer kimono, fan motifs are printed on fabric and paper, arrows are carved into the molds for incense burners and painted in ceramic glazes, and ikebana baskets are painted on fans and elaborate golden screens. Illustrated books devoted to *shokunin* became popular from the seventeenth century, attesting to the importance of the craftspeople themselves. *Shokunin* in various stages of craft-making—dyeing fabrics, drying umbrellas, or constructing buckets and barrels—were made famous worldwide by artists such as Hokusai. Like some of his contemporaries, Hokusai also published design books whose motifs, which were to be used as inspiration for paper and fabric designs, included crafts items (umbrellas, tops, etcetera) among the painted vines and geometric shapes.

Family crests (*kamon* or *mon*) have been used for centuries in Japan to identify family possessions.[13] In war, *kamon* were prominently displayed on banners to identify troop affiliations. Clothing, helmets, and storage baskets all displayed *kamon* as a symbol of the family itself, and this practice continues today, albeit to a lesser degree. Emblematic of a culture that relishes its connection to nature, *kamon* often feature plants—flowers, bamboo, pine—as the primary design element. In addition, these crests frequently include beautiful miniaturized and stylized renditions of manmade objects, especially crafts. Among these small design treasures are representations of temple bells, helmets, umbrellas, hats, candles, anchors, fans, keys, and *temari* thread balls. It is a matter of pride to wear a crest on one's kimono, and long ago the family was mindful that the choice of design reflected the family's status. A fact that so many families chose to identify themselves so proudly with crafts is a tribute to the crafts themselves.

Crafts are often incorporated in crest designs. Here, fans, arrows, and umbrellas are featured, each of which relies heavily on bamboo in its production.

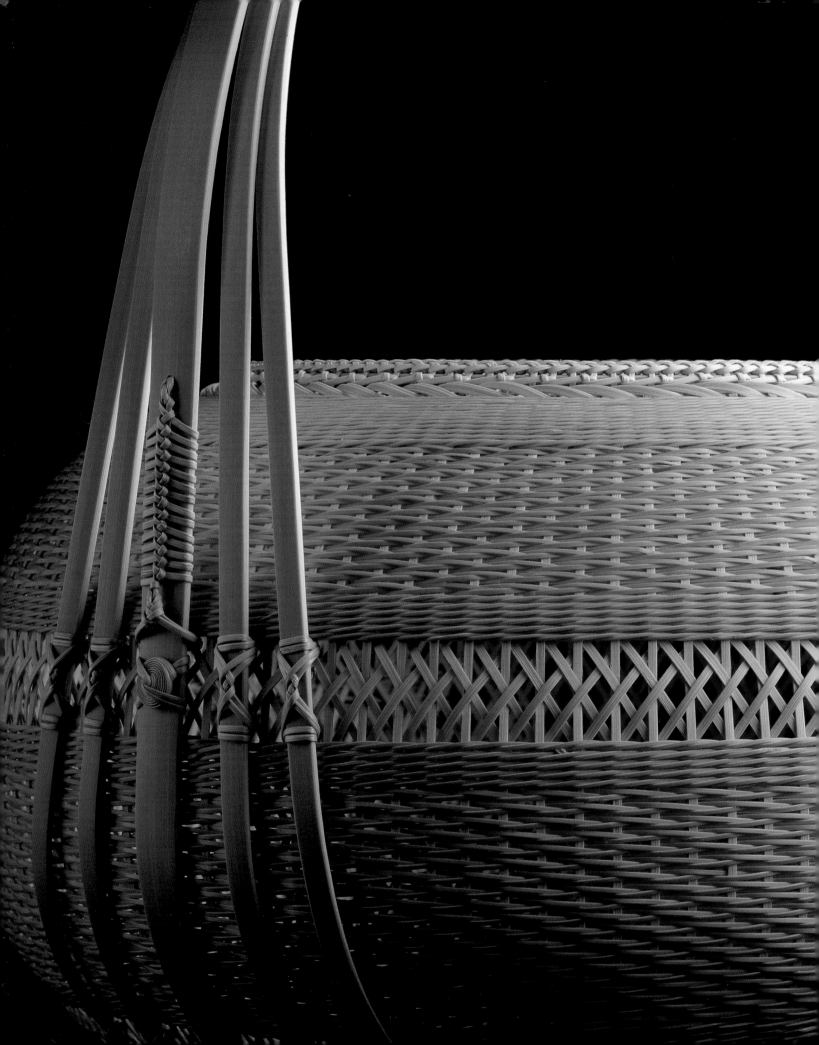

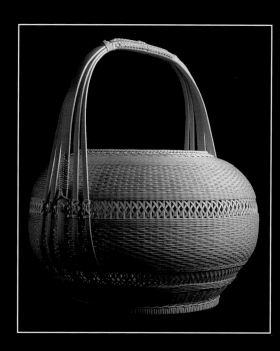

BASKETRY

Japanese bamboo baskets are used to deliver beer, hold singing crickets, inspire artists, carry rocks, collect fallen leaves, hold tea ceremony charcoal, display flowers, catch summer beetles, offer dry higashi *sweets, trap fish, and gather vegetables in the mountains or tea leaves on gentle hillsides. Baskets hold bamboo shoots and bonito flakes at morning markets, store kimono, keep rice warm, and decorate the home. From garden to gallery, and tea ceremony hut to fishing boat, baskets have a unique position in Japan— they are the ubiquitous bamboo craft.*

Iizuka Shokansai's *Wind in the Pine*, completed in 1993, reflects his recognized ability to marry tradition with superb design. (Courtesy of Tai Gallery, Santa Fe, New Mexico; photo by Pat Pollard)

BASKETS, BASKETS, BASKETS

AMONG ALL JAPANESE CRAFTS, basketry holds a unique place. Basketry alone covers every phase of life in Japan. It serves all socioeconomic strata of the population and spans the full spectrum from kitchen disposable to museum piece, from garden to gallery, and from utilitarian object to art. The diversity in basket forms, weave patterns, and functions allows basketry to contribute to all aspects of Japanese life. Despite bamboo's simple properties, craftspeople continue to create a never-ending variety of beautiful and complex baskets that reflect their uses in earlier times.

There are two kinds of bamboo used in basketry: green bamboo (*aodake*) direct from the grove and processed, or cured bamboo that has had the oil removed (*sarashidake*). Oil is removed primarily to prolong the life of the bamboo. The process is time-consuming, and for strictly functional baskets which are replaced frequently, unnecessary. The simplest work baskets are made with green bamboo. These are baskets of the field, the garden, and the roadside and are woven in a strong plain or open-hexagonal weave of *madake* bamboo, often with an exoskeletal support system of the larger, stiffer *moso* bamboo. The handles must be an integral part of the support structure to provide the strength needed

Sebe Kozan designed this basket for flower arranging, but it is so beautifully proportioned, it can easily be displayed alone.

for the loads they will carry, and larger work baskets often have handles framed in wide bands of rigid *moso* for reinforcement. The carrying straps of backpacks and fishing creels are designed to free the hands for harvest or fishing and are made of strong cord easily replaced, plaited strips of bamboo, or bands of finger-woven fabric remnants. Seen often in the media, work baskets remind the viewer of the beauty of everyday life and evoke a kind of nostalgia (*natsukashi sa*), sometimes for a lifestyle only imagined.

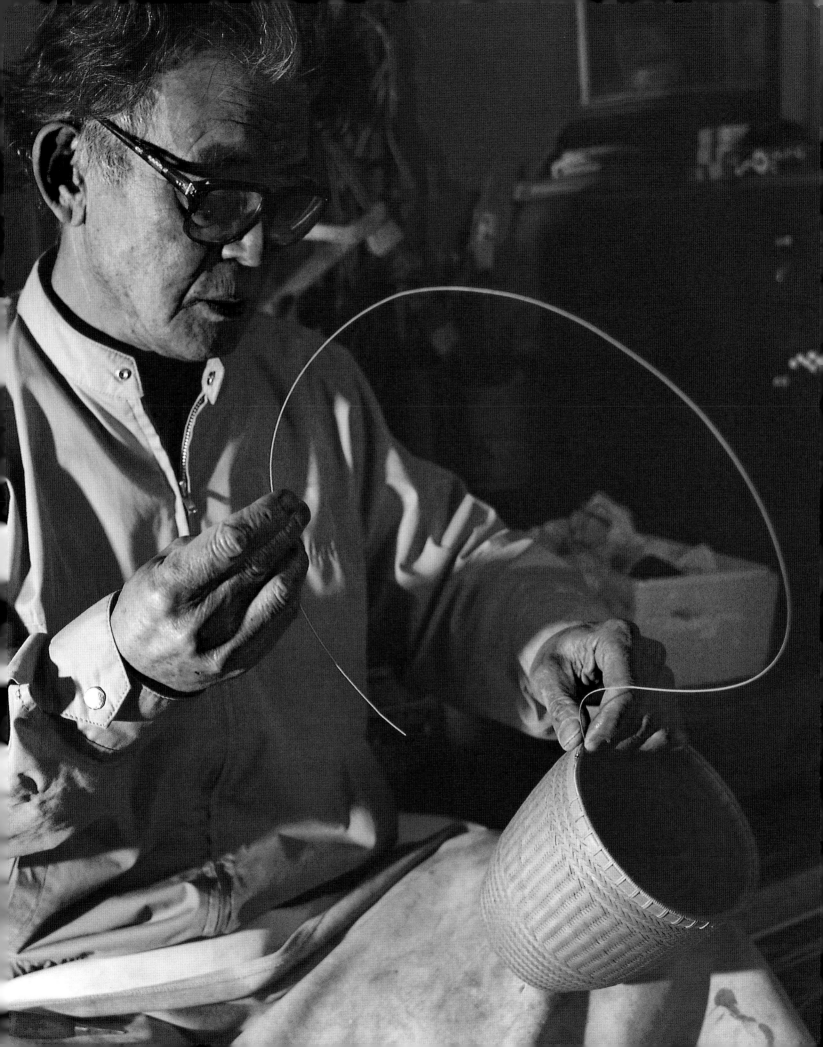

REGIONAL VARIATION

There are several regions in Japan that are known for distinctive basketry styles.[1] In the town of Beppu on the southern island of Kyushu, bamboo businesses developed as a direct result of the area's natural hot-springs (*onsen*) tourism and have evolved to include a much wider range of products than the food-presentation, clothing, and towel baskets seen at all Japanese resorts. A dark lacquer finish is a trademark of the region. A complex twill weave (*ajiro*, a term applied to fence weaves as well) is used on rectangular storage baskets, such as those used for kimono. Smaller versions are suitable for writing materials and documents. For the tea ceremony, formal shapes tied with wide bands of braided cord (*kumihimo*) hold utensils. A low, large-mouthed basket that holds charcoal specific to the ceremony is woven in a simple twill-weave pattern and lined with black paper before the lacquer process. These formal containers contrast sharply with the other patterns for which Beppu is famous, open-weave baskets (e.g., *tessen* and *yatsume* weave patterns) made of a light-colored *sarashidake*. Despite the open weave of their diagonal patterns, they are nonetheless strong enough to be used as large trays. For greater stability, the edge is wrapped using techniques ranging from simple lashing to multistep procedures, with names such as "arrow" (*yahazu maki buchi*) and "shrimp" (*ebidome buchi*) that reflect the classic pattern wrapped into the border.[2]

Below Mount Fuji, the Shizuoka area is home to another unique basketry style—openwork characterized by round strips (*maru higo*) rather than flat elements—which is commonly known as Suruga bamboo ware. These round elements most resemble manufactured materials or some commercially cut rattan products, and the visual effect is simpler than the complex twills of Kyushu and the more formal baskets of Kyoto. However, the construction of Suruga bamboo ware is actually quite time-consuming and requires considerable skill. The first stages of the splitting process are similar to those for all woven products—the clean bamboo is cut into narrow strips, almost square in formation rather than thin and flat. The process then diverges. In order to round out the square, each piece of bamboo must be pulled through a metal drawplate into which successively smaller holes have been drilled. It is a long, slow process, and the craftspeople know at which hole to stop for each specific project. The resulting round pieces are bundled and later cut to exact lengths. Eventually they are glued into a framework of bamboo prepared at the same workshop, though not necessarily by the same craftsperson. In contrast to the assembly of umbrellas and paper-covered boxes, the entire process for making Suruga ware takes place at one site.

With all products utilizing cut bamboo—fans, umbrellas, baskets—the bamboo is made pliable through the application of heat or by soaking in water. In Suruga ware, heat is used almost exclusively to shape the curved frame and to facilitate the manipulation of the individual round elements into distinctive shapes. There is also noticeably more use of power tools here than in the preparation of bamboo for other products. Though the individual elements are cut and shaped by hand, electric saws, drills, and heaters are used for preparing the frame and shaping all the materials. Individual craftspeople take great pride in their tools, and the draw-plates and heaters are often made by the people who use them, the tools being viewed as extensions of themselves. In Suruga ware, *construction* is the key word.

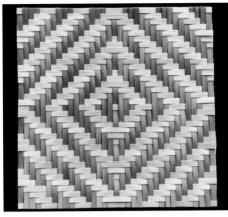

Masu-ajiro; radiating twill pattern.

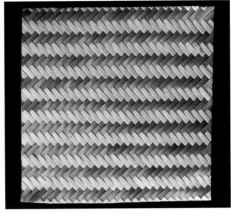

A common *ajiro* pattern.

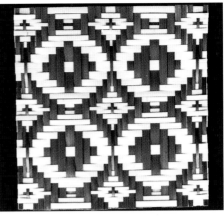

A mixed color *hana-ajiro* pattern; flowerlike.

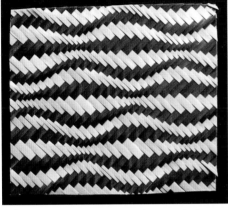

Nami-ajiro pattern; frequently used in storage baskets.

Finely split bamboo.

Soko-ami; popular basket base.

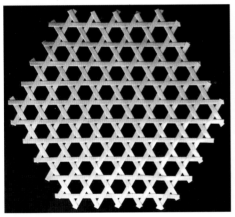

Mutsu-me; basic pattern; open-hexagonal weave.

Yotsu-me; basic pattern; simple open-plain weave.

Mutsu-me; dense diagonal weave suitable for trays and baskets.

Open-plain weave of large elements; suitable for work baskets.

Pattern for round baskets; chrsanthemum-like.

Yotsu-me, ikaki-ami on basket side.

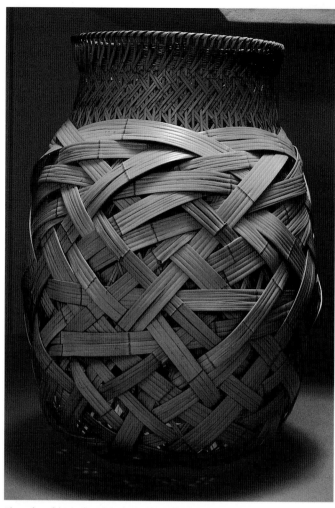

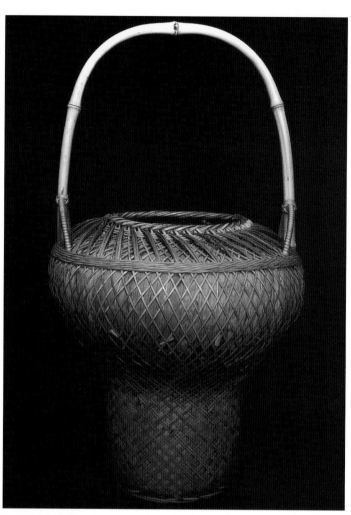

The surface of this work made by the Bamboo Industrial Art Research Development Institute in Beppu appears to be woven in a random pattern, but beneath the top layer lies a carefully constructed basket which functions like a skeletal support system.

The high arch of the handle is an essential part of Iizuka Hosai's basket design—it creates a frame for the flower arrangement yet to come.

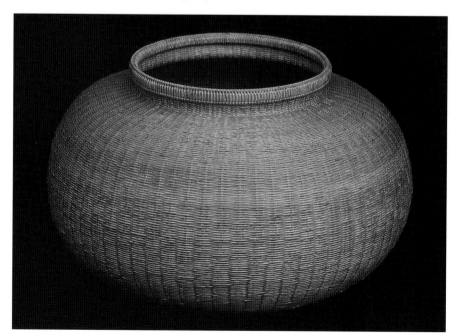

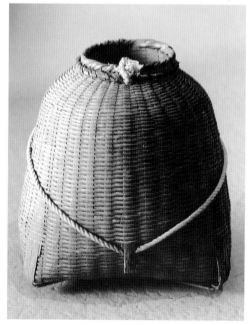

Tanabe Chikuunsai II. Hours and hours are required to weave finely cut bamboo strips into such a large, precisely formed vessel, a style associated with Chikuunsai I.

Beautiful enough for flowers or a folk art collection, this 120-year-old basket was originally a modest fishing creel.

BAMBOO IN THE KITCHEN: More Than a Sushi Mat

Bamboo serves many functions in the Japanese kitchen, but bamboo baskets make the most obvious contribution. Many home kitchens have five to ten *zaru*, simple woven bamboo basket-trays used to drain and rinse *soba* noodles, spinach, and blocks of tofu. In *soba* shops, cold *soba* noodles, the connoisseur's choice, are served on a square lacquered *zaru*. In displays and advertisements, the *zaru* is used to display seasonal fruit, freshly caught fish, or the first bamboo shoots of spring. The utilitarian *zaru* are as familiar to stainless-steel counters as to the rustic, hand-planed wooden ones.

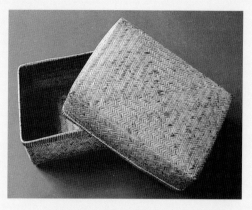

In some Japanese homes, the woven *o-bento* basket is a thing of the past. Yet each spring, department stores continue to display a new selection of bamboo *o-bento* containers and kitchenware—back by popular demand.

Another small basket—lidded, rectangular, and woven of fine *sasa* bamboo—is used as a lunch box (*o-bento*) throughout Japan. In competition with the brightly colored plastic versions decorated with images of favorite cartoon characters, these baskets, lined with bamboo leaves (which are naturally anti-bacterial) and filled with rice, pickles, and a favorite treat, still appear at family outings and occasionally in the classroom.

Baskets used in the kitchen, or in connection with food, come in a wide variety of shapes, sizes, and weave patterns, each variation determined by the function served. Deliveries of groceries or beer are made in flat-bottom baskets that fit on the back of delivery bicycles, and last night's cooked rice is held in a round, lidded basket with bamboo feet. Bamboo scoops for rice and round banded trays for steaming are still common in the Japanese kitchen, but other types are becoming scarce, some now made only as display items or for private collectors of folk art.

STORAGE

A variety of bamboo storage baskets are found in many Japanese homes, particularly in rural areas. A traditional favorite is a larger version of the fine bamboo *o-bento* basket. A low, rectangular form (of either willow or bamboo, depending on the region), these baskets are woven in a simple twill weave, often with leather squares protecting the corners. The shape of this basket, referred to as *take zori* when woven in bamboo, reflects the shape of a folded kimono, and the storage of kimono is its primary function. Because the sides of the lid slip over and completely duplicate and reinforce the sides of the container, this basket is stronger than would be expected of a receptacle woven of such fine material. Smaller versions store everything from sewing accessories to documents and linens.

The shelves of this Tokyo shop are filled with lacquered baskets traditionally used for kimono storage. The bamboo "under-baskets" of these remaining four will be covered with paper and many layers of lacquer. The bamboo brush, handmade by the craftsperson, is easily replaced.

Traditionally, kimono are also stored in paper-covered bamboo baskets of a similar shape. The bamboo frames of these are often woven at one site and then shipped to the place where the final steps of covering, lacquering, and stenciling with the family crest (*kamon*) will be completed. For example, some of those baskets could be woven on Sado Island in the Sea of Japan, but finished in a Tokyo shop on the other side of the country. Various sizes are available, but the kimono storage version remains the most popular. Recently, when a sumo wrestler was promoted to the highest rank of grand champion (*yokozuna*), a local basket maker from his home region in Kyushu was kept busy for several weeks creating all the baskets needed to store the ceremonial aprons (*kesho-mawashi*) given to the new champion by his enthusiastic supporters.

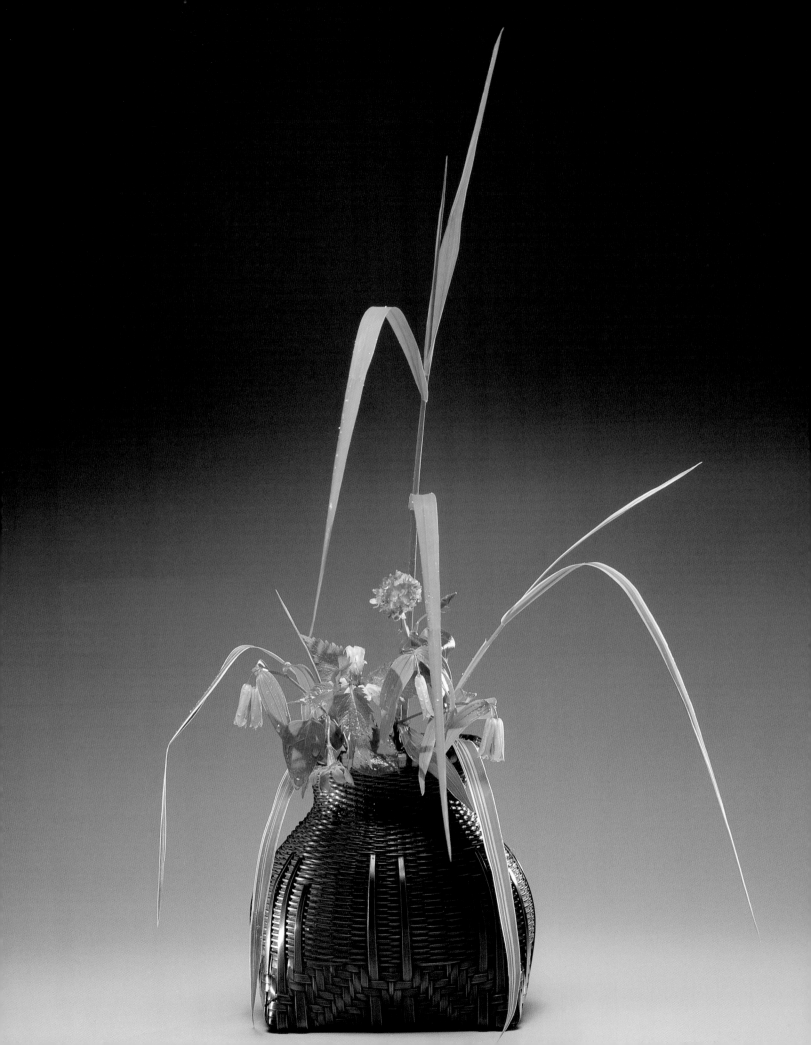

The dark form of this basket offers a perfect complement to the arrangement—suitable for city apartment or country home.

BASKETS FOR *IKEBANA*

THE CUSTOM OF OFFERING FLOWERS TO BUDDHA

became very popular in the seventh century. What began as simple presentations of hand-held lotus blossoms developed into the *ikebana* arrangements of today. The offering became a studied art, and its development is well documented in historical scrolls, books, and prints. Yet flower arranging in Japan goes far beyond decoration. *Ikebana* heightens the student's awareness of nature, seasonal changes, and plant life.

In contrast with *chabana*, in which flowers for the tea ceremony are arranged with a natural, unselfconscious style (see chapter 5), *ikebana* arrangements follow styles as prescribed by the various schools, with Sogetsu, Ikenobo, and Ohara being among the best recognized. Each school has its own rules about how to use flowers at different stages (buds, partially opened blossoms, flowers in full bloom), which traditional form to emphasize (e.g., *rikka*, "standing flowers"; *moribana*, "profuse"), and what scale and proportions are appropriate for arrangements. Each master has his or her favorite plant materials and containers. However, in each arrangement, regardless of school or teacher, the relationship between vessel and plant material is key. The vessel selection ranges from simple ceramic vessels and baskets to antiques and found objects, such as cupped broken roof tiles and plastic tubes. The baskets range from utilitarian field and fishing baskets to those elaborate, multilayered constructions woven in a style inherited from China centuries ago. The historical context of these baskets is reflected in the use of terminology (*shin*, formal; *gyo*, semiformal; *so*, informal), a Chinese classification system originally applied to ancient calligraphy.[3] To the collector of Japanese antiques, these baskets exemplify quintessential Japanese aesthetic quality, and they command both attention and high prices—thousands of dollars—in antique shops worldwide.[4]

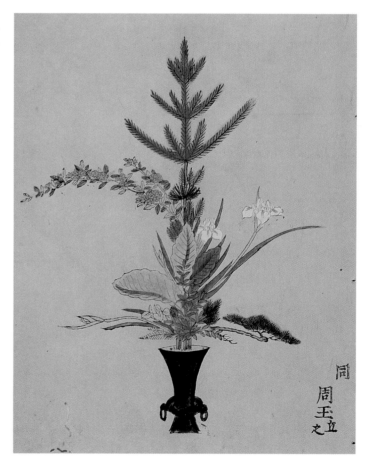

This drawing from a seventeenth-century text illustrates the formality of early flower styles. The containers—whether bamboo, celadon, or bronze—were symmetrical and supportive of the strong vertical line.

BY THE BEGINNING OF THIS MILLENNIUM, only three craftspeople working in the field of bamboo had been distinguished as Bearers of Intangible Cultural Properties. That they were all basket makers highlights the importance of basketry in the world of bamboo. Bearing the title Living National Treasure, each of these basket makers made his own distinctive contribution to what is finally recognized as basketry's significant place in Japan's cultural history. One objective of such designations was to preserve traditional arts and share this rich history with the Japanese people (for a full discussion, see A Partnership: Government and the Arts, in chapter 3). By designating these three craftspeople—Shono Shounsai, Iizuka Shokansai, and Maeda Chikubosai II—the sponsoring agency insured their place in history. The public viewing of their work at regular exhibitions has become a source of national pride.

In 1967, Shono Shounsai became the first bamboo artist to be designated a Living National Treasure. His early work reflected the formal Chinese baskets that first attracted him to basketry—precise and complex works with elaborate centers and lashed rims. However, the pieces which are now more closely associated with his name are *visually* more simple and more sculptural, though no less precisely constructed. He always maintained that, as a craftsperson, he had to be "true to the spirit of the bamboo"[5] and work with its natural characteristics.

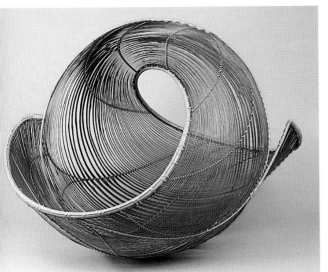

Shono Shounsai's basket, entitled *Doto* ("Surging Waves"), was made in 1956 and, even today, exemplifies his vision and skill.

Iizuka Shokansai was awarded the designation in 1982. Unlike Shono, he came from a family of bamboo artisans, and his father, basket maker Iizuka Rokansai, is considered the major influence on modernizing bamboo in the twentieth century. His own work has a traditional feel along with a sense of almost perfect balance and composition.

The last bamboo basket maker to be honored with the designation in the twentieth century, Maeda Chikubosai II was named in 1995, nearly thirty years after Shono. As his name implies, Maeda studied with his father, though his work is his own, and marries function with sculpture.

Not unlike some of the Living National Treasures, many of the recognized basket makers of today worked first as apprentices (*deshi*) to master craftspeople. There they learned more than technique: they learned self discipline and judgment as well.[6] That many were the sons or adopted sons of the masters often complicated the relationships,[7] but still, a new generation of master basket makers has emerged and continues today.[8]

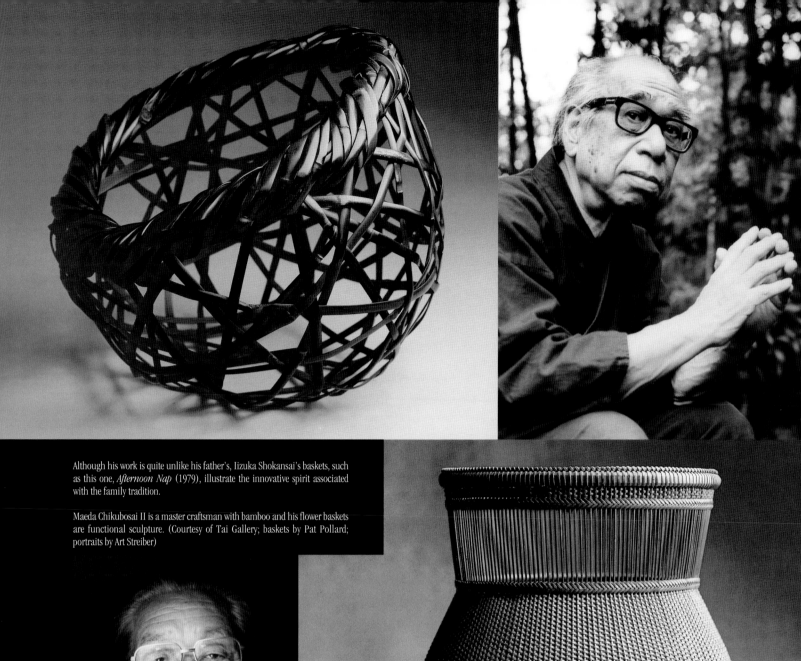

Although his work is quite unlike his father's, Iizuka Shokansai's baskets, such as this one, *Afternoon Nap* (1979), illustrate the innovative spirit associated with the family tradition.

Maeda Chikubosai II is a master craftsman with bamboo and his flower baskets are functional sculpture. (Courtesy of Tai Gallery; baskets by Pat Pollard; portraits by Art Streiber)

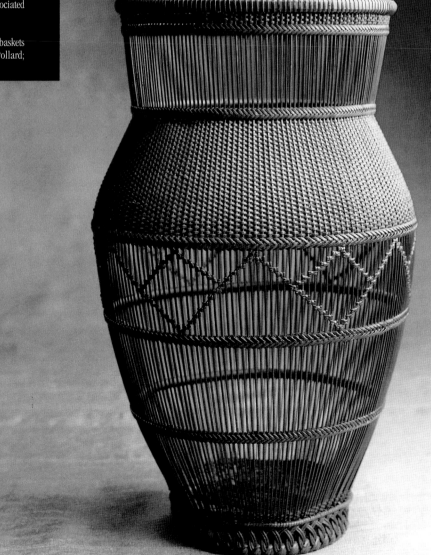

NEW AND INNOVATIVE

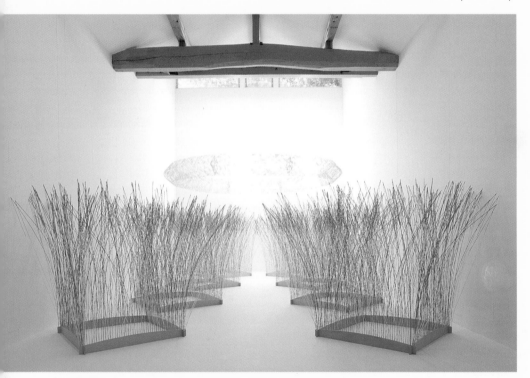

Textile artists Naomi and Masakazu Kobayashi sometimes collaborate on large installation pieces. In *Sound from the Cosmos* (1995), finely cut and painted bamboo elements introduce color, vertical line, and movement.

YOUNG BASKET MAKERS WHO WORK with traditional forms are guided and inspired by older examples. Some follow with precision, others make modest adaptations for use with flowers or as sculpture. In production workshops, simplified versions of classic baskets are constantly in demand, and if, in some, the cutting and finishing is less than perfect and the product made by rote, the resulting form can still be pleasingly familiar and available within a reasonable price range to the general public.

At the other end of the spectrum are a small number of contemporary basket makers who do not look to basketry masters, *ikebana* baskets, regional styles, or traditional examples for their inspiration. Some are largely self-taught or have moved away from their roots. Though little recognized in Japan, a few of these basket makers have achieved international recognition. Sekijima Hisako and Nagakura Kenichi, for example, use traditional techniques (knotting, weaving, wrapping) to create sculptural forms that are nonfunctional in the classic sense. Their vessels, whether created in bamboo, *akebia* vine, or bark, encourage discussions about space, tension, and form. Sekijima is the most widely recognized of this group, with work in such major collections as the Victoria and Albert Museum in London and Lloyd Cotsen's private collection.[9] Occasionally taking up residence in the United States and Europe, Sekijima exhibits extensively[10] and is held in high regard in the textile field known as art basketry. A much sought after teacher, she is an articulate proponent of the sculptural use of natural materials, and her many students follow a similar course of exploration. Nagakura remains in Japan, but is now receiving recognition, especially in the United States, for his baskets in bamboo that have a presence far greater than their size might suggest.

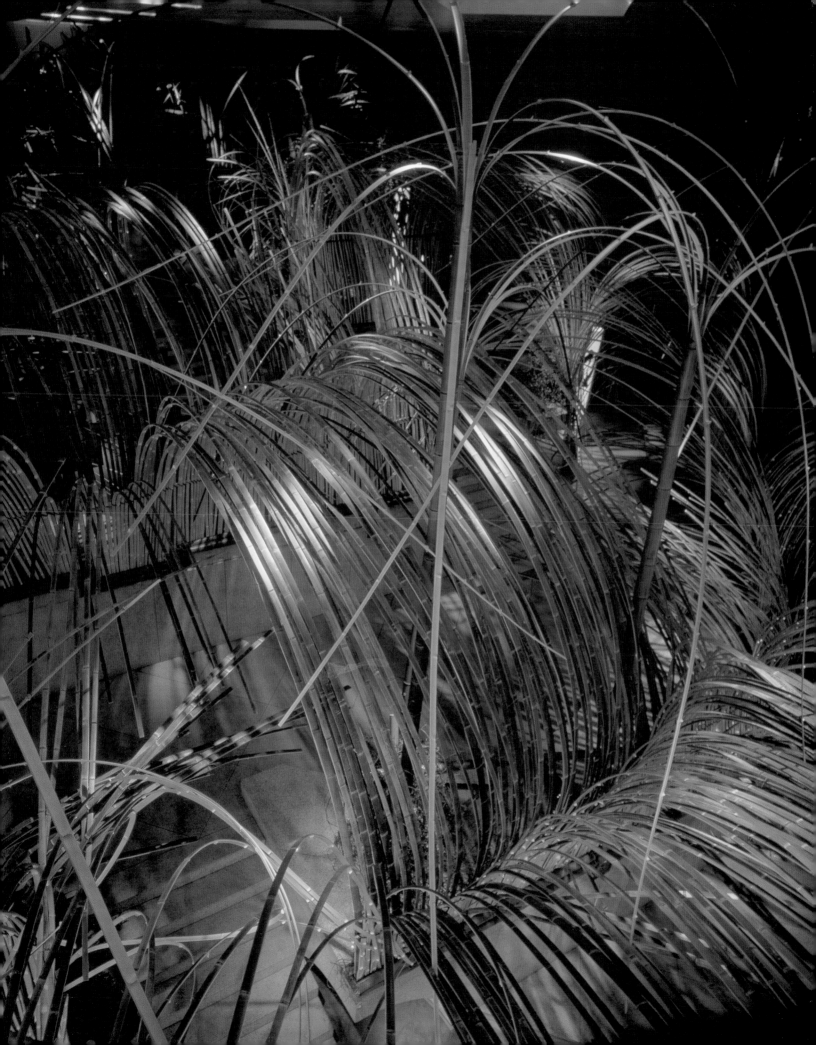

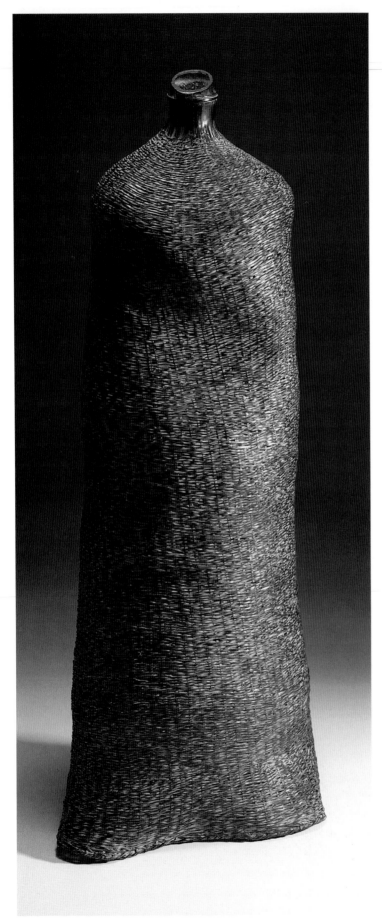

His vessels are often finished with ashes forced into the weave, which mute the dark bands of bamboo and create a skinlike surface that emphasizes both form and texture. Yonezawa Jiro has chosen another direction. Trained in Beppu, he risked moving permanently to the United States, where his reputation has grown as quickly as his exhibition calendar. He has transformed the lacquered, twill-patterned form associated with Beppu into a sculptural vessel. He now adds cedar roots from his adopted home region, Oregon, and completes each piece with his unique lacquering technique.

The Japanese art community is not favorably disposed toward the art basketry field, and other nontraditional basket makers work quietly and diligently, hoping to find advocates for innovative forms. While fine art galleries that exhibit quality ceramic and lacquer wares may be reluctant to show contemporary basketry, Japan has rental galleries that offer an opportunity to exhibit in central urban areas, even if only for a very short time. Individuals or groups of artists use these occasions to attract interest and, ideally, to expand the audience for such innovative basketry.

Elegant and refined, the figure in Nagakura Kenichi's *Human Being* (1999) has been woven from strips of the same bamboo culm. Newly recognized with the first Cotsen Bamboo Prize, Nagakura relies on traditional skills for his contemporary artistry. (Tai Gallery, photo by Pat Pollard)

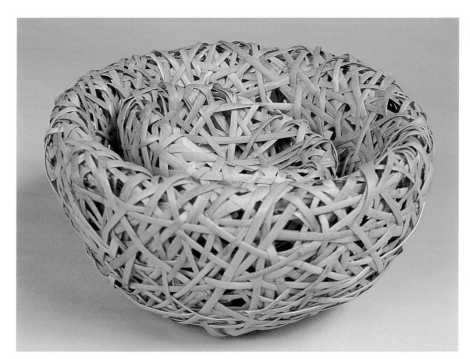

Sekijima Hisako's sensitivity to natural materials and her love of form is reflected in all her work, including this nested pair of baskets.

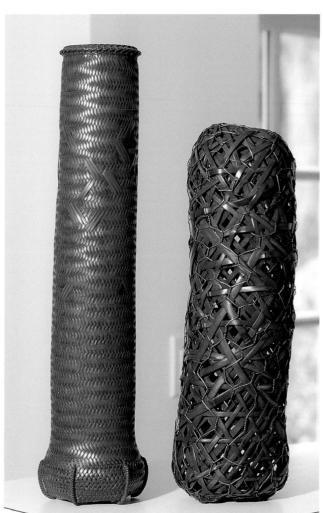

Trained in the traditional bamboo arts of Beppu, Yonezawa Jiro contributes his own signature style to his vessel forms—complex twill and distinctive lacquer. (Courtesy of browngrotta arts, Wilton, Connecticut)

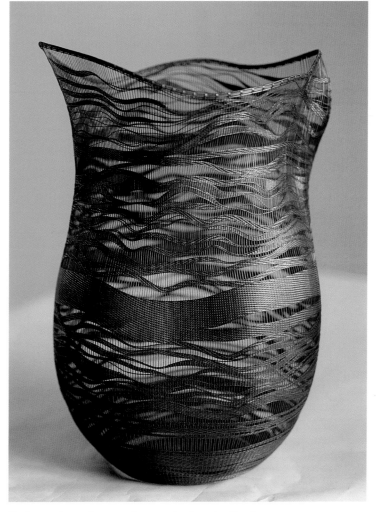

The Beppu region continues to produce young bamboo artists. *Dancing* is a recent work by Morigami Jin and reflects his skill with finely prepared bamboo.

BAMBOO AND THE TRADITIONAL ARTS

SEEKING BEAUTY: WABI, SABI, SUKI, SHIBUMI

In Japanese, the phrase wabi-sabi *is used to describe the aesthetics of evaluating and appreciating beauty, and one cannot discuss Japanese art, craft, or culture without these terms.*[1] Wabi *has connotations of poverty and naturalness. Perfect examples are found in the inherent beauty of nature's simple materials, such as an unassuming bamboo sheath, with its natural color and texture, wrapped around a tea sweet or a seasoned-rice snack.* Sabi *refers to the natural wear that comes from aging and daily use, for instance the patina of a naturally aged bamboo ceiling in an old villa, where the once green bamboo has mellowed to a range of soft grays and golden browns. The idea of* suki *is reserved for elegance that sometimes has an unexpected twist. The unusual fabrics used by Issey Miyake are apt examples, as is the glow of Isamu Noguchi's* Akari *lamps. Donald Richie describes* shibui, *an adjectival variant of* shibumi *with lighter connotations, as "severe good taste,"*[2] *using a lemon as a literal example, and a simple single-color kimono with a hint of contrasting shade as a cultural example.* Jimi, *understated and unexceptional, and* hade, *flashy and slightly outrageous, could be added to the vocabulary of Japanese aesthetics. The variety of choices in itself suggests that how one perceives beauty is of great importance in Japan.*

Many Japanese instinctively understand this aesthetic vocabulary. Yet, to ask for a translation of wabi-sabi *is to invite the response, "It just cannot be translated into English." This answer is not only a reminder of the questioner's outsider position in Japanese society, it is also an honest response. Most Japanese can identify an item's* wabi *aesthetic, but not why it qualifies—not exactly. Ensuing discussions only add to the intrigue.*

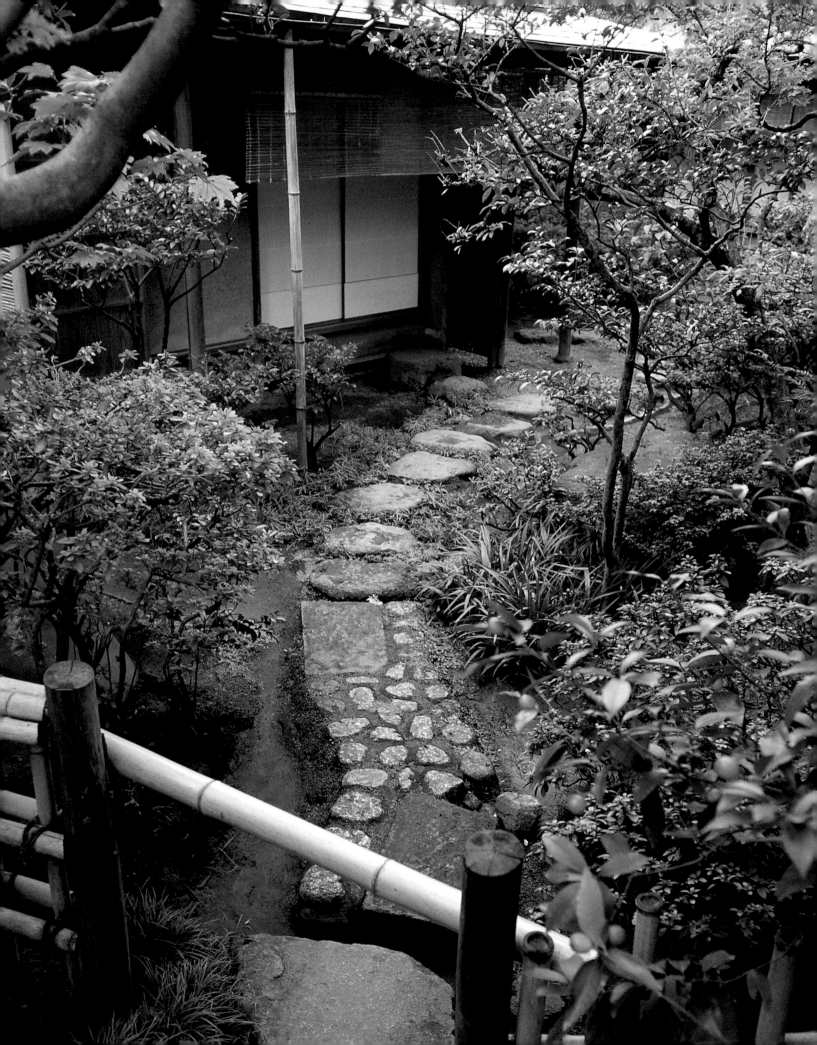

TEA CEREMONY IN JAPAN

THERE IS A SENSE OF PEACEFULNESS in the garden that surrounds the teahouse. Simple bamboo fences isolate the grounds from the world beyond, creating a contemplative retreat. The pathway is marked by large stepping stones set slightly above a layer of pine needles or moss. A water basin with a bamboo ladle is placed among several larger boulders; dark green ferns soften the arrangement. Set among a grove of trees and bamboo, the tea hut's simple thatched roof is what first catches the eye. Built in the rustic style favored by tea enthusiasts, the exterior walls are a golden plaster, with bamboo gutters, and the windows are covered on the outside with bamboo blinds. A sheltered bench in a nearby waiting area holds a tobacco box, with an ashtray of bamboo. The box, a bamboo-sheath hat that hangs on the wall above it, and grass sandals on the ground below are signs of welcome and contribute to a sense of timelessness. Bending to enter the traditional low doorway, and humbled in the act of doing so, one smells the grassy aroma of the *tatami* mats. Gradually the eyes adjust, and in the soft light one sees the bamboo ceiling and *tokonoma* alcove. Tea utensils are arranged on a small shelf edged in bamboo; a calligraphy scroll of Zen poetry hangs in the alcove; a simple clematis vine cascades naturally from a cylindrical ceramic bud vase hung on the bamboo alcove post. Awaiting the entrance of the host, closed folding fan placed near the knees, one anticipates the event. Whether the tea ceremony takes place in a hut like this one, on a stage in an urban auditorium, at the Urasenke Center in Honolulu, or as an offering in front of the ceno-taph at the Hiroshima Peace Memorial Park, harmony, respect, purity, and tranquility (*wa, kei, sei, jaku*) are present. The participants vary, but the ritual remains intact at its core.[3]

The tea ceremony is, first of all, a sharing of tea with friends. The tea host, whether tea master or novice, tries to create a timeless atmosphere in which participants are gradually separated from the stress, noise, and decisions of daily life, even if only for a brief time. It is often said in describing the tea ceremony, "*Ichi go, ichi e*"—once in a lifetime. This is a "separate" moment, a

Even at rest, tea ceremony utensils convey a sense of peacefulness and harmony.

unique opportunity. Even in the midst of an extended campaign, warriors would engage in the ceremony between battles, momentarily removing themselves from the horror of war.

One kneels silently as the host prepares the selected utensils, arranges the charcoal, and boils the water. One by one, the guests are served tea. The sequence of movements is quiet, peaceful. Each motion, refined through hours of practice, seems effortless. The water ladle is used at a prescribed angle, and the tea bowl is passed in such a way as to reveal its most attractive surface to the guest who is receiving it. Before the tea is sipped, small sweets are served as a counterpoint to the slight bitterness of the tea. Afterward, everyone quietly discusses the glaze of the tea bowl or the beauty of the seasonal flowers. The guests, too, follow an established pattern of movements, in accepting the bowl, sipping the tea, returning the bowl to the host. In such a singular moment, in the presence of humble but perfect objects, all the senses are stimulated.

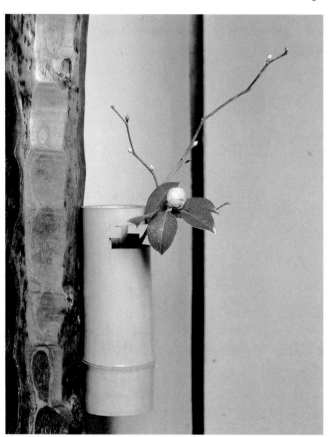

In the *tokonoma* alcove, a simple bamboo container is hung on the post, and a single camellia bud signals the season.

The tea ceremony as it is practiced today is far removed from the introduction of green *matcha* tea to Japan from China at the end of the twelfth century. Tea was at first a medicine, a means to stay awake during long hours of meditation. While the ceremony has retained the connotation of meditative qualities, the Japanese made their own contribution to the ritual use of tea, and the result was the vocabulary of *chado* (the Way of Tea), *cha-no-yu* (literally, "tea's hot water"), and the cult of Teaism. The words are now almost interchangeable, referring in one way or another to the tea ceremony. For many outsiders and non-participants, the tea ceremony appears rigid and overly formal, even exclusive. There seem to be rules for every aspect—how to rotate the tea bowl, when and how to wipe the tea scoop, when to speak and when not. However, participants often choose words such as "creative" and "enlightening" for their description and cite an enhanced awareness of and capacity for appreciating beauty. For them, the tea ceremony is a living, adaptable art form. Such contradictory views are part of the intuitive, yet often evasive, aspects of the Japanese sensibility.

The tea tradition evolved over the centuries, changing with each leading tea master, but remaining closely linked with the austere aspects of Zen Buddhism. The individual most associated with the tea ceremony as it is currently perceived is Sen no Rikyu who was tea master to Toyotomi Hideyoshi, a sixteenth-century military leader of Japan. Most often referred to simply as Rikyu, it was he who emphasized what came to be known as the *wabi* aesthetic, a standard of appreciating beauty that excluded ostentation, excess, and self-aggrandizement. It was Rikyu who used everyday items in his ceremonies—an old fishing creel or a cracked bowl—and he who first included single pieces of bamboo as part of the ceremony. To this day, his descendants lead the major tea schools—Urasenke, Omotesenke, and Mushanokojisenke.[4]

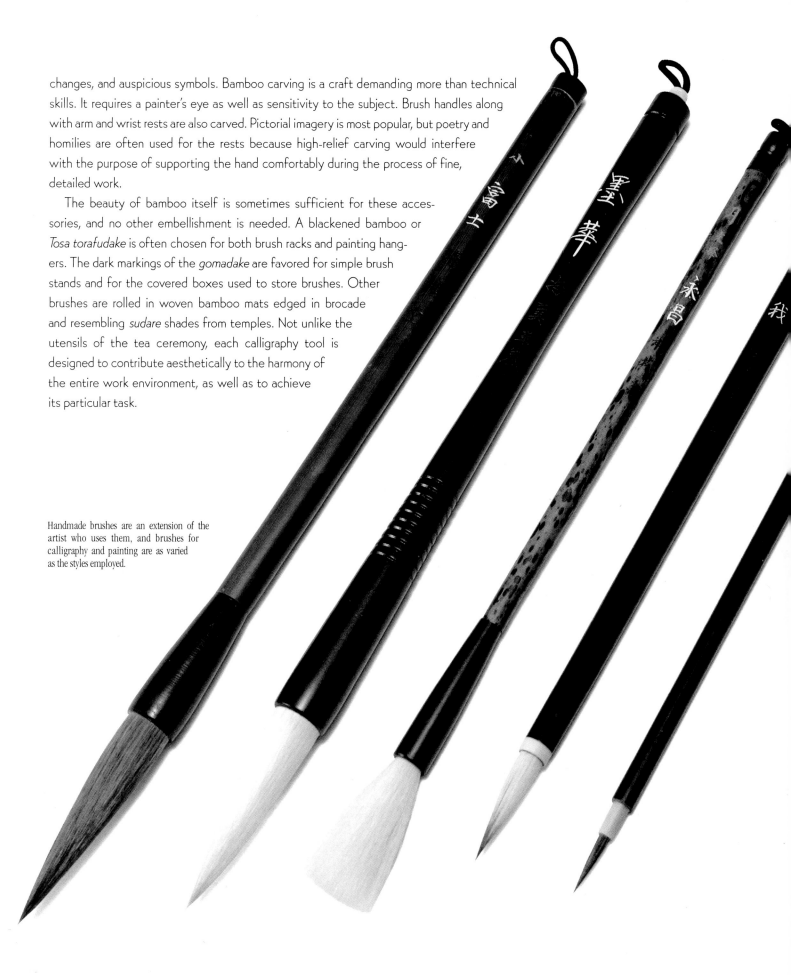

changes, and auspicious symbols. Bamboo carving is a craft demanding more than technical skills. It requires a painter's eye as well as sensitivity to the subject. Brush handles along with arm and wrist rests are also carved. Pictorial imagery is most popular, but poetry and homilies are often used for the rests because high-relief carving would interfere with the purpose of supporting the hand comfortably during the process of fine, detailed work.

The beauty of bamboo itself is sometimes sufficient for these accessories, and no other embellishment is needed. A blackened bamboo or *Tosa torafudake* is often chosen for both brush racks and painting hangers. The dark markings of the *gomadake* are favored for simple brush stands and for the covered boxes used to store brushes. Other brushes are rolled in woven bamboo mats edged in brocade and resembling *sudare* shades from temples. Not unlike the utensils of the tea ceremony, each calligraphy tool is designed to contribute aesthetically to the harmony of the entire work environment, as well as to achieve its particular task.

Handmade brushes are an extension of the artist who uses them, and brushes for calligraphy and painting are as varied as the styles employed.

Paper-covered glass walls invite diffused light into this tea room, the bamboo ceiling and *tatami*-mat floor contributing to a feeling of timelessness. Urban Tokyo is just outside.

GARDENS AND ARCHITECTURE

Harmony is the key to understanding and appreciating the design of Japanese environments—harmony between buildings and grounds, between natural and manmade elements. The use of bamboo in the garden and as a building material contributes to the ease of transition between interiors and exteriors in residential, religious, and commercial sites alike. Verandahs, walls, fencing, and landscape plantings are all designed to meet this end. Whether the setting is a traditional inn or a contemporary apartment, interior space can be linked to the outdoors by the careful choice of bamboo elements, which retain a reference to nature.

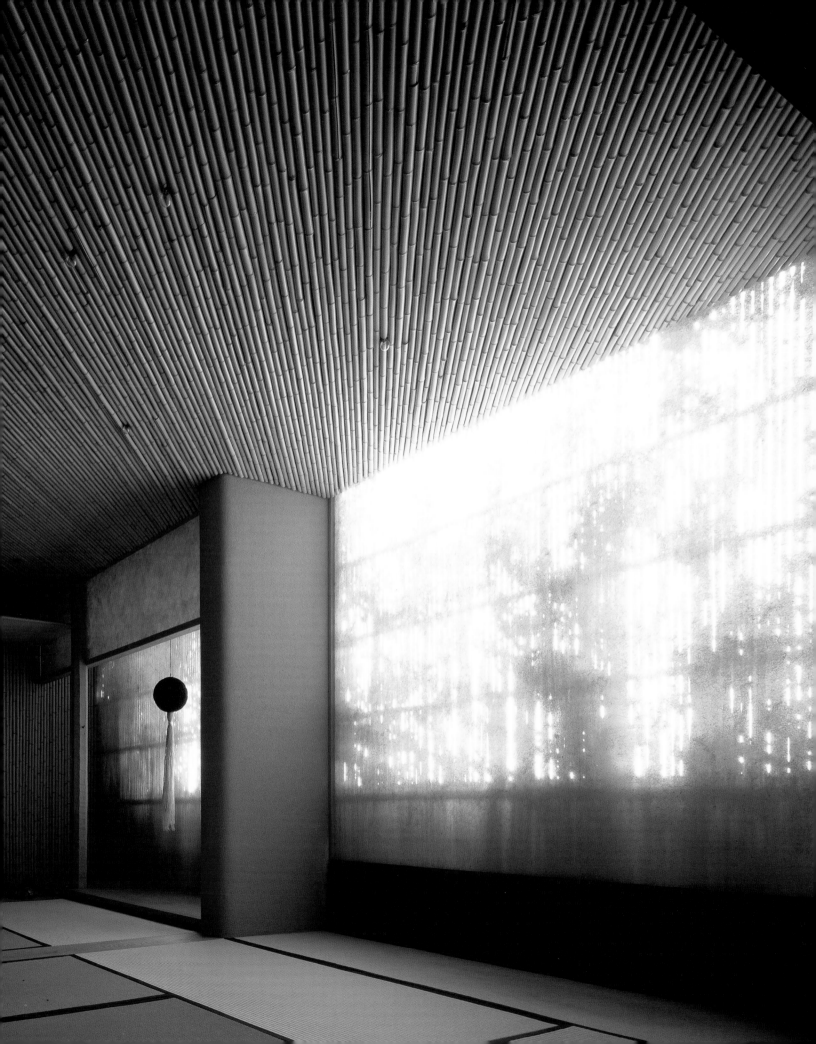

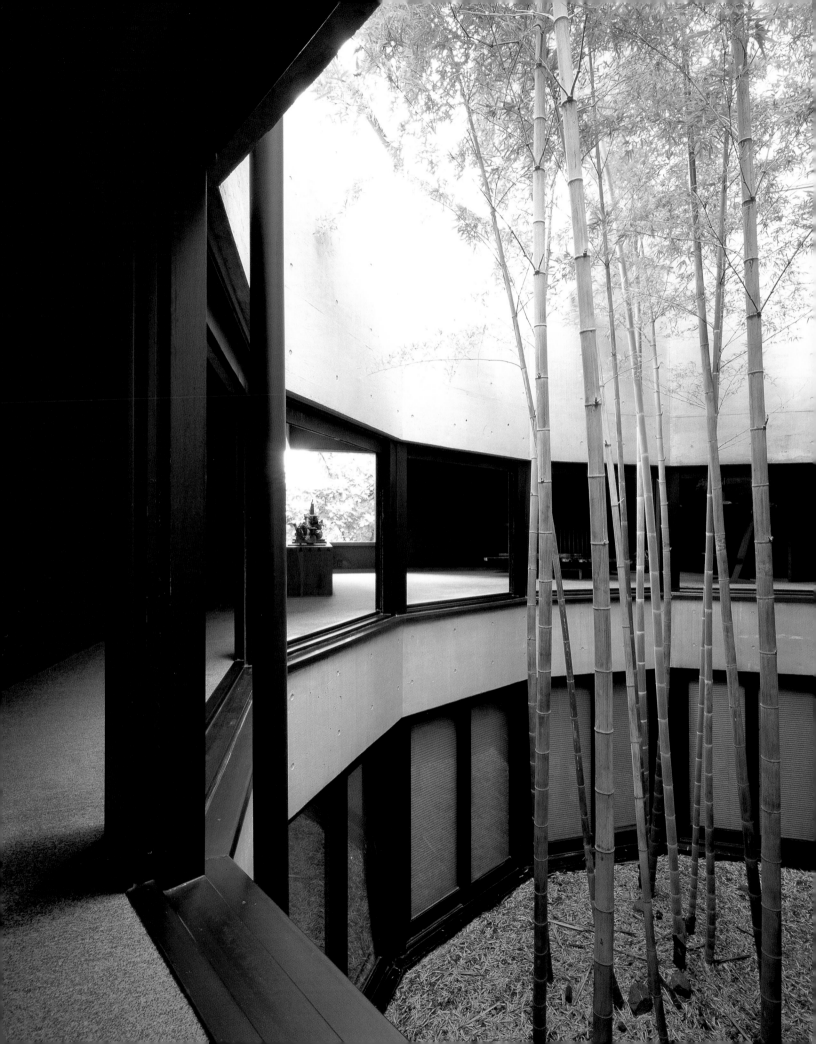

G A R D E N S

BAMBOO IN THE JAPANESE GARDEN begins as a single, unadorned

pole. Even in cities, the pole often used under the eaves to dry onions or in balcony gardens to support plants is bamboo. Smooth, strong, and light in weight, it is used to hold drying persimmons and *daikon* radishes, to contour trees, and to serve as a handle for brooms and rakes. Several bamboo poles are joined, sometimes with wood, to construct ladders. When multiple poles are used in a brace that supports heavy tree limbs, the effect becomes almost architectural. A clutch of bamboo branches can be used to sweep fallen leaves from the path or to capture leaves on a pond; tied to a bamboo pole the branches become a more permanent broom. The same bamboo can be transformed into simple rakes and complex baskets.

In the Western garden, bamboo's most important contribution is as an horticultural specimen, and landscape architects in Europe and the United States take great care in selecting a variety of bamboo that complements and enhances their garden design. In the Japanese garden, bamboo as a planting is less important than its

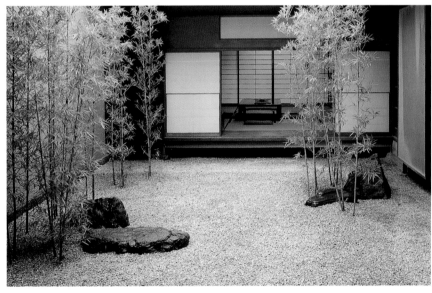

Bamboo, tall and flexible, contributes a vertical line that balances the stone placement in this private garden. Careful selection and maintenance of the bamboo ensures year-round pleasure—especially on a breezy summer day.

use as a material for fencing and other design elements. This is not to say that horticultural use of bamboo is insignificant. Many old documents refer to both the symbolism and practicality of planting bamboo near a residence. (A 1649 ordinance,[1] for example, mandated that peasants plant bamboo in order to use the leaves for fuel.) Designers of the large formal Japanese gardens frequently photographed rarely include bamboo in their landscapes. However, contemporary designers of small interior or side gardens for residences and restaurants often use bamboo plantings to create a peaceful, welcoming atmosphere. Outside a Japanese restaurant, a beautiful planting of black bamboo, an indigo *noren* (shop entryway curtain), and a discreet stone lantern communicate the style and atmosphere within. Bamboo is often planted around the perimeter of an historical site, where the soft top branches accentuate the drama of red tea umbrellas or tile rooflines while simultaneously marking the site boundaries.

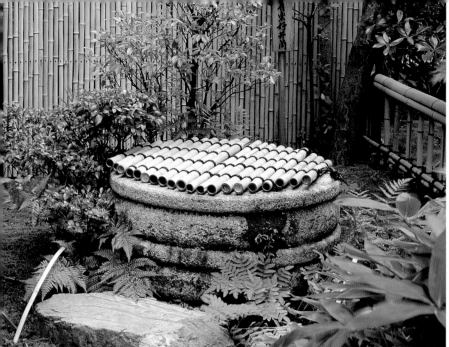

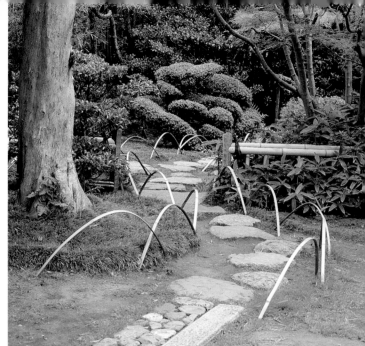

TOP LEFT Functional, as well as beautiful, this bamboo mat covers a cistern while blending into the natural landscape.

TOP RIGHT Simple to construct of readily available bamboo, this modest fence nevertheless clearly declares the path's boundary.

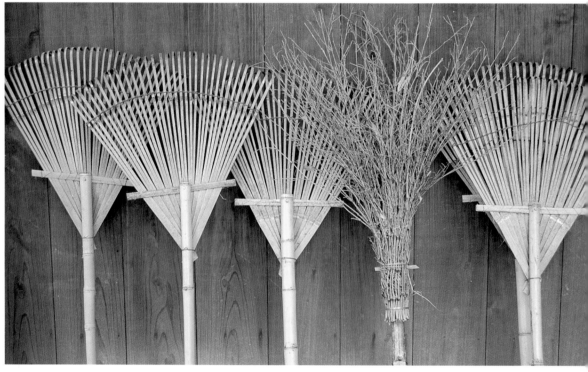

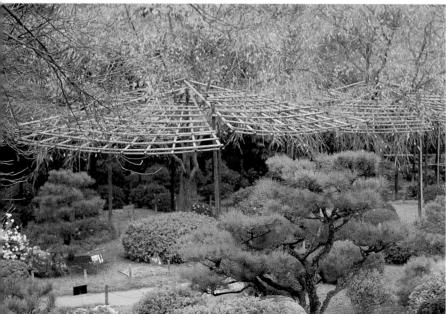

CENTER There can never be too many bamboo rakes and brooms in a Japanese garden.

LEFT The bamboo armature used to support trees and vines at this Kyoto garden remains unnoticed during the spring and summer months. Only as the leaves fall in the autumn does the structure reveal itself.

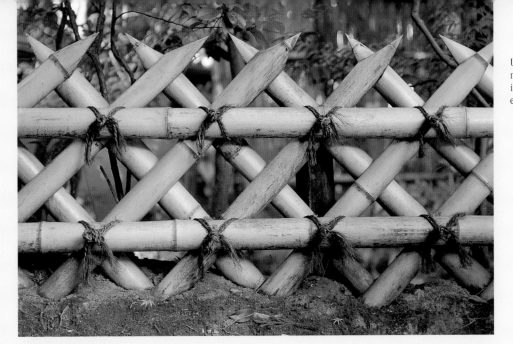

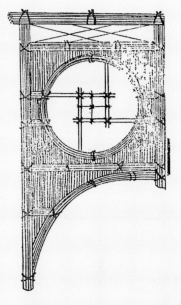

Unsplit bamboo poles are arranged into a fence and mounted on top of a stone wall at the Daitokuji temple in Kyoto. The sharp spikes at the top discourage intruders and, perhaps, evil spirits as well.

Antique books, prints, screens, and scrolls include detailed sketches that help document the history of fencing styles.

FENCING

Japanese bamboo fences are glorious! Bamboo has been transformed into an almost endless variety of fencing styles, and it is in this capacity that bamboo makes its greatest contribution to the Japanese garden. Fencing establishes privacy, defines and protects family space, declares boundaries of ownership and usage, and creates and preserves personal environments. Nowhere is the utilization of space, both indoors and out, more beautifully controlled than in Japan, where bamboo—whole, split, woven, lashed, bent, and manipulated—is used in fences that serve multiple functions. Fencing requires large quantities of high-quality bamboo, especially the highly valued *madake*, which for centuries has been easily obtained for fence building. Yoshikawa Isao, whose research and garden design is known worldwide, maintains that the superlative quality and variety of bamboo fences in Japan is due to the vast groves of readily available *madake*.[2]

Japanese fencing is so diverse it can be examined from many different perspectives—function, style, and materials, among others. Fences function primarily as a partition (in which case the fence is likely to be open in construction, small in scale, or portable) or as a screen (blocking visual access to the garden).[3] Within these two categories, fences are additionally classified by what materials are used, how the material is placed within the fence, and by the fence's identification with places, people, and specific religious sites.[4] In all, bamboo remains a key material.

Partition fences range from bent bamboo strips to elaborately woven structures, and may be as long as tens of yards or as short as an arm's length. Long, low fences are often placed in a garden to change the mood from one section to another or used in a more formal garden to highlight particular plantings. The simplest partition fences are reminders that outsiders may have visual but not virtual access. For example, lengths of bamboo strips can be bent, overlaid, and imbedded in the ground to mark a simple pathway. The light weight and smooth surface of bamboo are well suited to its use as a temporary barrier. Other simple fences are constructed of small subunits that can be removed when intermittent access to a site is allowed. For example, at a compound which is open to the public only for special events, a low portable barrier of bamboo is placed in front of closed entry gates as an additional

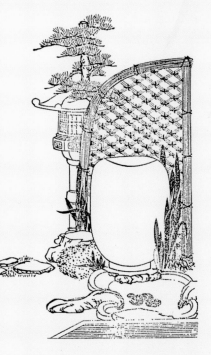

The garden elements shown in this nineteenth-century illustration are still popular today—sleeve fence, stone lantern, and water jar.

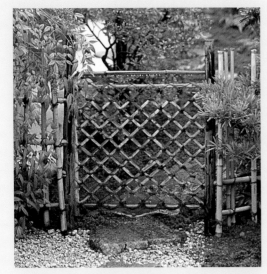

See-through gates and fences mark borders and emphasize plantings. In this garden, the traditional *shiorido* gate, softened by plantings, draws the visitor to the end of the garden.

reminder that the site is not always accessible. When such a fence is in place, no one misunderstands and rings the bell for entry.

Partition fencing has boundless possibilities for design. One of the most popular examples, both in Japan and abroad, is the "sleeve fence," so named because its shape resembles a kimono sleeve. A small, narrow version is often placed next to a residence to separate the front yard from the more private family garden. This kind of fence works equally well in traditional and contemporary settings. Landscape designers will often place a sleeve fence at the entry of a restaurant to create atmosphere. The small scale is unobtrusive, yet the design has considerable impact. When a fence with a rustic look is desired, the "rain-cape" version with its long bamboo branches might be selected. An understated design might include only an elegant vine outline of a sleeve with minimal use of bamboo or other secondary materials. Sleeve fences with see-through designs have many popular names, including "four-eyed" fence and "stockade" fence. Each has distinctive characteristics and makes its own contribution to garden design. See-through construction is also used extensively for gates. The *shiorido* style is the most popular. It is constructed by simply bending a bamboo strip diagonally across and around a bamboo frame, creating an effect that works well in tea ceremony gardens as well as residential ones. Placed at the beginning of a path or the back of the garden, the *shiorido* presents a simple, attractive point of departure or entry.

In contrast with partition fencing, screening fences are often used as a clear demarcation of property boundaries, especially where privacy is an issue. A screening fence may also serve as a backdrop for special plantings and other garden elements while at the same time offering a surface that is itself ornamental. Styles range from those built almost entirely of large-scale bamboo, to those with woven bamboo surfaces, to others that combine bamboo poles with brushwood or fine bamboo branches. Such fences can be framed in wood, mounted on stone walls, and/or topped with bamboo spikes. A very popular example of a screening fence is the *Kenninji-gaki*, named after the fence at Kenninji Temple in Kyoto. It is constructed of closely mounted vertical bamboo poles held in place with horizontal bamboo half rounds. The result is a solid barrier that manages to remain spare and light, rather than massive. This style can be easily modified by changing the height, the number, and the size of the horizontal elements, or by including a bamboo molding (*tamabuchi*) along the top edge. One especially exciting

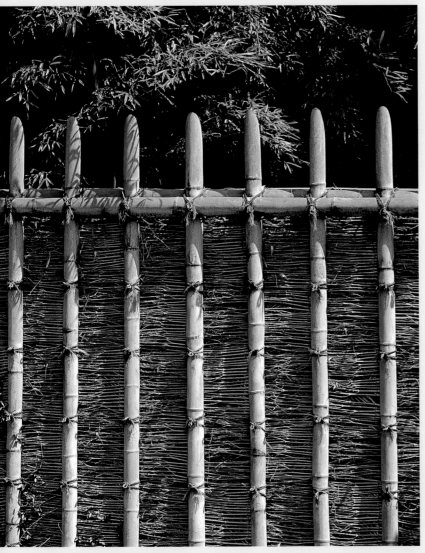

The original *Katsura-gaki*, which surrounds much of the Katsura Imperial Villa in Kyoto, has inspired many adaptations around the country.

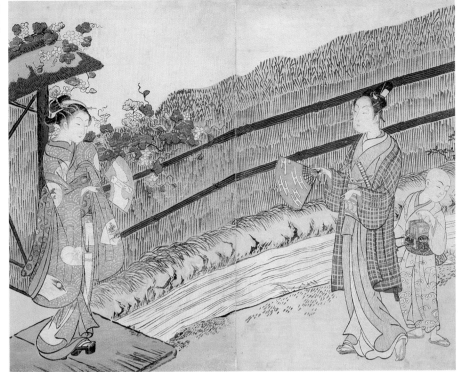

The solid construction of this *takeho-gaki* (bamboo-branch) -style fence serves as a backdrop for a significant meeting in the eighteenth-century woodblock print by Suzuki Harunobu, *Parody of "Evening Faces."* (Courtesy of the Honolulu Academy of Arts)

version captures the look of fishing nets laid out to dry and, accordingly, is named the *amiboshi*, "net-drying" pattern. In *amiboshi*, the horizontal struts are rotated to become the diagonal lines of the fishing nets and are juxtaposed with plain, vertical background bamboo. This pattern has been adapted by many fence builders because it adds a contemporary look to a solid, traditional fence suitable for a property boundary.

The names of Japanese fences are rich with history. *Gaki* is the most common word for "fence" in Japan; thus, *ajiro-gaki* refers to woven fences (*ajiro* taken from basketry nomenclature). *Numazu-gaki* and *Otsu-gaki* are woven fences that refer to the regions where the finest examples, now seen countrywide, originated. The decorative surfaces of these fences makes them a favorite for residential properties where even a single small unit has impact.

Perhaps the most famous style of screening fence carries the name of the revered Katsura Imperial Villa in Kyoto. *Katsura-gaki* is distinguished by many small-diameter bamboo branches placed horizontally and held by strong verticals of large bamboo. This fence is so popular that it is replicated throughout the country, though not always with the same high standards. At Katsura, as the eye follows the contour of the long drive leading to the guarded entrance, the formality of the long curved fence emphasizes the grandeur of the garden within. Several other fences at Katsura could be classified as partition fences, while each serves other unique functions as well. The "living fence" of black bamboo that marks the river side of the property is actually more of a hedge than a fence and presents an impenetrable tangle as a barrier. An equally formidable but impeccably constructed fence in the *tokusa-gaki* style defines the area adjacent to the Katsura villa entry gate. Large bamboo poles are mounted tightly side by side with no ornamentation; the horizontal lines of the bamboo nodes contribute to the effect of the clean, solid, impressive surface. This historic site is open to the public by appointment only, but the entry is so beautifully designed that even a naive passerby immediately knows an important landmark lies within. Entry to the palace grounds is carefully guarded, and their protected nature is supported visually by the design of the perimeter fences. There is no mistaking the message all these fences are intended to convey.

Landscape design often begins with consideration of existing, permanent features, such as buildings, boulders, hillsides, and views. Following this, the fencing choices (including hedges, walls, and gates) are made. Fences frame and define both indoor and outdoor space. Only after the fences are chosen can the rest of the design proceed.

There are many historical sources for traditional fence designs, each one an exciting find for landscape and fence designers.

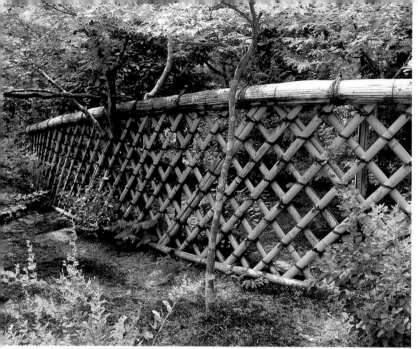

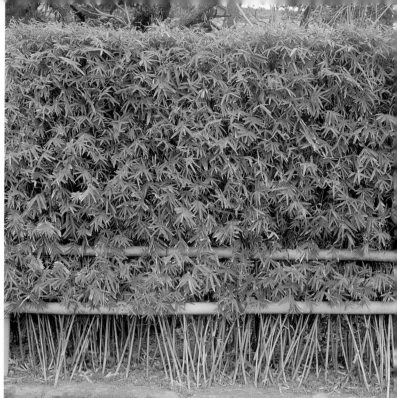

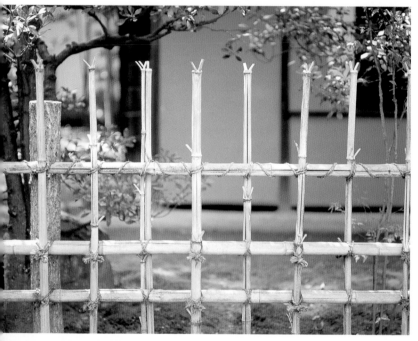

TOP LEFT The diagonal elements of this see-through fence are characteristic of the *Koetsu-gaki*. The split-bamboo ridge at the top is also distinctive.

TOP RIGHT A "living fence" becomes an impenetrable barrier as it matures.

CENTER At Sento Palace in Kyoto, the simple four-eyed fence is distinctive because trimmed branches have been left at the nodes, an unusual approach in fence construction.

LOWER LEFT This style of fencing, called *shimizu-gaki*, is identified by its use of fine *medake* bamboo for the vertical elements and a larger bamboo for the horizontals. Multilayered fences in Japan take advantage of the wide variety of bamboo available there.

LOWER RIGHT This fence design is straightforward, and the bamboo formidable.

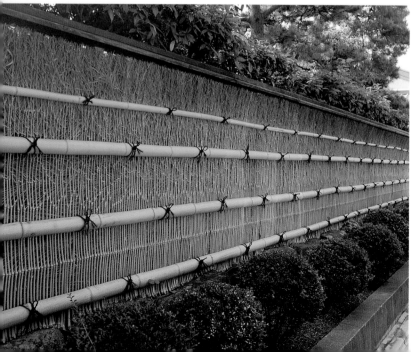

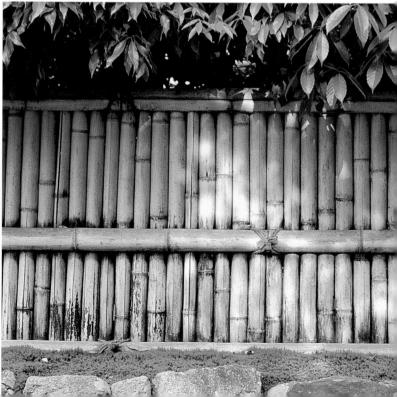

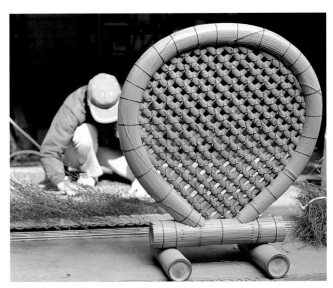

The Nakagawa Bamboo Materials Company in Kyoto has a long history of building fences and architectural elements. Fine bamboo branches are laboriously layered for a complex construction. An experimental fence is on display.

CONSTRUCTING BAMBOO FENCING

Bamboo fences are constructed by skilled craftspeople, farmers, gardeners, and factory workers. A simple fence, such as the arched bamboo strips that mark pathways, can be constructed quickly. The same construction can be used to support or highlight small plants and to hold plastic tarps off seedlings. When a farmer in Chiba needs a simple fence to support his vegetables, he makes one this way: bundles of bamboo branches are tied and lashed against a simple bamboo frame, then two such frames are tilted toward each other and tied together. This traditional fence, used and repaired as needed, can be seen all over Chiba Prefecture, which still retains some of its agricultural flavor despite its growth as a bedroom community for Tokyo. Yoshikawa Isao has adapted the farmer's fence in a garden he designed for an instructor in flower arranging. In the teacher's garden, this fence makes a reference to the region's agricultural history, while providing a fresh backdrop for demonstrating the skills of flower arranging.[5]

Movable fence units are often constructed in advance, stored, then delivered when ordered. Small side fences, such as the sleeve fence, can also be constructed indoors in quantity and subsequently mounted and finished to order. Such products are highly cost-effective for the bamboo showroom that builds and sells them, as they can be built indoors any time of year and installed later. In the off-season (usually, winter or the rainy season), a great deal of time is devoted to cleaning and preparing materials for later use.

Other fence styles require considerable planning and advance preparation. Even those that appear at first glance to be simple combinations of vertical bamboo poles have a structural foundation that requires some care. Anchor posts, usually of treated wood, must be imbedded in the ground and properly aligned. All interior horizontal elements that comprise the fence's skeletal framework must be leveled and secured. In some styles, such as the bamboo-branch fence, preassembled bamboo units can be mounted onto this framework; however, most styles of permanent fencing require full assembly on site.

Regardless of fence style, or place of assembly, certain procedures are always observed in order to minimize the need for repairs. For example, when whole poles of bamboo are mounted

vertically, the bamboo is cut just above the node so that no natural basin is formed. Water collecting at this point would seriously reduce the life of the bamboo. Likewise, care is taken that the bamboo not come in direct contact with the ground, where leeching water (referred to as "wicking") would do damage. The traditional ties used on bamboo fencing are made of rope plied from tough coconut fibers, which are extremely strong and slow to decay. Even so, the rope must be replaced every few years, and most fencing, every ten. When the cost of fence replacement is too high, some will purchase a plastic version. For those who desire the natural beauty of bamboo, however, evidence of the aging process is part of the aesthetic, and no substitute is acceptable.

OTHER GARDEN ELEMENTS

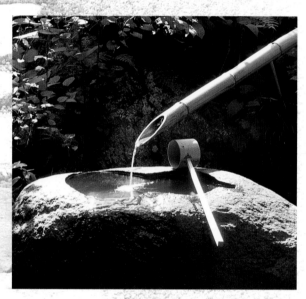

Water is an important element in Japanese garden design. Here water cascades from a bamboo pipe into a natural stone basin, thus introducing sound. A simple bamboo scoop is available for guests to cleanse their hands and mouths.

Sound is introduced into Japanese gardens by running water, rustling bamboo leaves, and the clacking of "deer scarers" (*shishi odoshi*). As recently as the 1940s, deer and boar were scavenger problems even in suburban areas, and though the deer scarer is rarely used now to protect property, its name retains a reference to its original use. This ornament can be seen in Japanese-style gardens throughout the world. Simple to construct, it captures a bit of the Japanese ingenuity at working with natural materials. A length of bamboo is turned into a tubular vessel by removing the interior membrane from one end while, at the other end, leaving a second membrane as a stopper. The bamboo is then mounted at an angle on an axle (sometimes of wood, sometimes of bamboo) and placed so that the heavy end rests on a platform of wood or rock, enabling its open end to collect running water trickling out from a pipe (also of bamboo). When the tube becomes full, the weight of the water causes it to tip downward on its axle and the water flows quickly out into a basin or pool. As the bamboo pops back into position to collect more water, the heavy end of the bamboo hits the platform with a resounding clacking sound that resonates throughout the garden.

The waterbasin (*tsukubai* or *mizubachi*) is usually one of the last ornaments to be selected in the course of garden design, when the owner is looking for just the right final touch. A basin may be a stone with a natural concavity, an old stone lantern, or molded concrete. The pipe that introduces water to the basin is often bamboo, and a bamboo ladle may be set at the basin's edge or may rest beside it on a length of bamboo or on a woven bamboo mat. At the entrance to a temple or

shrine, this arrangement takes on more import as the water is used symbolically to purify the hands and mouth before visitors enter sacred grounds. During New Year's celebrations and other religious festival occasions, care is taken to use bright green bamboo for its connotations of purity and freshness.

One unusual garden ornament with many variations is descriptively called the "snake basket" (*jakago*). In water gardens, it is a "tube" woven in the open-hexagonal weave pattern using long strips of bamboo. This tube is filled with large stones and submerged. A second version woven of finer bamboo sits on top of the first, and is only partly submerged. The *jakago* is used as an ornamental barrier to isolate water plants or contain pond carp (*koi*). Similarly, smaller basket shapes filled with stones are used at the edge of a stream or pond to control erosion. In China and Indonesia, boulders are bound with bamboo strips and used for erosion prevention along the coastline. Variations of this structure are common elsewhere in Japan. Smaller versions filled with beautiful black stones are used as wrist rests in calligraphy, while tiny ones serve as chopstick rests (*hashi oki*). As varied in size and function as these structures are, they share a common characteristic: the same strong open-hexagonal weave pattern often seen in garden work baskets.

This "deer scarer" is in the resting position. When it is once again full of water, it will tip forward and empty itself, and then crash back to this position, hitting the stone at its base.

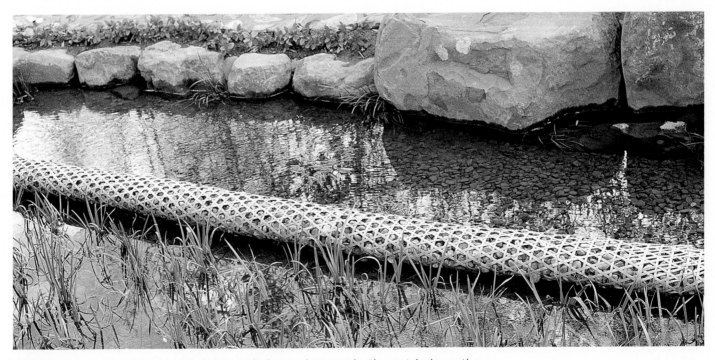

Stones held within a woven tube, known as a "snake basket," provide a barrier in this water garden. Plants are isolated to one side as the water flows freely over the carefully selected pebbles on the opposite side.

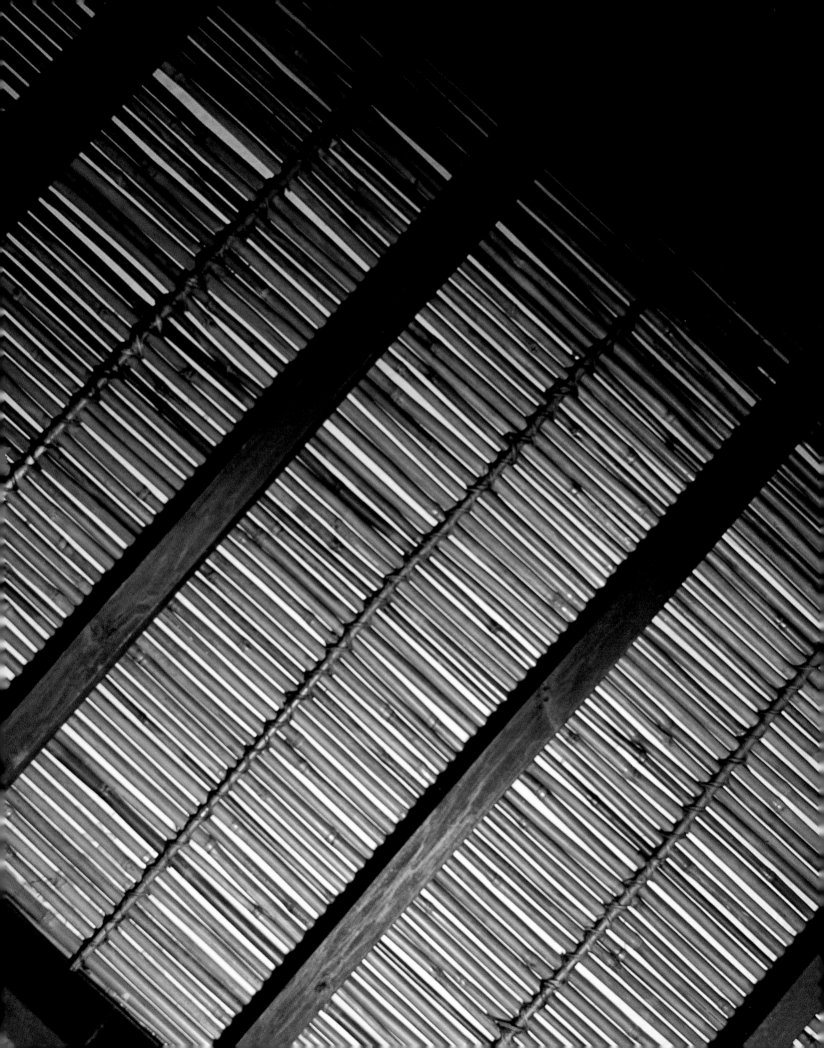

Bamboo in the ceilings of traditional farmhouses (*minka*) provided support for a solid covering and the warmth of a natural material when viewed from below.

A R C H I T E C T U R E

WALKING THROUGH ALMOST ANY JAPANESE TOWN,

the discerning observer will see small bamboo details in many buildings. In one edifice, split bamboo covers the seams in a bark wall, creating a series of strong vertical lines. A plaster wall that surrounds a private home may have fan-shaped openings that reveal bamboo grillwork. The downspout and gutters of an older building might be made of bamboo, serving a second purpose of visually linking the building to the garden fence. Bamboo is not the primary building material in Japan, but it makes a distinctive contribution.

Conversely, throughout most of Asia, bamboo traditionally has been a basic material for construction. Available in abundance to rich and poor alike, it has been used in structures as varied as the simple, all-bamboo tribal houses in the hills of Thailand to dramatic, saddleback roofs in Sumatra, which incorporate both bamboo and wood. In some regions of the world, all-bamboo structures are simple buildings connoting poverty and impermanence. In others, such buildings are a life-long dream. Current architectural and engineering research is doing much to improve the quality (and therefore, the popular acceptance) of bamboo construction. In Japan, however, with the availability of high-quality stands of cedar, cypress, and pine, builders have for centuries relied primarily on post-and-beam construction, using earth, grass, paper, and bamboo as supplementary materials.[6]

Japanese architecture is the subject of extensive popular and scholarly research. Bookshelves are filled with titles devoted to such architecturally important sites as the Sento Palace, Katsura Imperial Villa, and Shugakuin. The names of contemporary architects—Ando, Tange, Isozaki, and Maki—have become increasingly familiar, and words such as *kura* (storehouse), *minka* (common farmhouse dwelling), and *sukiya* (refined dwelling) have become part of architecture's international vocabulary.

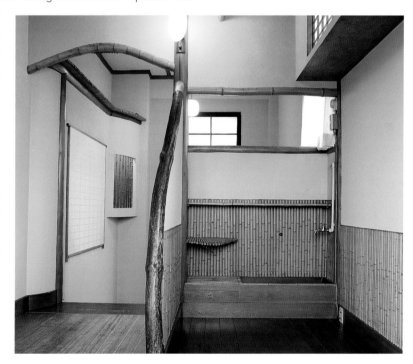

Historical sites, such as the Asakura Setsu Museum, have been responsible for preserving many traditional landmarks. This teahouse preparation room, with its emphasis on natural materials, is still being used today.

MINKA AND BAMBOO

The importance of bamboo in Japanese architecture is illustrated most dramatically in the construction of *minka*—literally, "house of the people"—an architectural style during the feudal age that lasted about seven hundred years, from the late twelfth to the mid-nineteenth century. *Minka* share some construction details with buildings used by the noble class in the *shoin* and *sukiya* styles, while claiming some unique design characteristics to themselves—especially roof ridges and supports.

Perhaps the most distinctive feature associated with *minka* is the thatched roof, and it is here that bamboo's contribution to Japanese architecture is first identified. As traditionally constructed, an elaborate grid system of whole bamboo poles, tied in place with ropes of rice straw (*wara*) or split bamboo, supported the weight of these massive roofs. Visible only from the interior, or at the edges of the eaves outside, this network formed the skeletal system of

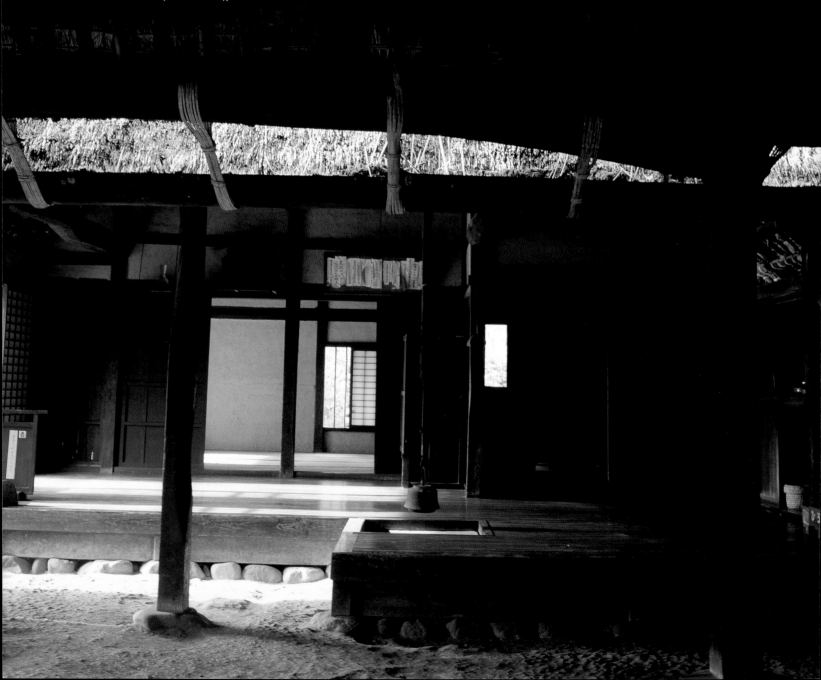

The distinctive thatch, wood, and bamboo construction of this *minka* blend into the countryside scenery. The earthen floor of the kitchen/entry seen below was typical.

the entire roofline. Occasionally, a simple open grid of bamboo poles was also placed over the thatch and lashed in place as an additional measure to secure the thatch from above. Quite simply constructed, this exterior grid was easy to repair or replace. A whole length of bamboo, sometimes complete with root ball, was a striking ornament across a roof ridge. Even during the Edo period, when building materials and styles were restricted by sumptuary laws, individual and regional tastes were expressed in the roofs of *minka*. Such creativity might be manifest in a roof ridge of bleached driftwood on the southern island of Shikoku, or an elaborate bamboo grid securing the thatched roofs of Taketomi Island in Okinawa.

In recent times, these extraordinarily dramatic buildings with their thick thatch and breathtakingly dynamic rooflines are less and less in practical use. Their maintenance is costly and time-consuming, and in an era of virtually ubiquitous air conditioning and microwave ovens, materials that are subject to insect infestation and mold, and need constant repairs, have little appeal. Fortunately, many excellent examples of this endangered architectural treasure have been preserved. Some *minka* have been restored to become restaurants and gift shops. A large number have been relocated to various park sites, such as Kawasaki Municipal Park of Japanese Houses (*Kawasaki Shiritsu Nihon Minka-en*), and have been made available to the general public for visits and to scholars for research. Many publications make the *minka* style accessible to an even larger audience. A fine example of restoration completed by an individual owner in Yufuin, Kyushu, has been documented by Amy Katoh.[7]

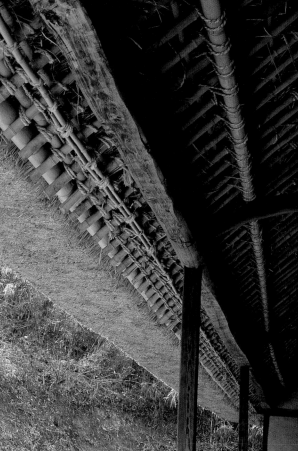

Roof ridges on *minka*—here a multilayered construction—reflect the creativity of the builder and selection of local resources.

Today, bamboo salvaged from inside the roofs of old *minka* enjoys a second life in the hands of contemporary designers and builders. When an ancient *minka* is torn down, the bamboo is saved for use in decorative architectural elements, or for crafts such as basketry, woven arm and wrist rests for calligraphy, and storage boxes. The rich color of this bamboo, called *susudake*—"soot bamboo"—darkened by years of exposure to the smoke of the hearth, is highly valued by interior designers, architects, and craftspeople. The surface areas where bamboo poles were originally lashed together remain somewhat lighter in color than the rest, and it is these variations in color, as well as the patina of age and soot, that make *susudake* so desirable. A thinner bamboo comes from a ceiling lattice (*sunoko tenjo* or *amada*) sometimes used inside *minka*. Open construction allowed the hearth smoke to move easily from the lower level to the upper rafters. Though this umbered bamboo lacks the dramatic scale of the larger roof supports, it is valued for smaller furniture and basketry. With the increasing scarcity of this beautiful material, craftspeople have tried to duplicate the subtleties of its color with dyeing techniques, but the rich patina is elusive and difficult to re-create.

In contrast to the exposed bamboo grids of the roof supports and

Under the eaves, bamboo serves as a support material.

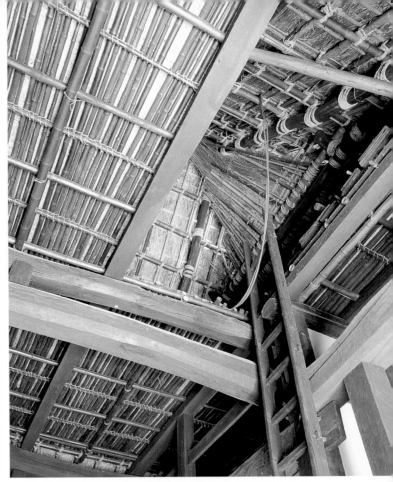

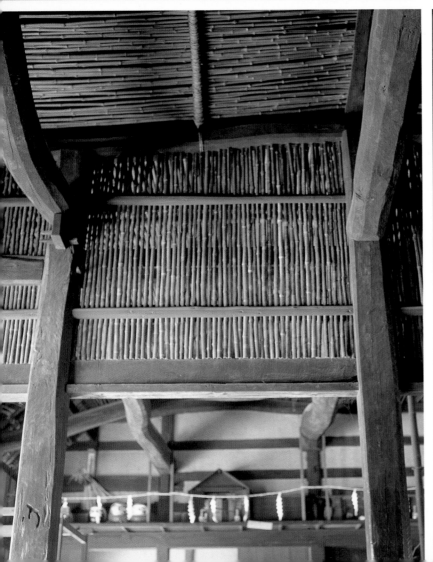

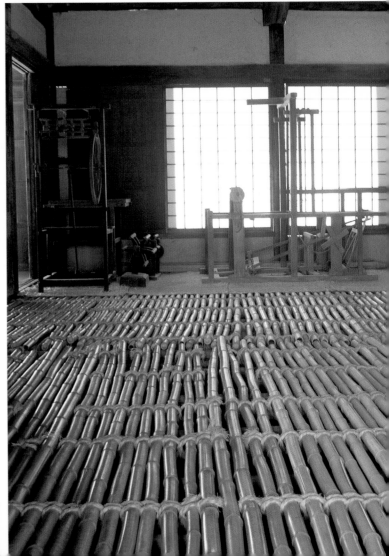

The open hearth (*irori*) was the center of the living area and an important source of heat. An iron pot would often be hung from a system of hook, rope, and ornamental adjuster (*yokogi*) suspended from the beams. Iron, wood, and bamboo were commonly used together and ingenious designs evolved.

ceilings in the traditional *minka*, another bamboo grid—common to *minka*, urban structures, and historical and contemporary buildings—remains invisible. For centuries, lengths of small, whole, and split bamboo (*etsuri* and *shitaji*) have been used to form an irregular, open-grid support system for plastered walls (*shinkabe*, *komaikabe*, and *o-kabe*). Tied in place with straw and covered with earthen plaster, these supports were truly a construction of indigenous materials. The skeletal grid was usually invisible to all but the construction crew, but as older walls wear thin over the years, bits of straw and bamboo are exposed. And when older buildings are torn down, the bamboo grid system is revealed. Today, the split bamboo used in such walls is sold by bamboo wholesalers who specialize in a wide range of bamboo products for home interiors—windows, prewoven panels for the ceiling, and details for the *tokonoma* alcove. The assembly of the interior wall grids would be the responsibility of the contractor or plasterer doing such construction. Although it is possible to preassemble such panels, building construction in Japan now relies mainly on wood, concrete, and steel, and the demand for more traditional elements is insufficient to warrant keeping a large inventory.[8]

Other intriguing examples of bamboo in Japanese architecture exist but are rarely replicated in modern times. Bamboo roof tiles, for example, were used more frequently in the southern regions because large bamboos (e.g., *moso*) were so readily available. With these lightweight tiles, a large roof could be constructed with relative ease and would not require the sturdy support that a heavy-tile roof demanded. On the other hand, these roofs were not durable and had to be repaired or replaced frequently. Such tiles are now seen mostly on older outbuildings, tea ceremony huts, or entry gates. They age gracefully, covered with moss and ferns, but their numbers are diminishing. Similarly, except at historic sites where preservation is mandated, bamboo downspouts and gutters are considered impractical, and when older examples become damaged, they are often replaced with inelegant metal or plastic substitutes.

INTERIORS

The builders of the original *minka* created windows by simply leaving an opening in the plaster on exterior walls, so that a part of the bamboo grid was exposed. Because the walls are not load-bearing in post-and-beam construction, there was no loss of support by not plastering the entire wall. Such windows (*shitaji-mado*) allowed air to circulate but contributed little aesthetically, except perhaps in a tea ceremony hut in which a rustic aesthetic was desired. A more refined version of open bamboo grids evolved. Like a window, it is fitted into the finished wall

A stylish raised entry in a Kyoto home, with woven bamboo on the walls and floor.

OPPOSITE This traditional space is warm and slightly elegant—red lacquer and fine bamboo complement the wood, *tatami*, bamboo, and golden walls.

and sometimes interlaced with vines. More elaborate window lattice designs are woven into patterns that evoke basketry or even depict whole scenes (e.g., Mount Fuji), usually with references to nature. Kyoto is known for the beauty of its buildings, perhaps because, as Itoh notes, early Kyoto was relatively free of building restrictions. As a result, exceptionally fine window designs evolved there, with some lattice patterns even representing specific trades.[9] Because Kyoto was spared the horrific bombing of World War II, many examples of architectural treasures remain.

When windows or grills are placed in the plaster walls used to surround private property and mark the entry, the open frames—geometric or bell-shaped, and sometimes fan-shaped—are filled with elements of fine bamboo. Some of these designs are still custom-made and must be constructed as the wall is assembled. However, for most such wall and window lattices, standard rectangular and circular sizes are readily available from bamboo wholesale showrooms. The open-lattice window styles, originally specific to *minka* construction, have been incorporated into Japanese buildings over the years and continue to influence architects today, as they are easily adapted to contemporary spaces.

One popular example of architectural detailing in which bamboo can be both material and motif is the transom (*ranma*), the openwork panel mounted above interior doorways. In older buildings with many windowless interior rooms, this panel allowed both light and air to pass from room to room, even when the sliding panels that divided the spaces were closed. In newer buildings, often air conditioned and with windows in every room, transoms continue to make a decorative contribution. During the Momoyama period, known for its opulent style, wooden transoms were true sculptures, and reflected favorite images, many from nature, including pine, blossoms, waves, and of course bamboo. In *minka*, with its strong, horizontal support beam made of an entire curved tree trunk, the vertical bamboo mounted in the transom followed the natural curve of the tree. When a transom is constructed from bamboo itself, the lines are simpler. Fine-scale whole bamboo, sometimes with distinctive markings or nodes, is mounted vertically side-by-side, beautiful in silhouette when light comes from the adjacent room. Similarly, when taller and thicker bamboo is split lengthwise, the cross-sections reveal the horizontal membrane that links the outer skins

Gentile aging is evident in this tea ceremony room, from the worn paper to the darkening wood and bamboo. This space is at once elegant and unpretentious.

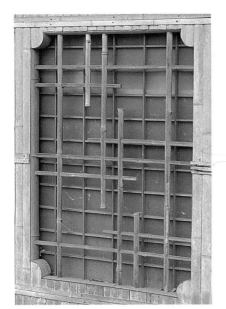

Window coverings constructed in an open grid of bamboo refer back to the traditional wall construction in which a similar grid was plastered over.

much like a ladder. This silhouette often appears in printed fabric and paper designs, one of many examples of the crossover of design motifs—bamboo is the material in one craft, the motif in another, and the bamboo artifact itself a motif in a third.

Woven bamboo panels for walls and ceilings are becoming increasingly popular for a wide variety of uses. Originally used extensively in spaces devoted to tea ceremony, they are now seen frequently in restaurants where their spare but patterned surface creates a contemporary tone while maintaining historical references. As a result of new lamination techniques, an expanded selection is becoming available at lower costs.

The *tokonoma* alcove has a special traditional place in the Japanese home, be it a farmhouse or a Tokyo apartment. A slightly raised platform originally intended to display scroll paintings (*kakemono*), the design of *tokonoma* was borrowed from that of a Zen priest's quarters, and it still offers a small place for contemplation. It is in this alcove that a family will display its ancestral or acquired traditional treasures, varying them by season and occasion. Though Oliver Statler cynically suggests that the space may now be used for a television,[10] in a more traditional home one might see during the autumn season a calligraphy scroll accompanied by a display of red maple leaves in a darkened bamboo (*susudake*) basket and, in spring, a sprig of the season's first cherry blossoms. The vertical post (*tokobashira*) that defines the *tokonoma* space

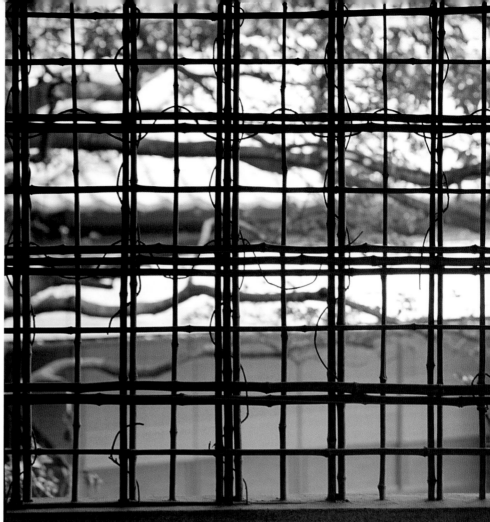

LEFT, ABOVE, AND BELOW Bamboo lattice work can be used in window openings of any shape and scale. The inclusion of vine emphasizes the connection between interior and exterior spaces—perfect for garden rooms, teahouses, and porches.

is a crucial design element for which squared, patterned bamboo is especially popular. The staggered shelves adjacent to the *tokonoma* are often constructed or edged with fine bamboo as well, creating an integrated harmonious ambience. Bamboo here is decorative, rather than structural, an embellishment of choice. When bamboo and architectural elements are mentioned together, it is often the *tokonoma* and/or window lattices that come to mind. Both have a long history in Japan and a strong connection with tea ceremony structures.[11]

The traditional architecture of Japan is closely connected to its natural surroundings, and the Japanese-style verandah (*engawa*) is an example of a building extending itself into exterior space. In fact, the verandah is both interior and exterior space. A verandah made entirely of bamboo is rarely seen in contemporary structures, but it remains a common sight in older country homes, historic buildings, and *minka*. Attached to a large dwelling, the verandah might accommodate a loom by day, allow interaction with passersby, and provide a place to escape the heat of the summer. The moon-viewing platform at the Katsura Imperial Villa is the most renowned example of the *engawa*. At one time, the flooring of the exterior verandah was made of whole, small bamboo poles, as was much of the interior flooring in *minka*. This flooring, irregular by nature, allowed air flow, in summer and winter. Because of its unevenness, it was often covered with straw mats, and though it was never comfortable, it was always inexpensive and

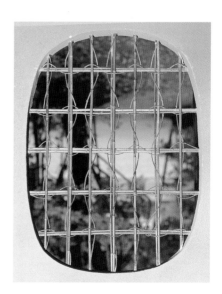

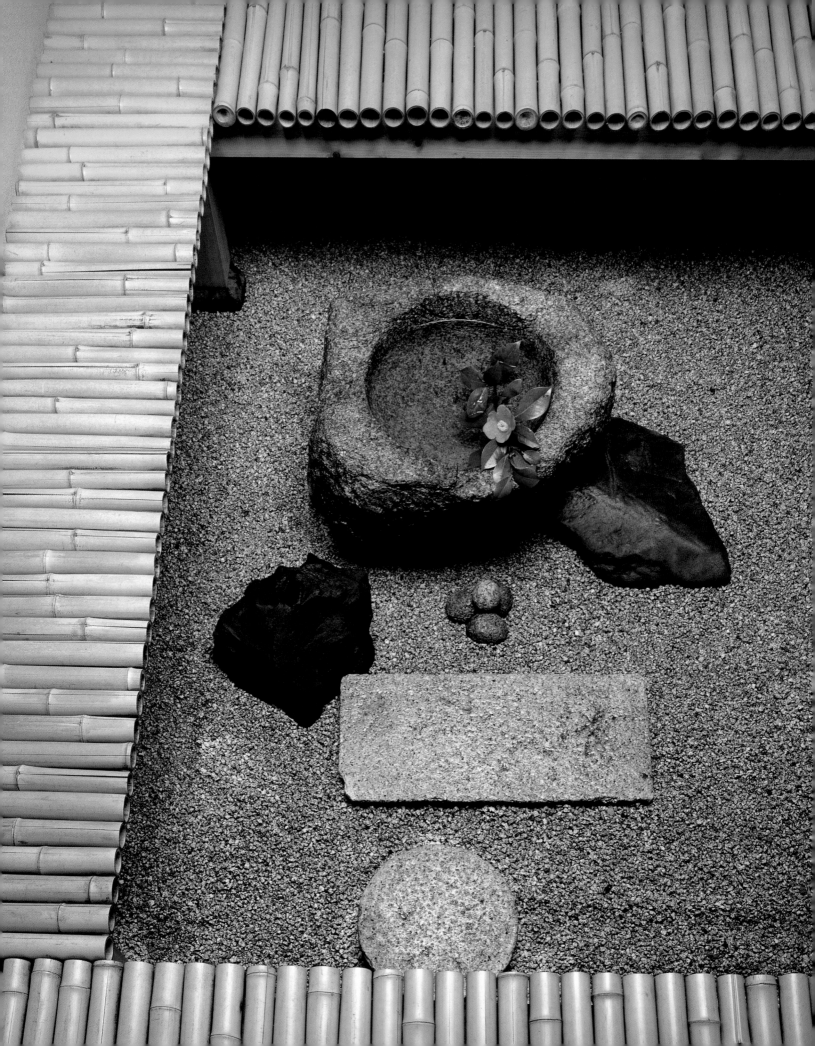

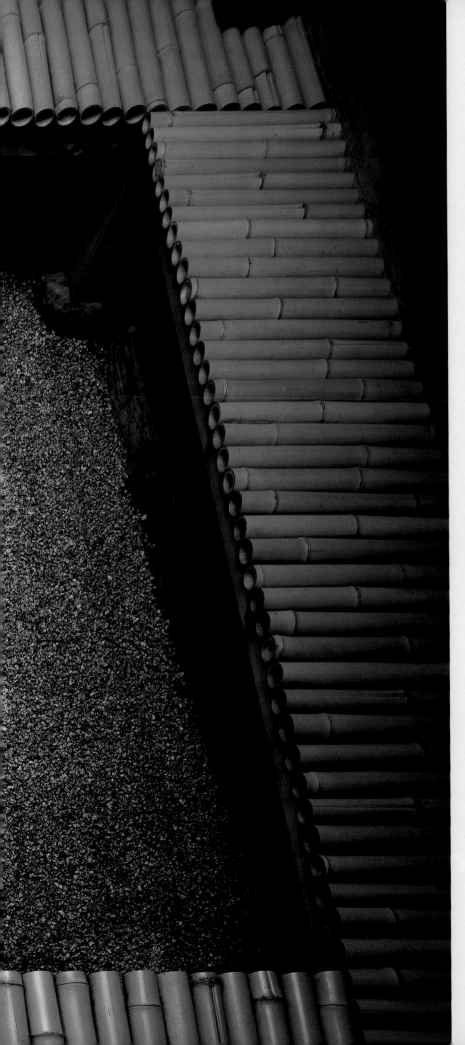

easily rebuilt. Similar floors are still used in other cultures, but in Japan, bamboo flooring using whole poles is limited to replacing the original elements in historic buildings. Wooden floors and beautifully woven grass mats, called *tatami*, replaced the straw mats thrown over bamboo floors and continue to support the connection between interior space and the outdoors.

Most of the bamboo details used in the last hundred years continue patterns of use from earlier times. The window lattices and alcove posts show no sign of diminished popularity. With the development of new processing techniques (see the Afterword), bamboo products now have a longer life, which makes them more desirable as building materials and less apt to be replaced by plastic versions. Most bamboo building products are available through specialized businesses that make a wide range of building components, from windows, to fencing, to display items used in stores and restaurants. These businesses may take the form of a single factory employing groups of craftspeople, an individual who supplies several shops or wholesalers, or a wholesaler may represent work from other regions in addition to its own. The businessmen involved are more than just salesmen. They know bamboo, they know the history of the designs, and they keep up-to-date with new technical developments.

Unadorned bamboo, stone, and gravel were used to create this perfect, small oasis.

NEW DIRECTIONS

Exciting new uses of bamboo in architecture have arisen recently, primarily in public buildings. Architects are experimenting with bamboo in "minimal" atmospheres to create a clean, spartan mood. Koizumi Makoto is known for such interiors, seen in gallery and restaurant spaces. He works frequently with the Torado Company in Kamakura and, as a result, he is able to capitalize on the subtle

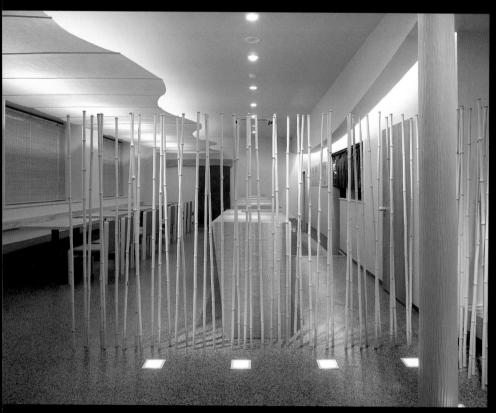

differences in bamboo. Others use bamboo to emphasize an Asian ambience. Monsoon, a restaurant in Tokyo, is an excellent example: panels of woven bamboo cover the high-peaked ceiling in the main dining room, and nine varieties of bamboo are used in other architectural details, such as railings and door frames.

Among the most dramatic recent uses of bamboo are Yoh Shoei's ceiling applications at two sites in Fukuoka built in the early 1990s. Yoh is an architect known for his responsiveness to the natural surroundings of his buildings,[12] and his use of bamboo is significant for several reasons. First, since bamboo is not a legally recognized building material in Japan, because its tensile strength varies considerably with growing conditions and processing techniques,[13] Yoh had to go through a lengthy process of negotiation in order to integrate bamboo into the design. Second, as an architect, he chose to use and expand upon regional craftsmanship while inte-

Bamboo can be successfully incorporated into contemporary interiors, such as this restaurant interior by Koizumi Makoto. Bamboo, as the simple vertical line, successfully suggests a barrier without blocking light and air flow.

grating traditional skills with advanced technology. And finally, his use of the bamboo grid, specifically in a ceiling, is an historical reference to the powerful grids of *minka*. Yoh's structures not only point out future directions but also illustrate bamboo's potential in the creation of buildings that relate to Japanese heritage.

In contrast to Yoh's public spaces, which he designed to accommodate and serve the community, Saito Yutaka has concentrated on designing private, urban dwellings. Often challenged by small building sites, he nevertheless achieves a feeling of intimacy, space, and light. His use of such contemporary materials as black plaster and concrete in combination with the more traditional elements of bamboo, paper, and lattice softens the hard lines of the architecture, and expands the tradition of harmony between garden and dwelling. Saito's designs sometimes include small inner courtyard gardens, often referred to as *tsubo niwa*, which bring a feeling of nature and serenity indoors. His provocative use of bamboo in the garden of the Rurururu-abo House makes a strong case for the attractiveness of bamboo in contemporary landscape and architecture design.

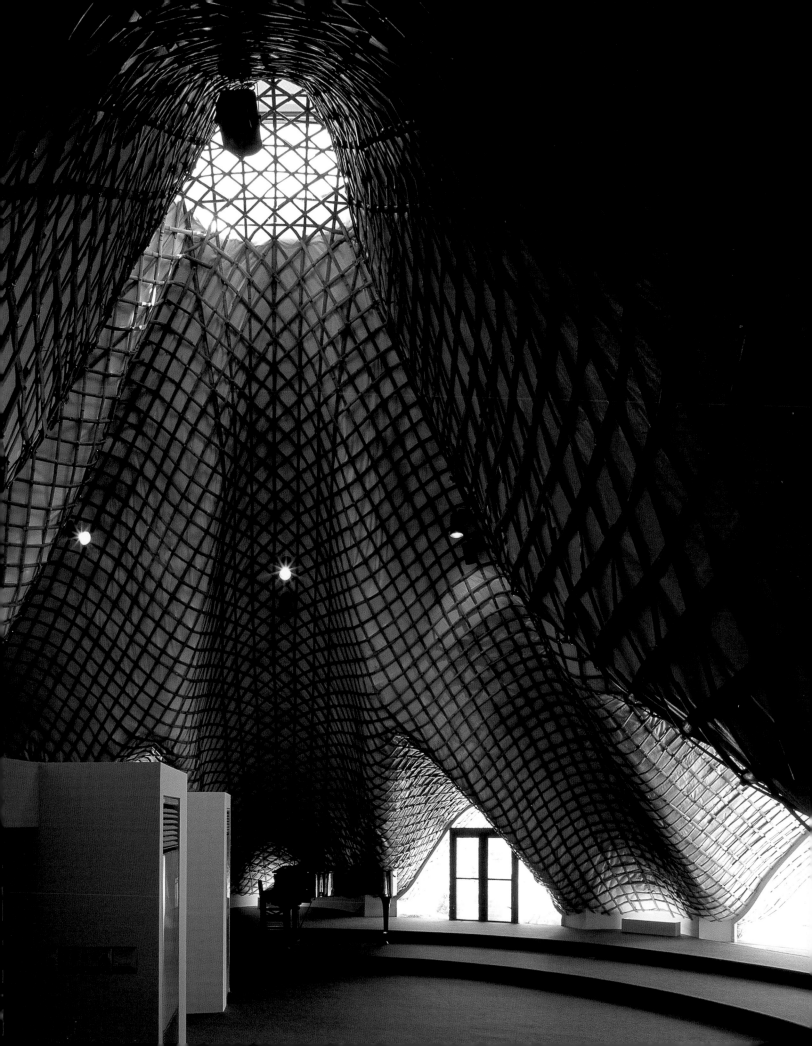

Chapter **7** BAMBOO IN THE HOME

One may detect a striking difference between the crafts and the arts. People hang their pictures high up on walls, but they place objects for everyday use close to themselves and take them up in their hands.

Yanagi Soetsu
The Unknown Craftsman

Household furnishings serve, soothe, and decorate. On a bright summer day, woven bamboo blinds are lowered over windows or wrapped around a small balcony to shield the interior from heat and sun. As evening approaches, lights are switched on—an overhead fixture, perhaps a paper lantern with bamboo ribs that rests in the corner, or a paper globe in the entry. In late July, flowers are arranged in a basket woven of golden bamboo, and in autumn, berries and dried leaves fill a rustic pack basket near the front door. These items are chosen to enliven the living space and are used on a daily basis; they both support and modify the atmosphere established by the garden and architecture. In contemporary as in traditional space, bamboo offers an aesthetic and symbolic link between the natural and the manmade.

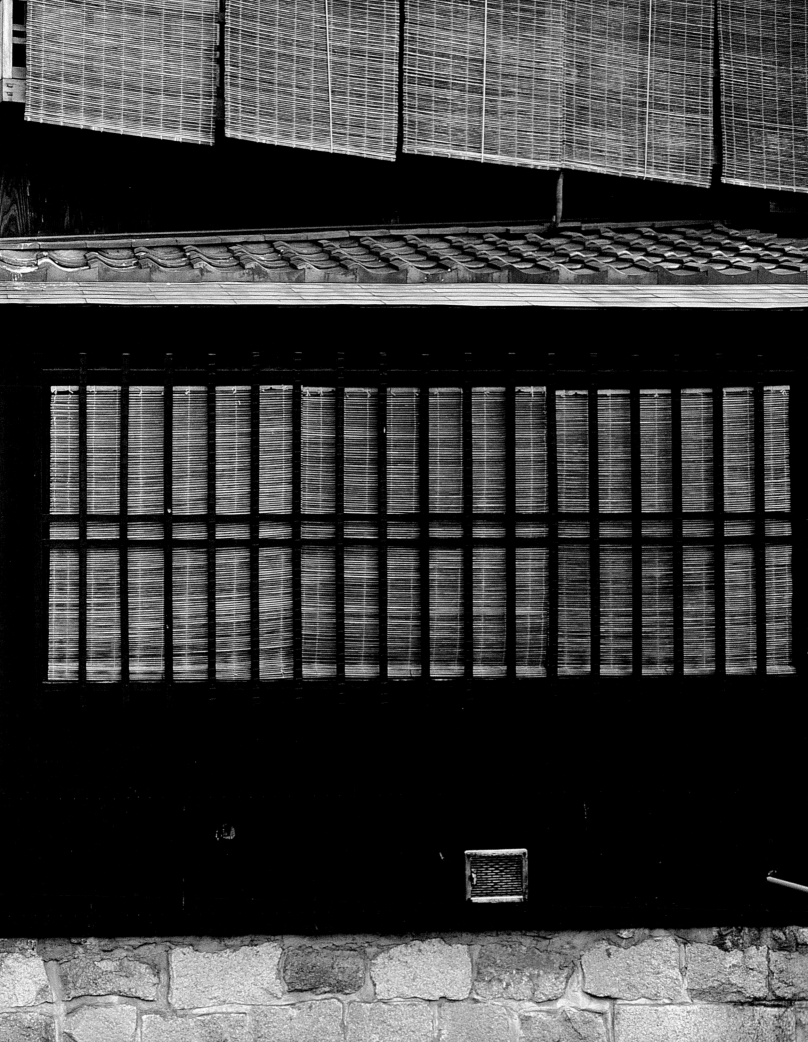

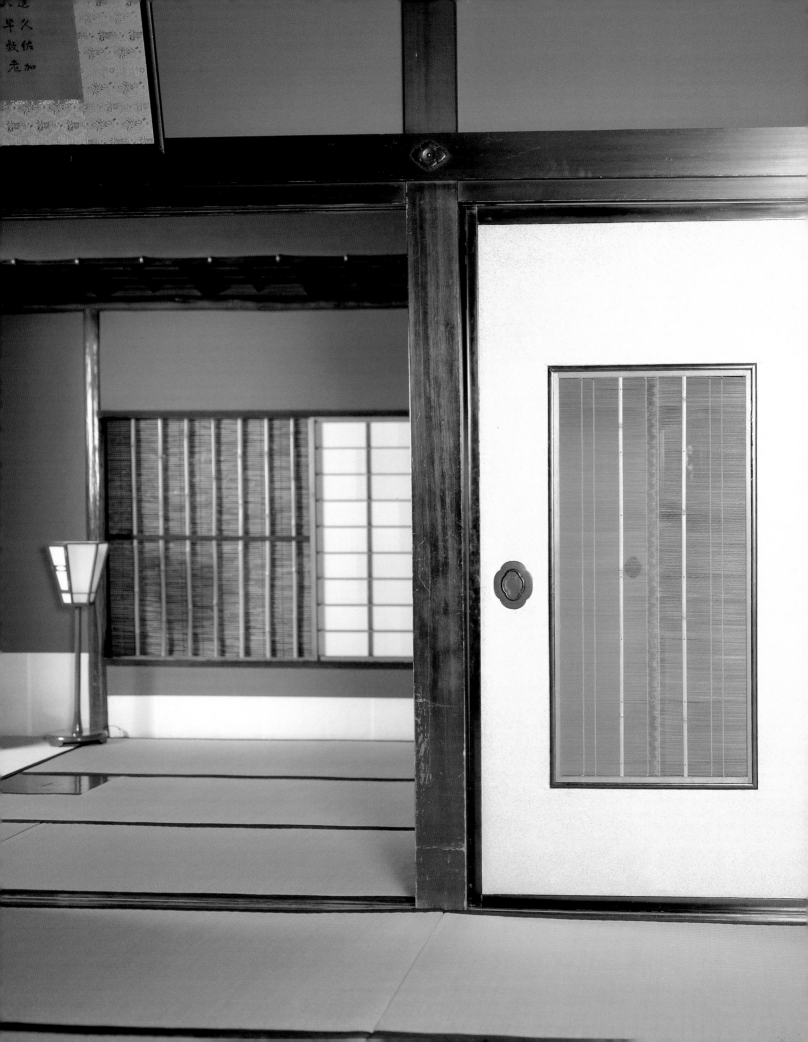

ONE SPACE, MANY FUNCTIONS

SPACES ARE DIVIDED, household items stored, food prepared, and rooms lit and warmed under the constraints and challenges imposed by Japan's traditional architecture. It is part of the genius of the Japanese imagination to be able to design one space for multiple functions, in part through the use of temporary, portable dividers. For example, the separation of inside from outside (*uchi-soto*), so symbolic in Japanese culture, can be quickly achieved through the use of sliding panels (opaque *fusuma* or paper *shoji*), a part of traditional architecture. The interior walls in post-and-beam constructions are not load-bearing and the panels, slotted into permanent groves, function more like screens than walls. The movement of *shoji* and *fusuma* panels allows the expansion of the indoor space to include the outdoors or a selected part of it. A partially, rather than fully, opened panel can refresh the perspective by revealing a tree in bloom or a distant mountain. Indoors, by repositioning a folding screen (*byobu*) or a free-standing single panel (*tsuitate*), a work table may be concealed from the view of guests. Bamboo can be the primary structural material, an embellishment to the panels, or even the painted element or pattern on the screen. At another time or in another home, the same screen becomes the backdrop for a flower arrangement.[1]

A bold twill-weave panel of wide bamboo is balanced by an unusually strong wooden frame and leg system in this free-standing screen (*tsuitate*).

Woven bamboo blinds (*sudare*) serve a slightly different purpose than screens or panels. Used in Western homes as an informal replacement for curtains, these blinds have a much wider application in Japan. As in the West, they are hung to screen the sun from interior rooms and provide privacy. In addition, more formal versions (*misu*), edged in brocade fabric, are used in interior design for residential spaces. Much care is given both to the preparation of bamboo for blinds and to the placement of the node ridge. The most elaborate variations are still seen today at temples and shrines. The famous antique stores and flea markets of Tokyo, Kyoto, Hiroshima, and other cities offer a chance to see and buy beautiful examples of old screens and blinds, treasured for the patina of the old bamboo and the richly brocaded fabric. When the craftspeople who make *sudare* demonstrate their skills at museums,

historical sites, or regional exhibitions in department stores, they often use a quaint old loom with wooden weights and bobbins. The rhythm of the thrown bobbins and the quick development of the pattern formed by the nodes make the demonstration a favorite. In the factory, however, an electrically powered loom or, at the very least, a production line, is more efficient. Even where the machine dominates, however, the hand of the craftsperson is still needed to select the bamboo, position the node, and place the bamboo strips carefully into the machine.

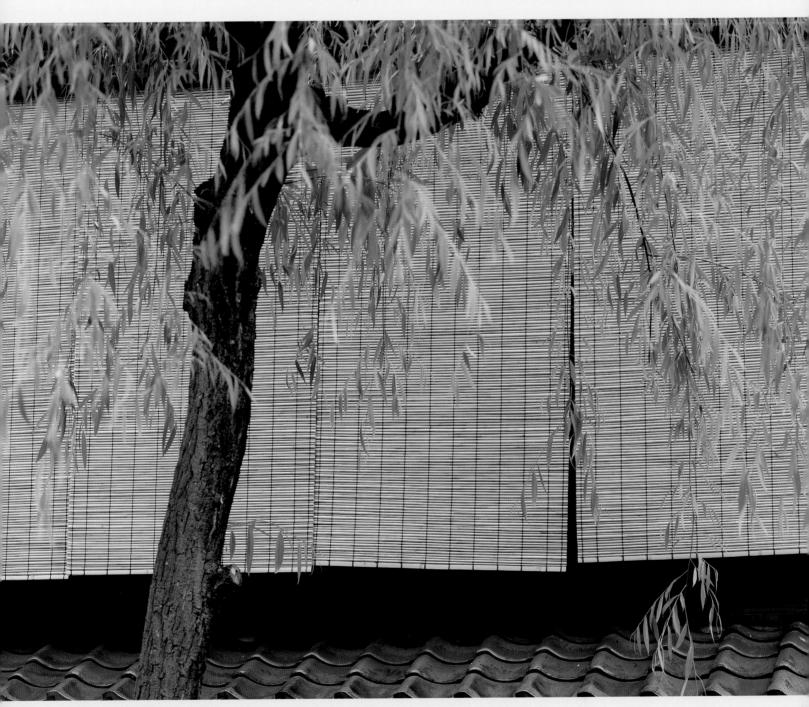

Along the river on a summer afternoon in Kyoto, a breeze rustles willow branches as *sudare* blinds are lowered against the heat of a summer sun.

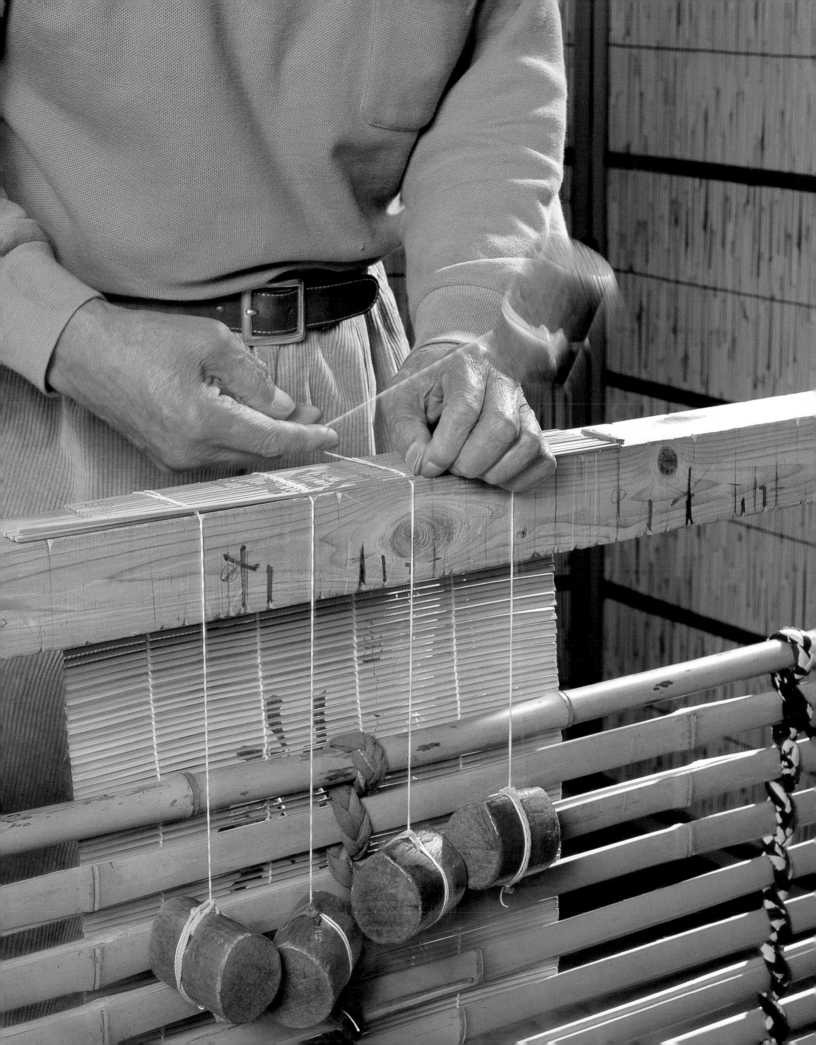

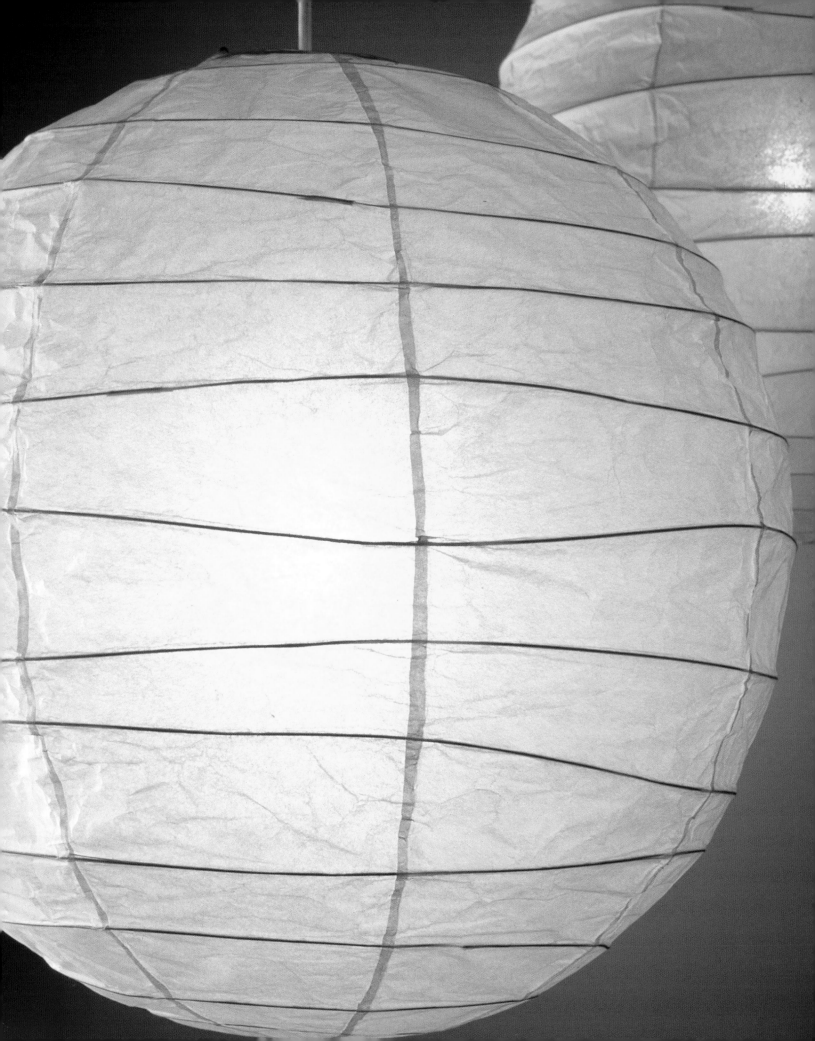

LANTERNS AND LIGHT FIXTURES

THE GLOWING WHITE *AKARI* LANTERNS designed by Isamu Noguchi in the early 1950s remain emblematic of Japanese crafts worldwide. In Japanese homes, such lanterns still sit alongside the plastic shades from the local department store, the occasional Tiffany shade, or the contemporary Scandinavian lamp. The light from the *Akari* is softly diffused and contributes more to atmosphere than to ease of reading. Often it is placed strategically to establish the tone—in the entry or in a special Japanese-style room with its *tatami* mats and *tokonoma* alcove. Designers of restaurants, hotels, and Japanese inns (*ryokan*) often use *Akari* to reinforce the sense of traditional hospitality.

Lanterns made of paper and bamboo have been widely used in Japan since the beginning of the fourteenth century. The lanterns used in festivals, especially the *obon* festival of late summer, are constructed in much the same way as other paper-and-bamboo lanterns, although plastic versions abound. Decorations on the surface are particular to the event. For *obon* parades, the lanterns light a path for ancestral spirits to find the way home. At the end of the festival, the sight of hundreds of these soft lights moving along on a summer night is breathtaking. The cylindrical *chochin* (in which the paper-covered spiraling bamboo shade collapses into the wooden end caps) were associated with the region of Odawara in particular, and to this day bear its name, *Odawara-jochin*. Temples, shrines, restaurants, inns, and other businesses use lanterns in many ways—to advertise, celebrate, and announce—and the lantern makers and craftspeople who brush on special messages are kept busy replacing old versions every few years. Stenciled designs of family crests (*kamon*), or hand-painted floral designs for gift lanterns, are often painted at the lantern factory, but commercial messages are usually penned at the shop of one who specializes in such tasks. In Kyoto, old lanterns with various messages and designs hang outside the door to announce that the lantern painter's shop is open. No other sign is necessary. The lanterns are removed at night, and the building becomes just another wooden home on a busy street, until morning when the lanterns once more announce that a business is located inside.

Not all lanterns and light fixtures involve bamboo and paper, in part because they cannot be

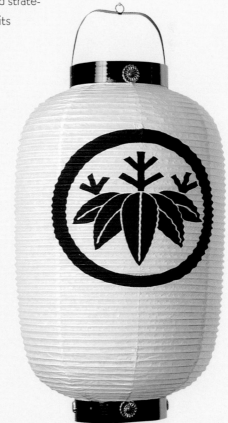

The distinctive *chochin* lantern is collapsible for easy storage. They are often painted with advertisements or family crests—this of a bamboo pattern.

121

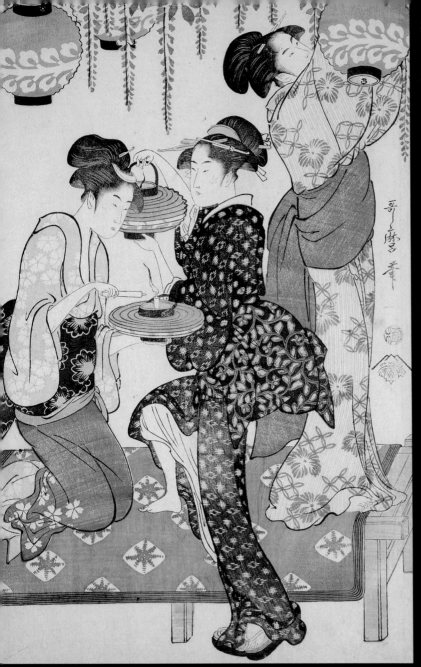

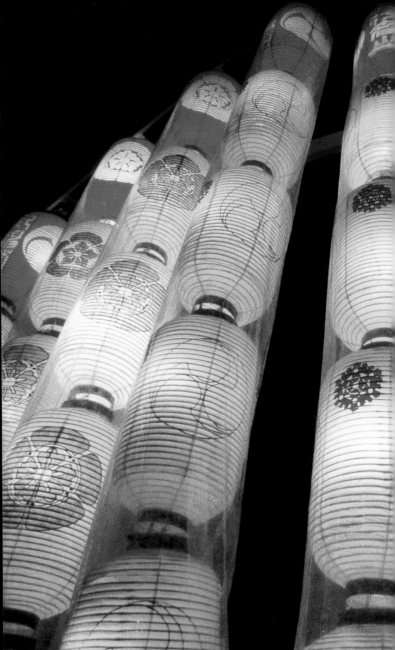

Hanging flowers, bare feet, and lanterns—Kitagawa Utamaro has captured an early summer evening in this late eighteenth-century print, *Teahouse Maidens under a Wisteria Trellis*. (Courtesy of the Honolulu Academy of Arts)

used safely with high wattage bulbs. A favorite alternative is a boxy ceiling fixture, now usually of molded plastic, which can accommodate multiple bulbs. The style of this fixture, sometimes decorated with bamboo patterns, evolved from a bamboo cricket cage. When roundcut bamboo pieces (*maru higo*) are used in these ceiling fixtures, they are prepared by the same method as those used in cricket cages, some openwork flower vases, trays, and mirror frames. Cricket cages originated in China, where collecting and training crickets to fight has a long history. To celebrate the beginning of summer, many Japanese families once bought crickets in bamboo cages and hung them under the eaves or indoors. This long tradition, well documented in the *ukiyo-e* prints depicting themes of everyday life, continues even in some urban centers.[2] The sound of insects chirping reassures everyone, not only that summer has come once again, but that the seasons (and life) move forward as they should.

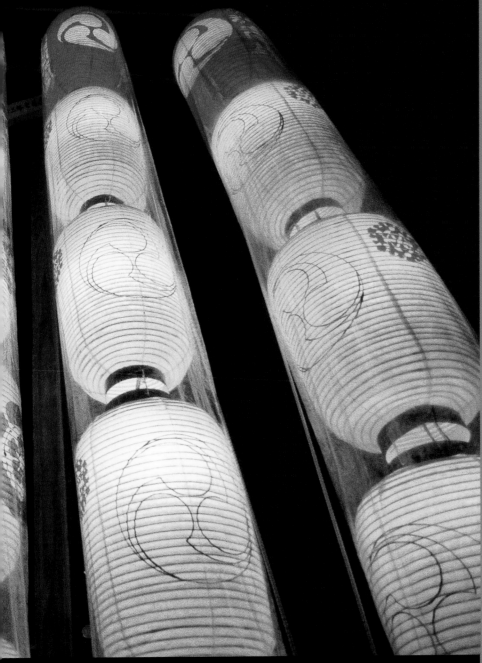

Hundreds of painted lanterns like these illuminate festivals throughout Japan.

TOP For over a century, Ozeki & Company have been making traditional paper and bamboo lanterns in Gifu. Notched forms, many used for years, are opened and will be wrapped with fine bamboo or wire.

CENTER Once the bamboo is in place, each panel of high-quality paper will be carefully glued into place, giving the lanterns a distinctive appearance.

BOTTOM A large *Akari* lantern, still on its form, is too big to fit into the drying oven and stands illuminated by a heat lamp.

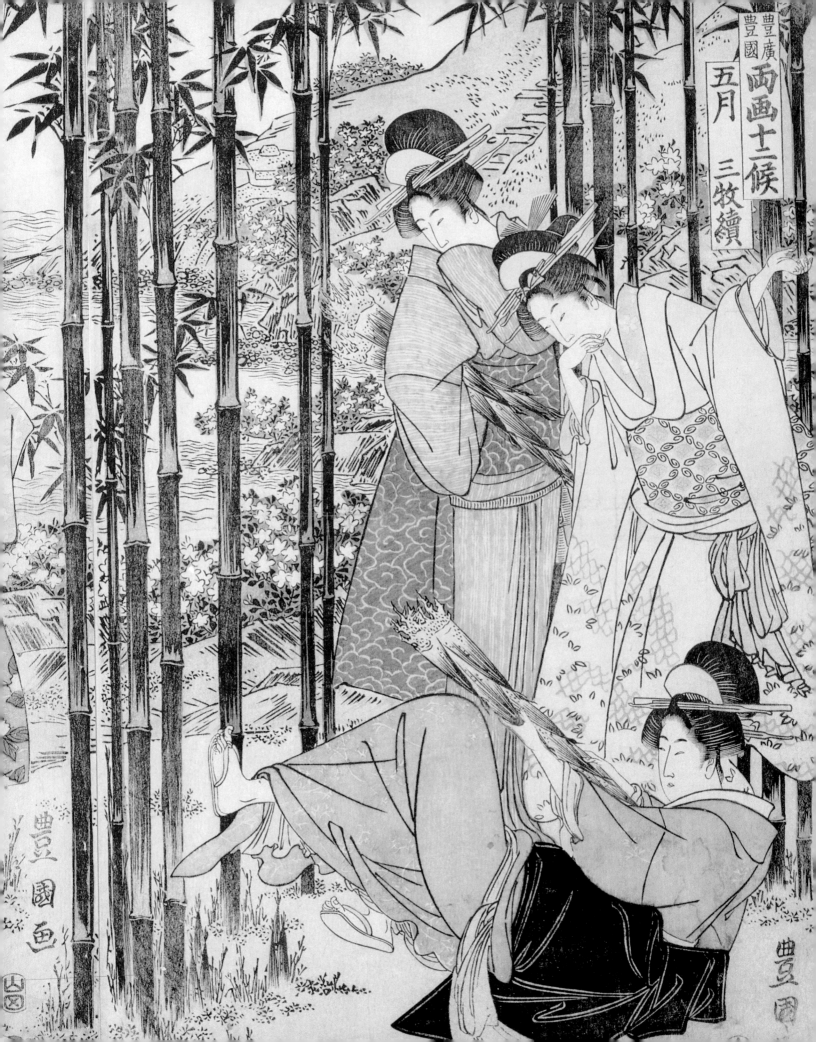

IN THE KITCHEN

IN JAPAN, FOOD is a major preoccupation. A stimulating and informative introduction to the Japanese kitchen can be seen on any given day on Japanese television; indeed, to watch television in Japan is to learn about food and see bamboo in one of its various guises as a food, utensil, or presentation basket.[3] There are contemporary dramas, baseball games, silly game shows, and the ever-popular historical dramas with lords and samurai, but most of all, there is food. Each day there is at least one quiz program in which the unknown final ingredient of a regional recipe is the focus of contestants' attention. Daily news coverage may include the first harvest of a seasonal crop, such as melons, wild mushrooms, rice, or bamboo shoots. Viewers from Tokyo to Sapporo to Nagasaki watch as a family hikes into the mountains in early spring with a bamboo basket to gather, cook, and eat the first mountain vegetables of the season. The idea of "first of the season" (*shun*) is important in Japan[4]—another example of the Japanese sensitivity to nature.

Whether the kitchen is in a *kaiseki* restaurant in Kyoto, a cooking teacher's studio in Tokyo, or a farmhouse in Hiroshima, where there is food, there is bamboo. First, bamboo is itself a food. While canned bamboo shoots are known throughout the world as an easily accessible ingredient in Asian cuisine, fresh bamboo shoots are the focus in Japan. They have always been part of the Asian diet and are becoming familiar in other cuisines as well. In Japan, the fresh shoots, referred to always as *takenoko*—"bamboo's child"—are available via import from other parts of Asia much of the year. As a fresh, regional product they mark the beginning of spring as it marches northward from Kyushu to northern Honshu. In most Japanese homes and restaurants, *takenoko gohan*, rice cooked with bits of fresh bamboo shoots and traditional seasonings, is served only at this time of year. Even fast-food shops and department store food displays herald spring with packages of this specialty. Although several prefectures in southern Japan provide most of spring's bamboo shoots, bamboo-shoot farming in some Kyoto locales dates back over one hundred years and involves agricultural techniques not used anywhere else. In early spring, special *takenoko* booths are opened on shopping streets in Kyoto in anticipation of the crop. For the remainder of the year, bamboo shoots, fresh and canned, are a cooking staple and appear frequently, if without the excitement brought by the first harbingers of spring.

The interior of a bamboo shoot reveals a design wonder—every membrane and node of the bamboo to come is already in place.

Bamboo baskets are versatile carriers. Here the delivery of beer and Japanese boxed lunches is complete and the motor scooter heads back to the restaurant.

Bamboo kitchen tools are efficient, mostly inexpensive, and part of daily life. Bamboo whisks the eggs, rolls the sushi, grates the *daikon* radish, and skewers the fish. No bamboo implement is more important than the ubiquitous *zaru*—the simple woven bamboo basketlike tray that is made to withstand water for daily draining, rinsing, and serving needs. In advertisements, this insignificant little basket is often used to display vegetables, freshly caught fish, or seasonal fruit. Kitchen shelves and drawers are further supplied with bamboo tongs, graters, chopsticks, small picks, baskets, and mats. New displays of bamboo kitchenware routinely appear in stores each spring, and bright green bamboo tubes filled with gelatinous sweets are sold each summer.

Bamboo is not only of significance as a food and in the preparation and serving of food, it also plays a behind-the-scenes role in the growing, gathering, packaging, and transportation of food products, a role not as well known as its place in the kitchen. Lighter than wood, cheaper and easier to replace, and more resistant to the ravages of seawater, bamboo makes ideal con-

The Nagaichiku factory in Beppu produces a number of kitchen and restaurant products, including this simple grater cut from a piece of large-diameter bamboo.

Local hardware and kitchen stores offer a wide range of supplies, many made from local bamboo.

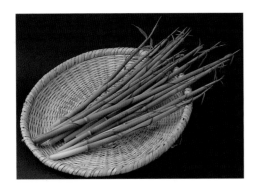

Nothing is more useful in the kitchen than the simple *zaru* basket tray.

tainers for collecting sea vegetables and salt as well as for oyster farming. Bamboo baskets accompany fishermen and eel catchers to the rivers and the sea. Bamboo work baskets are carried along the paths between the endless green rows of the tea plantations and through the terraced tangerine (*mikan*) orchards. Long bamboo poles are used to harvest persimmons, and shorter strips of bamboo are inserted into octopi drying in the sun, causing them to resemble nothing so much as small kites (with which they share a common name, *tako*). Few Japanese are aware that the bamboo poles and grids they see in the bays along Japan's coastline mark the sites for collecting oysters and *nori* (a sea vegetable). Yet *nori* gathering is of such importance that part of the protest over the opening of Narita Airport near Tokyo revolved around the potential disturbance of the *nori* beds in Chiba Prefecture. In other regions, early in February, when the ocean is still icy cold, the older women in coastal towns still go out into the waters with bamboo baskets and gather the local seaweed, just one of the seventy sea vegetables eaten in Japan. The beaches are covered in bamboo mats and trays as the highly prized culinary delicacy dries in the sun.[5]

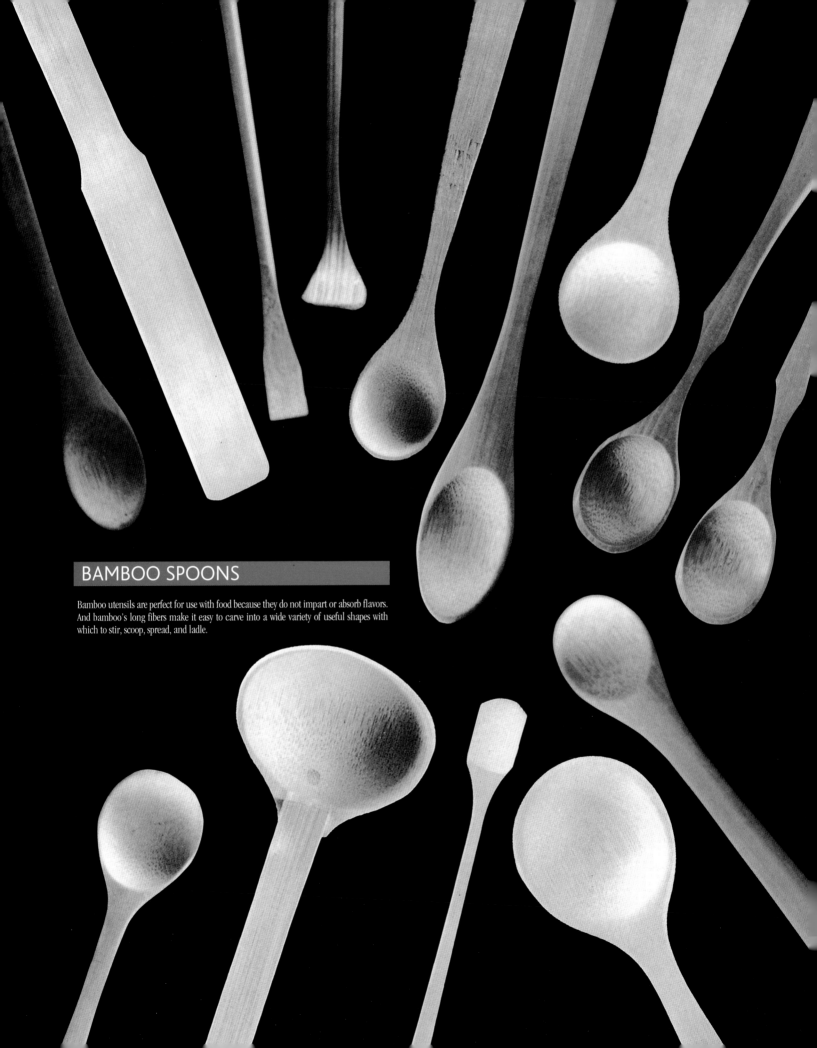

BAMBOO SPOONS

Bamboo utensils are perfect for use with food because they do not impart or absorb flavors. And bamboo's long fibers make it easy to carve into a wide variety of useful shapes with which to stir, scoop, spread, and ladle.

Bamboo baskets have a long association with food in Japan. Traditionally, baskets are employed to carry and transport the fish and produce, used in the kitchen during food preparation and, to finish the progression, find their way to the table as serving vessels. Light, strong, adaptable, and readily available, few materials are as suitable as bamboo.

Strong back baskets easily hold a heavy load of vegetables or other produce. The woven straps and bamboo verticals stabilize the load, and the open weave allows air flow.

These decorative little baskets were originally designed to be used at wedding banquets. Quickly constructed using the interior cuts of bamboo with no skin, these baskets were discarded after one use.

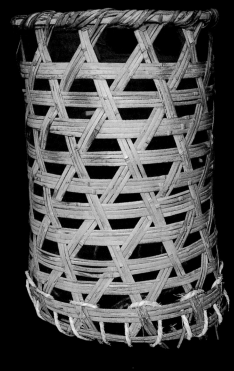

An airy open-weave construction makes this container suitable for light materials only, such as leaf or paper-trash collection.

Woven scoops and baskets are used in the home and the field. Sizes, weave patterns, and functions vary from region to region.

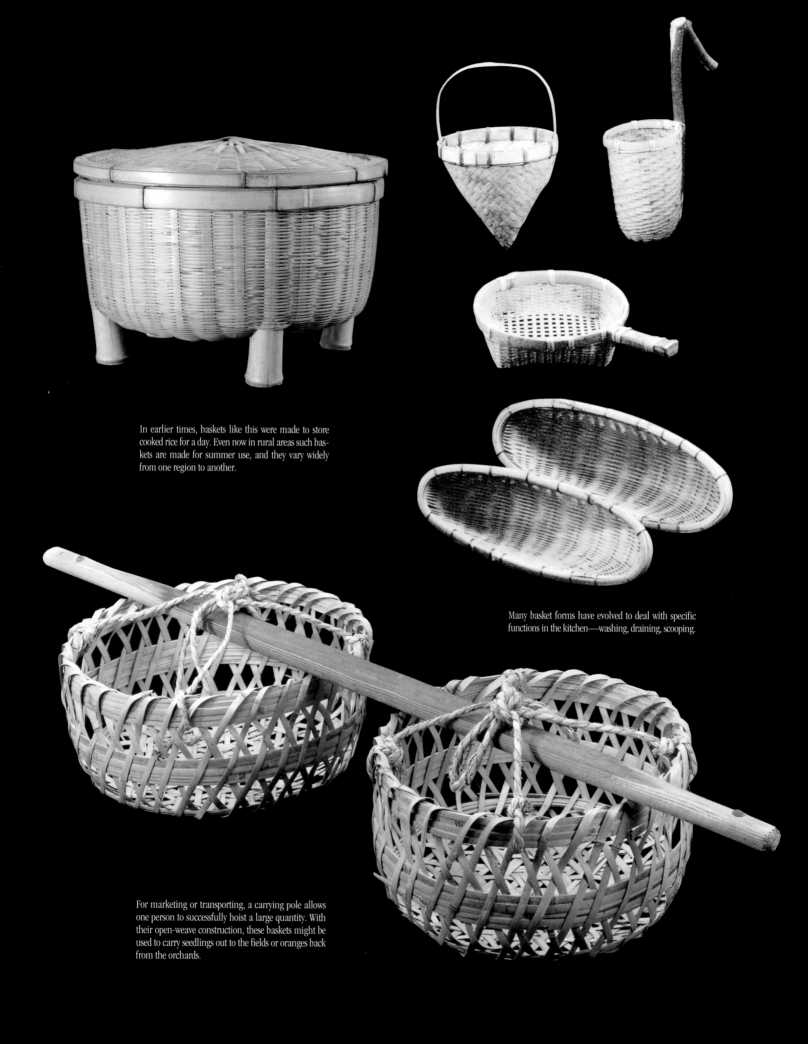

In earlier times, baskets like this were made to store cooked rice for a day. Even now in rural areas such baskets are made for summer use, and they vary widely from one region to another.

Many basket forms have evolved to deal with specific functions in the kitchen—washing, draining, scooping.

For marketing or transporting, a carrying pole allows one person to successfully hoist a large quantity. With their open-weave construction, these baskets might be used to carry seedlings out to the fields or oranges back from the orchards.

PERSONAL ACCESSORIES

Personal accessories announce an individual's style, mood, and, at times, age and station in society. Westerners are often surprised to see kimono-clad women carrying bamboo-and-paper fans in urban centers such as Tokyo and Osaka. But in truth, kimono, traditional fans, and umbrellas are still carefully selected and highly valued. Though they are no longer used on a daily basis by most Japanese, they are indeed used. A woman might select one kimono ensemble—outer garment, obi, slippers, hair ornaments, fan, bag—for a fall wedding, but another for a wedding in spring. A young woman might limit her use of kimono to special events, such as New Year's or Coming of Age festivities. The same woman's wardrobe is more likely to contain a bamboo motif on clothing than accessories made out of the material itself. Still, she will use a folding fan with her summer yukata and buy an expensive bag with a bamboo handle to match. A man might wear a summer yukata, complete with an old-fashioned netsuke-and-inro set, if dressing for a summer festival, yet put on a suit to go to work. In summer, men often still tuck a folding fan into their kimono and, whether on a train platform or participating in a parade, use it vigorously. Along with miniskirts, hennaed hairdos, and shouldered satchels, the traditional kimono and accessories of Japan continue to make a statement.

Bamboo is both an integral material and the design in these classic *uchiwa* fans. The choice of bamboo and flowers motifs means these are fans for hot summer days.

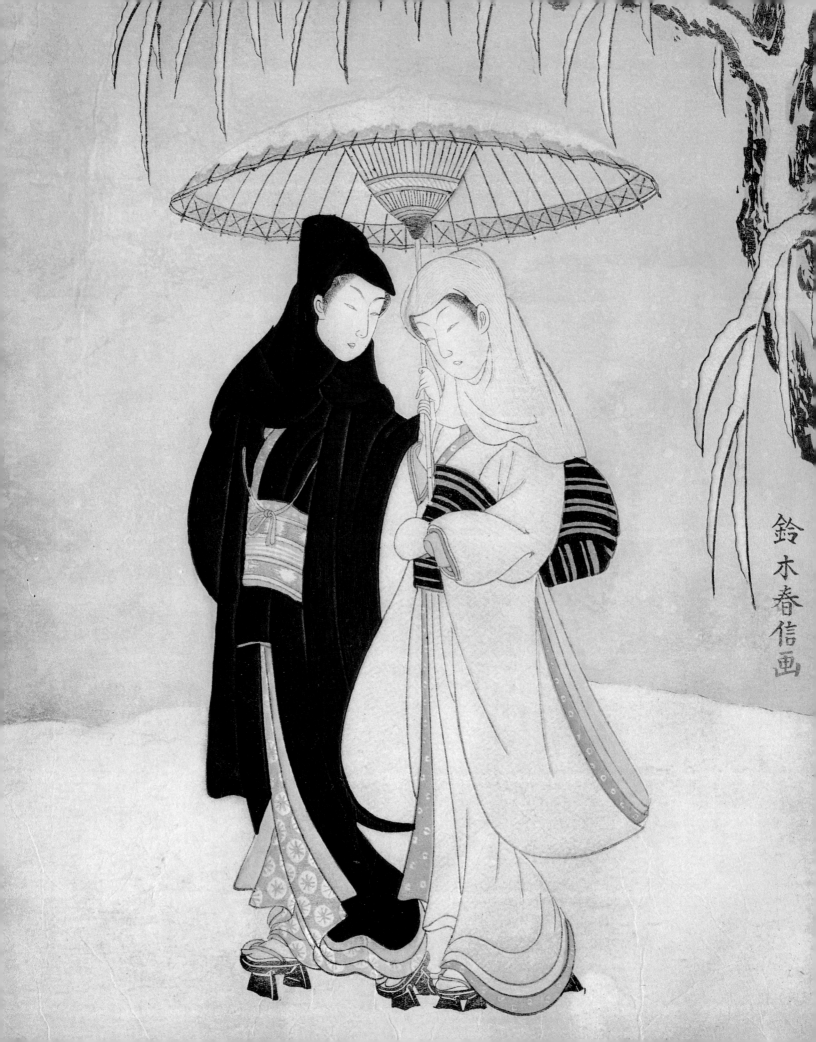

JAPANESE UMBRELLAS

MOST SCHOLARS AGREE THAT UMBRELLAS, used for protection in both heat and rain, originated in the hot, tropical climates of such countries as India and Egypt. The first written record of umbrellas in Japan appears in A.D. 720,[1] although the details of their arrival remain unknown. By the eighteenth century, umbrellas were in common usage.

The Japanese have since contributed a great deal to their image: eye-catching Japanese umbrellas (*wagasa*) drying outdoors; old umbrellas hanging in the entryway of an inn; the large, red teahouse umbrellas silhouetted against tall bamboo; the *janome* umbrella with its distinctive snake-eye design. Each example is clearly identified with Japan, though the basic form is universal.

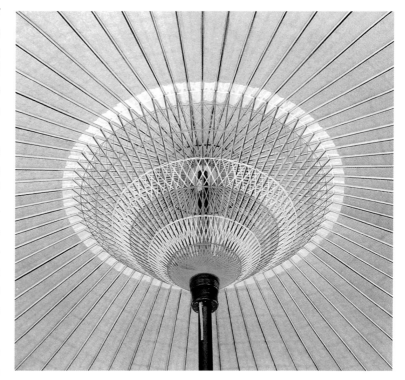

n some of the most beautiful Japanese umbrellas, a complicated system of "thread lace" is visible on the interior.

Several significant events mark the history of Japanese umbrellas, punctuated by the feudal era's sumptuary laws which so severely limited the consumption of "luxury items" that umbrellas' size, color, use, and design details were dictated. Another important milestone occurred about 1600, with the adoption of the spring, or "click," a simple mechanism that allowed the umbrella to be quickly secured in an open position and greatly enhanced the ease of use. At about the same time, documentation of the role of umbrella makers themselves began appearing in art.[2]

In the 1700s, umbrella making came to Gifu, a town in central Japan now famous for its fine umbrellas.[3] During the political upheavals of the mid-1800s, when the Tokugawa shogunate was replaced and the feudal system dissolved, many samurai became unemployed and were pressed into the production of bamboo crafts. As a direct result, the umbrella industry thrived.[4] The Gifu area was particularly well-suited for the production of umbrellas and lanterns (see chapter 7) because of its large stands of flexible *madake*, a bamboo easily cut lengthwise, and because of high-quality, locally produced paper. The most famous concentration of umbrella makers in Japan is still active in the twenty-first century in Gifu, where about seventy percent of traditional Japanese umbrellas are produced each year.[5]

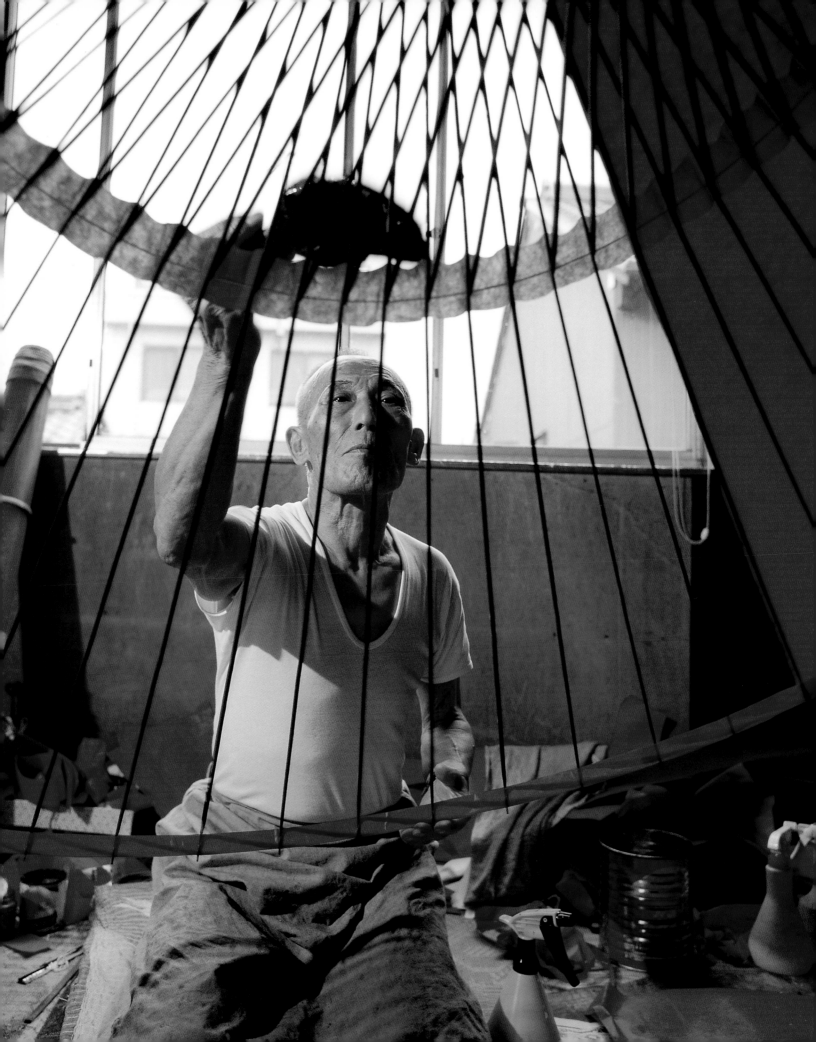

■ CONSTRUCTION

Although mass-produced umbrellas of metal, fabric, and plastic are used regularly throughout Japan and the rest of the world (even by umbrella makers themselves), the true umbrellas of Japan are still made of bamboo and paper, and their beauty is the direct result of the hand, the eye, and the experience of the craftspeople who construct them. Power tools facilitate cutting, shaping, drilling, dyeing, and drying, but all are tasks that require considerable skill. Even when efficient production procedures are in place, it takes approximately one month for a single umbrella to go through the entire process.

As in other bamboo-based crafts, the painstaking selection, cleaning, and processing of the raw material is essential to the quality of the final product. Before the bamboo is cut into smaller, individual pieces, each pole is cut to the approximate length needed and marked with diagonal lines on the surface. These lines will allow the craftsperson to keep the smaller elements in sequence after they are cut, a step unique to umbrellamaking[6] that contributes subtly to the even application of the paper surface of the umbrella.

In addition to the central shaft, two sets of ribs, called "parent and child bones," are cut from bamboo for each umbrella. The longer set includes the ridge formed on the inside of the node by the remains of the inner membrane—usually carefully removed in other bamboo crafts. The placement of the node is essential to umbrella construction. Although the outer surface of each rib is planed smooth, the inner ridge of the node is retained. A hole will be drilled in it to receive the stringing that distributes the ribs evenly across the surface of the umbrella.

The construction of a single umbrella involves a dozen separate steps and is so complicated that umbrellas are rarely made at one site or by one person.[7] Usually each step in the preparation of the bamboo is completed by an individual craftsperson at a different location within a town. In Gifu, for example, the small ribs, or stretchers (which push up the longer outer ribs when the umbrella is opened), are cut and planed into shape on two specialized machines by one craftsperson. Once cut, the ribs are soaked in water for a week before being finished by hand and being dried in his driveway. All the pieces that will be used in one umbrella he cuts from one culm and holds together by a ring cut from the same culm. These bundles, each representing one umbrella, will remain together, moving from one workshop to another, during the entire process. When the craftsperson has completed a large quantity of these ribs, he delivers them to a different site where they will be dyed, dried again, and passed on for final assembly elsewhere.

The wooden umbrella top and runner, the circular piece that holds the bottom ends of the short ribs and slides up the shaft, are cut, shaped on a lathe, and notched to receive the ribs, which are laboriously stitched into place with strong thread. Wood from the local *chisa* tree is preferred, but other woods can be used. Since this process requires specialized tools, these components are often produced elsewhere and delivered to the final assembly site of the umbrellas.

Before the bamboo and wooden elements are united, the central shaft of bamboo must be lacquered and the holes drilled. These holes will accommodate the metal springs that allow the

umbrella to stay open. Little more will be done to this piece of bamboo until the grip area is wrapped at the very end of the entire umbrella-making process. The bamboo and wooden elements are united, eventually followed by the positioning of the paper cover. Older skilled hands accomplish these tasks deftly. Trainees must practice for years, their every step overseen by experts.

Before applying paper, the step that will transform this bamboo skeleton into the object that is distinctively Japanese, the umbrella skeleton must be opened and firmly secured in a rack to prevent any movement (special paper tape is glued in place to space the long ribs properly). The paper will be applied along the bottom edge of the umbrella first and will cover one half the surface or an area of three to five ribs, varying from craftsperson to craftsperson. Paste is applied to one area at a time and that paper laid, before moving on to papering the next section. To ensure that adequate bonding has taken place, skilled fingers, brushes, and tools press each sheet of paper onto the ribs. This early step in the papering process contributes greatly to the final look of the umbrella and is continued until the entire top surface is covered. The central area near the top knob is papered separately, and this step is particularly difficult.[8] After all the papering has been completed and the wooden top also colorfully covered with multilayers of paper, the open umbrella is put outdoors to dry. There is still much handwork required before the umbrella will be turned over to the next craftsperson: each umbrella is repeatedly rolled, with fingers and tools used to create just the exact creasing needed between the ribs, and rings (previously bamboo, now replaced by plastic or metal) are used to constrict the umbrella so it assumes the proper proportions. Only then will it go on to the final stage. Each of these stages is carried out by older craftspeople in the same way their predecessors have done for decades. One craftperson holds hundreds of sheets of paper to the light and eliminates the two or three with imperfections. Another cuts the paper using a die that he has used his entire career. There is a rhythm to many of these procedures, with no wasted motions, no indecision.

Painting, oiling, and lacquering are all that is needed to complete the long umbrella-making process. Some bold patterns, such as the *janome*, can be stenciled or painted before the paper is glued into place. Others are hand painted at this point, after the entire paper cover has dried thoroughly. Persimmon tannin is used to set the colors. Cutouts are used only occasionally to add to the design possibilities. The best umbrellas are finished with both oil and lacquer. Warmed oil is painted onto the paper surface of the opened umbrella, and then wiped off. When done properly, the umbrella will be waterproofed and have a distinctive aroma. The lacquer is applied to a tightly closed umbrella and will adhere only to the ribs. The exposed tips of the ribs are painted, often in a high-contrast color. These steps, and the final shaping, are what craftspeople declare the most difficult and definitive steps in creating an umbrella of superior quality. They lament that few can distinguish between a thirty-dollar umbrella and one priced at three hundred dollars. They feel even an amateur should be able to discern a good umbrella by its shape when folded, the number of ribs (over eighty-four long ones), and the aroma of the oil.[9]

A few details remain: the wooden top will be covered with a square of paper or vinyl, and special umbrellas might be further decorated with a "thread lace" on the short ribs inside,[10] and the bottommost sections of the shaft wrapped. The umbrella is ready for use—a tea garden, a summer festival, a family treasure.

UMBRELLAS IN FESTIVALS, DANCE, AND THEATER

Yoshida Mitsukuni, a frequent writer and editor on the topic of Japanese culture and folk art,[11] in writing about Shintoism explains that the umbrella is a "canopy of holy space" where the gods (*kami*) can safely reside. Therefore, in festivals, which are often based on Shinto rituals and observances, attendants often hold umbrellas over important participants to invite the favor of the gods. The heavily ornamented flower umbrellas (*hana gasa*) in the Kyoto Aoi Festival play a relatively minor role in the festival, though they are often featured in images of the event because of their beauty and connection to history and ritual. Umbrellas are included in the *kabuki* costuming of the Kodomo Kabuki Matsuri[12] in Gifu Prefecture, and as part of the monk's formal accessories in the Okuri-Daishi Matsuri[13] in Chiba Prefecture, and in other ritual processions. Hundreds of twirling umbrellas, all making cheerful sounds with their ringing bells and flapping poem cards from a popular game, are a major feature of the Shanshan umbrella festival[14] in Tottori City. Umbrellas are set afire in ceremonies known as *kasa-yaki*. The Soga-no Kasa-Yaki Matsuri,[15] a festival held each May in Odawara City and Kagoshima, commemorates the legend of the twelfth-century Soga brothers, who used burning umbrellas as torches to lead the way for a night attack against their enemy.

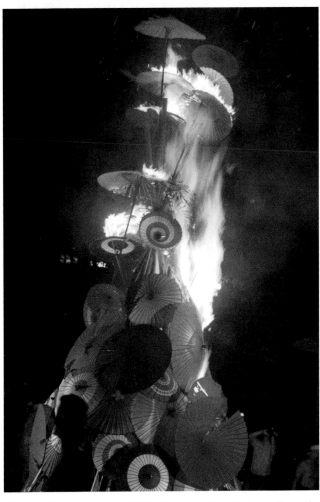

It is high drama when the umbrellas are ablaze in the Kasa-Yaki Matsuri (umbrella-burning festival). Participants and observers are reminded of a twelfth-century legend in which the Soga brothers used umbrellas as torches to seek out an enemy. (Courtesy of Fujisawa Kenichi, Fujisawa Shoten)

Sometimes it is not the umbrella itself, but only the umbrella's image that is used, as in the firemen's standard (*matoi*),[16] a pole with a large ornament (*dashi*) at the top. Historically, each fire brigade had its own unique *matoi* that was taken to the site of the fire and held near its core to urge the men on. Now the *matoi* is used only in parades and New Year's festivals as a symbol of courage and a reminder of the brigade's gallant history. Those *matoi* whose terminal ornament is of woven bamboo include examples with large, Chinese-style umbrellas (*tojingasa*). *Matoi* enjoy a second life as design motifs for fabrics, textiles, and prints.

The extensive use of umbrellas in dance, theater, and ritual has resulted in a wide range of umbrella styles. The simple *bangasa* has the fewest spokes, which makes it the least expensive style to manufacture. The ideal vehicle for advertisements, it can still be found available for use by customers at the entry to traditional restaurants, though its main contribution is toward decor. The popular *janome* style, with its distinctive snake-eye center, continues to be used both by men and women, especially when they are in kimono attire; larger versions are carried in ritual events. In traditional dance, the *maigasa* cover is constructed of sheer silk rather than paper, so the dancer can both see and be seen at all times. Just as a Confucian scholar or doctor may use a *soigasa* (*janome*-type) when walking down a rainy street, other professionals, such as *kabuki* players on stage, use an umbrella appropriate for their attire.

FANS

FANS HAVE LONG BEEN ASSOCIATED WITH LOVERS,

poetry, games, and music and were described in the early eleventh century in *Tale of Genji* and *Pillow Book*.[17] In contemporary Japan, both round flat fans (*uchiwa*) and folding fans (*sensu* or *ogi*) have their own roles and functions, and each has a separate history.

Uchiwa

The round flat fan was originally based on a mask, to which a handle was added. By the time it reached Japan from China, via Korea, its primary function had changed from concealing the face to creating a breeze.[18] The *gyoji* fan, a direct descendant of the handled mask, is still used today in the *sumo* ring by the umpire. The position of the face of the *gyoji* (sometimes held like a mask in front of the umpire's face) tells the wrestlers and the audience what step has been reached in the sequence of *sumo* rituals. Another historical version of the Chinese flat fan was constructed of leather and metal. Serving initially as a military shield, it evolved into a weapon with which the enemy could be struck.[19]

Several regions in Japan are well known for their *uchiwa*, and each has enriched the history and design of fans in different ways.[20] Simple fans were originally made in Marugame for sale to the pilgrims en route to shrines in the center of the island. Decorated with auspicious markings, these fans became a major source of income for the community. The Marugame fan differs from the *Kyo uchiwa* of Kyoto primarily in the way the handle is joined to the papered surface. By the early twentieth century, the flat surfaces of fans became a vehicle for advertising (not unlike other bamboo and paper crafts, particularly umbrellas and lanterns). This led directly to mass production and the use of alternative materials such as plastic.

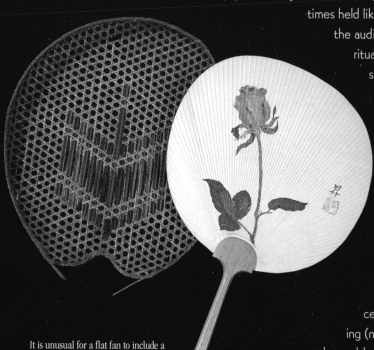

It is unusual for a flat fan to include a protective case.

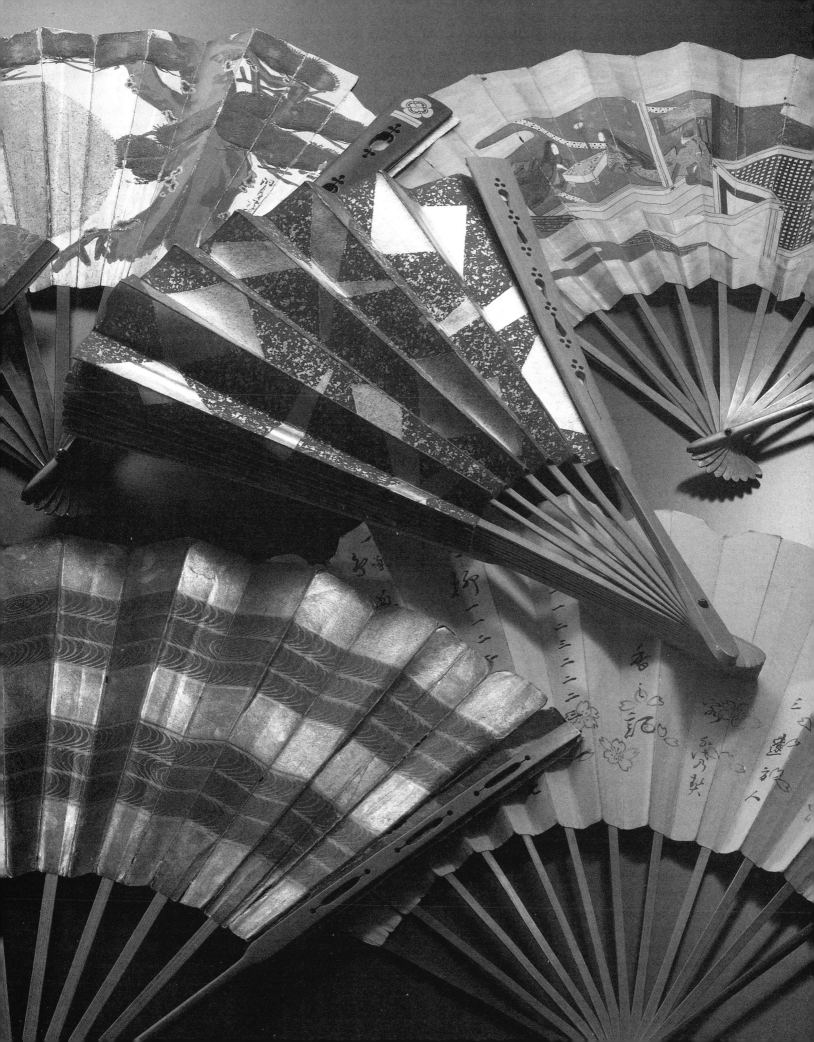

Fine ribs of bamboo are glued into place between two layers of decorative paper. In this Chiba workshop, the handle and ribs are cut from one piece of bamboo.

■ *UCHIWA* CONSTRUCTION

The use of bamboo in Japanese fans originally set them apart from those of China and Korea. For traditional construction, *madake* is preferred, combined with Japanese *washi* paper. The crafting of a Marugame-style *hirae-uchiwa* involves drilling the handle and inserting a flexible length of bamboo that is bowed to define the outer rims and final shape of the fan. The dense tissue of the *madake* node is often strategically placed to prevent the bamboo from splitting further down into the handle. The vertical elements that will become the ribs are cut from the bamboo above the drill hole, then spread out and held in place with colored thread, twined to control for even spacing. Paper is then glued in place on both sides of the bamboo. In small workshops, the ribs are secured by hand rubbing the paper into place; in mass-production, rubber rollers are now used. When the glue is dry, the outer edges of the raw fan are trimmed, and a narrow strip of paper tape or fabric is folded over the cut edge and glued in place.

The *uchiwa* made in Kyoto is usually referred to as *Kyo uchiwa* or *Gosho uchiwa*.[21] *Moso* or *hachiku*, as well as *madake*, may be used. Although the assembly process is much like that in Marugame, in Kyoto the handle (sometimes of bamboo, sometimes carved from wood or ivory) is added after the body of the fan is completed. Because the handle is not part of the initial setup, the fan's final shape can be varied—squared, rounded, or made elliptical. Each rib is a separate piece of bamboo which is laid onto the glued surface of the fan, after which the second layer of paper is glued in place, sandwiching the bamboo ribs into the interior.

There are many ways to evaluate a fan's quality. The most obvious is by the number of ribs. With the exception of the tea ceremony fan, the more ribs, the finer the fan. Another distinctive feature of fine fans is the sculpted surface created by the way the paper is pressed around each rib.[22] The tool used here is very similar to the one used to secure paper to umbrella ribs. In both cases, great care must be taken to avoid tearing the paper. Some fans, especially those from Kyoto, are known for their decorations of gold and silver leaf and for their elaborate cut-out designs.

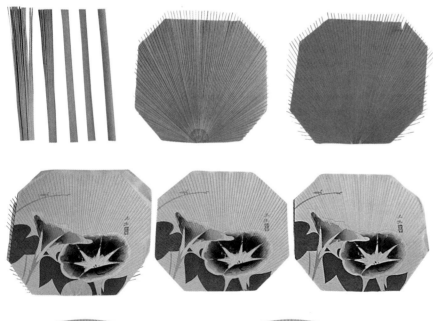

The making of a flat *uchiwa* fan: bamboo and paper progress step by step toward a decorated and fully-realized functional object.

UCHIWA IN CONTEMPORARY JAPAN

Less formal than *sensu*, *uchiwa* are the fans of the home, the kitchen, and the man or woman on a hot day. The traditional red kitchen fan continues to be used to cool *sushi* rice or to fan a flame, even in the most modern of kitchens. Elderly women wave to friends across the alley with *uchiwa* given out by the local store during summer sales. In a steamy bar, next to the bowls of green soybean snacks (*edamame*), a stack of fans awaits customers coming in for a cold beer. *Uchiwa* are carried by dancers in festival processions or in dance competitions during the observance of *obon* each summer and are often tucked into the back of the *obi* when not in use. Period re-enactments in festivals would be incomplete without the appropriate fan. But, although *uchiwa* are seen in festivals and the performing arts, they do not have quite the symbolic import of *sensu*.

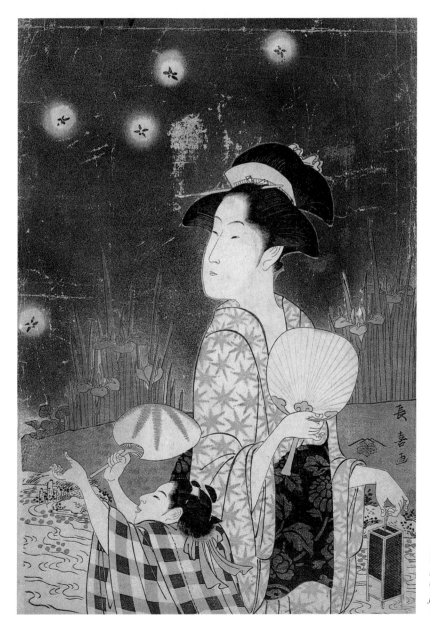

In this late-eighteenth-century *oban tate-e*, Eishosai Choki has created the complete image of summer—fireflies, *uchiwa* fans, loose summer *yukata*, and insect cages. One can almost feel the heat of a summer night. *Hunting for fireflies* from the series, *Beauties of the Four Seasons*. (Courtesy of the Honolulu Academy of Arts)

SENSU AND OGI

A dispute regarding the origins of the Japanese folding fan has raged for centuries. Some declare it was invented in Japan, while others cite tropical palm leaves as the inspiration, if not the precursor, of the folding form. If Salwey's[23] interpretation is correct, the folding fan was invented in Japan in the late seventh century A.D., during the reign of Emperor Tenchi. By the eleventh century, court fans had developed as ceremonial objects, and their use was limited to those of noble birth, whose rank was indicated in the fan's design. So it is not surprising that Kyoto, the seat of the emperor, became the center for *sensu* production.

Despite its role as a fashion accessory in Japan, as in the Western world, the *sensu* retained its symbolic status as "an emblem of life."[24] The rivet or pivot (*kaname*), the crucial element that holds the fan together, has been described by Salwey as "the starting point." She says that "as the rays of the fan expand so the road of life widens towards a prosperous future."[25] Writing one hundred years later and referring to the fan's *suehirogari* ("forward spreading") shape, Stephan similarly notes that "the spreadout form suggests expanding fortune."[26] *Sensu* still bring this powerful imagery to celebrations such as New Year's Day and marriage ceremonies. Yoshida, with his emphasis on the "supernature" [sic], states that the folding fan was considered "a dwelling place suitable for the gods."[27]

In contemporary Japan, the *sensu* is still found in many social contexts. On the face of a folding fan, a poem inscribed with the graceful flow of the calligrapher's brush is, at once, art, seductive love poem, and treasured secret folded away from view. As a personal accessory, the folding fan is essential to any kimono ensemble and tea ceremony event. In general, a gift of a fan is considered a token of esteem.[28] Boxed sets of folding fans are considered appropriate gifts for foreign guests or on specific holidays. Special fans are designated for the usual pre-engagement gift exchange (*yuino*), a custom from the Heian period.

■ *SENSU* CONSTRUCTION

Sensu construction follows a process that is essentially the same everywhere in Japan: preparation of bamboo, preparation and decoration of the paper, folding of the paper, and joining of all the elements. Within this sequence the details vary from craftsperson to craftsperson. For a fine *sensu*, preparation of the bamboo alone can involve as many as thirty steps. Because the fan is so small and the paper so delicate, it is especially crucial that the bamboo, preferably *madake*, be perfectly smoothed so that no bamboo fibers penetrate the paper. The repeated openings and closings of the fan require that friction be minimized. The element that will become the "parent" or "middle" rib is polished and refined and, in some styles, it is carved and ornamented. In addition, each rib must be carefully drilled so that it can be joined at the rivet end of the fan.

In earlier times, only one side of the fan was papered, leaving the ribs on the other side exposed. Today, the most common process involves three layers: the core, or "pocket" layer, and a cover layer on each side. The type of paper used has also changed. Originally the core paper was constructed in such a way as to allow openings to be "pulled"[29] by a highly skilled crafts

Kite-maker Takazawa Fumio frequently travels from Chiba to participate in kite festivals throughout Japan. He adds his own unique touch to the back of his kites by wrapping the bamboo supports in colorful papers cut from his old family record books.

■ KITE CONSTRUCTION

Several of Japan's most distinctive crafts—fans, lanterns, umbrellas, and kites—are created with two of Japan's ubiquitous materials, paper and bamboo. Kites in other cultures use more cloth than paper, but Japan has a tradition of producing a wide range of handmade papers, and the special papers used for kites (and umbrellas) are particularly strong because of their long fibers.[4] Paper making is an art unto itself, so most kite makers do not make their own paper. And although they do not grow their own bamboo either, they are skilled at preparing the bamboo to their own aerodynamic specifications.

The face of the kite is often quite beautiful, depicting calligraphy, auspicious designs, or heroes from history and mythology. Without skilled construction and a well-designed bamboo skeletal system, however, the kite would be merely decorative. The bamboo ribs are placed on the backside of the kite. Although they are hardly seen, questions about the ribs are essential to kite making. Each kite maker has his own preferences about the variety of bamboo selected, the length of aging, and the method of oil removal (obviously, green bamboo, heavy with oil, is unsuitable). He must know enough about aerodynamics, either instinctively or by study, to understand how to assemble the elements successfully, including where to tie the towline. He must know how thin to carve the ribs, how much glue is needed to hold the paper securely, how many crosspieces are required to maintain the stability of the overall design. All this must be determined before he selects from his collection of styles and designs, and boldly paints the surface.

KITES IN FESTIVALS

Kites are often regarded as mere toys in other cultures, but they have much greater significance in Japan. As they soar above the fields, they are viewed as a link between heaven and earth—between the spiritual and the temporal.[5] As such, they have an important role in festivals, holidays, and celebrations.[6] For example, on Kite Day (Tako Ichi) at the Oji Inari Shrine in Tokyo, kites with samurai faces are sold as talismans against fire,[7] even though that danger, rooted in the history of wood-and-paper houses, is not a major concern in contemporary Japan. Kites are still purchased for Boys' Day. A popular image on these kites, especially in Chiba Prefecture, remains that of Kintaro, the young warrior. Parents and grandparents who want their sons and grandsons to grow up to be just as strong and fearless as that exuberant youth buy these kites to help the children "soar." Miniature kites, developed in crowded Tokyo, are often given as gifts or fashioned into hair ornaments. But small as they may be, miniature kites are only deemed successful if they can actually fly.

DOLLS

THERE IS A LONG TRADITION OF doll making in Japan, where dolls (*ningyo*) are not only toys, but also charms.[8] The paper dolls of Kyoto, ceramic dolls of Kyushu (*Hakata ningyo*), as well as the wooden *kokeshi* and papier-mâché dolls from many regions are among Japan's most reasonably priced and sought-after collectibles. Although bamboo is only

The imperial couple is often depicted in doll form (*hina*), especially for Girl's Day in March. This paper version is protected by a bamboo frame.

one of many materials used in doll making, with its smooth surface, hollow interior, and accessibility, it is a natural choice. One of Japan's first dolls, *amagatsu*, with a T-shaped body of bamboo, was a plaything for the children of nobility.[9] Long before the importation of playthings from other regions and countries, similar versions were constructed by and for children in the countryside. Bamboo versions of cylindrical *kokeshi* were developed in the southern areas that did not have the dogwood and maple trees of the northern regions. Other more stylized figures constructed of bamboo could also be termed "dolls," but they are more sculptural and made primarily for display. Cut-outs and negative space are important aspects of the design, and craftsmen often apply these techniques to lamps and sculpture as well. Made throughout much of Japan, the stylized dolls from Echizen that depict scenes from *noh* and *kabuki* are particularly well known. Some traditional bamboo dolls wear dance costumes and assume the dance postures associated with specific festival events or geographic regions. The bamboo insect musicians from Shikoku are favorite souvenirs (*omiyage*), especially during the *obon* festival in summer.

Late in February, in many households all across Japan, boxes are unpacked, red felt is ironed, and furniture moved. Preparations for the multitiered display of dolls for Girls' Day (Hina Matsuri, also called the Doll Festival) are under way. The most elaborate collections include dolls that represent the Heian court, complete with attendants (holding bows and arrows as a sign of protection), miniature household accessories (baskets, bamboo shelves, birdcages), and even temple façades, including tasseled *sudare* bamboo blinds and bamboo-ribbed paper lanterns. For the two-week period up to the festival date itself, on March 3, these displays will be the

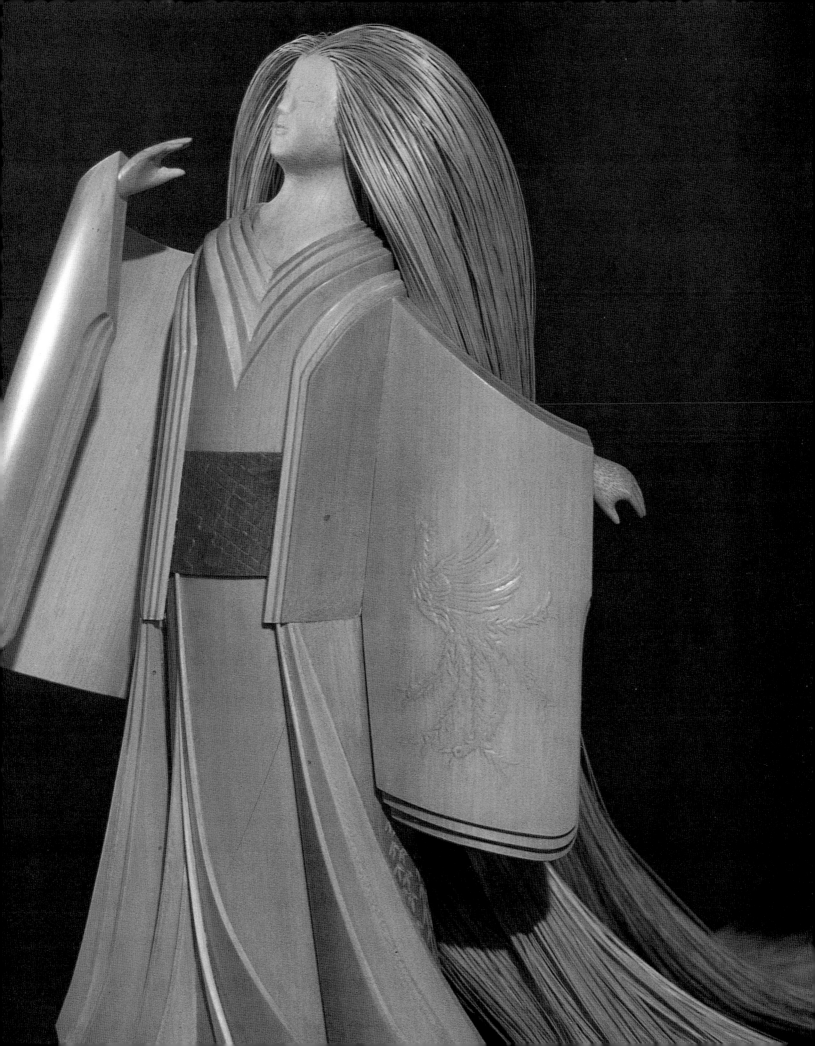

REGIONAL BAMBOO DOLLS

The spirit of Shikoku's *obon* festival parades is captured in these miniature bamboo musicians.

This figure of a young girl is simplicity itself.

Dolls can convey the costuming of regional festivals.

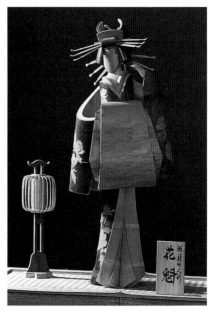

Dolls illustrate figures from history and theater.

Dolls depict regional costumes as they change through the seasons.

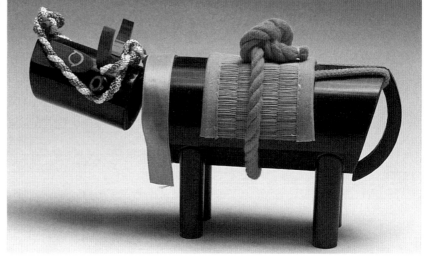

Not all dolls take human forms; here, a bull.

focal point of many households. During the Edo period, restrictive laws were enforced to limit the size of dolls displayed as they were deemed to be an ostentatious display of wealth. The public responded by miniaturizing the dolls and making them much more elaborate. These sets continue to be so valued that young women often take them as part of their trousseau when they marry.

During the celebration of Girls' Day, one type of doll, *nagashi-bina*, was traditionally used to represent each female child in the house. *Nagashi-bina* were (and still are) placed in a stream or at the edge of the sea and, as they floated away, they symbolically took with them any problems that might have befallen the child. This practice, now performed rather mechanically by many, originally reflected purification rites associated with Shintoism.[10] Most often the *nagashi-bina* doll and miniature boat are constructed with rice straw (*wara*). One style, however, includes paper dolls caught in a slit-bamboo holder. It is not uncommon to see news coverage on March 3 include a photograph of small rice-straw or bamboo boats, loaded with dolls, being pushed out into the harbor, or kimono-clad girls, hand in hand with their grandmothers, placing little rice-straw boats into local streams.

Dolls represent the mores, customs, and history of a society. In Japan, some dolls are entrusted to protect the child from calamity, some are for play, and others are only for display. When dressed in formal kimono, dolls carry folding fans, often with *sho-chiku-bai* designs. Musician dolls carry simple bamboo flutes and *shakuhachi*. Warriors and court retainers stand at the ready with full complements of bows and arrows. Kintaro, the robust boy-warrior so beloved in Japan, carries a bamboo fishing pole. Dolls and toys illustrate details of daily life, including bamboo's contribution.

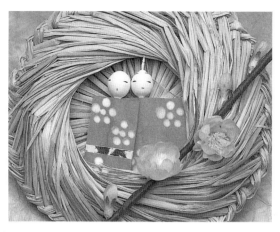

ABOVE AND BELOW Several types of dolls appear during the celebration of Girls' Day. These *nagashi-bina* dolls are used as talismans for the girls they represent. As the dolls move downstream and out to sea, the safety of the girls is ensured for another year.

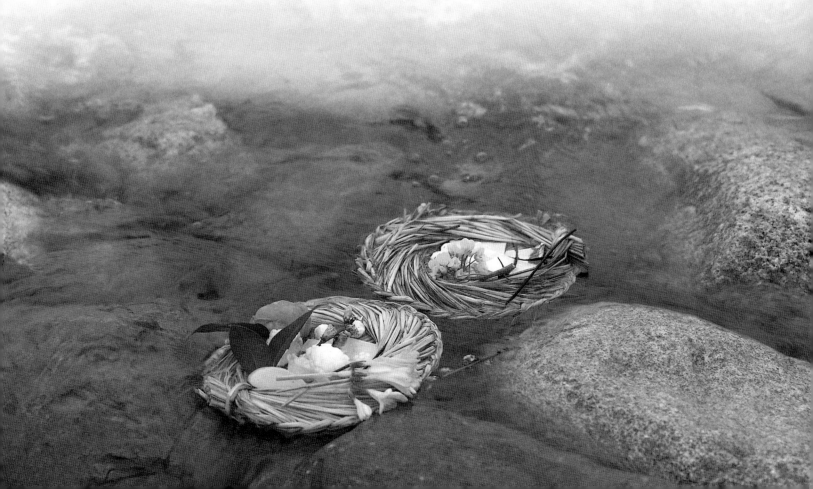

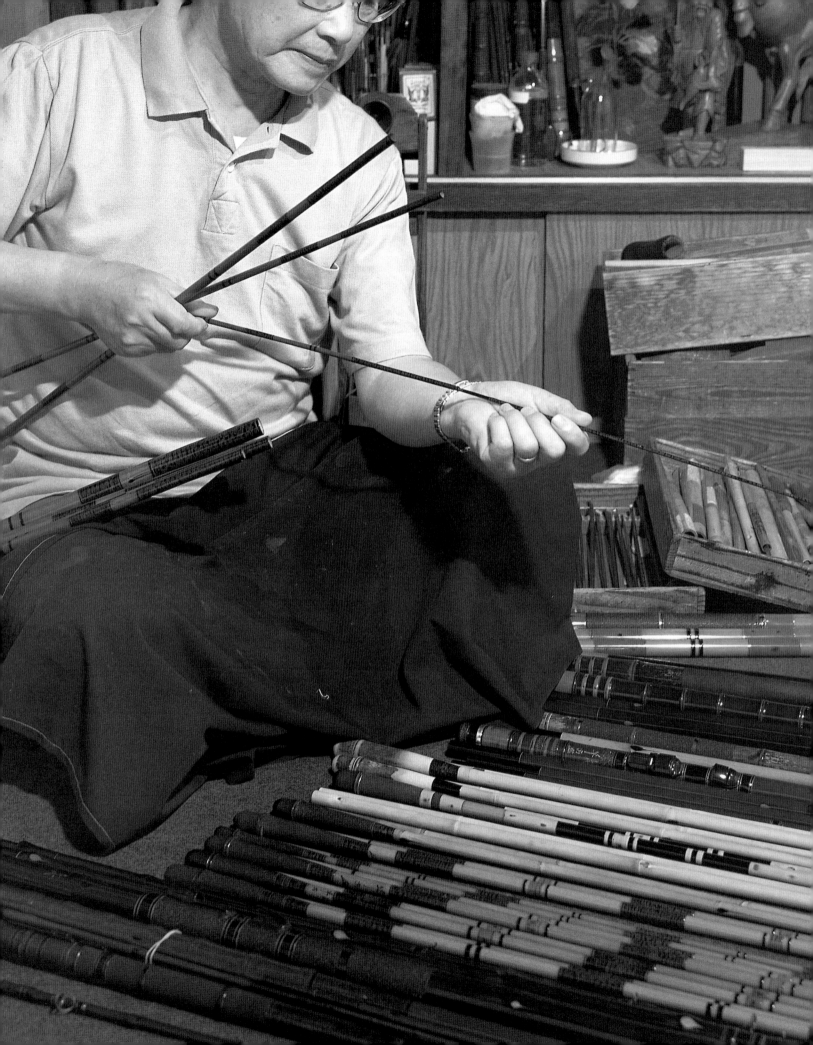

For some fishermen, Japanese bamboo fishing poles are an essential part of fishing gear. It sometimes requires several kinds of bamboo in one pole in order to achieve the desired result.

FISHING

JAPAN IS SURROUNDED BY WATER, its multiple islands touched by the Pacific Ocean and separated from the mainland by the Japan Sea. From the frigid seas of northern Hokkaido to the subtropical waters of Kyushu and Okinawa, the irregular coastline is a fisherman's paradise. Fishing, as a hobby, became popular during the Edo period, when financial stability allowed time for many to pursue personal pastimes with intensity. Now sports fishermen include the person who sits on an upturned box in a rental space at a fishing moat (*tsuribori*) in Tokyo, the lake fisherman in Hokkaido, and weekend fishermen who fill the night trains for a nocturnal ride to a distant fishing spot. The equipment they use is as varied as the men who fish, and the tackle reflects the type of fishing (ocean, deep-water, river, lake) as well as economic considerations. Different types of fish require different styles of poles. In lure fishing for freshwater fish, a flexible-tipped rod is required,[11] whereas the Japanese rainbow trout, *masu*, calls for a heavier rod. For live-bait fishing, fishermen use light and long rods that make it easy to maneuver the bait. Fishermen are compulsive in seeking the appropriate rod, be it flexible at the tip, heavy, or responsive and lively.[12]

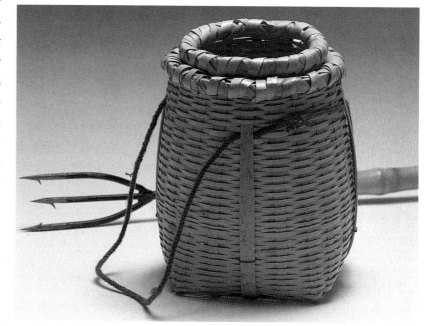

Bamboo baskets for bait and bamboo-handled spears still find use among the fishermen of Japan.

Nostalgic remembrances of childhood often include recollections of fishing. A short length of hollow bamboo tied with a string handle makes a perfect container for bait. Rarely seen today in contemporary Japanese stream fishing, a long bamboo pole with a line and hook, or perhaps an eel trap made with a drill and a few feet of bamboo,[13] helped the hours pass on many a warm afternoon. When such a day ends with the scent of grilled fish, anyone can become addicted to a lifelong passion for fishing. Even now, when fishermen return on Sunday evenings, with their ruddy cheeks, old coolers, and great fish stories, their gear ranges from poles barely more refined than those of childhood to rods imported from England or from L. L. Bean in the United States. Among the best are those made from bamboo by Japanese craftspeople.

FISHING RODS—HISTORICAL BACKGROUND

Prior to the import of English fishing rods in the late 1800s,[14] there were two basic styles of bamboo rods (*tsuri zao*) in Japan. The *nobe zao* was constructed of a single length of bamboo. In contrast, the *tsugi zao* was a jointed rod attributed to the craftspeople of early Kyoto. Jointed rods were used for freshwater fishing or for smaller saltwater fish. They are still constructed just as they were a hundred years ago. A few craftspeople have adopted a Western-style rod[15] attribute in which the bamboo is split and reassembled (*seiyo zao*) in order to take advantage of the areas in the bamboo culm that have maximum fiber density. The construction is much like that of the bamboo *kendo* sword.

■ SINGLE-ROD CONSTRUCTION

Strong, flexible *madake*, four or five years old, is the preferred material for this simple rod. For the best poles, the bamboo is bleached in the sun for a month. The oil is then removed and the bamboo straightened (see Chapter 2), following which it is stored in a dry environment until needed. Flexibility is critical, and great care must be taken not to overheat the pole, as it will harden and become rigid. Some fishermen use cheaper "green" bamboo. Such poles may need to be replaced after one season, or even one use.[16]

■ JOINTED-ROD CONSTRUCTION

Again, *madake* is the preferred material, but all parts are not necessarily from the same piece of bamboo. For example, the base length might use *hotei chiku* bamboo, whose raised, closely aligned nodes make a beautiful and practical hand grip. Elsewhere on the rod, the nodes are carefully planed so that when the separate joints are inserted one into the other, they work as one, ensuring smooth casting. After the joint areas are wrapped (preferably in silk) and lacquered—an essential, but time-consuming process—the metal tip and loops that hold the line are mounted. Some fishermen prefer a special jointed rod (*nakadoshi*) for sea fishing (occasionally still used for ice fishing on lakes) in which the line runs through the rod's interior.[17] The entire pole is lacquered and the insignia of the company or craftsperson is painted on the grip.

CREELS AND TRAPS

Beautifully constructed creels (*take biku*) are not limited to Japan, but it is here they are apt to be woven of bamboo.[18] Smaller versions with replaceable twine straps are shaped to fit against the fisherman's side, while larger ones come in varied shapes to suit the type of fish sought. An inverted woven bamboo basket is inserted tightly into the mouth of the creel to keep the catch from escaping. Since the lid faces upward rather than down, as a traditional lid would, the concave form can also hold the bait. Fishing creels can have multiple purposes. Kudo Kazuyoshi in his excellent book, *Japanese Bamboo Baskets*, describes creels that are used for gathering seaweed, carrying salt for pickling fish, and keeping fish alive in water.[19] Baskets based on fishing creels are often used in the tea ceremony for flowers.

As with all fine crafts, the selection and early preparation of the bamboo are crucial steps in achieving a high-quality fishing rod.

Each length of bamboo is cut into three pieces, heated to make it perfectly round, and then sanded.

Special attention is paid to the root end, for this handle area contributes greatly to the overall quality of the rod.

Putty is used to fill any small imperfections in the bamboo surface and then sanded so that the addition is not discernable to the eye or hand.

On the finest rods, silk thread is wound around the ends of the cut bamboo—each row carefully laid next to the previous one. Lacquer will be applied over this silk surface to hold it in place.

Joining rods are built and inserted into the ends to firmly fix the sections together.

Small metal or whale bone tubes are added as the final section of the rod for maximum flexibility of the tip.

To finish the rod, more rounds of sanding and lacquering are required. The final step is to add the metal guides through which the fishing line runs.

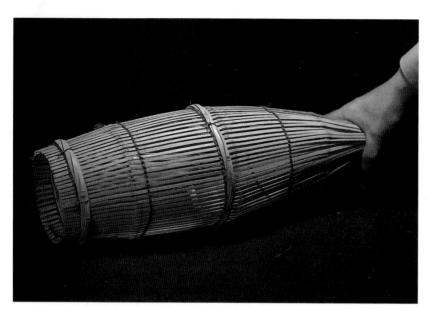

Traps for catching eels, small river fish, and crabs are woven of bamboo that has the outer layer left intact. This material is stronger and more durable than pieces cut only from the interior of the bamboo and is durable even when submerged in water for long periods. With the aid of drills and wood, some eel traps are constructed of whole pieces of bamboo and involve no weaving at all. Other traps are intricately woven and shaped. Mats woven of reed or bamboo are sometimes used to channel fish into traps and serve as important, if simple accessories.

Until the 1980s, huge bamboo baskets, up to the size of a basketball court, were still woven for the commercial fishing industry. Submerged in the ocean, they held live bait. Others were placed in a ship's hold filled with water. Each day's catch was added to the hold until the ship returned to port.[20] No longer used in the industry, these baskets are still woven on commission, usually for a museum collection or as part of an interior design project.

The shape and construction of this bamboo fish trap is familiar throughout the Pacific basin.

FISHING IN ART AND LITERATURE

Fishing tackle does not have the spiritual or symbolic connotations of archery equipment and is not often represented in festival or religious ritual. The fishing pole is sometimes featured with

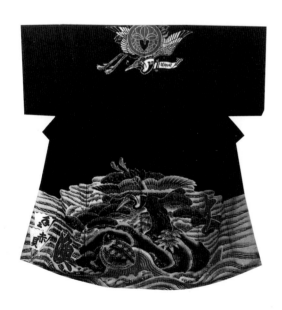

the god Ebisu, as he must catch his constant companion, the red snapper (*tai*), who serves as both a good luck charm for success and protection against evil spirits.[21] Similarly, the robust picture of the legendary Kintaro is sometimes that of a child with pole and carp, his character being a symbol of courage.[22] Commercial fishermen, however, may have poles and fishing imagery incorporated into the design of the outer jackets (*maiwai*) they wear only on ceremonial occasions, especially at New Year's.[23]

Fishing tackle is not often a featured design element in textile or paper printing, except when included as part of a scattered-toy pattern or when a spirit of playfulness (*asobi*) is the theme. Although rods and nets are not found in Japanese heraldry designs (*kamon*), they do occasionally appear as part of a larger image, such as a nostalgic fishing scene or in conjunction with sea bream in prints illustrating symbols of good fortune. Folktales and stories set in or near water may include a fishing pole in the illustration, but the pole will not be the focal point. It will be drawn with little detail, much like the simple length of bamboo it may have been.

Maiwai jackets are traditionally worn by fishermen on auspicious occasions (such as New Year's) and are decorated with appropriately auspicious symbols.

TOYS

A BAMBOO STICK IN HAND is easily transformed into a royal scepter, a sword, or merely used as is to poke into the mud. Even leaves and sheaths of the bamboo plant become toys when turned into temporary boats and whistles. Children are immediately attracted to bamboo because of its light weight and flexibility. Its hollow interior makes it manageable as a handle or pole for pinwheels (*kazaguruma*) and for the strong, vertical element in such toys as stilts (*takeuma*) and play swords. The simple bamboo flutes of childhood evolve into the complex musical instruments used in festivals and concerts. (Interestingly, small flutes are part of all cultures with bamboo resources.) The curved exterior surface of bamboo, combined with its open interior also led to the development of bamboo shoes (*take kapo*, or bamboo cup). With the minimal skills, a few drilled holes, and some string, pieces of bamboo are easily tied onto the bottoms of shoes, upon which children are seen galloping through the neighborhood, mimicking the sound of wild horses. Children can also easily turn bamboo into a snake (*take hebi*), squirt gun, or cup on a stick. Of all these simple, joyful toys, none is more loved than the bamboo dragonfly, the *taketonbo*. So popular are these toys that beautiful boxed sets—with gold leaf and lacquer finishes—are given as gifts to foreign guests.

Lightweight and hollow, bamboo is the perfect material for children's toys.

The characteristics that allow bamboo to be easily cut and woven also permit the basic carving and manipulation needed to create the colorful pinwheels and ornaments often seen in warmer months. Large versions made of bamboo or metal are placed on top of the bamboo poles that fly carp banners on Boys' Day. Additions of color and metallic papers make pinwheels a favorite with small children on a breezy day. Later, pinned to a curtain, they are a reminder of summer fun and sunshine. Mounted near the doorway, a pinwheel is expected to repel evil spirits.[24] At shrine fairs and festivals the booths selling such toys rival the candy stands in color and interest.

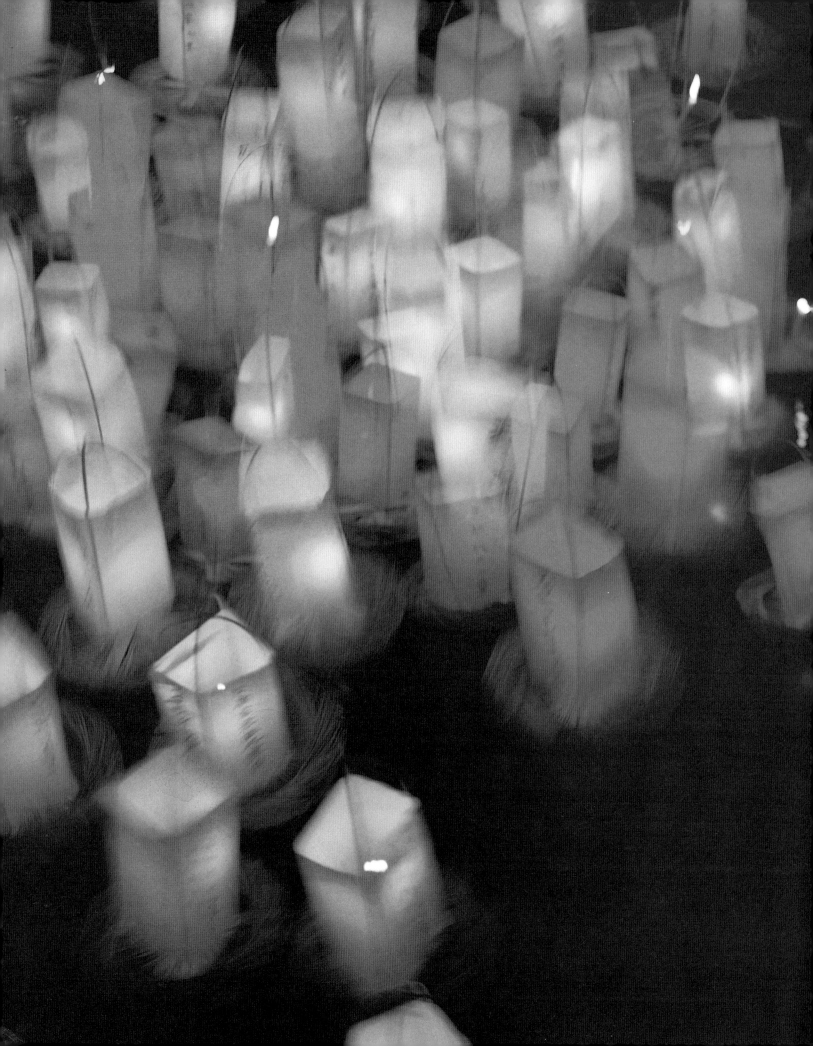

CELEBRATION, PERFORMANCE, AND RITUAL

In Japan, the special relationships between man and nature and the earthly and the spiritual are reflected in religious practices and celebratory festivals with origins dating back hundreds of years. The resulting rituals and celebrations—large and small, public and private, artificial and genuine—blend comfortably with folk ritual, magic, and philosophy,[1] *and imply much about the Japanese people and their beliefs.*

Shintoism is often called Japan's indigenous religion. Its strong connections with nature reflect Japan's agricultural heritage; it is neither a worship of nature nor an attempt to control it, but a celebration of man's oneness with the rest of the living world and spirits, an acknowledgment that the forces of nature are everywhere. Shintoism infuses gods and spirits (kami)[2] *into natural things that possess beauty and inspire awe.*

In the sixth century, the introduction of Buddhism from China supplemented Shintoism's concern for everyday life with Buddhism's philosophical base. Today, these religious institutions continue side by side, often sharing the same physical compound—a Shinto shrine next to a Buddhist temple, for example. A popular view in Japan is that one is born and dies according to Buddhist ritual, celebrates through Shintoism, and may even marry according to the Christian faith without having to give up any of the religious preferences. Today, these religions are not competitive in the Western sense, though historical events of past centuries illustrate that this was not always the case.

At the end of the *obon* festival, lanterns of bamboo and paper are released on the river.

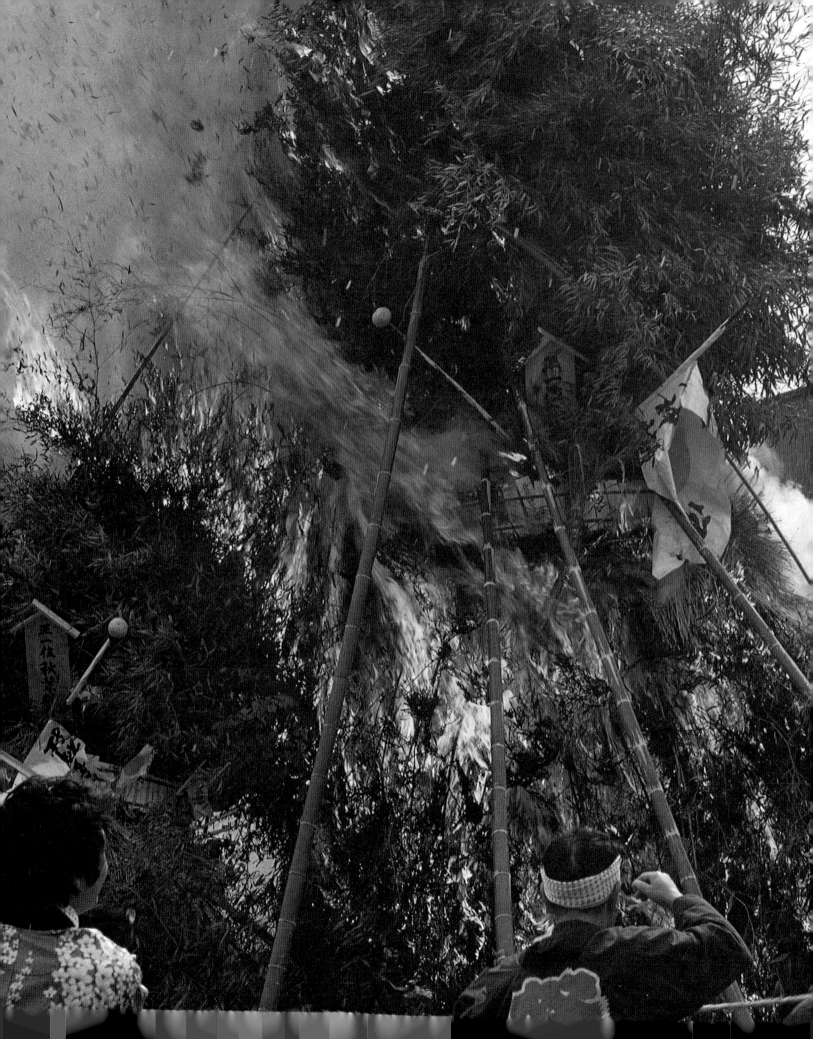

WHERE THE DIVINE AND THE WORLDLY MEET

JAPAN IS THE LAND OF FESTIVALS (*matsuri*). Travelers consult calendars of annual events and plan their itineraries so as to catch a glimpse of horseback archers in traditional costumes or the splendor of ornate processions with carefully rehearsed rituals, music, and dance. They want to share in the exuberance of celebration, a celebration of history and tradition. A Japanese festival may involve the entire population, an individual community, or a single local priest or official. Regardless of scope, each celebration offers insight into the spiritual identity of the Japanese.

Bamboo and bamboo crafts are present in most of these events. Within one festival, bamboo may appear in many guises: purifying utensils, walking canes, woven blinds, bows and arrows, *kendo* sticks, fences, umbrellas, fans, tea ceremony accessories, flower containers, lanterns, poles, pipes, and flutes. Sometimes, bamboo is merely a practical tool—a lightweight pole for lifting lanterns, a prop, or a boundary. In some festivals, bamboo is chosen for its symbolism— its fast growing characteristics, its flexibility, or for the bright green image of purity and renewal, for which there is no acceptable substitute.

Most festivals have an indigenous Japanese religious ritual at the core, though participants may have long forgotten the specific origins. As Japan becomes increasingly Westernized and urbanized, Western holidays such as Christmas and Valentine's Day continue to capture the attention of young people. A young woman in Osaka or Tokyo may well be more interested in receiving cards on White Day (the equivalent of Valentine's Day for girls) than attending a local festival with all its traditional activities. Young people feel little connection with the agricultural or historical roots of most festivals and seek instead new celebrations from other cultures, though they are likely to continue throughout life celebrating New Year's and the Japanese Festival of the Dead. Older participants often despair of such lack of interest and resent this impact of Western culture.

Kadomatsu ("guardians of the gate") are ornaments associated only with New Year's and are designed to attract beneficial *kami* spirits.

165

Just before the new year, at the entry to this traditional storefront, a pair of *kadomatsu* stand guard, inviting the divinities to bestow good luck by their presence and repelling evil spirits at the same time.

The rituals and observances attendant in Shintoism and Buddhism vary from region to region and from rural to urban settings but express as a constant the strong Japanese tie with ancestry. At a time when communities were economically self-sustaining, festivals reinforced the sense of community, acknowledging mutual dependency.[3] Those festivals with Shinto associations include purification rites (*monoimi*), offerings, and references to an agricultural cycle appropriate for a nature-oriented society. Other holidays[4] have long followed an annual calendar of events and may change dates from year to year. More recently, the word *matsuri* has taken on a generic definition and is now commonly held to refer to any festival. On these occasions, which are set apart from daily life, man makes contact with the spiritual world.

Festivals that are Shinto in origin often celebrate seasonal change, marking the cycles of birth, life, and death. Reflecting a culture that once depended on rice cultivation for survival, spring festivals are inextricably associated with planting, autumn with harvest, and the New Year with an opportunity to begin the cycle anew. When Japan discontinued the lunar-based calendar system in 1873 and adopted the solar-based Gregorian calendar, several festivals fell out of step with the natural cycle—spring being celebrated while there was still snow on the ground, for instance. People in rural areas still feel the power and influence of the moon's cycle and continue to observe some festivals according to the old lunar schedule. Thus, throughout Japan, New Year's and the beginning of spring may be celebrated for several weeks.

NEW YEAR'S

With its symbolic decorations, games, celebratory foods, rituals, festive atmosphere, and countrywide participation, New Year's (*shogatsu*)[5] is the quintessential Japanese celebration. All the prerequisite elements for a true Shinto event are present—purification prior to the event (cleaning, settling accounts), preparation of sites to invite divinities and repel evil (the traditional decorations of *kadomatsu, shimenawa,* and *miki-no-kuchi*), entertainment (music, food, *sake*, games, competitions), and rituals sending the deities and ancestral spirits away content (burning of old decorations). From start to finish, the role of bamboo in this glorious celebration is prominent.

The groundwork for the new year begins with the *tori-no-ichi* (festival of the rooster) celebrations in November. Bamboo rakes decorated with auspicious symbols (miniature representations of lobsters, gold rice bales, coins, figures of the Seven Lucky Gods, pine, bamboo, tortoises, and so on) are purchased by business owners in order to guarantee "raking in" success and prosperity in the new year. The rakes are available in sizes ranging from one small enough to fit in the palm of the hand to those too large and heavy for a single person to carry, and businessmen often purchase increasingly large versions in successive years. When an especially large, heavily decorated, and elaborate rake is sold, all the nearby vendors shout best wishes for the new year and strike their old-fashioned flints, creating sparks to deflect evil. Few know or care that the original festival was an agricultural fair for purchasing new tools—including rakes. Some older references call attention to the rake's resemblance to a bear's paw or an eagle's talon, suggesting the idea that one can "grasp" good luck almost as a predator catches prey.

Purchasing elaborately decorated rakes at the November *tori-no-ichi* festivals is said to ensure prosperity for the new year—the larger and more elaborate, the better.

Regardless of the history, each November brings the vendors' cries of *"Kakkome! Kakkome!"* as people flock to the shrines in hope of ensuring a prosperous new year.

The first acts of purification for New Year's begin about December 13. In ancient times, a green, leafy bamboo branch would have been used much like a broom to symbolically clean the hearth and kitchen in anticipation of a successful new year. Today, purification still includes a general scrubbing down of home and business, and sometimes the repair and replacement of *tatami* mats and *shoji* paper. The process also includes cleaning and repairing the celebratory clothing and household items reserved for this occasion. Other preparations include settling accounts and debts to greet the new year free of guilt. As the event draws nearer, special foods are bought and prepared, cards are mailed, and year-end presents are shipped. Transportation home is secured well in advance because so many want to arrive before December 31. Finally, after all the preparations, midnight of New Year's Eve is marked by 108 peals of bells at Buddhist temples across the country and the soul is symbolically cleansed. During the holiday celebration, other acts of purification occur at Shinto shrines and Buddhist temples. At religious sites as well as at the entries to homes and rice fields, the hands and mouth are cleansed with water dipped from green bamboo ladles, and cut paper prayers (*gohei*) mark purified areas made ready for the arrival of the deities.

The Japanese return to their hometowns at New Year's and, if at all possible, in summer for the Festival of the Dead (*obon*). In Japan, there is great importance attached to the place of one's birth (*furusato* or *kokyo*), and holiday visits reaffirm ties to ancestors, family, and community. A part of this holiday is devoted to welcoming *kami*. Several bamboo items are particular to New Year's and are part of creating a welcoming environment for these important protective spirits. The most significant are the "guardians of the gate," or "pine guardians" (*kadomatsu* or, less frequently, *matsu-kazari*), which appear outside doorways throughout Japan shortly before New Year's, inviting deities to reside within during the holiday season. These symbolic constructions are made frequently with the tops of three vertical poles of bamboo cut at sharp angles (some suggest these points are to impale evil spirits). The poles are surrounded by pine boughs and sometimes decorated with auspicious symbols, such as lobsters, *daidai* oranges, and ferns. Pine and bamboo are appropriate symbols for the new year: pine, its role borrowed from China, has a long association with constancy and longevity. Green all year round, it is strong and rugged, and its sharp needles are said to scare away evil. Bamboo's inclusion dates back only to the early 1400s, but its qualities of uprightness and rapid growth, as well as strength and flexibility, are highly valued in Japanese life. The image of *kadomatsu*, associated only with New Year's, is a popular design for the cards (*nengajo*) sent to mark the end of the year. Always displayed in pairs, *kadomatsu* guard the entries to office buildings, small businesses, and private homes and remain in a vigilant posture until January 5 or 15, when they are removed and burned, thus allowing the spirits to depart.

Plying the gods with food and drink is an important part of *shogatsu*, and *sake*, a favorite drink of the gods, is featured in many New Year's rituals. Available only on New Year's Eve, *miki-no-kuchi* ("sacred *sake*'s mouth") are bamboo ornaments inserted into small ceramic *sake* bottles often seen on religious shelves (*kamidana*) in homes and offices. These ornaments are designed

to invite good spirits to reside in the *sake*, thus ensuring a good future. With each passing year, fewer *miki-no-kuchi* are made, and they are no longer widely distributed. Regional museums collect and display them in the hope of maintaining their place in New Year's rituals, yet fewer and fewer people remember the meaning of these little gems of craftsmanship. Bent from a single piece of bamboo into elaborate curves and shapes, decorated with bits of gold and red paper, these are artifacts from an older tradition. Interestingly enough, while the craft is lost in many parts of Japan, in the suburbs of Tokyo, at the shrine in Fuchu, *miki-no-kuchi* are still sold every December 31. At the outdoor market, among the stands of vinegared octopus, *sake* bottles, sacred rice-straw ropes (*shimenawa*), and new household altars, one can find two or three tables displaying hundreds of *miki-no-kuchi* rubber-banded into pairs.

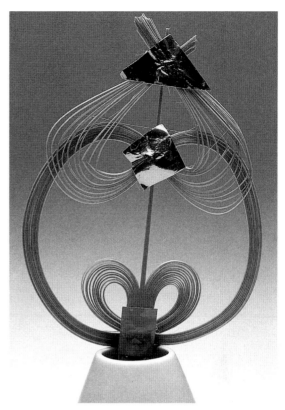

Bamboo is split and bent into elaborate curves for the New Year's ornament (*miki-no-kuchi*) used in *sake* bottles for home altars.

The official *shogatsu* celebration lasts three to five days (depending on where January 1 falls on the weekly calendar), during which time the entire country shuts down. A substantial preparation period added to a long sequence of first-of-the-year events extends the celebration into weeks. The most important of these "first" events is the first visit to a shrine (*hatsumode*). On the morning of January 1, even in snow and rain, the queue of patient participants circles down the side streets. Sometimes visitors are given small treats or samples of pounded rice (*mochi*), but all are rewarded with the satisfaction of beginning the new year with participation in the appropriate ritual. In the days immediately following, there will be the first *sumo* tournament, the first fair, and the first tea ceremony. In a fishing town, celebrations would include the first fishing, while in the home, the importance of "the first" would be attached to many large and small occasions. Even one's first dream of the new year can be celebrated as a significant event. The first use of tools for carpenters, instruments for musicians, and even calligraphy brushes for children is celebrated on January 2 in the hope that skillful use of these items will continue throughout the coming year.

The "first" event takes on special significance in professions where safety is an issue. The most famous of such celebrations is reserved for firemen. Each year fire companies across Japan have a first event (*dezomeshiki*) which usually includes a parade and demonstrations. Firemen dressed in Edo-period firefighting attire, carry traditional firemen standards (*matoi*) and ride on both antique and modern fire trucks. To ensure a safe year and to pay respect to the old firefighting traditions, designated firemen climb tall bamboo ladders and perform thrilling acrobatic feats with the cheering support of thousands of observers. In an earlier era of wooden buildings, entire villages depended on the skills of firemen, and these performances pay tribute to the past while hoping to guarantee continued safety and success in the coming year.

Fishermen, too, lead a life of some danger. However, the banners and seasonal ornaments hung from bamboo poles on boat masts for the first trip to sea are displayed less to seek protection than to give thanks to the sea for their livelihood and to guarantee a prosperous future. The large banners (*tairyobata*) from Chiba are famous for their colorful display as are the jackets (*maiwai*) worn on this occasion each year. Textile craftsmen from the region are known for their skills in resist dyeing, auspicious designs, and bold graphics. Among the painted images of pine and plum, tortoise and tigers, there is always bamboo.

Bamboo and pine are often combined with plum blossoms into the Three Friends of Winter (*Sho-Chiku-Bai*). At New Year's the trio are frequently seen on greeting cards, *sake* labels, in print advertisements, and as a design pressed into special New Year's sweets. Pine (*sho*) has long been associated with longevity, and bamboo (*chiku*), with strength and flexibility. Plum (*bai*), the first tree to bloom in cold weather, was in bloom at the new year when the lunar calendar was used and is symbolic of beauty and hope for a good year. All three express a green life-force that is symbolically powerful in the snow of New Year's. Their use is not, however, limited to New Year's activities; they appear as a design motif in fabric, printed paper, painted fans, and advertisements year round. An auspicious design, *sho-chiku-bai* is also seen in the fabrics and fans of the dolls that represent the imperial couple on Girls' Day (March 3).

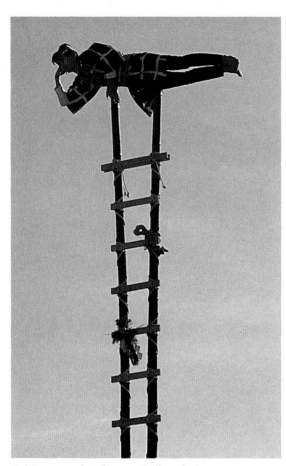

Each January, acrobatic firemen enthrall crowds at *dezomeshiki*, the first parade event for firemen in the new year. Their antics are a reminder that firemen historically played a crucial role in the towns and cities across Japan. This image is the subject of fabric and print art as well.

Bamboo appears repeatedly in large and small ways throughout celebrations for the new year. Small bamboo sticks holding paper amulets (*gohei*) are placed on altars and inserted into the ground near entrances to homes and at the edge of rice fields, where they are eventually carried away by wind and rain. Bamboo leaves are placed under the traditional pounded rice cakes seen in every home and every store window at this time of the year. Flat, bamboo winnowing trays are used to harvest the sacred five grains[6] and later to display the same, paying homage to past harvests and seeking a plentiful harvest in the year to come. Small ropes of rice straw (*shimenawa* or *shimekazari*) are decorated with symbols of good fortune and longevity—bamboo leaves, ferns, and small *daidai* oranges. Placed on boat masts, the front of cars, and near doorways, they appeal for a year of safety and prosperity.

In small towns along Japan's coastline, where New Year's bathing in the sea is a common purification rite, two tall bamboo branches are stuck in the sand at the water's edge, with the narrow *shimenawa* rope connecting them. Does the sea still symbolize the source of life, as it did in Shinto mythology?[7] For some, but surely not for all. Nonetheless, the ritual continues, with regional variations, as community members share traditions among themselves and with their ancestors. The local priest, in full formal attire, blesses the bathers and the *sake* as well. The bathers slowly approach the sea, walking between two lines of young women holding tall umbrellas covered with paper flowers (an invitation to good spirits to join in), then continue under the *shimenawa* into the sea. One bather carries a bamboo bow and shoots an arrow in a long arc to the sea hoping to divine a safe, prosperous year ahead for the community. Another carries a small *kamidana* shelf complete with *sake* bottles and, facing the sea, offers the *sake*. As each bather emerges from the water, a towel and hot *sake* are offered. Everyone then shares in the keg, even out-of-towners who happen by, and a tape player provides traditional music as all enjoy the celebration of the new year. At the end, the bamboo poles are unceremoniously burned in a bonfire.

Bamboo crafts have their own roles during *shogatsu* and are especially associated with

activities that entertain *kami* and their earthly hosts alike. Kites, traditionally regarded as a physical connection between the divine above and the human below, are flown in spirited competitions as well as by individual children enjoying a New Year's gift. Artists, such as the printmaker Hokusai, have captured the joy of kites flown on a New Year's morning. At shrines, special arrows (*hamaya*) wrapped in pure white paper are bought to repel evil. The *kanji* of *hamaya* means "break the devil." Ceremonial bows and arrows are taken from storage and used in ritual-based activities to divine the future, though few now take the prophecy seriously. The use of these traditional bamboo crafts enriches and supports the history of this most important occasion.

Shogatsu ends dramatically with a community event, *donto-yaki*, in which the ornaments (*shimenawa, miki-no-kuchi, kamidana*) of the previous year are burned, the spirits sent away content on the smoke of the fire.

FESTIVAL OF THE DEAD

Observed in July or August, Japan's Festival of the Dead (*obon*) shares several characteristics with New Year's. Again, people try to return to their place of birth. Cleansing rituals are performed, especially at grave sites, and specific foods and decorations are prepared. In contrast to *shogatsu*, however, *obon*, with Buddhist underpinnings, is solemn and tied to death. Ancestral spirits are summoned to return and welcomed with freshly decorated grave sites, scrubbed headstones, and fresh flowers in simple bamboo cups. Whether the flower holders are ceramic or plastic, they are made in the image of a piece of bamboo, complete with node.

Each region of Japan observes *obon* on its own schedule and with its own traditions. In Hiroshima, for example, each returning spirit is greeted at the graveside with an individual suitable resting place—a bamboo pole about two feet high which is topped by an inverted pyramid-shaped container made of bamboo and paper. The paper surface is decorated with small pieces of colored paper or with gold-leaf squares, and the edges are hung with short streamers of the same colors. Looking into the hillside graveyards that edge the Hiroshima valleys, the ornaments (*shoro*), which each accommodate a candle, suggest festivity rather than grief.

One of the most familiar images of *obon* is that of the bamboo-and-paper lanterns that light the way for spirits to return home. Frequently depicted in photographs and Japanese prints, each bamboo pole carries multiple lanterns, and to take in hundreds of illuminated lanterns at one site is breathtaking. In midsummer, stores catering to Buddhist observances, as well as local department stores, sell traditional lanterns with special stands, tassels, and hand-painted floral designs for display in the home during the *obon* season.

There is considerable regional variation in the outdoor dancing (*bon-odori*) associated with *obon*, and each community takes pride in its distinctive style. Dance groups practice in meeting rooms, community parks, and garages for weeks in advance. The results of local competitions make front-page news, and summer cotton kimono (*yukata*), music, and dramatic use of bamboo fans (both folding and flat styles) temporarily replace more serious news reports. Bamboo fans

play an important role in *bon-odori*, well beyond their contribution to the costuming. Sometimes their use extends the gestures of the dance and emphasizes coordination within the group. The folding fans may be snapped open in unison to emphasize the beat of the music. On the island of Shikoku, miniature parade figures made of bamboo are a favorite travel gift (*omiyage*). After *obon* is complete, these little sets are taken home by people returning to such faraway urban areas as Sapporo, Tokyo, and Osaka. Copies of the lyrics to the traditional music are included in these gifts as an additional reminder of bygone days, and it is not uncommon to hear visitors returning on the night trains softly humming Shizuoka's lulling refrain to themselves.

THE FUTURE OF *MATSURI*

In an era of satellite dishes, digital cameras, and instant world news, there is a danger that the ritual aspect of *matsuri* will be transformed into a theme-park spectacle. One can almost see the *shogatsu* setting at Disneyland in the Tokyo suburbs, with miniature *shimenawa* key rings and *kadomatsu* sweat shirts. What were originally rites of personal and community-based offerings to the deities that strengthened community ties are now in danger of becoming "photo ops," valued as entertainment or vacation days from school or work. Alan Booth laments the intruding influence of shallow news coverage and, in *Looking for the Lost*,[8] presents a scathing commentary on one such bastardized event in which newsmen demanded that villagers perform over-the-top antics to enliven the evening news report.

However, at even the most garish festivals, there are still participants who remember the religious ritual at the core of the occasion as well as those who celebrate the identity of the community—local or nationwide. Parents continue to carry children on their shoulders, walk through festivals, and point out important sights. Even now, both in rural areas and large cities, shrines and temples remain the emotional center of small neighborhoods. Early on misty mornings, local housewives, still in their aprons, arrive at the shrine and, with watering cans and bamboo brooms, prepare the site for a new day. At least one ritual event will take place here each year, though sometimes with only a few participants, no news coverage, and no booths lining the adjacent streets. In such communities, *matsuri* continue to reflect and preserve some of Japan's traditional values.

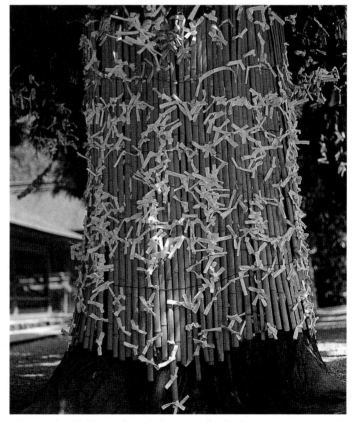

When an unfavorable fortune is drawn, the diving papers (*omikuji*) in question are hung out to dry, so to speak, to ward off bad luck. Here, hundreds of undesirable divining papers are tied to this cluster of bamboo poles.

MUSIC

JAPAN IS FILLED with music—in the home, the concert hall, the street at festival time, even the local supermarket where taped Japanese folk music provides a background for commerce in the fish aisle. In the small department stores, music blares from competing radios, each tuned to a different station. Music is at the core of the performing arts, from *noh* drama, to puppetry (*bunraku*), to *kabuki* theater, all of which have origins in religious festivals (*matsuri*) where flutes and percussion instruments provide the pulse. While compact-disc sales range from avant-garde American jazz to Beethoven (the Ninth Symphony is a favorite in Japan), traditional music, much of it played on bamboo instruments, accounts for a constant percentage.

Bamboo instruments contribute to the entire body of Japanese music, from the elegant court music of twelve hundred years ago to the boisterous music of festivals throughout the ages.[9] In the construction of some instruments, bamboo's role is minor: a slender bamboo stick used to beat a drum or fashioned into a mouth harp. Others are made almost entirely of bamboo.

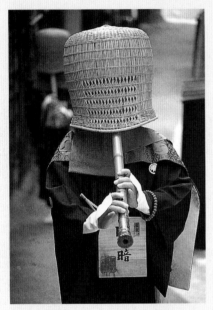

Mendicant monks wear bamboo hats in order to maintain their anonymity while playing *shakuhachi* flutes and seeking alms.

BAMBOO FLUTE

Bamboo flutes come in a variety of sizes and shapes, each unique in its musical character. Perhaps the most important, both in Japan and in the West, where it has captured the imagination of performers and composers from a number of musical disciplines, is the *shakuhachi*.

A vertical bamboo flute with a notched mouthpiece and five finger holes, producing tones in the pentatonic scale, the *shakuhachi* takes its name from the length of a Chinese prototype brought to Japan in the Nara period that measured 1.8 *shaku*, *hachi* being the Japanese word for "eight." (A *shaku* equals 30.3 centimeters.) The instrument re-emerged in the Edo period in a more stylized Japanese form, retaining the name. Today, the *shakuhachi* comes in many sizes, with corresponding variations in sound.

The *shakuhachi* is a versatile instrument with a reedy, ethereal tone. In the hands of an artist who understands its capabilities and has the considerable technical skill to realize them, this flute can lend itself to a range of musical genres including classical, jazz, and avant-garde as well as the unique repertoire of deeply spiritual solo music developed during the Edo period. This music, based on the principles of Zen, was played by Zen monks as an exercise in meditation and spiritual discipline. Those who have mastered the instrument believe it capable of levels of

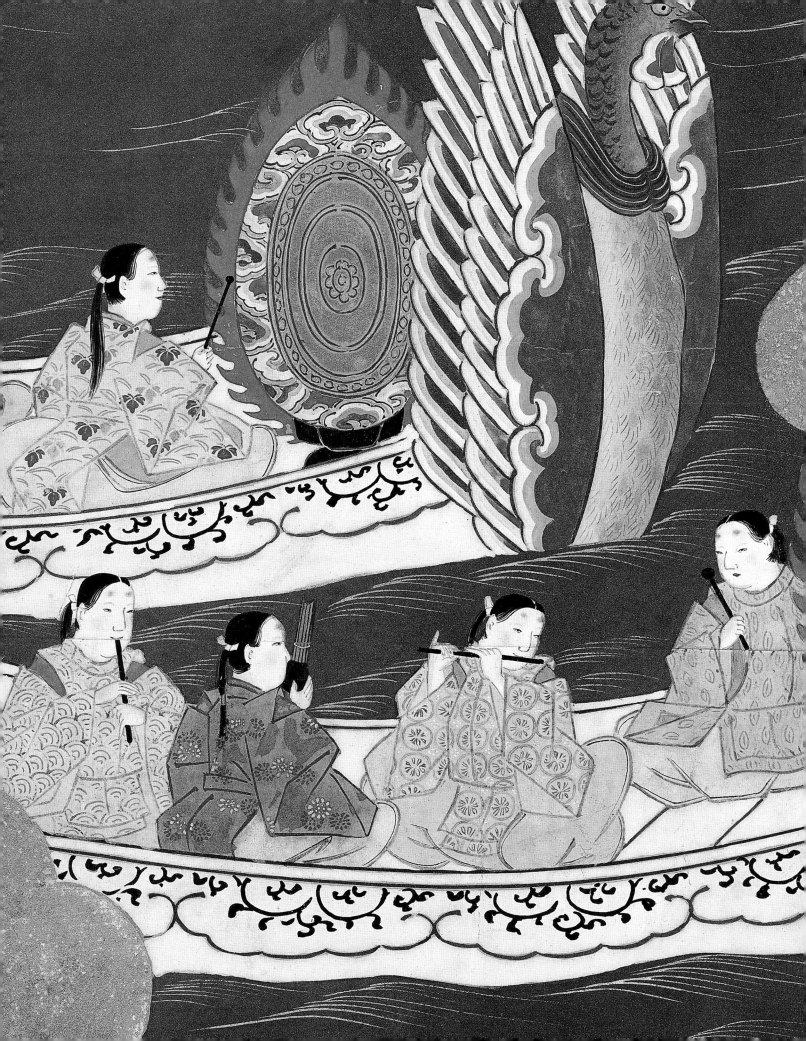

subtlety unequaled by any other flute in the world.

The *shakuhachi* is distinctive in appearance in that it alone among all flutes incorporates part of the bamboo plant's dramatically configured root ball. Interestingly, this characteristic was not part of the *shakuhachi*'s original design, but emerged in the late sixteenth century.[10] At that time, the ranks of Buddhist monks were joined by samurai warriors who were no longer affiliated with a feudal lord and wished to become priests. These masterless samurai, called *ronin*, sought alms and were known as *komuso*. To maintain their anonymity they wore bamboo hats, a practice still observed by some mendicant priests. It is reported that the heavy, root end of the bamboo was incorporated into the instrument's design for defensive rather than musical reasons, transforming the flute into a disguised weapon.[11] There is a musical benefit as well, in that it gives the instrument a deeper, more sonorous tone.

The finger holes (four on the front and one on the back) are slightly larger than those on other flutes, allowing the difficult half- and quarter-hole fingering, which is responsible, in part, for the range of notes this flute can produce; beyond the pentatonic scale, it includes two (sometimes three) chromatic octaves. Other factors that vary its capabilities include the angle of blowing, how the mouthpiece is held in relation to the mouth as well as the quality of the instrument. Listening to a master *shakuhachi* flutist play is to understand the meaning of "blowing Zen."

■ *SHAKUHACHI* CONSTRUCTION

In contrast to the spontaneous flutes of childhood in which any piece of bamboo is cut and drilled with a pocket knife, great care is given to the selection and handling of bamboo for high-quality musical instruments. In instrument making as in many crafts in Japan, *madake* is the preferred bamboo. For making a *shakuhachi*, however, not all *madake* will do.[12] Craftspeople

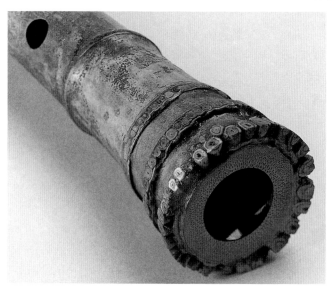

By incorporating the root end of the bamboo, the Japanese *shakuhachi* is visually distinctive and so is the tonal quality.

typically seek a small, dense *madake* and often look for it in poor soil or in mountainous regions as it grows. In addition to hardness, they seek other vital characteristics, including placement of the nodes, color, and size, and each maker's demands are slightly different. Few culms pass their critical inspection, and of those selected, most are eventually discarded for imperfections revealed in processing. Because of the difficulty in locating the perfect bamboo, and because many *shakuhachi* makers live far from the ideal bamboo groves, most buy bamboo from brokers who sell many varieties of bamboo for diverse uses.

After the culms are harvested and cut to approximate length, they are allowed to age, first out of doors, and then in storage. Storage time varies with each piece of bamboo and the craftsperson's schedule, but it is measured in months and years, not days. Before the bamboo can be drilled, it must be straightened. The bamboo as it grows may appear straight, but is not straight enough for use in most crafts that involve an unsplit culm (e.g., arrows, some flower holders, and *shakuhachi*).

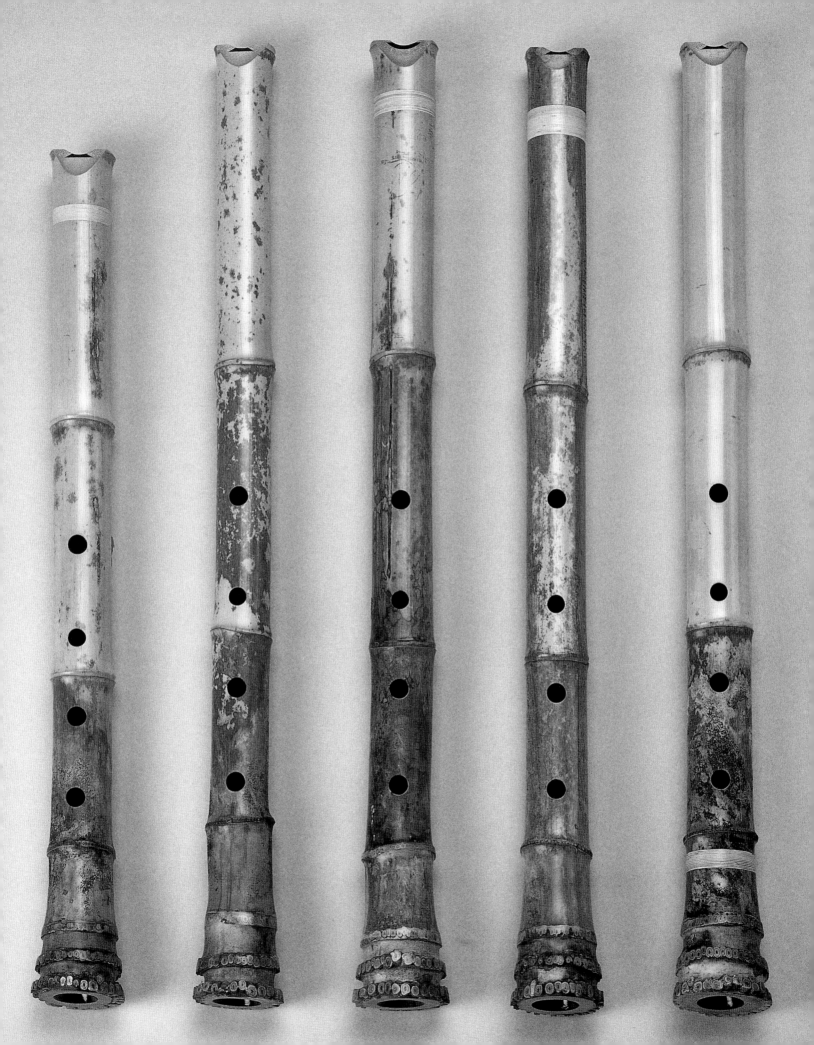

Heat and small hand tools are used in the process of straightening (see chapter 2), but the distinctive curve of the root is considered highly desirable, and this area is not straightened. It is difficult and unwieldy to drill the interior of a two-foot length of bamboo. Some contemporary craftspeople, therefore, cut the bamboo in half to make it easier to handle.

To produce an instrument with the distinctive timbre, balance, and tonal color of the *shakuhachi*, great care is given in drilling the central cavity of the bamboo, referred to as "the bore." Lasers now facilitate such endeavors, but older craftspeople still prefer to do all their drilling by hand. The blowing edge at the upper end of the bamboo is crucial not only to the final sound produced, but also to the ease of blowing. The craftsperson cuts first with a saw and then refines with a small hand blade. The opening is finished with an insert referred to as *uta-guchi* (literally, "singing mouth"). Finger holes are carefully placed and drilled in order to assure the fidelity of the note range desired. Some of the highest-quality *shakuhachi* are lacquered on the inside. When complete, the flute is rubbed with oil on the outer surface. Several areas of the instrument are tightly bound with fine cord (often silk) to restrict the expansion and contraction that normally takes place as bamboo responds to changes in moisture and temperature. A musician often has several *shakuhachi*, each with a different fundamental pitch and a distinctive personality. The longer the instrument, the lower the tones it can produce.

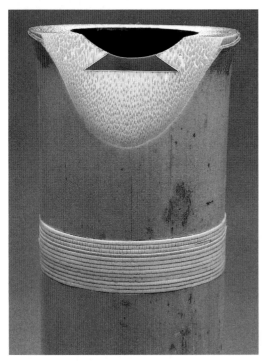

Binding placed at critical points along the length of the *shakuhachi*, in this example near the blow hole (*uta-guchi*), helps control bamboo's natural tendency to expand, contract, and split.

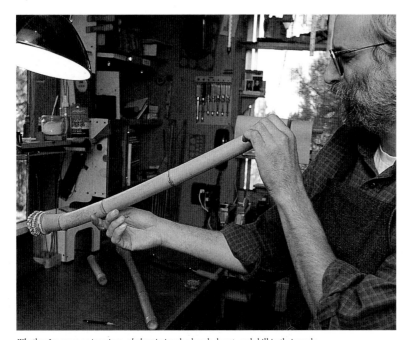

Whether Japanese or American, *shokunin* involve hands, heart, and skill in their work.

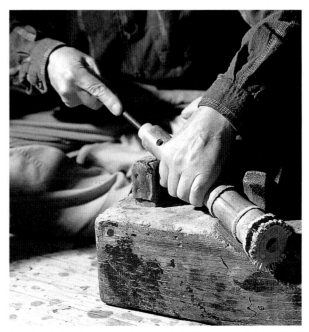

Preparing the bore is an essential part of creating high-quality *shakuhachi* and involves much more than removing the interior membrane.

MUSICAL INSTRUMENTS IN FESTIVALS AND THE PERFORMING ARTS

Music is an integral part of festivals in Japan. Simple bamboo flutes, probably Japan's oldest folk instrument, are played at all major events, accompanying a variety of other instruments for festival songs and dances. *Noh* and *kabuki*, reflecting Shinto roots, would be incomplete without the bamboo wind instruments of *sho*, *shakuhachi*, and *shinobue*.

The seventeen-pipe *sho* is a dramatic instrument featured in festival and religious parades. It also accompanies other instruments in court music and dance (*bugaku*) and in Buddhist chants (*shomyo*). The sight of elaborately robed priests parading with *sho* to mouth is a solemn and powerful reminder that music is one way man magically transcends the boundaries of daily life.

Some of the older bamboo instruments are now seen only on major holidays or in rural areas. For example, the *sasara* is made of two simple bamboo sticks, one notched, one smooth. When rubbed together, they emit a chattering sound.[13] *Kokiriko* are bamboo dance batons that are split at one side of the bamboo's node and have some bamboo removed on the opposite side. Hitting two together and shaking them overhead extends the gesture of the dance and at the same time produces a rattling sound as the bamboo pieces repeatedly bang against one another. Popular in the Muromachi period, now they are seen only in museums and a few select festivals.[14] Numerous other percussion instruments, many homemade from bamboo, produce a beat that can be intoxicating.

THE BLEND OF NEW AND OLD

Bamboo instruments have found their way into contemporary Japanese music. In the 1990s, several musical groups began to rely exclusively on bamboo instruments. The jazz group Take Dake ("Bamboo Only") released its first CD, *Asian Roots*, in 1997. Drawing musically from many cultures, the instruments reflect this diversity: some resemble the conga drums of the Caribbean, others the Indonesian gamelan. In all, bamboo is the only material—even the skins of the drums are made of bamboo.

The Bamboo Orchestra of Japan, based in Tokyo with a second ensemble in Marseilles, France, specializes in traditional Japanese music blended with other Asian influences, particularly those from Indonesia. They use up to twenty bamboo instruments as well as the Japanese wooden harp (*koto*) and a variety of other traditional drums. In 1998, the orchestra was invited to perform in San José, Costa Rica, during the International Bamboo Conference. They received standing ovations from bamboo enthusiasts equally responsive to the traditional *sho* and *shakuhachi* and to the playful sounds of Indonesia. The orchestra maintains a very strong education program and provides workshops on making bamboo instruments.

The Take Dake musical group first performed in 1996. Their all-bamboo instruments were inspired in part from founder John Kaizan Neptune's trip to Bali, Indonesia, to participate in the Fourth International Bamboo Congress.

179

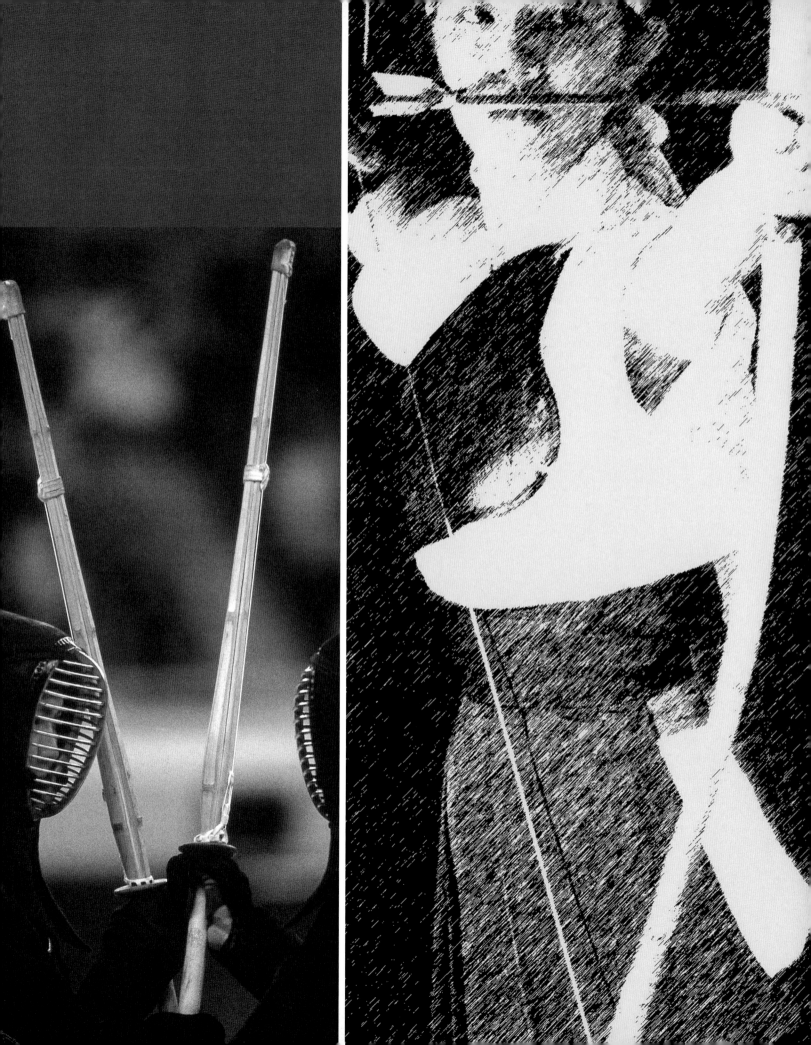

FAR LEFT In *Kendo*, two opponents are at a stand-off.

LEFT An archer in traditional garb lines up a shot.

TRADITIONAL SPORTS

KYUDO—THE WAY OF THE BOW

In January, throughout Japan, twenty-year-old archers crowd into Buddhist temples to perform the ancient ritual of ceremonial archery (*toshiya*) to celebrate their coming of age. This occasion for ritualized archery performed in traditional costumes gives participants a lifelong link with the past and reminds all that archery is more than a sport. In *kyudo*, as in *kendo*, "the way of the sword,"[15] mental and spiritual preparation, ritual, and form are as valued as technical accuracy.[16] Furthermore, *kyudo* can be "practiced by warriors, noblemen, priests, and the ordinary citizen."[17]

Archery came to Japan from China and Korea as a military survival skill. In the early years, the bow was very short, but by the fourteenth century it took on a unique Japanese character—over seven feet in length with the grip mounted uncharacteristically low, below the midpoint. Replaced by firearms in warfare, archery evolved into the martial art known as *kyudo*. The Amateur Archery Federation of Japan,[18] with a membership of over three hundred thousand and an abundance of *kyudo* schools, attests to its widespread popularity. Contemporary tournaments include both long-distance shooting with a target (*enteki*) and without (*inagashi*), as well as archery on horseback (*kisha*) and from a standing position (*busha*). The underlying spiritual discipline of archery draws heavily on Buddhist philosophy, especially Zen, and offers mental and physical challenges. Bows and arrows appear symbolically throughout literature, art, and ritual, and they often represent power and/or protection in religious festivals. The bow even appears in contemporary *sumo* (a sport rooted in Shinto and not commonly associated with bamboo equipment): in a tradition dating back to the Heian period,[19] a bamboo bow is twirled in the final ritual ending each day's *sumo* matches

A New Year's archery event is visible through the clouds on this folding fan.

BOW

Bamboo bows (*takeyumi*) are commonly divided into two broad categories: the lacquered (*Kyo yumi*) developed in Kyoto, and the unlacquered (*shiraki-yumi*).[20] Within these categories, there are five basic styles of bows (*yumi*) which evolved in different regions of Japan, largely as a result of specific functions. Each style has a unique shape when strung, leading to the use of the word *nari*, meaning "shape," in naming them.[21] For example, the famous bow style of the Miyakonojo region of Kyushu is called *Miyakonojo oyumi* and falls into the category of *Kagoshin nari* (referring to the larger Kagoshima township). Described as being neither beautiful nor elegant, it nonetheless is noted for its accuracy.[22] The Miyakonojo area is most famous for producing ninety percent of the bamboo bows made in Japan.[23] *Miyakonojo oyumi* were officially designated as a traditional craft of the prefecture in 1984,[24] and a cooperative was established to protect the high standards needed to maintain the designation of this traditional bow.

■ BOW CONSTRUCTION

Two thousand years of bow making have produced a complex sequence of cutting, gluing, and shaping that requires craftsmanship, evaluation, and judgment at each step.[25] The process is exacting and unforgiving: hours of work can be ruined during the final stage of construction.

As in all fine bamboo crafts, bow making begins with the selection and processing of bamboo. High-quality, unblemished three- to four-year-old *madake* bamboo is preferred, as it is for many crafts that require split bamboo. Because each bow maker uses his own distinctive pattern, the length, the placement of nodes, and the curvature are clear in his mind. Often he will put aside and avoid using a section of bamboo which has ideal characteristics (especially the spacing between nodes) in order to carry it into the grove when he selects the next plants to be harvested, assuring consistency in his production.

After the bamboo poles are aged for over a year and the oil is removed (see chapter 2), the bow maker cuts the bamboo to near-final length. The placement of the nodes and diameter of the bamboo pole are key factors in this step. The outer surface is removed to be used at a later stage of the assembly. The interior bamboo is then cut lengthwise into three to nine "boards"[26] of equal width (less than two inches) and then slightly charred over a charcoal fire to harden. These boards are planed, often with a tool made by the craftsperson himself, until all are of identical thickness and width (much less than half an inch), and until the surface is smooth, even at the point of the node ridge. Small hand-held gauges are used to assure uniformity in width and thickness.

The bamboo boards will be joined with sumac (*hazenoki*) boards that have been similarly prepared, to form the core of the bow. The quality of a great bow is determined by just how well the assembly (referred to as *hariawase*) is accomplished. The sumac boards are inserted and glued between layers of bamboo. The outer surface of the bamboo, cut away earlier, is applied to the joined boards of bamboo and sumac to comprise the outer surface of the bow, masking the complexity of the interior. The multiple layers are bound with strong cotton cord, and wedges of bamboo are driven into this lashing to create the basic curvature distinctive to each style.

When the assemblage has dried and the lashing has been removed, it has the appearance of a bow, but there is still much to do before it becomes a true *yumi*. The outer surface must be planed and finished, and the shape refined. Using skills acquired through years of practice and inherent aesthetic sensitivity, some craftspeople use their bodies for controlling the final shaping of the bow and their eyes for evaluating it. Others use a wood cutout as a template and a jig to assure uniformity.[27] The ends of the raw bow must be cut to create the notch (*hazu*) which accommodates the bow string. The cane must be wrapped at key points and a leather grip (*nigiri*) coiled in place. The bowstring (*tsuru*) is usually provided by another craftsperson. Several types of bows, ranging from those suitable for beginners to those used by skilled archers, will be produced in one workshop. For some archers, *kyudo* is a passionate hobby pursued from youth into old age. Those who practice it for years become loyal to one style of bow and one bow maker, despite the competition of fiberglass bows. Sadly, partly owing to the extremely long apprenticeships (up to ten years), only eighteen master craftspeople remain to uphold the famous tradition of wood/bamboo bow making in this Kyushu area.

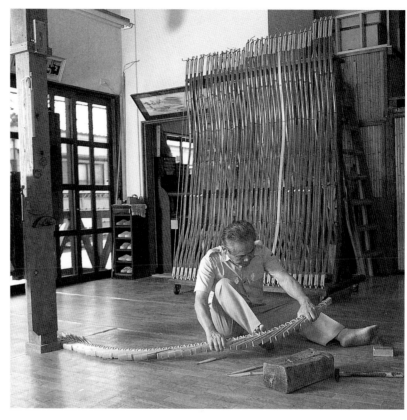

The *Miyakonojo* bows from Kyushu are famous throughout Japan and uphold a long tradition, recognized by the Japanese government.

ARROWS

Though the arrow (*ya*) naturally accompanies the bow, it is made by a different craftsperson. Narrow, hard *yadake* is so frequently the bamboo of choice, it is often called "arrow bamboo." There are three basic styles of arrows, varying with usage.[28] Japanese prints[29] and museum collections reveal that arrow tips were once made in a wide range of sizes and shapes, as were arrow feathers, with a still greater variety.

The seeming simplicity of the arrow—bamboo shaft with feathers and arrowhead—belies the complexity of its construction and the skills (straightening, determining the balance, and so on), which take years to develop. Each arrow is crafted individually, but because arrows are usually made and sold in sets, a great deal of bamboo must be harvested at one time (usually in November or December). Oil removal begins the following spring, so the bamboo must be carefully stored and aged until then. Arrow makers prefer hibachi-type charcoal heaters for removing oil, as opposed to the larger heaters that can handle multiple poles at one time (see Chapter 2). Small, domed heaters are especially effective because the heat is evenly distributed, as in an oven.

Each pole is cut near the finished length of the arrow and, once the oil is removed, the same heater is used to maintain the bamboo's temperature during the straightening process. The

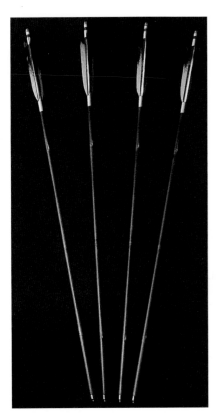

Seemingly simple, high-quality arrows require many steps in their preparation. Within a set, they are nearly identical.

arrow's form can only be altered while it is warm. A small wooden tool (*tamegi*) is used to apply pressure on the bamboo to straighten it. The bamboo is moved back and forth from heater to *tamegi* until it is considered straight. The arrow shaft is then scraped, planed, and polished with an emery powder-and-water paste until it is smooth and until each arrow in the set is the same weight. The shaft is then heated once again for a final straightening.[30]

The addition of the non-bamboo elements—feathers, arrowhead, and the notched end that receives the bowstring (the last two usually of made of steel)—completes the arrow. Hawk or falcon feathers are preferred, and each is split down the center into two equal halves. Parts of two feathers are needed to complete the total of three-feather sections that are glued and expertly tied into place. Balance at this point is crucial. When all the arrows in a set are completed, they are checked once again for uniformity.

A local craftsperson knows his clients, often young people studying *kyudo*, and listens to their needs. Contemporary archers often purchase arrows in sets and become so attached to their favorites that they return those damaged in use to the craftspeople for repairs. This ongoing relationship can continue for years.

QUIVER

Of all the implements of archery, the quiver (*yazutsu*) is the most decorative. Contemporary versions range from a simple vinyl tube to a large cylindrical, lacquered basket of woven bamboo, a design dating from the Muromachi and Heian periods. Specialized racks for quivers and arrows, and boxlike quivers (*ebira*) that were tied to the hip can be seen in museum collections. Quiver styles changed over the years to accommodate evolving changes in usage and variations in the style of arrows, and some quivers became so elaborate they were impractical. Their use is now limited to ceremonial events.[31] The contemporary, everyday quiver is a lightweight carrier that protects the arrows in transit and keeps them readily available in practice and tournaments. In some regions, Saturday trains are full of noisy, enthusiastic groups of adolescents on their way to practice sessions, their bows tied into narrow canvas pouches, their quivers hanging from their shoulders.

BOWS AND ARROWS IN FESTIVALS

Arrows have long been associated with both protection and divination. Appropriately, they appear at events marking transitions to uncertain but, one hopes, happy futures—a new home, a new business, a newborn child, the new year. Most people no longer believe in the power of the symbol, but "it can't hurt" is typical of the attitude.

An arrow with a white feather (*hamaya*), often wrapped with white paper, is purchased each New Year's Day at local shrines throughout Japan. It is regarded both as a good luck charm and a symbol of evil cast off.[32] *Hamaya* are kept for one year only and then replaced to ensure another year of good luck. The previous year's arrow, along with other New Year's ornaments, is

ceremoniously burned at the end of the New Year's fes-
tivities. When the rafters of a new building are secured,
prayer papers (*gohei*) plus a bamboo pole and an arrow
(point up, to deflect evil spirits from this new structure)
are placed under the eaves.[33] In the joyous event of a
birth in the imperial family, six arrows are shot into the air
to dispel potential evil.[34] Archery events have always
been part of the New Year's celebration. Although the rit-
uals of archery may vary from place to place and from
occasion to occasion, exorcism of evil spirits remains at
the core. Sometimes the mere presence of a company of
archers is deemed sufficient protection.[35]

For foreigners, *yabusame* (horseback archery), which
originated in the twelfth century, evokes the image of
feudal Japan. By imperial decree, contemporary participants

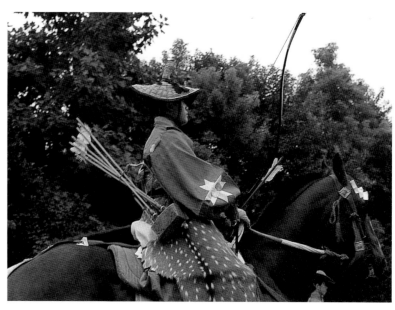

Yabusame archers evoke the image of twelfth-
century warriors and draw large crowds to their
occasional displays.

in *yabusame* tournaments still wear the traditional clothing of Kamakura-period warriors.[36] The
tournament at the Hachiman Shrine in Kamakura remains one of the public's favorite events with
thousands in attendance each year. Originally, the event was, at least in part, to entertain the
deities[37] and ensure a good crop.[38] Sollier writes that "gradually the bow and arrow came to be
thought of as dispersing evil, stopping or avoiding calamity, and bringing peace and happiness."[39]
What began as an implement of war evolved into a symbol of protection and peace.

BOWS AND ARROWS IN ART, DESIGN, AND EVERYDAY LIFE

One popular image of archery is linked with play (*asobi*). In textile design, a bow and arrow
might be held by a frog in a playful print of frolicking frogs and rabbits. The cotton fabric for
children's summer festival *yukata* includes bows and arrows scattered among other children's
playthings. The arrow motif, often with emphasis on the feather element, was a pattern fre-
quently used by those who served in samurai households during the Edo period,[40] and it contin-
ues to appear in both printed and woven textiles. Family crests sometimes include archery
motifs, though arrow parts—feathers, notches, and tips—are featured more often than the
complete arrow.[41]

Even as toys, archery sets are not exclusively playthings; they have a symbolic aspect. An
arrow-toss game was originally played as an act of divination. On Girls' Day in Japan, a collec-
tion of court dolls, from emperor and empress to attendants and accessories, would not be
complete without fully outfitted archers as attendants. On Boys' Day (now officially called
Children's Day), an appropriate gift would be a miniature bow and arrow which might be played
with or displayed only.[42] A slightly different set (*hamaya* or *hamayumi*) might be given on a boy's
first New Year's to ensure a life free from evil spirits.[43]

KENDO—THE WAY OF THE SWORD

Kendo, like *kyudo*, is more than a sport—it is a philosophy. Its challenges are mental as well as physical, and its standards of hard work, training, respect, and self-discipline extend far beyond the sports arena into everyday life. These values connect the samurai warrior with the twenty-first century. Drawing upon both Shintoism and Buddhism, *kendo* prepares those who practice it for a life of self-discipline and spiritual focus.

Today's *kendo* has evolved from the two-handed fencing style, called *kenjutsu*, used by samurai in military encounters; their weapon was a straight metal (later copper, then iron) sword.[44] *Kenjutsu* flourished during the Kamakura period. In later times, as it lost military significance, rules and rituals came to dominate the sport.

After World War II, the United States Occupation Forces banned *kendo* on the grounds that it had encouraged "militarism"[45] in prewar years. When the Occupation ended in 1952, the practice of *kendo* was reintroduced, and today it is offered in most schools. There are many levels of participation through local teams and clubs, and some large corporations even maintain elaborate practice facilities for their employees.

BAMBOO SWORD

The steel Japanese sword was regarded as the spirit and soul of the warrior, at one with its owner. Swords, along with armor, were prized personal possessions. Increasingly, they have been sought after by museums and collectors. Today, the sword guard (*tsuba*) is still considered an important collectible worldwide.

The bamboo sword (*shinai*) used in *kendo* today does not have as lofty an image as its steel predecessor. It is a piece of sports equipment that allows fencers to concentrate on technique in their rigorous practice without concern about causing or sustaining major injuries. When fencing moved from the military field to the sports arena, changes were necessary, bringing about the development of the *shinai* in the mid-Edo period.[46] It was eventually adopted by most fencing masters. An early version was constructed with sixteen to thirty-two pieces of reed covered in cloth.[47] The bamboo *shinai* that finally evolved more closely resembles a "live blade" and thus makes practice more constructive while, at the same time, maintaining safety. *Shinai* are now produced in varying lengths, and young practitioners may seek out a local craftsperson for a high-quality product.

■ *SHINAI* CONSTRUCTION

At first glance, the *shinai* appears to be a single piece of bamboo carved into a sword. Actually, the shaft is made of four separate pieces of bamboo joined through a process that involves as many as twenty-four steps. The preferred bamboo is *madake*, harvested after three or four years of growth, air-dried, then heated for straightening. The four components are then carved until they are of equal weight and fit perfectly together. Today, much of the fitting is done with power tools before the *shinai*'s outer surface is polished. Of all these steps, it is the carving that is of the greatest importance. There must be no splinters or irregular surfaces. The grip is secured with leather and tied, and the tip cover (which holds the four pieces together) is put in place. Leather or string binding at two points along the shaft further secures the pieces into a

...single unit. When the final product is checked to confirm quality, one criterion is the sound produced when the *shinai* is struck against a hard surface; another is a whining sound made during basic practice strokes. When watching a *kendo* match, it is clear why balance in the *shinai* is essential. Balance, centering, patience, and alignment are paramount in the fencer as well.

FENCING ACCESSORIES

With the development of the *shinai* for the fencers' protection, other protective gear evolved as well. Bamboo is used only in the chest protector (*do*), perhaps reflecting the historic construction of armor out of bamboo and hides.[48] The heavy bamboo slats lie vertically inside the canvas vest and are not visible. Making the *do* involves different materials and skills than those necessary for the *shinai* and, therefore, different craftspeople.

A popular image of ancient Japanese life includes samurai warriors, battlefields, and swordfights. Swords and armor continue to be seen in museums and private collections, appearing in theater and literature as well. However, the implements of contemporary *kendo* do not have the romance of the finely crafted iron swords and *tsuba* of earlier times and, unlike its predecessors, the *shinai* is not featured in textile or paper designs or considered a collectible. The maker's skills are dedicated to creating a perfectly balanced piece of sporting equipment, rather than a collector's treasure. An older bamboo sword is not revered; it is, perhaps with some regret, simply replaced.

The *shinai* bamboo sword used in *kendo* appears to be a single piece of bamboo. In reality, it is four pieces carefully carved to fit together. Binding reunites them into a safe substitute for a metal sword.

The Future of Bamboo in Japan

The romance of a life devoted to bamboo, coupled with the appealing concept of a nation honoring select craftspeople as Living National Treasures, has contributed to an idyllic image of the bamboo craftsperson as one who enjoys the dual luxuries of independence and creativity. But in reality, few craftspeople in Japan achieve fame, and few expect it. The common goals of serious craftspeople are the same worldwide: to make a good product, improve their skills, and earn a living—goals that are as difficult to achieve in Japan as elsewhere. Whether such goals will continue to be realistic for those who work with bamboo depends on a number of factors, some of which have little to do with the craftspeople themselves. Bamboo is big business, even in Japan, and the question is not if bamboo will survive, but whether bamboo crafts will continue as a viable part of Japanese life, rather than as a mere nod to the past. Craftspeople play an important role in deciding the future. Survival depends, in part, on how many younger craftspeople will be willing to devote their lives to the inherently insecure lifestyle of crafts, and on whether bamboo craftspeople will anticipate changes in fashion and decorating styles, responding by combining their traditional skills with new designs and new applications.

There are numerous other factors that lie beyond the craftsperson's hands. Bamboo moves through a complex system from grove to craft. Taxes must be paid on the property on which it is grown; groves must be well maintained to be productive; culms must be harvested, transported, processed, and sold—each step involving salaries and other costs. One person or one business does not do it all. Bamboo's future also depends in part on the vagaries of various market forces: how well marketers succeed in engaging public interest in new bamboo products, for example, and whether crafts can compete successfully with manufactured goods that fill the same function.

Some answers will come from the international community[1] and some from within Japan itself. Systematic research must be conducted to better understand and control the physical properties of bamboo. This information is vital for the crafts industry as well as for bamboo's future in architecture and the broader construction business. Bamboo is not recognized as a legal structural building material in Japan because its tensile strength changes in response to different variables present during bamboo's growth cycle. The relationship between fiber length and strength must be established.[2] Walter Liese, highly recognized internationally for his research and expertise, notes that "different fiber arrangement and percentage affect a number of properties, such as density, strength, bending behavior, shrinkage, and splitting."[3] Such technical information from scientific and industrial sources must also be shared with craftspeople if bamboo work is to flourish. The Japanese government and regional agencies already send Japanese bamboo experts abroad for information exchange. Ongoing Japanese research and

experimentation using lamination and epoxy fiberglass, lasers, and chemical and carbonizing processes will result in a wider range of more durable bamboo products that, in turn, will encourage the survival of a broad bamboo craft industry. There are other encouraging signs.

Retail businesses must realize it is short-sighted to dilute the market with inferior imports—a practice that is especially damaging when even Japanese customers believe these products to be Japanese. Some shops at favorite tourist sights sell poorly made imitations of Japanese baskets and other local bamboo products that were actually produced overseas. When a region's reputation is based on its fine bamboo ware, especially its precisely woven baskets, the local economy would be better served by designing small bamboo products that could be produced relatively inexpensively to satisfy the needs of the Japanese tourist who must purchase travel gifts (*omiyage*) for those back home.

Individual craftspeople must also recognize that their products are competing with inexpensive imports and plastic equivalents. Just as older crafts were not all made by people with sensitivity and skill, contemporary craftspeople, too, are divided into a hierarchy of skill, talent, and perseverance. Each craftsperson must find his or her own way and blend creativity and skill with savvy marketing and knowledge of the competition. Some gifted young craftspeople may go elsewhere to find their creative voices, leaving tradition to established but aging craftspeople and their successors. The future for bamboo crafts in Japan is in the hands of the young person who does not reject the past, but encompasses it while looking to express the modern Japanese spirit. Such a person will contribute to the world of Japanese crafts and find a place alongside the traditional *shokunin*.

Antique traditional crafts—what was humble in making, useful in life—are now collectible and revered. Recently, exhibits of private collections of Japanese bamboo crafts (particularly baskets)[4] have received much attention at major museums in the United States, resulting in an intense renewal of interest in both the objects themselves and the traditions that produced them. Such interest outside Japan has alerted connoisseurs and collectors within Japan as well. That the craftspeople who produced these objects span almost a century suggests that continuity in bamboo traditions does, indeed, exist.

There is little doubt that some bamboo crafts will continue: baskets will hold flowers for the tea ceremony and *zaru* will still find a place in the kitchen; bamboo bows, arrows, *kendo* sticks, and fishing rods will be used in recreation and ritual; summer sweets, bean paste, and condiments will be packaged in green bamboo tubes. Increasingly, however, some of the baskets will come from China and Thailand, as will other bamboo products; some of the new fishing rods will come from the United States; some of the bamboo tubes will be plastic. The most complex crafts, such as folding fans and umbrellas, may be made only in a few isolated workshops. Simpler decorative items may be made in a production line by workers who don't regard themselves as craftspeople, but as employees.

Finally, however, it is important to remember that the depth of bamboo's significance in Japan is not limited to the craft world, but emerges—and will continue to emerge—in rituals, music, folk tales, legends, designs, and other artifacts.[5] As long as the Japanese walk through a door-curtain stenciled with indigo umbrella designs, wear summer *yukata* with fan motifs, or hear the husky softness of the *shakuhachi*, they will continue to be reminded of the subtle ways in which bamboo and crafts enrich their lives.

SOURCES FOR OBSERVATION AND RESEARCH

NOTE: Because information about many sites changes regularly, supplementary sources are suggested. In particular, *The Official Museum Directory*, which lists not only museums but major gardens and historical sites as well, is a worthwhile resource. Various websites make computer searches relatively quick. See <www.gardenweb.com> and <www.jgarden.org> to start.

Native bamboos grow naturally in every continent in the world except Europe and the land masses near the poles. Distribution maps illustrate a wide path of bamboo located both north and south of the equator, with much of North America, northern Asia (including old Russia), and Europe excluded.[1] Findings reported at the 1997 European Bamboo Society meeting indicated that France may soon be officially added to the indigenous site list.[2]

The natural geographic distribution of bamboo has been greatly modified by the intervention of collectors, researchers, and botanists. Writing in the nineteenth century, Freemen-Mitford (whose publication The Bamboo Garden is still held in high regard) describes how the English brought in specimens of bamboo from the south of France and as far away as Japan. The exotic descriptions of luxurious groves in Brazil and the dramatic flowering and subsequent death of vast bamboo stands in India spurred collectors to look for increasingly exotic varieties for their gardens.[3] Tom Wood speaks eloquently on the topic of the "pioneers who spread interest and plants of bamboo around the world"[4] and who thus contributed to bamboo's currently worldwide distribution. Some of those pioneers have been immortalized in the names of bamboos, among them, von Siebold, Simon, Henon, Young, Makino, McClure, and Munroe. Their research and the resulting collections are echoed by the work of the more recent contributors to the field, including Ueda, Bol, Yasui, and Widjaja.

As a result of international efforts, bamboo can now be found around the world. Bamboo societies are forming to further the distribution of bamboo, but also to disseminate information about bamboo's horticultural characteristics and its potential for multiple uses. Japan plays a major role in the history of bamboo, and as such, must be examined as a primary source of technical and artistic information.

JAPAN

■ MUSEUMS, GARDENS, AND RESEARCH ORGANIZATIONS

Aside from the Japan Bamboo Society, there are a handful of research institutes, gardens, and museums in Japan devoted to bamboo. Each organization has a separate history, government affiliation, and purpose. While many other gardens and museums include bamboo in their program or displays, the following list contains the major sites for bamboo research, regular exhibitions, or large landscape installations. For schedules of public events or for further information, most organizations can be contacted directly, in Japanese.

NATIONWIDE
**Japan Bamboo Society
(Nihon no Take Bunka Shinko Kyokai)**
Kyoto Industrial Exhibition Hall
9-1 Seishoji-cho Okazaki, Sakyo-ku
Kyoto 606-8384
☎ (075) 761-3600
Within Japan, sources of information about bamboo are extensive and varied. Among the most significant is the Japan Bamboo Society, begun in the 1970s by a group of dedicated bamboo enthusiasts with the primary mission of disseminating information about bamboo to the public. Recognized authorities, including Ueda Koichiro, were listed among the originators of this important organization. The society's newsletter, *Take* (Bamboo), is published several times a year and includes information ranging from announcements of meetings, to research findings and educational projects. In addition, a scientific magazine, *Bamboo Journal*, is published once a year. Most people associated with the business of bamboo belong to the society, though many do not travel the long distances to attend the meetings, relying instead on the society's publications for their updates. The society is considered the international representative of bamboo concerns in Japan.

BEPPU
**Beppu City Traditional Bamboo Crafts Center
(Beppu-shi Takezaiku Dento Sangyo Kaikan)**
8-3 Higashi Shoen-machi
Beppu-shi, Oita Prefecture 874-0836
☎ (0977) 23-1072

This center was designed to illustrate Beppu's central role in the world of Japanese bamboo and to act as a resource for bamboo information. The gallery spaces, as well designed as a museum's, are educational and entertaining. Classrooms upstairs accommodate workshops, lectures, and meetings. The nominal entrance fee includes a brochure.

**Beppu Industrial Arts Research Division
(Beppu Sangyo Kogei Shikenjo)**
3-3 Higashi Shoen-machi
Beppu-shi, Oita Prefecture 874-0836
☎ (0977) 22-0208
This research site focuses on designing new bamboo products in order to stimulate bamboo enterprises and on conducting research to develop techniques to improve the quality of bamboo items and widen the industrial application of some known techniques. Each year the institute releases to the public a series of new designs suitable for bamboo products. Some of these have received international design recognition.[5] Research here has resulted in new lamination techniques and the use of laser equipment. The research continues. Contact only for serious research.

**Japan Bamboo Museum
(Nihon Take-no Hakubutsukan)**
6-8-19 Ishigaki-higashi
Beppu-shi, Oita Prefecture 874-0919
☎ (0977) 25-7776
The Japan Bamboo Museum is located on the floors above Gallery Kishima, which specializes in bamboo products. The museum was created in the 1990s from the private collection of a wholesale merchant. The written material within the display is educational, and workshops, especially for schoolchildren, are available. A brochure is part of the nominal entrance fee.

CHIBA
**Chiba Prefectural Industrial Research Institute
(Chiba Kenritsu Kogyo Shikenjo)**
880 Kasori-cho, Wakaba-ku
Chiba-shi, Chiba Prefecture 264-0017
☎ (0472) 31-4325
This research institute includes bamboo as part of its mandate. Efforts to support the local bamboo industry include some international research by staff and the promotion of local products with special events. Contact Mr. Hayashi, for serious research only.

Otaki Forest for the Citizens of Chiba
(Chiba-kenritsu Otaki Kenmin no Mori)
486-21 Otaki, Otaki-machi
Isumi-gun, Chiba Prefecture 298-0216
☎ (0470) 82-3110
This park includes a museum with extensive bamboo displays, videos on bamboo, and literature. A bamboo craft center frequently schedules workshops and festival events here. Brochures are available upon request. This site was originally established by the prefectural government but is now maintained by the town of Otaki, which is located about two hours east of Tokyo on the Boso Peninsula. There are many bamboo craftspeople in this area, known for its agricultural history.

KAGOSHIMA
Kagoshima Prefectural Forestry Experiments Station
(Kagoshima-ken Ringyo Shiken-jo)
182-1 Kamigyutoku, Kamou-cho, Aira-gun
Kagoshima Prefecture 899-5302
☎ (0995) 52-0074
This experimental site was established in 1929. As one of the earliest experimental research centers in Japan, it focuses on the modernization and development of forestry in Japan. Pamphlets are available listing ongoing research. This site should be contacted only for forestry and horticultural research.

KYOTO
Kyoto Rakusai Bamboo Park
(Kyoto-shi Rakusai Chikurin Koen)
2-300-3 Kitafukunishi-cho, Ooe
Nishikyo-ku, Kyoto 610-1112
☎ (075) 331-3821
This famous bamboo site was the inspiration of Dr. Ueda Koichiro, one of the world's foremost authorities on bamboo. The city of Kyoto began the park in 1981, and today the site has developed into a mature garden and research center that encourages the public to become familiar with the positive attributes of bamboo. Besides the gardens that display over 120 bamboos, the museum exhibits bamboo crafts, while adopting an educational approach. There is also a tea ceremony room and a small gift shop. The garden is a frequent stop for international figures of the horticultural world.

SHIZUOKA
Fuji Bamboo Garden
(Fuji Takerui Shokubutsuen)
Minami-isshiki, Nagaizumi-cho, Sunto-gun
Shizuoka Prefecture 411-0932
☎ (0559) 87-5498
In 1951, Fuji Bamboo Garden started to collect and study bamboo. The systematic research done here has resulted in a widely known series, *The Reports of the Fuji Bamboo Garden*, and many other scholarly contributions. Currently, the garden provides the public with mature, clearly identified plantings of all the varieties of bamboo grown in Japan. Also on the grounds are a museum, library, and gift shop filled with bamboo artifacts and related publications. Bamboo festivals, workshops, and meetings are often scheduled.

■ PREFECTURAL CRAFTS EXHIBITS AND THE JAPAN TRADITIONAL CRAFT CENTER
Japan has a long tradition of formalized gift giving. When traveling, Japanese often return home with an omiyage, or travel gift. Each region, indeed even single towns, have special foods and craft items considered appropriate as gifts. Prefectural offices often have displays of these items at major train stations or in a gallerylike office near the station. Illustrated brochures are printed and distributed at craft fairs, department store exhibits, regional expositions, and the Japan Traditional Craft Center in Tokyo. This center also sponsors major craft events around the country with the specific intention of introducing fine-quality crafts to a larger audience.

Japan Traditional Craft Center
(Zenkoku Dento-teki Kogei-hin Center)
3-1-1 Minami Aoyama
Minato-ku, Tokyo 107-0062
☎ (03) 3403-2460

■ BAMBOO WHOLESALE/RETAIL BUSINESSES
The following are just a sampling of the specialty businesses in Japan. Many are multigenerational. Whenever possible, contact them in Japanese.

Iwao Chikuran
1-5 Hikari-machi
Beppu, Oita Prefecture 874-0930
☎ (0977) 22-4074 Fax: (0977) 22-4342

Takehei Bamboo Corporation
403 Omiya-Gojo
Shimogyo-ku, Kyoto 600-8378
☎ (075) 841-3803 Fax: (075) 802-6277
EMAIL: takehei@mbox.kyoto-inet.or.jp
WEBSITE: web.kyoto-inet.or.jp/people/takehei
CONTACT: Kagata Junji

• Taketora
913-1 Awa
Suzaki-shi, Kochi Prefecture 785-0024
☎ (0889) 42-3201 Fax: (0889) 42-3283
EMAIL: info@taketora.co.jp
WEBSITE: www.taketora.co.jp
CONTACT: Yamagishi Yoshihiro

• Taketora, Hirome Office
2-3-1 Obiya-cho
Kochi-shi, Kochi Prefecture 780-0841
☎ (088) 820-6505 Fax: same

Torado, Inc.
2-9-60 Yuigahama, Kamakura-shi
Kanagawa-ken 248-0014
☎ (0467) 22-2503 Fax: (467) 24-1103
EMAIL: Toradou@aol.com or torado@za2.so-net.ne.jp
CONTACT: Yamada Shuichi

UNITED STATES

American Bamboo Society
The American Bamboo Society (ABS was formed in 1979 with the following objectives: to provide "information on the identification, propagation, use, culture and appreciation of bamboos; to promote the utilization of a group of desirable species for distribution to public gardens and to the general public; to provide plant material for research in the taxonomy, propagation, and culture of bamboo species; and to support bamboo research in the field."[6] The Society remains the single, most important information source on bamboo within the United States. In addition to *The Journal of The American Bamboo Society*, ABS publishes a bimonthly newsletter, which along with chapter newsletters keeps the membership up-to-date on research findings, national and international events, and relevant available publications. ABS chapters may be contacted directly for information concerning regional Asian museums and organizations, garden sites, and specific seasonal activities. This is an ever-changing, not-for-profit organization, and chapter specifics will vary. The following members have a long-standing commitment to bamboo and will forward your mail to the appropriate chapter. The Quail Botanical Gardens address remains constant.

American Bamboo Society
Quail Botanical Gardens
230 Quail Gardens Drive (Saxony)
P.O. Box 230005
Encinitas, CA 92023

Michael Bartholomew
750 Krumkill Road
Albany, NY 12203

Elizabeth Haverfield
755 Tiziano Avenue
Coral Gables, FL 33143

Susanne Lucas
9 Bloody Pond Road
Plymouth, MA 02360

Carole Malone
6707 Willamette Drive
Austin, TX 78723

Rosalie Ross
5 Boston Ship Plaza
San Francisco, CA 94111

George Shor
2655 Ellentown Road
La Jolla, CA 92037

■ MUSEUMS, ASIAN ORGANIZATIONS, AND GARDENS

Many organizations are committed to introducing bamboo and bamboo crafts to the public and serve as information resources as well. The following list is offered as a starting point for gathering what information is available within the United States.

ALABAMA
Birmingham Botanical Gardens
2612 Lane Park Road
Birmingham, AL 35223
☎ (205) 879-1227 (membership office)
WEBSITE: www.bbgardens.org
The Gardens include a Japanese garden with twenty-five bamboo and a reconstructed Japanese teahouse. Descriptive pamphlet available.

CALIFORNIA
Adam E. Treganza Anthropology Museum
Department of Anthropology
San Francisco State University
1600 Holloway Avenue
San Francisco, CA 94132
☎ (415) 338-1642
WEBSITE: www.sfsu.edu/~treganza/welcome.html
 or SFSU.edu/~anthro/treganza.htm
The ethnological collection includes Japanese artifacts, some of which were included in the recent Japanese Folk Rituals exhibit.

Asian Art Museum of San Francisco
The Avery Brundage Collection (relocating in 2002)
Golden Gate Park
San Francisco, CA 94118
☎ (415) 379-8800 (visitor info, ☎ 8801)
WEBSITE: www.asianart.org
The museum's collection includes extensive holdings of lacquer, textiles, and applied arts.

The Bamboo-smiths
Doug and Martha Lingen
P.O. Box 1801
Nevada City, CA 95959
☎ (916) 273-8818
Doug Lingen's training in Japan has evolved into a bamboo-construction business. Utilizing fence-making techniques he learned in Kyoto, Lingen also offers workshops, which are in great demand.

Bamboo Sourcery
666 Wagnon Road
Sebastopol, CA 95472
☎ (707) 823-5866
WEBSITE: www.home.earthlink.net/~bamboosource/index.htm
This business, which is a "commercial grower," is listed because it was begun by the late Gerald Bol, who contributed much to the introduction of new bamboo varieties to the United States. A past president of ABS, Bol's penchant for establishing international friendships among the bamboo community and for aggressively collecting varieties abroad is reflected in the bamboo available at the seven-acre demonstration gardens. By appointment only.

Bareis Bamboo Tours
2900 Smith Grade
Santa Cruz, CA 95060
☎ (831) 427-1034
EMAIL: ibabambu@cruzio.com
CONTACT: Karl or Ginger Bareis
The Bareis's long history with Japan and China is reflected in their tours to those regions. For many years, Karl was an international representative for ABS.

Craft & Folk Art Museum
5800 Wilshire Boulevard
Los Angeles, CA 90036
☎ (213) 937-5544
WEBSITE: cafam@www.lam.mus.ca.us
Japanese folk art and contemporary craft and design are part of the museum's holdings. A multimedia library and educational programs are open to the public.

Descanso Gardens
1418 Descanso Drive
La Canada, CA 91011
☎ (818) 952-4401
WEBSITE: www.descanso.com
This non-profit garden of 165 acres includes a Japanese garden with teahouse, bamboo in the landscape planting, seasonal exhibits, and a cafe. The gift shop offers some bamboo items. The admission includes a brochure.

Hakone Gardens
P.O. Box 2324
21000 Big Basin Way
Saratoga, CA 95070-0324
☎ (408) 741-4994
WEBSITE: www.hakone.com
CONTACT: Hakone Foundation
Since its inception in 1917, Hakone Gardens has undergone repeated changes before becoming the hill-and-pond strolling garden seen today. The gardens continue to reflect the influence and dedication of Tanso Ishihara, the first city gardener, and more recently, Kiyoshi Yasui, fourteenth-generation architect from Japan. The extensive bamboo plantings (some quite rare) and the Cultural Exchange Center (a museum-quality replica of a mid-1800's Kyoto townhouse) reveal his supportive efforts.

The center has a fine tea-ceremony room, and the gardens now include a tea-growing area in addition to the formal gardens. A modest entry fee for nonresidents allows access to all the buildings and grounds, and a small gift shop is located near the parking lot. The foundation offers an extensive art- and cultural-program schedule, and the site is available for rental for corporate retreats and social events.

Hida Tool & Hardware Co.
1333 San Pablo Avenue
Berkeley, CA 94702
☎ (510) 524-3700
WEBSITE: www.hida-tool.com
This company specializes in Japanese tools, including the saws, hatchets, knives, and splitters used in preparing bamboo for fencing and crafts.

Huntington Library, Art Collections, and Botanical Gardens
1151 Oxford Road
San Marino, CA 91108
☎ (626) 405-2100
WEBSITE: www.huntington.org
Within the Japanese Garden, there is a Japanese house (the site of numerous activities), a Zen-garden courtyard, and a bonsai court. Bamboo is included in the landscaping. A bookstore, restaurant, and gift shop are all within the larger botanical gardens. Brochure available with admission.

Japanese-American Cultural and Community Center
The James Irvine Garden
244 South San Pedro Street
Los Angeles, CA 90012
☎ (213) 628-2725
WEBSITE: www.jaccc.org
The gift shop in the center sells bamboo items.

Japanese Cultural Center and Bamboo Garden, Foothill College
12345 El Monte Road
Los Altos Hills, CA 94022-4599
☎ (650) 949-7777
WEBSITE: www.bamboogarden.org
The garden, which now contains fifty-five varieties of bamboo, was established in 1989 with the assistance of the Northern California Chapter of ABS. Frequent cultural activities are scheduled here, both in the garden itself and in the Center.

Japanese Garden of the DC Tillman Water Reclamation Plant
6100 Woodley
Encino, CA 91436

☎ (818) 756–8166 for reservations
WEBSITE: www.cityofla.org/SAN/sanjad.htm
Bamboo is used in this stroll-style garden, part of a large complex owned by the City of Los Angeles. The Japanese garden was designed by Koichi Kawana and includes a teahouse and ponds. By reservation only. A pamphlet is available with the guided tour.

Japantown
Post and Buchanan streets
San Francisco, CA 94115
A commercial center, Japantown includes a wide variety of stores selling many common Japanese items for the home. In addition, an excellent hardware store sells tools suitable for working with bamboo. Several shops specialize in selling bamboo gift items. Seasonal festivals and activities are scheduled.

Los Angeles County Museum of Art
The Pavilion for Japanese Art
5905 Wilshire Boulevard
Los Angeles, CA 90036
☎ (323) 857–5600, (323) 857–6565 Japanese Art Department
WEBSITE: www.lacma.org
Bamboo is included in the exterior landscaping of the museum. The collection includes bamboo baskets and an extensive selection of Japanese decorative arts, some of which have bamboo motifs.

Mingei International Museum of World Folk Art
Plaza de Panama
Balboa Park
P.O. Box 553
La Jolla, CA 92038
☎ (619) 239–0003
EMAIL: mingei@mingei.org
WEBSITE: www.mingei.org
This collection has recently been consolidated into one large building within the Balboa Park complex of gardens, historical sites, and museums. The exhibits of indigenous arts includes bamboo from many cultures. Folk craft (*mingei*) items from Japan are always on view.

Phoebe Hearst Museum of Anthropology
103 Kroeber Hall
University of California
Berkeley, CA 94720–3712
☎ (510) 642, 3682
WEBSITE: www.qal.berkeley.edu/~hearst
Known for its extensive holdings of Native American artifacts and documents, this museum also includes ethnological specimens from Asia. The gift shop sells arts and crafts, books, and slides.

Quail Botanical Gardens
230 Quail Gardens Drive (Saxony)
P.O. Box 230005
Encinitas, CA 92023–0005
☎ (760) 436–3036

WEBSITE: www.qbgardens.com
Quail Gardens has a spectacular collection of bamboo, thanks to the ABS, whose quarantine site is located within the gardens. ABS was founded at this location in 1979, and a strong commitment to the garden continues.[7]

San Francisco Craft & Folk Art Museum
Building A, Fort Mason Center
San Francisco, CA 94123
☎ (415) 775–0990/91
Recent exhibits have included "The Art of Okinawa" and "Textiles of Old Japan."

Sequoyah Ridge Nursery
3790 Harrison Grade Road
Sebastopol, CA 95472–9724
☎ (707) 874–1045
CONTACT: Hastings and Terri Schmidt
Specializing in bamboo installations in landscaping, this business is also the occasional site of bamboo events and meetings. Tours of bamboo sites within the Bay Area can be arranged.

Tai Hei Shakuhachi
Monty Levenson
P.O. Box 294
Willits, CA 95490
☎ (707) 459 3402 Fax: (707) 459 3434
EMAIL: monty@shakuhachi.com
WEBSITE: www.shakuhachi.com
Each year, Monty tries to travel back to his in-laws on Shikoku to harvest and prepare bamboo for *shakuhachi*. His research and experimentation have resulted in a precise bore process for creating the interior aperture. He often collaborates with other *shakuhachi* players, such as John Neptune, who lives in Chiba, near Tokyo.

UCLA Hannah Carter Japanese Garden
10619 Bellagio Road
Los Angeles, CA 90077
☎ (213) 825–4574
This garden was created in 1961 and donated to the university in 1965. The main gate, viewing bridge, and teahouse are all reminiscent of old Kyoto. Brochure available. By reservation only.

COLORADO
Denver Art Museum
100 West 14th Avenue Parkway
Denver, Colorado 80204
☎ (720) 865–5000
WEBSITE: www.denverartmuseum.org
The museum was founded in 1893 and currently has over forty thousand objects of art in its collection, four thousand of which are within the Asian collection. Among the Japanese items are bamboo artifacts exhibited in the galleries devoted to Asian art. Museum shop and cafe are on site.

FLORIDA
The Morikami Museum and Japanese Gardens
4000 Morikami Park Road
Delray Beach, FL 33446
☎ (561) 495 0233
EMAIL: morikami@co.palm-beach.fl.us
WEBSITE: www.morikami.org
This two-hundred-acre park is anchored by the Museum of Japanese Culture, whose extensive library holdings, cafe, and exhibition space all reflect a focus on Japanese culture. This is a site for frequent festival and exhibit events year round. Brochure available.

GEORGIA
Atlanta Botanical Garden
1345 Piedmont Avenue
Atlanta, GA 30309
☎ (404) 876–5859
MAILING ADDRESS
P.O. Box 77246
Atlanta, GA 30357
WEBSITE: www.atlantabotanicalgarden.org
The Japanese Garden includes a teahouse, bamboo plantings, and a bamboo fence. It is but one of many gardens within the thirty-acre site.

Bamboo Farm and Coastal Gardens
2 Canebrake Road
Savannah, Georgia 31419
☎ (912) 921–5460
EMAIL: coastal@uga.cc.uga.edu
CONTACT: Frank Linton
One of the oldest bamboo sites in the United States, the gardens were started as a Plant Introduction Station by the Department of Agriculture in order to observe imports of bamboo, fruit and nut trees, and miscellaneous ornamentals. Now owned by the University of Georgia, it holds the largest collection of *Phyllostachys* in the United States, and myriad other genera useful in arts, crafts, music, and construction. The southeast chapter of the ABS often schedules events at this location. A collection of bamboo artifacts is also on the premises. The road on which the farm and gardens have always been located is named after America's only native bamboo, *Arundinaria gigantea*, or "canebake."[8] Until recently, the site was referred to only as Coastal Gardens.

HAWAII
Bishop Museum
1525 Bernice Street
Honolulu, HI 96817–2704
☎ (808) 847–3511
WEBSITE: www.bishopmuseum.org
Primarily a cultural and natural history museum, the Bishop holds extensive Japanese immigrant documents. Bamboo artifacts from other Pacific Rim regions are also included. Festivals and performing arts events are frequently scheduled.

East-West Center
1777 East-West Road
Honolulu, HI 96848
☎ (808) 944-7111
WEBSITE: www.ewc.hawaii.edu
The center is located adjacent to the University of Hawaii campus at Manoa and shares the island's magnificent landscape. The grounds include a Japanese garden and teahouse. Many festivals, performing arts presentations, and literary events on Asian themes take place here. Within the main building, the East-West Center Gallery is highly reputed. Recent exhibits have included Japanese kites and toys.

Honolulu Academy of Arts
900 South Beretania Street
Honolulu, HI 96814-9938
(808) 532-8700
Website: www.honoluluacademy.org
The Academy is a dynamic institution with programs involving film, the performing arts, festivals, lectures, and special exhibitions. The Asian Collection includes items of bamboo as well as those with bamboo motifs. Cafe, library, and gift shop are all on site. A brochure is available upon entry.

Japanese Cultural Center of Hawaii
2454 South Beretania Street
Honolulu, HI 96826
☎ (808) 945-7633
Located near the University of Hawaii campus, the center includes a library, museum shop, and exhibition spaces, all with an emphasis on Japanese-American history in Hawaii.

Pacific Bamboo Council
P.O. Box 454
Pahoa, HI 96778-0454
☎ (808) 965-7182
CONTACT: Milo Clark, Executive Director
The council researches, advocates, and promotes bamboo and bamboo use worldwide.

MARYLAND
Brookside Gardens
1500 Glenallan Avenue
Wheaton, MD 20902
MAILING ADDRESS
1800 Glenallen Avenue
Wheaton, MD 20902
☎ (301) 962-1401
WEBSITE: www.gardenweb.com/directory/bg
This fifty-acre public garden includes the five-acre Gude Garden in the "hill-and-pond" style, as well as a teahouse. The garden hosts a gift center on site and regular educational programs. Pamphlet available.

MASSACHUSETTS
Arnold Arboretum
Harvard University
125 Arbor Way
Jamaica Plain, MA 02130-3519
☎ (617) 524-1718
WEBSITE: www.arboretum.harvard.ed
A wide variety of bamboos are now established in the arboretum plantings, concentrated near the visitor center. The northeast chapter of the ABS often meets at this site and contributes regularly to the arboretum's bamboo collection.

Bamboo Fencer
179 Boylston Street
Jamaica Plain, MA 02130-4520
☎ (617) 524-6137
WEBSITE: www.bamboofencer.com

Japan Society of Boston
22 Batterymarch Street
Boston, MA 02109
☎ (617) 451-0726
WEBSITE: www.us-japan.org
Established in 1904, the Japan Society of Boston is one of the oldest societies devoted to promoting understanding and communication between Japan and the United States.

Peabody Essex Museum
East India Square
Salem, MA 01970-3783
☎ (978) 745-1876, (978) 745-9500
EMAIL: pem@pem.org
WEBSITE: www.pem.org
The museum's collections include Asian, Oceanic, and African arts; "Asian export art"; and many others. Approximately twelve hundred of the museum's objects contain bamboo. The compound includes the Phillips Library, a cafe, and a gift shop. Seasonal hours. Brochure available.

MISSOURI
Seiwa-en, The Japanese Garden
Missouri Botanical Garden
4344 Shaw Boulevard
St. Louis, MO 63110
☎ (314) 577-5100
WEBSITE: www.mobot.org
This fourteen-acre garden was designed by Koichi Kawana and includes a lake, "wet-stroll" garden, teahouse, Zen-meditation dry garden, and much more. Dedicated in 1977, the garden offers a place of peace and harmony. Brochure available upon entrance.

NEW MEXICO
Museum of International Folk Art
706 Camino Lejo
Santa Fe, NM 87505
P.O. Box 2087
Santa Fe, NM 87504-2087
☎ (505) 827-6350
WEBSITE: www.state.nm.us/moifa
This collection of folk art represents cultures from around the world and includes textiles, costumes, and toys.

NEW YORK
Asia Society
725 Park Avenue
New York, NY 10021
☎ (212) 288-6400
WEBSITE: www.asiasociety.org
The Society offers a variety of exhibits and programs reflecting the cultures of Asia.

Hammond Museum and Japanese Stroll Garden
Deveau Road
North Salem, NY 10560
MAILING ADDRESS
P.O. Box 326
North Salem, NY 10560
☎ (914) 669-5033 Fax: (914) 669-8221
WEBSITE: www.hammondmuseum.org
The museum, in the variety of activities it offers, often reflects Japanese themes, as does the small exhibit area.

Humes Japanese Stroll Garden
Dogwood Lane and Oyster Bay Road
Mill Neck, New York 11560
☎ (516) 676-4486

Isamu Noguchi Garden Museum
32-37 Vernon Boulevard
Long Island City, New York 11106
☎ (718) 721-1932
WEBSITE: www.noguchi.org
The Noguchi Museum is an unexpected oasis in an industrial area at the edge of New York City. The museum building displays Noguchi's sculpture, *Akari* lamps of bamboo and paper, as well as examples of his contributions to the performing arts. The garden includes a series of paths that meander peacefully through sculptures and garden. Open only from April through November. Brochure available with admission.

Japan Society
333 East 47th Street
New York, NY 10017
☎ (212) 832-1155
WEBSITE: www.jpnsoc.org
In New York City, the Japan Society is the center for information on topics related to Japanese culture. A wide variety of activities are scheduled in their gallery, theater, and library. A recent remodeling has resulted in the expansion of the bamboo garden.

Urasenke Chanoyu Center
153 East 69th Street
New York, NY 10021
☎ (212) 988-6161
The mission of the Urasenke Center is to introduce the tea ceremony to the rest of the world. In doing so, many bamboo utensils, flower baskets, and bamboo architectural details are utilized.

OREGON
Hoyt Arboretum
4000 SW Fairview Boulevard
Portland, OR 97221
☎ (503) 228-8733
A substantial collection of bamboos has been planted with the cooperation of the northwest chapter of the ABS.

Japanese Gardens
P.O. Box 3847 (business office)
611 S.W. Kingston
Portland, OR 97201
☎ (503) 223-1321
The 5.5-acre garden site was designed in 1963 by Professor P. Takuma Tono, an authority on Japanese garden design. Open year round, the five gardens, teahouse, and gift shop offer a glimpse of old Japan.

Tradewinds Bamboo Nursery
28446 Hunter Creek Loop
Gold Beach, OR 97444
☎ (541) 247-0835
WEBSITE: www.harborside.com/bamboo
CONTACT: Gib Cooper
Aside from supplying bamboo for landscaping, Tradewinds is known as a resource for bamboo information. Offering one of the largest bamboo book lists in the country, it is a distributor of INBAR and ABS publications. Tools used for crafting bamboo are also available.

PENNSYLVANIA
Shofuso: The Pine Breeze Villa
Japanese House & Garden (House Museum)
West Fairmont Park
North Horticultural Drive
Philadelphia, PA 19131
MAILING ADDRESS
Ohio House
4700 States Drive
Philadelphia, PA 19131
☎ (215) 878-5097
WEBSITE: www.libertynet.org/jhg
CONTACT: Friends of the Japanese House & Garden
This Momoyama-style garden surrounds a sixteenth-century *shoin*-style house. Bamboo was used for the construction, decoration, and landscaping. Pamphlet available. Open May to October.

TENNESSEE
Cheekwood-Tennessee Botanical Garden and Museum of Art
1200 Forest Park Drive
Nashville, TN 37205-4242
☎ (615) 353-2155
WEBSITE: www.cheekwood.org
The Japanese garden includes a large grove of *Phyllostachys*.

TEXAS
Forth Worth Botanic Garden
3220 Botanic Garden Boulevard
Forth Worth, TX 76107
☎ (817) 871-7686
The 7.5-acre Japanese garden is but one of many within the larger botanic garden. Teahouse, five lakes, and a meditation garden enhance the ambiance of the garden. Brochure available upon entry.

Mercer Arboretum & Botanic Garden
22306 Aldine Westfield Road
Humble, TX 77338-1071
☎ (281) 443-8731
Within the teahouse garden are over twenty varieties of bamboo. A small shop is on site and a brochure is available.

Zilker Botanical Gardens
2220 Barton Springs Road
Austin, TX 78746
☎ (512) 477-8672
WEBSITE: www.zilker-garden.org
The oriental garden was designed and installed by Isamu Taniguchi. His plantings and design have been continued through the efforts of the Texas chapter of the ABS. The garden is an unexpected oasis within the more traditional southwest landscape.

VIRGINIA
Norfolk Botanical Garden
6700 Azalea Garden Road
Norfolk, VA 23518-5337
☎ (757) 441-5830
WEBSITE: communitylink.org/nbg
This 155-acre public garden includes sixteen theme gardens, one of which is the Japanese Garden with a bamboo arbor and bamboo used in the landscaping. Seasonal hours. Pamphlet available.

WASHINGTON
Seattle Asian Art Museum
Volunteer Park
1400 East Prospect
Seattle, WA 98112-3303
MAILING ADDRESS
P.O. Box 22000
Seattle, WA 98122-9700

☎ (206) 625-8900
WEBSITE: www.seattleartmuseum.org
With the building of the new museum downtown (see the following entry), this lovely old building in Volunteer Park in the hills above the city is now dedicated to the display and research of its extensive Asian collection. Among its treasures are Japanese textiles.

Seattle Art Museum
100 University Street
Seattle, WA 98101-2902
☎ (206) 625-8900 Administration,
 (206) 654-3255 Information
Affectionately referred to as SAM, this new site includes a research library, lecture halls, and auditorium. Both a gift shop and cafe are on site. One of the most exciting Asian collections in the country, the Asian Art Museum (see previous entry), is housed here.

Wing Luke Asian Museum
407 Seventh Avenue, South
Seattle, WA 98104
☎ (206) 623-5124
WEBSITE: www.wingluke.org
With an emphasis on immigrant history, this collection includes Asian-American and Asian history, art, and culture. The gift shop sells a collection of new and traditional art, crafts, and books.

WASHINGTON, D.C.
The National Zoological Park
3001 Connecticut Avenue, NW
Washington, D.C. 20008
☎ (202) 673-4721
WEBSITE: www.si.edu/natzoo

Arthur M. Sackler Gallery
1050 Independence Avenue, SW
Washington. D.C. 20560

Freer Gallery of Art
Jefferson Drive at 12th Street, SW
Washington. D.C. 20560
☎ (202) 357-4880
Both of these outstanding galleries, part of the Smithsonian Institute, offer exhibits, educational programs, special events, and publications that focus on Asia. The bamboo crafts of Japan is but one topic addressed in recent years. See Cort's *The Basketmaker of Rural Japan* in the bibliography.

INTERNATIONAL

■ INTERNATIONAL ORGANIZATIONS

The International Bamboo Association (IBA) was formed with the primary goal of "providing better global coordination and communication of all aspects related to bamboo."[9] The founders felt these goals could best be accomplished by encouraging the formation of new bamboo societies in areas where bamboo is naturally prevalent. Coordinating with the International Network for Bamboo and Rattan (INBAR), IBA has facilitated the subsequent International Bamboo Congress (IBC) meetings held around the world. Scheduled IBC sites included Bali, Costa Rica, and India.

IBA
The IBA website, provided and updated by the Australian Bamboo Society, can be accessed at <www. bamboo.org.au/iba/organization.htm>.

INBAR
Dr. I. V. Ramanuja Rao, Principal Scientist
208 Jor Bagh
New Delhi, India 110–003
Email: RRao@idrc.ca
Many publications on the topics of propagating, collecting, utilizing and preserving bamboo and rattan are available through INBAR.

■ EUROPE

European Bamboo Society
Individual bamboo societies in Europe have been loosely structured for some time. The European Bamboo Society (EBS) now meets annually and varies the site with each meeting. As with the annual meetings of the ABS, the program includes lectures, demonstrations, and tours to nearby bamboo sites, all with the intention of sharing information and resources, while upholding good business practices. Most of the EBS participants are commercial growers, landscapers, or dedicated collectors. Because they are volunteer representatives of their individual societies, they should be contacted only with serious questions regarding bamboo and bamboo sites, and in the appropriate language whenever possible.

EBS
311, avenue du Prado
13008 Marseille, France
☎ 04 91 76 12 16

Secretariat General
Mme Roselyne Mauzole-Fosse
19, avenue Anne de Noailles
95200 Sarcelles, France
☎ 01 39 94 52 31

EBS Germany
Frau Edeltraud Weber
John Wesley Strasse 4
63584 Grundau, Germany

EBS Spain
J. M. Viure
Apartado de Correos 19
Carretera Cardedeu a Canovec
E–08440 Cardedeu
Barcelona, Spain
Fax: 93–846-26-00

EBS Great Britain
David Helliwell
43 Whitehouse Rd.
Oxford OX1 4QJ, England
EMAIL: djh@vax.ox.ac.uk

EBS Belguim
Johan Gielis
Notte bohmstraat 8
B-2018 Antwerpen, Belguim
EMAIL: johan.gielis@rug.ac.be

EBS Italy
Mario Bradazzi
Via Dosso di Mattina 19
Credera Rubbiano CR, Italy

EUROPEAN BAMBOO SITES
Bamboo Information Center
Bamboo Parc
Dorpsweg 125
1697 K J Schellinkhout, The Netherlands
☎ (0229) 501309
Begun in 1988 by the Younge family, who continue to expand the business and the gardens, the center focuses on bamboo plants and bamboo products. With strong ties to Indonesia, it is the largest supplier in Europe of plywood constructed of bamboo (Plyboo), a major new product internationally. Contact directly to inquire about business hours, new bamboo products, and bamboo events. Brochure available.

Bambus-Centrum Deutschland
Baumschule Eberts
Saarstrasse 3–5
Baden-Baden 76532, Germany
☎ (07221) 50740
Bamboo is only a part of the Eberts's nursery and landscape business, but a major part, indeed. Contact them directly to inquire about business hours and the frequently scheduled bamboo festivals and craft events. A color catalogue (in German) is available at a cost of US$10.

La Bambouseraie-Prafrance Generargues
30140 par Anduze, France
☎ 04 66 61 70 47
There are few bamboo gardens, even in Asia, to rival the Bambouseraie, in the southeast of France. Eugene Mazel introduced bamboo to the region in the nineteenth century, and his original site is still maintained by Muriel Crouzet and her husband, Yves. With a crew of 35, they nuture 150 species of bamboo in the midst of plantings of giant sequoias, chestnuts, tulip trees, and rare plants from Asia. Extensive clumps of bamboo create a forestlike setting for walking trails, bamboo festivals, and an Asian village. The 30-acre park is open to the public from March to December, and any visit may unexpectedly include a concert presented on bamboo instruments, an international bamboo meeting, or a bamboo-craft demonstration. A small museum-shop offers additional information and historical notes about bamboo and bamboo ware. Easily accessible from both the Nimes or Montpellier airports.

A color catalogue is available in English or French for a fee. Yves Crouzet has also written a hard-bound book, also available in English or French with exquisite color photograph . Call for details about all publications and special events.

Royal Botanic Gardens, Kew
Richmond, Surrey
TW9 3AB, England
☎ (020) 8332-5000
WEBSITE: www.rbgkew.org.uk
The original bamboo garden was laid out in 1891, inspired in part by Freeman-Mitford (see Freeman-Mitford's *The Bamboo Garden* in the bibliography). Expanded in 1978, the collection continues to reflect the enthusiasm and contributions of several dedicated staff members and benefactors, such as Peter Addington. In addition to the Bamboo Garden, bamboo is located in the Grass Garden, the Palm House, and the Temperate House as well. The extensive collection reflects the garden's long history of research in bamboos, especially those from the Old World.

BOOK SOURCES

There are several worldwide bookstore chains where publications on bamboo can be found or ordered. The Japanese chain Kinokuniya is located in many major cities around the world and can order in-print books published in Japan, as well as publications with Asia as the primary topic. In addition, there are two other notable sources available to the bamboo audience.

ABS Bookstore
Gerald "Stinger" Guala
Fairchild Tropical Garden, The Herbarium
11935 Old Cutler Road
Miami, FL USA 33156

Bambus Buch
Skalitzer Strasse 43
D–10997 Berlin, Germany
☎ (030) 618-8842
This bamboo book list is published as one part of a large bookseller's list and includes an extensive collection of books devoted to bamboo. Not limited to German and English-language books.

NOTES

INTRODUCTION

1 The book I saw originally, *How to Wrap Five More Eggs: Traditional Japanese Packaging*, is now joined by several Japanese-language versions by the same author, Oka, and several books on contemporary Japanese package design.

2 Jacknis offers a succinct summary on the impact of Morse's writings in *Getemono*, 2–4. See also, Moes, "The Men Who Brought Us *Mingei*" in *Mingei*, 19–25.

CHAPTER 1

1 Chamberlain, *Japanese Things: Being Notes on Various Subjects Connected with Japan*. 5th revised edition, 57.

2 Dorson, *Folk Legends of Japan*.

3 *We Japanese*, Vol. 2, 184–85.

4 Matsuo Basho, *Narrow Road to the Deep North*.

5 In McAlpine's *Japanese Tales and Legends*, several stories feature bamboo. Others use bamboo as an illustration.

6 Thanks to Sue Cassidy Clark for introducing the author to *The Taiheiki: A Chronicle of Japan*. Trans. by McCullough.

7 Ibid., chapter 1, 25.

8 Ibid., chapter 2, 49.

9 Ibid., chapter 3, 90.

10 *Bahan*, 10.

11 In *Houses and People of Japan*, Taut describes these scenes from a 1937 perspective, adding new insights.

12 Analyzing art to evaluate culture is not a new approach, but Hibi's *Pastimes* is particularly effective.

CHAPTER 2

1 There is extensive international documentation on this topic in both popular and scholarly publications, though it should be noted that much disagreement over classifications and measurements still exits. The author relies heavily on the writings of Ueda Koichiro. See in particular: *Tanko*, 1995, 15–27; "Varieties of Bamboo," 209–16 in Takama, *The World of Bamboo*. See also *Bahan*, 1993, "Take no Zukan," 18–22; Ranjan, *Bamboo and Cane Crafts of Northeast India*, 1986, 19–26; and Suzuki, *Index to Japanese Bambusaceae* 1978. For a recent European perspective, see Crouzet, *Bamboos*, in both English and French editions.

2 The IBC and INBAR are doing much to encourage such research. See chapter 6.

3 *Shiga-ken Dentoteki Kogeihin*, 27.

4 Ranjan, 24.

5 Ueda refers to this in "Varieties of Bamboo," in Takama's *The World of Bamboo*, 209, and notes that *madake* was flourishing within ten years after flowering.

6 Bushell, *The Art of Netsuke Carving*, 55.

7 Ranjan, 23.

8 *Shiga-ken Dentoteki Kogeihin*, 25.

9 Many craftspeople use the terms *processing* and *curing* interchangeably.

10 There are many documents describing these practices, but none seem to be so frequently used as Sato Shogoro's *Zusetsu Take Kogei*.

11 Videos, *Meichiku* (Special Bamboo) and *Bamboo is Life and a Philosophy*.

12 Watanabe and Takano, "On the Polishing Process of Precious Kyoto Bamboos," from *Fuji Chiko-rui Shokubutsu-en Hokoku* (The Reports of Fuji Bamboo Garden), No. 37, 71–78, in Japanese.

13 Takano Tadao, personal interview, Kyoto, January 1996.

14 Sato, *Zusetsu Take Kogei*, 37.

15 Suzuki, *Index to Japanese Bambusaceae*, 12 and 80, and Ueda in Takama, 210.

16 Ueda, in Takama, 210.

17 See Austin and Ueda, *Bamboo*, 207. E-mail correspondence with Kagata Junji of the Takehei Company in Kyoto confirms this information and provides more details, as does the video he made available, produced by Kyotofu Rinmu ka. See also Suzuki, 12.

18 The term "chemical mud" is popularly used. See Ueda, *Take to Jinsei*, 87. Documented in English in Austin and Ueda, 207, and confirmed by numerous interviews.

19 Ueda, in Takama, 210.

20 Video produced by Kyotofu Rinmu ka.

21 Satow, in *The Cultivation of Bamboos in Japan*, identified this natural occurrence as *shikaku-dake*, 11. Fairchild, in *Japanese Bamboos*, cites *Bambusa quadrangularis, Fenzi*. Dr. Ueda identified this as *Chimono bambusa quadrangularis*, cited in Marden, in *National Geographic*, October 1980, 521. Others use different terminology, but the point remains the same—the natural occurrence of squared bamboo does not meet the demand.

22 Ueda, *Take to Jinsei*, 86–87, and in English read Austin and Ueda, *Bamboo*.

CHAPTER 3

1 Moeran writes eloquently of this community. See especially his *Lost Innocence: Folk Craft Potters of Onta, Japan*. For a history of this ceramics community, see Inumaru and Yoshida, *The Traditional Crafts of Japan: Ceramics*, Vol. 3. In his painting "Old-Style Mortar," Taiji lovingly and accurately portrays this region's craft. See *The World of Taiji Harada*.

2 Nishi, *What Is Japanese Architecture*, 49–52.

3 See Judge's introduction in *Edo Craftsmen*, a passionate tribute to *shokunin* supported by the photographs of Hiroyuki Tomita.

4 See the exhibition catalogue, McCarty and McQuaid, *Structure and Surface: Contemporary Japanese Textiles*, and Nuno's own publications. The videos *From Basho to Spun Steel* and *Textile Magicians* introduce other contributors to contemporary and traditional textiles.

5 Mr. Hiroshima, the focus of Cort and Nakamura's *A Basketmaker in Rural Japan* (both book and video), relates a touching view of the life of traveling craftsmen, self-taught basket makers, and non–first-borns in the rural community.

6 Next door to the laboratory is Japan's leading bamboo training school established by the local Department of Labor.

7 See Smith and Harris, *Japanese Decorative Arts from the 17th to 19th Centuries*.

8 See Jacknis, *Getemono*.

9 Yanagi, *The Unknown Craftsman*, 103.

10 There is extensive documentation discussing Yanagi and *mingei*. See Hauser's succinct "*Mingei* and Japanese Society" in Moes, *Mingei: Japanese Folk Art*, 11–17. From the Japan Folk Crafts Museum itself, see *Mingei: Two Centuries of Japanese Folk Art*, as well as Yanagi's own writings, in particular, *The Unknown Craftsman*, adapted from the Japanese by Leach. In contrast, read Kikuchi's "The Myth of Yanagi's Originality: The Formation of *Mingei* Theory in Its Social and Historical Context," in *Journal of Design History*, Vol. 7, No. 4, 247–66, and the writings of Moeran.

11 The most accessible summary of governmental support for the arts can be found in Durston's introduction to the Japan Craft Forum's *Japanese Crafts* (previously *Japan Crafts Sourcebook*). In Japan, see the English-language introduction to the Japan Traditional Craft Center's own *Traditional Crafts of Japan*, a 54-page pamphlet with illustrations of all 184 designated crafts.

12 The seventeen-volume series, *Nihon no Isho* (*Japanese Design in Art*) is an excellent resource. Each volume has a singular focus, e.g., Volume 1, *Genji Monogatari* ("Items from the *Tale of Genji*"), in which many craft items are seen.

13 In *The Compact Culture*, Lee writes of *mon* as an example of Japanese miniaturization. See the Bibliography for publications on *mon* and Japanese design.

CHAPTER 4

1 *Japanese Crafts* (previously *Japan Crafts Sourcebook*) by the Japan Craft Forum, and Inumaru and Yoshida's *The Traditional Crafts of Japan* offer an easily accessible, English-language description of several distinctive basketry styles, including those based in Beppu and Shizuoka.

2 Unfortunately, the great sources for such technical information are only in Japanese and not readily available. The Industrial Craft Laboratory manual is difficult to obtain. It is possible to order Sato's *Zusetsu Take Kogei*. Several regional chapters of the American Bamboo Society have sought to remedy this shortage of technical information in English and have formed strong ties to bamboo companies in Japan. Kagata Junji of Take Hei in Kyoto has been especially forthcoming by establishing an English-language website at <web.kyoto-inet.or.jp/people/takehei>.

3 Faulkner credits the great basketry artist Iizuka Rokansai with applying this system of formal, semiformal, and informal styles to basketry. See Faulkner, *Japanese Studio Crafts*, (91–92). Castile, in the classic *The Way of Tea*, 45, expands on the history of this terminology and places it in the context of the tea ceremony. See also Oster, *Bamboo Baskets*, 70.

4 The personal basket collection of Lloyd Cotsen includes many examples of ikebana basketry, all beautifully documented in the publication *Bamboo Masterworks* and in the more readily available *Containing Beauty* by McCallum and *Contemporary Japanese Bamboo Arts* by Coffland.

5 Video, "Chikugei."

6 Shono's thoughts on apprenticeships and other related issues are beauti-

fully recorded by Adachi in *The Living Treasures of Japan*, 56–59.

7 See Coffland's introduction in *Contemporary Japanese Bamboo Arts*.

8 There are several quality publications dedicated to discussions about Living National Treasures. For views that focus on basketry and place it in a larger historical context, see *Bamboo Masterworks* and Coffland, *Contemporary Japanese Bamboo Arts*.

9 The popularity of the Cotsen collection and the resulting books by Cotsen and Coffland have increased the visibility of these fine craftspeople both in Japan and abroad.

10 See Faulkner, *Japanese Studio Crafts*, 98–101, and Koplos, *Contemporary Japanese Sculpture*, 55–56.

CHAPTER 5

1 Itoh (with Tanaka and Tsune) describes these terms with some clarity in *Wabi, Sabi, Suki: The Essence of Japanese Beauty*. For a different perspective, see Koren, *Wabi-sabi*. Most publications on the tea ceremony, especially those that include commentary about Rikyu, include some information about the *wabi* aesthetic.

2 See Richie, "A Vocabulary of Taste," *House & Garden*, 20–22.

3 In completing this initial description of the tea ceremony, I must give credit to Ronald Otsuka, curator of Asian art at the Denver Art Museum. His unpublished lectures and small catalogs on the Lutz Collection have greatly influenced my view of bamboo's contribution to the overall atmosphere of the tea ceremony environment.

4 *Chanoyu Quarterly: Tea and the Arts of Japan* is an excellent source of information on the tea ceremony from the Urasenke School perspective, including details about utensils. There are many other English-language documents as well. For a brief summary, see *Japan: An Illustrated Encyclopedia*, 1535–39. See also Castile, *The Way of Tea*, and Okakura, *The Book of Tea: A Japanese Harmony of Art, Culture and the Simple Life*.

5 *Crafts 100*, 136.

6 Ikeda, "Appreciating Tea Scoops," *Chanoyu Quarterly*, No. 54, 10.

7 See Fontein and Hickman, *Zen Painting and Calligraphy*, for a complete historical presentation with emphasis on Chinese influences.

8 Addiss, *The Art of Zen*, 9.

CHAPTER 6

1 Dunn cites from Sansom, *A History of Japan, 1615–1867*. London: The Cresset Press, 1964. The author, being unable to locate a copy of this older work, cites from Dunn, *Everyday Life in Imperial Japan*, 69.

2 Farrelly, *The Book of Bamboo*, 261, and Yoshikawa, *The Bamboo Fences of Japan* (131–32). Yoshikawa's contribution to English-language information on the subject is invaluable; the combination of photographs, text, and diagrams is unparalleled outside Japan.

3 Kahlenberg, *A Book About Grass: Its Beauty and Use*, 109.

4 Yoshikawa, *The Bamboo Fences of Japan*, 133–36.

5 Japanese Garden Research Association, *Create Your Own Japanese Garden*, 44–46.

6 There are many publications about traditional construction techniques for dwellings in Japan, none more complete than those translated from the writings of Kawashima Chuji. Especially easy to locate is *Japan's Folk Architecture* (previously *Minka: Traditional Houses of Rural Japan*). Less easily found, but worth the effort, is Itoh's *Traditional Japanese Houses*, with a particularly succinct introduction. Cross-cultural references to architectural styles and techniques are also readily available. See especially Piper, *Bamboo and Rattan*, and Anderson, *Plants and People of the Golden Triangle*.

7 See all of Katoh's publications, but especially *Japan Country Living*, 82–87, for the focus on restoring and living in *minka*.

8 My understanding of bamboo enterprises has been substantially expanded by contact with Takehei Bamboo Corporation and Nakagawa Bamboo Materials Corporation in Kyoto, Torado Inc. in Kamakura, Iwao Chikuran and Mr. Ohkuma in Beppu, and Taketora in Shikoku.

9 Itoh, *Traditional Japanese Houses*, 175.

10 Statler's *Japanese Inn* is a must-read for anyone interested in life in Japan. This comment regarding space and the art of living in Japan comes from Katoh, *Japan: The Art of Living*, 7–8.

11 Inax Gallery, in Tokyo and Kyoto, mounted a small but impressive exhibition in 1987 devoted to the use of bamboo in architecture and gardens. The accompanying video and Inax booklet, *Take to Kenchiku*, Vol. 6, No. 4, were made widely available and did much to expand the public's knowledge about bamboo. Inax booklets remain in print.

12 Iannacci, *Shoei Yoh: In Response to Natural Phenomena*, 115. Two chapters devoted to the Naiju Community Center and Nursery School, and the Uchino Community Center for Seniors and Children, respectively, detail the use of bamboo and the local craftsmen's contribution to the projects.

13 There is a great body of international research on this topic, and architects and builders worldwide will benefit from the work of Walter Liese, Jules Janssen, Oscar Hidalgo López, and work done at the University of Stuttgart's Institute for Lightweight Structures.

CHAPTER 7

1 Koizumi writes with great humor about the enormity of analyzing Japanese furniture in *Traditional Japanese Furniture*, 9–13.

2 Drawing heavily on Lafcadio Hearn and Berthold Lauder, Lisa Gail Ryan has pulled together an interesting presentation on this topic in *Insect Musicians & Cricket Champions*.

3 Ronald Otsuka of the Denver Art Museum has written an unpublished paper on the subject of bamboo as food and presentation packaging that was presented at the Japan Society, New York City, in April 1998.

4 Elizabeth Andoh writes and lectures extensively about food in Japan. One theme of her presentations is the role of *shun*, seasonality.

5 Regional publications and local news broadcasts often cover sea-vegetable gathering, but *Serai* magazine has especially astute coverage. Back issues are often available at the better used bookstores in Japan.

CHAPTER 8

1 Cited in *Tokubetsu Ten, Ukiyo-e no Bi*, 70–74.

2 Meech, *Rain and Snow: The Umbrella in Japanese Art*, 47.

3 The Japan Craft Forum's *Japanese Crafts* includes a one-page summary on unbrellas, 176.

4 *Sakaida Eikichi no Janome-gasa* (Designed Oiled Paper Umbrella by Eikichi Sakaida), 54.

5 *Japan Crafts Sourcebook*, 176, and *Tokubetsu Ten, Ukiyo-e no Bi*, 55.

6 Ibid.

7 Yabushita, "History and Production of the Japanese Umbrella" in Meech. Yabushita maintains that this description (and his) describe the particular multiple-site system of Gifu, but that the Edo-style umbrella was often a one-person or family operation.

8 The video *Densho, Bushi ga Sodateta Gifu Gasa* captures with its close-up shots the difficulty of this process particularly well. For a step-by-step English account of the umbrella-assembly process, read Yabushita, 22–35.

9 *Dento Kogei hin, Shumi no Kasa.*

10 Yabushita describes those used for *janome*, *maigasa*, and tea-ceremony umbrellas, 32.

11 Yoshida, *The Culture of Anima*, 41. See also 128, in which the author further supports his thesis by describing an open umbrella as the center of the cosmos, with flowers as an extra incentive for *kami* to reside there.

12 Yabushita, in Meech, 21, Figure 13.

13 Ibid., 21, 23, Figure 14.

14 Ibid., 21, 23, Figure 15. See also *Tokubetsu Ten, Ukiyo-e no Bi*, 70.

15 Ibid., 21, 24, Figures 16a and 16b, 36. See also, *Tokubetsu Ten, Ukiyo-e no Bi*, 70.

16 Yanagi, *The Unknown Craftsman*, plates 50, 52–53.

17 Earle, in Dorrington-Ward, 38.

18 Schiffman, *Japan: The Land of Fans*, 2.

19 Schiffman, 4. See also, Earle in Dorrington-Ward, 41. Several authors make a similar historical observation regarding the military fan's evolution but use the term *gun-sen* in their texts. Salwey 14, and Schiffman, 15.

20 *Crafts 100*, 179. See the more readily available *Japan Crafts Sourcebook*, 178–79.

21 Inumaru, Vol. 7, 156.

22 Ibid., 156–57.

23 Salwey. *Fans of Japan*, 5–6.

24 Ibid., 67.

25 Ibid., 67

26 Stephan, "Sacred Symbols: The Decorations of the New Year," in Brandon and Stephan, *Spirit and Symbol: The Japanese New Year*, 47.

27 Yoshida, *The Culture of Anima*, 36–37, text on 127.

28 Lee, 36.

29 Inumaru, Vol. 7, 154–55.

30 Ibid., 154

31 "The Folding Fan," *The East*.

32 *Rakugo in English!* Performance by Katsura Shijaku at the University of Hawaii, June 2, 1996.

33 "Miyawaki-baisen-an, Folding Fan/*Sensu*" in *Ima Shokunin-Tachi wa* (Craftspeople Now), 52–53.

34 Hutt and Alexander, *Ogi: A History of the Japanese Fan*, 17.

35 Lee, 37. For Lee, the folding fan is but one example in his thesis that the Japanese have a "propensity for making things smaller," 31, and a history of using folding as a means of doing so, 39.

36 See especially Lane, *Images from the Floating World*.

CHAPTER 9

1 I was delighted to find several publications that acknowledge both the strong work ethic in Japan and the sense of play. See *Asobi* from the Katonah Museum of Art, as well as Hibi's *Pastimes*, in both Japanese and English.

2 Wang, *Chinese Kites*, and Ha, *Chinese Artistic Kites*. Both publications offer historical information on the relationship between Chinese and Japanese kites.

3 "*Nihon no Dento Tako Shishitachi*," the recent video by Dentsu about traditional Japanese kites shows not only the craftsmanship of kite-making but also the exuberance of kite contests.

4 Streeter, *The Art of the Japanese Kite*, 124.

5 Ibid., 159.

6 Ibid., 157. This point is repeated in many publications. See in particular Brandon and Stephan, *Spirit and Symbol: The Japanese New Year*, 36, and Yoshida, *The Culture of Anima*, 119, 134–35;

7 Vilhar, *Matsuri*, 119.

8 See Baten's *Playthings and Pastimes in Japanese Prints* for a brief introduction to the place of toys and dolls in ritual, 13–19. See also the English introduction to *Japanese Folk Dolls and Toys*, Vol. 3 of the four-volume series, *The Doll: Dolls of Japan and the World*.

9 See Gribbin for an interesting account of this historically significant doll.

10 Saint-Gilles, *Mingei*, 66–67.

11 Sato, *Japanese Angler*, 7–9.

12 Ibid. This older publication, often found only in libraries, offers a clear summary of fishing in Japan. For example, see pages 16–22, for strategy.

13 The movie *Village of Dreams* beautifully captures childhood on Shikoku Island, in the late 1940s, where local fishing was a favorite activity.

14 This summary is based largely on *Crafts 100*, 130–31.

15 Hoagy B. Carmichael is the best known of these American pole makers. See Marden, *National Geographic*, Oct. 1980, 524–25.

16 Sato Minoru, personal interview, spring 1996.

17 Sato, *Japanese Angler*, 9.

18 See Cort and Nakamura, *A Basketmaker in Rural Japan*, for a detailed description of one basket maker's contribution to his community. His work includes a wide range of baskets for live fish and traps for fish, river crabs, eel, carp, and more.

19 This book is part of Kodansha International's series, *Form and Function*. Long out of print, it is extremely difficult to find. The clear black-and-white documentation photographs are supported by text at the end of the publication.

20 Elizabeth Andoh, unpublished lecture, Japan Society, February 1, 1999.

21 Baten, *Playthings and Pastimes in Japanese Prints*, 39.

22 Ibid., 53.

23 Brandon and Stephan, 38–39.

24 Massy, *Sketches of Japanese Crafts*, 178.

CHAPTER 10

1. Hori, *Folk Religion in Japan*. Preface, 10.

2. The way the public views *kami* has changed over the centuries. For a complete discussion, see *Kami*, published by the Institute for Japanese Culture and Classics.

3. Community bonding is identified as a key element in festival participation and is cited in both scholarly and popular publications. In English, see in particular Vilhar, *Matsuri: World of Japanese Festivals*, and the scholarly *Folk Beliefs in Modern Japan*, 178.

4. Kodansha's *Japan: An Illustrated Encyclopedia* offers a succinct listing under the entry "festivals," 362–63.

5. There is no English-language publication more complete in its description of New Year's in Japan than Brandon and Stephan's *Spirit and Symbol: The Japanese New Year*. For an older interpretation, look in the library for the leaflet by Gunsaulus, *The Japanese New Year's Festival, Games and Pastimes*, Helen Field Museum.

6. Although Brandon writes of five grains in *Spirit and Symbol*, 25, Gunsaulus, 29, writes instead of the *Go-sekku*, a series of five festivals, the first of which begins on January 7.

7. See Picken, *Shinto: Japan's Spiritual Roots*, 12.

8. See Booth, *Devils, Gods and Cameramen*, as well as *Looking for the Lost: Journeys Through a Vanishing Japan*, 91–94.

9. Kishibe, in *The Traditional Music of Japan*, writes in detail about these instruments. See especially pages 28 and 32.

10. Levenson, *Tai Hei Shakuhachi*. The author's updated sourcebook includes historical information and construction details, as well as a catalogue of flutes.

11. Ibid. See also, Kahlenberg, *Grass*.

12. Ibid. Levenson offers a particularly clear description of the difficulties of selecting bamboo for *shakuhachi*.

13. In *Japanese Folk Festivals Illustrated*, 167–71, Haga includes several pages devoted to just such instruments. The photographs enrich the presentation for those unfamiliar with these older instruments.

14. The 1998 Japan Society exhibit, "Japanese Theater in the World," included some interesting displays of these and other instruments used in festivals, many pictured in the catalogue.

15. *Japan: An Illustrated Encyclopedia*, 772–73.

16. Sollier, *Japanese Archery: Zen in Action*, 9, and *The East*, Vol. XIX, No. 5/6, 1983, 68–71.

17. Sollier, 1983.

18. *Japan: An Illustrated Encyclopedia*, 868. This publication offers excellent summaries on varied topics about Japan.

19. Schilling, *Sumo: A Fan's Guide*, 125.

20. *Crafts 100*, 157.

21. *Kyushu no Dentoteki Kogeihin*, 52–53.

22. Ibid., 53.

23. Ibid., 51–53. The chapter on the bows of Miyakonojo describes the history, production, and future of this craft. Though the text is in Japanese, the photographs alone can impart considerable information. In Japanese, see also *Nihon no Dento Kogei: Chikko-hin. Japan Crafts Sourcebook*, 109, offers a summary description of these bows and their history.

24. See chapters 3 and 4 for more information about the significance of this designation.

25. *Nihon no Dento Kogei: Chikko-hin*, 8–20.

26. Specifics regarding number of boards, type of wood, and glue vary from one text to another and often reflect regional differences. For example, Sollier cites three pieces of bamboo joined to two of mulberry and held by fish glue. In *Kyushu no Dentoteki Kogeihin*, four to seven pieces of bamboo are joined to sumac with deerskin glue, and in *Nihon no Dento Kogei: Chikko-hin*, three to nine layers are joined to two of sumac, again with deer glue. The process remains essentially similar.

27. I was able to confirm this information after witnessing several demonstrations of bow making over the years. The NHK video on making bows in Miyakonojo further illustrates the more individualized tools craftsmen design and use over the years. The jig, wooden forms, and individual calipers are especially important.

28. "*Kyudo*: Unique Art of Japanese Archery," *The East*.

29. Kaemmerer, *Trades and Crafts of Old Japan*, 104.

30. Sollier offers a straightforward summary of bow-and-arrow construction, 36–37. The TVK program produced by Kanagawa Education Department confirmed the technical information and places the craftsman in the context of his community.

31. Kaemmerer, 106. Kaemmerer's description of both the arrowsmith and the quiver shop is succinct.

32. Yoshida, *The Culture of Anima*, 133. See also Brandon and Stephan, *Spirit and Symbol*, 15, 43, and 45.

33. Taut, *Houses and People in Japan*, 196.

34. Sollier, 26.

35. Most publications dealing with *matsuri* in Japan make some reference to the role of bows and arrows. See especially Haga, *Japanese Folk Festivals Illustrated*; Anderson and Vilhar, *Matsuri*; Brandon and Stephan, *Spirit and Symbol*; and small publications devoted to specific festivals, such as *Aoi Festival Kamo-shi* and *Jidai Matsuri*. Vilhar's photographs make a powerful statement about the contemporary significance of these rituals.

36. Sollier, 86.

37. Vilhar, 12, and Picken, 67.

38. See *Aoi Festival Kamo-shi*, 34, and Vilhar, 12, 59.

39. Sollier, 26.

40. Reiko Brandon gives a concise description of these designs, well illustrated with a wide selection of kimono, in *Bright and Daring*, 24–31.

41. Dower, *The Elements of Japanese Design*, 102–4. This presentation of archery items in family crests is particularly thorough.

42. Baten, *Playthings and Pastimes in Japanese Prints*, 79.

43. Ibid., 18.

44. "The Art of the Sword," *The East*, Vol. III, No. 3, 1967, 30. This article is taken from the first book in English about *kendo*; Sasamori and Warner, *This Is Kendo*.

45. *Japan: An Illustrated Encyclopedia*, 772–73. This volume provides clear summaries of the history of both *kendo* and *kyudo*.

46. *Shigaken Dentoteki Kogeihin*, 23.

47. Sasamori and Warner. The primary source for the summary written here, *This is Kendo* includes a solid description of the evolution of *kendo* and its equipment.

48. Ibid., 38.

Afterword

1 See *Bamboo and Its Use* in particular, but all INBAR publications and *IL 31* as well.

2 Ibid. Janssen, 96.

3 Liese, *The Anatomy of Bamboo Culms*, 167.

4 See *Bamboo Masterworks*; Coffland, *Japanese Contemporary Bamboo Arts*; and McCallum, *Containing Beauty*.

5 Hibi, *Pastimes*.

Sources for Observation and Research

1 There are many references commonly available on this topic, including those listed in the bibliography of this book. See especially: Hsiung, in *The Journal of The American Bamboo Society*, 168–78. Marden, Luis, in "Bamboo: The Giant Grass," *National Geographic*, and Dunkelberg, *IL 31*, 51.

2 *Bambou*, No. 24, 4.

3 Freeman-Mitford, *The Bamboo Garden*, 4–5, 12–13.

4 Acknowledged as the authority on this field of historical research, Woods is often asked to address international bamboo meetings. Little of his extensive knowledge has found its way into the English literature, though it has been published in French and Flemish in the Belgian Bamboo Society Newsletter of 1994. Personal communication, 1997.

5 *Design Diffusion News*, No. 34, cover and 58–59.

6 *American Bamboo Society* (brochure).

7 Opincar, Abe. "Quail Gardens Spectacular Collection," *ABS Newsletter*, Vol. 17, No. l, 10–13. and *Quail Botanical Gardens* (brochure).

8 *Pacific Northwest Bamboo Newsletter*, Vol 11, Issue 4, 3 pages.

9 *The International Bamboo Association* (brochure), July, 1993.

GLOSSARY

ABS American Bamboo Society

abura nuki removal of oil; when applied to bamboo, part of the processing procedures. *Also abura nugu*

ajiro complex twill weave basketry pattern often associated with Beppu-style basketry

ajiro-gaki twill weave fence style that incorporates a diagonal weave pattern from basketry

akari light; also the name of the paper-and-bamboo sculptural lights designed by Isamu Noguchi

akebia vine used in Japanese basketry and for lashing

Akita northern region/prefecture of Japan known for beautiful bark crafts

amada ceiling lattice in *minka*; often constructed with bamboo

amagatsu one of Japan's earliest dolls; torso and arms of bamboo

amiboshi net pattern copied in fence design

Aoi Matsuri a spring festival in Kyoto that boasts one of the most beautiful processions in Japan

asobi "play" or "playful"

bangasa a style of simple umbrella

barren a tool used in woodblock printing; cover is made of bamboo sheath

bi "beauty"

bijutsukan art museum

Bizen one of the great ceramic kiln sites in Japan

bon-odori outdoor dancing associated with the summer festival, *obon*; varies from region to region

bonsai miniaturization of trees by artful pruning and other size-inhibiting techniques

bonten tall pole ornament for festival parades

Boryana form of *nigra* bamboo with cloudlike markings; in Japanese, *Tanba-hanchiku*

bugaku traditional court music and dance

bunjinga literati painting in the eighteenth and nineteenth centuries

bunraku traditional puppetry

byobu folding screen used to divide interior spaces

cha tea; used in compound words such as *o-cha* (green tea) and *cha-no-yu* (tea ceremony)

chabana arranging flowers for tea ceremony

chado the Way of Tea; one of several terms for the tea ceremony

chanoyu the tea ceremony; literally "tea's hot water"

chasen bamboo tea whisk used in the tea ceremony to bring traditional green tea to a froth

chashaku tea scoop; usually carved from bamboo

chawan tea bowl for the tea ceremony

Chiba prefecture to the east of Tokyo located on the Boso Peninsula

Chiba Ayano (1889–1980) weaver and dyer who was named Living National Treasure in 1955

Chiba ladies affectionate nickname for elderly vegetable gardeners who can still be seen hauling the produce to market from their Chiba Prefecture homes on the early-morning Tokyo-bound trains

chiku bamboo

chisa wood preferred for the non-bamboo elements in traditional umbrellas

chochin paper-and-bamboo lantern, usually collapsible

chukei one style of fan used in *noh* drama

culm main vertical element in bamboo

daikon long white radish essential to Japanese cuisine

daimyo feudal lords and landowners

dake see *take*

ebidome buchi elaborate lashing pattern used on trays woven in Beppu; resembles a shrimp (*ebi*) for which it is named

ebira boxlike quivers for arrows

EBS European Bamboo Society

Echizen (1) region that makes one style of bamboo dolls; (2) region known for its traditional ceramics

edamame boiled soybeans; a favorite summer snack

Edo (1) older name for what is now called Tokyo; (2) refers to the historical period from 1615–1867

emaki a single painting or a series of paintings rolled up in a scroll; also *emakimono*

engawa veranda

enteki archery (*kyudo*) tournament in which there is long-distance shooting at a target

fude brush for traditional calligraphy and ink painting, often having a bamboo handle

fudesake brushtip

Fujiwara the historical period also called Heian from 794 to 1185

fukusa small, square silk cloth used for wiping in tea ceremony

furoshiki large square of fabric used for bundling objects for easy carrying

furusato place of one's birth; very important in Japan

fushi node on bamboo; at that site a membrane crosses the interior

fusuma sliding door made of paper and wood frame, which is often decorated

futaoki lid rest used in tea ceremony

gaijin Japanese word for "foreigner"

getemono ordinary handmade items

Gifu (1) city in central Japan known for high quality umbrellas and lanterns; (2) Gifu Prefecture

Gion Matsuri a summer festival in the Gion section of Kyoto

gohei paper amulets

goma dake bamboo with markings resembling sesame seeds

Gosho-uchiwa one style of flat fan associated with Kyoto

gyo semiformal style; one of the terms used to classify ancient calligraphy and basketry; see also *shin* and *so*

hachiku common Japanese name for *Phyllostachys nigra* f. *henonis* bamboo

hade aesthetic term meaning flashy

Hagi one of the great ceramic kiln sites in Japan

Hakata-ningyo ceramic dolls associated with the Fukuoka (Hakata) area of Kyushu

Hamada Shoji (1894–1978) internationally famous potter and friend to Yanagi Soetsu and Bernard Leach

Hamamatsu town in Shizuoka; famous for its kite competition

hamaya arrows with white feathers purchased at shrines at the new year to ward off evil

hana ire flower vase for tea ceremony

hariawase the complex assembly process of gluing, wedging, shaping traditional bows for archery

hashi (1) chopsticks; (2) bridge

hashi oki chopstick rests; made from various materials including ceramic, wood, bamboo, and lacquer

hatsumode first visit to the shrine in the new year

hazenoki a type of sumac wood preferred for bamboo bow construction

Heian the historical period from 794 to 1185

Heian-kyo the earlier name for the city now called Kyoto

hibachi charcoal heated grill; used for food preparation and to heat bamboo for oil removal

Hideyoshi see Toyotomi Hideyoshi

higashi sweets served at the tea ceremony

Hina Matsuri Doll Festival or Girls' Day celebrated on March 3

hi-ogi one style of folding fan made from Japanese cypress

hirae-uchiwa flat fan associated with *marugame* in Shikoku

hishaku water ladle for tea ceremony

hizarashi technique for removing oil from bamboo

Hokkaido northern island of Japan

Hokusai Katsushika (1760–1849) internationally known *ukiyo-e* printmaker known for his woodblock prints and humorous sketches

hotei chiku common name for *Phyllostachys aurea* bamboo; also called "fish-pole"

IBA International Bamboo Association

iemoto literally, "head of the house"; business term for head of such large traditional organizations as tea-ceremony and flower-arranging schools

Iizuka Rokansai (1890–1958) famous basket maker of the early twentieth century

Iizuka Shokansai (b. 1919) son of Iizuka Rokansai; named Living National Treasure in 1982

ikebana formalized flower arranging

INBAR International Network for Bamboo and Rattan

jakago "snake basket"; woven bamboo tube filled with rocks in water gardens

janome umbrellas with snake-eye design

jimi aesthetic term meaning understated

kabuki Japanese theater with all-male cast involving narration and dancing, as well as elaborate costumes and makeup

kadomatsu "Pine Guardians" or "Guardians of the Gate"; pine and bamboo ornaments seen only at New Year's; also called *matsu-kazari*

kago (1) basket; (2) old traditional palanquin

kakemono scroll paintings

kakkome (1) bamboo rakes decorated for the *tori-no-ichi* festivals in November; (2) the cry "*kakkome, kakkome*" of the festival vendors

Kamakura (1) historical period from 1185 to 1333 (2) beautiful city just south of Tokyo that was the military heart of Japan during the Kamakura period

kami the divine spirits or "gods" in Shintoism; now, most often refers to the "good spirits" that one solicits

kamidana household altar

kamon family crests; also called *mon*

kana Japanese syllabary; often combined with *kanji*

kanji Japanese written characters based on Chinese system

Katsura-gaki style of fence copied from the great example at Katsura Imperial Villa

Katsura Imperial Villa villa of a seventeenth-century prince recognized today as one of the finest specimens of the *sukiya-zukuri* style of architecture, and known among Western architects for its architectural richness, use of natural materials, and *wabi*-influenced teahouses

Kawai Kanjiro (1890–1966) famous potter and friend to Yanagi Soetsu

kawatake common name for *Pleioblastus simonii* bamboo; also called *medake*

kendama ball and cup game; sometimes made of bamboo

kendo "the way of the sword"; traditional fencing now practiced as a martial art

Kenninji-gaki screening fence style named after the Kenninji temple in Kyoto

kogei crafts, but with an industrial connotation

kogo small incense container

koinobori banners of carp (*koi*) design; flown on Children's Day

kokeshi tall, cylindrical wooden doll with details painted onto surface; vary greatly from one region to another

kokiriko bamboo dance batons used in festival parades

koto traditional Japanese harp; played horizontally

kumade bamboo rake; decorated for *tori-no-ichi* festivals in November

kumihimo traditional braided cord used to tie boxes and baskets

kurochiku common name for *Phyllostachys nigra*; also called "black bamboo"

Kyo sensu folding fans associated with Kyoto

Kyo uchiwa traditional, flat fan made in Kyoto

Kyo yumi the lacquered bow (archery) from the Kyoto area

kyudo "the way of the bow"; traditional archery

Kyushu southern Japanese island known for large stands of bamboo

madake *Phyllostachys bambusoides*, the single most important bamboo in Japan

Maeda Chikubosai II (b. 1917) famous basket maker of the twentieth century; designated a Living National Treasure in 1995

maigasa dance umbrella; sheer cover allows the audience to see the facial expressions of the dancer, and allows the dancer to see as well

Marugame one style of flat fan (*hirae-uchiwa*) is associated with this area of Shikoku Island

maru higo round cut bamboo elements used in cricket and bird cages and some basketry

matcha green tea that was introduced to Japan from China in the twelfth century; now used primarily in the tea ceremony

matoi fireman's standard; traditionally used at fires to identify each fire brigade; now used in festivals and processions exclusively; also, design motif

matsu-kazari see *kadomatsu*

matsuri festival

medake common name for *Pleioblastus simonii* bamboo; also called *kawatake*

meguro-chiku a variant of *Phyllostachys nigra*

Meiji the historical period from 1868 to 1912 following the opening of Japan in 1868

mikan Japanese tangerine

miki no kuchi "sacred *sake's* mouth"; bamboo ornament used in *sake* bottles only at New Year's

mingei folk art; term created by Yanagi Soetsu and his colleagues to reflect anonymous crafts of high quality made with local materials for local use

Mingei-kan see Nihon Mingei-kan

minka traditional thatched farmhouse

Mino one of the great papermaking centers in Japan

miso soybean paste; the basis of Japan's favorite soup

misu bamboo shades with brocade borders; used in formal spaces, as well as in temples and shrines

Miyakonojo oyumi the traditional craft of bowmaking in the area of Miyakonojo, Kyushu

Miyazaki prefecture on the southern island of Kyushu; famous for the bamboo bows produced there

mizubashi water basin for garden; usually made of stone

mizusashi water jar for tea ceremony

Momoyama (1) the name of Hideyoshi's great palace; (2) name taken for the historical period from 1574 to 1614

mon (1) family crest; also called *kamon* or *monsho*; (2) gate; entry to shrine or other compound

monoimi purification rites associated with Shintoism

monsho family crest; more commonly *kamon* or *mon*

moso common Japanese name for *Phyllostachys pubescens* bamboo, the largest in Japan; also *moso-chiku*

Muromachi war-filled period in Japan from 1333 to 1573

Mushanokojisenke one of the leading tea ceremony schools

Nachi-Hi-Matsuri festival in Wakayama Prefecture in which fans play a major role

nagashi-bina miniature dolls and boat sent to sea on Girls' Day

Nara (1) Japan's first capital city; (2) a historic period from 710 to 793

nari (1) shape; (2) used in describing several types of bows, as in *Kagoshin-nari* (archery)

natsume tea caddy for holding green tea in tea ceremony

nenchu gyoji holidays that change dates from year to year

nengajo year-end cards; also called *nenga-hagaki*

Nihon Mingei-kan the formal Japanese name for the Japan Folk Crafts Museum, the most significant folk art museum in Japan; founded by Yanagi Soetsu and friends in the 1930s; located in Tokyo

Ningen Kokuho Living National Treasures; popular term for those designated Bearers of Important Intangible Cultural Assets (*Juyo Mukei Bunkazai Hojisha*)

ningyo doll; many styles of dolls are popular in Japan

Noguchi Isamu (1904–88) artist and designer whose work merged Western and Japanese sensibilities

noh traditional Japanese theater in which performers wear masks

noren split curtain hung in private, restaurant, and business entries

nori dry-sheet seaweed used in rolled sushi and other popular dishes

Numazu-gaki woven fence style; named after region near Mount Fuji

o-bento small lunch boxes

obi wide band of woven fabric used to tie kimono; women have many to choose from—keyed to age, occasion, season, and pattern

Obi Matsuri festival in Kyoto

obon Festival of the Dead; one of the major observances in Japan

Odawara-jochin collapsible paper lantern associated with Odawara, a castle town south of Tokyo

odori the traditional dancing associated with *obon*; varies from region to region; also called *bon-odori*

ogi folding fan

Oita prefecture on the southern island of Kyushu, the heart of industrial bamboo in Japan

Okinawa southern chain of islands of the Japanese archipelago; also called the Ryukyu Islands

Omiya town just north of Tokyo, in Saitama Prefecture

o-miyage souvenir gift; traditionally given upon return from a trip

o-mochi rice cake; part of the New Year's rituals

Omotesenke one of the major tea ceremony schools in Japan

onigiri rice ball; favorite portable snack in Japan

onsen (1) hot water resorts; (2) Beppu is among the most famous in Japan

Onta pottery site near Hita on Kyushu; sometimes written Onda

o-shogatsu see *shogatsu*

Otsu-gaki style of fence constructed by weaving split bamboo

pillow book type of erotic story book

rakugo comic storytelling; monologue with few props

ranma transom; architectural element directly over the door frame

Rikyu see Sen no Rikyu

ronin masterless samurai

Ryoanji one style of fence with see-through construction; the original is at the Ryoanji temple in Kyoto

Ryukyu see Okinawa

sabi literally "rust"; part of the aesthetics vocabulary in Japan that denotes an appreciation of the natural aging of objects; as in *wabi-sabi*

sabidake "rust bamboo"; darkened cloudlike markings on bamboo's skin

sake rice wine; popular drink and a favorite of *kami*

sarashi processing of bamboo involving aging, drying, and removing the oil

sarashidake bamboo that has had the oil already removed

sasa (1) a bamboo often used as low-growing ground cover; (2) term used nontechnically, especially in the food industry when referring to all bamboo leaves used in food presentation

sasara notched bamboo instrument played in festivals

sei purity; one of four primary objectives in Tea Ceremony (*wa, sei, kei, jaku*)

Sen no Rikyu (1522–91) greatest tea master in Japanese history; often just referred to as Rikyu

sensu folding fan

Serizawa Keisuke (1895–1984) well-known fabric printer; friend of Yanagi Soetsu

Seto one of the great kiln sites in Japan; located in Aichi Prefecture

shakuhachi special end-blown bamboo flute with five finger holes

shibu uchiwa name for flat kitchen fans; *shibu* refers to the persimmon juice used on the paper

shibui aesthetic term meaning severe; often used in reference to subdued or dark tones

Shiga region/prefecture just northwest of Kyoto

Shikoku island of Japan where cloud-patterned bamboo is famous

shin formal style; one of several terms used to classify ancient calligraphy and basketry; see also *gyo* and *so*

shinai bamboo sword used in *kyudo*

shinobue a simple bamboo flute with six or seven holes; associated with folk music

Shintoism religion native to Japan

shiraki-yumi general reference to unlacquered bows (archery)

shiorido one style of gate with see-through construction

shitaji grid of bamboo suspended from post construction of dwelling walls and covered in plaster (*shinkabe*)

shitaji-mado window of bamboo lattice

Shizuoka (1) area between Mount Fuji and the Pacific Ocean; (2) home of Suruga basketry and many museums (including the Shizuoka Prefecture Museum, Toro Museum and Serizawa Museum)

sho organlike bamboo flute with seventeen pipes used in Japanese traditional music ensembles and court music

sho-chiku-bai Three Friends of Winter; combination of these auspicious symbols of pine, bamboo, and plum

shogatsu New Year in Japan; the single most important holiday

shoji sliding paper panels used to divide rooms in traditional Japanese architecture

shokunin in this book used to mean craftspeople or artisans with well-honed skills; in a broader sense, the word encompasses such skilled tradespersons as sushi chefs and tofu makers who have mastered their craft

Shono Shounsai (1904–1974) first bamboo craftsperson named Living National Treasure

Shoso-in the Imperial art repository in Nara

so informal style; one of the terms used to classify ancient calligraphy and basketry; see also *gyo* and *shin*

Sogetsu ikebana school formed by the Teshigahara family

sudare woven bamboo blinds

suki aesthetic term; elegant

sukiya-zukuri refined, elegant architectural style

sumi "soot"; term used for the ink used in *sumi-e* (ink painting)

sunoko tenjo ceiling lattice in *minka*

Suruga ware bamboo products from the Shizuoka region characterized by round-cut elements

susudake "soot-bamboo"; refers specifically to old bamboo taken from *minka* farmhouses where the soot from the cooking fire has accumulated on the bamboo in the ceiling construction and fostered a rich brown patina

take bamboo; becomes *dake* in some compound usages

take biku bamboo creel for fishing

Take Dake jazz group formed by John Neptune that uses only instruments constructed of bamboo

take gushi a wide variety of small bamboo skewers used to cook and serve food

take hebi "bamboo snake"; simple child's toy

take kapo "bamboo cup"; simple bamboo shoes

takekawa bamboo sheath

takene bamboo roots that are used in crafts

takenoko bamboo shoots

takenoko gohan special recipe for rice cooked with fresh bamboo shoots in the spring

taketonbo "bamboo dragonfly"; favorite childhood toy in Japan

Taketori Monogatari one variation of the "Bamboo Princess" story

takeuma "bamboo horse"; type of stilts used as a child's toy

takeyumi bamboo archery bow

take zaiku bamboo ware

take zori storage basket of woven bamboo

tako kite

Tako Ichi kite festival at the Oji Inari Shrine in Tokyo

Tale of Genji eleventh century novel; one of the most famous in Japan

tamabuchi ridge along the top of a bamboo fence; decorates and protects the fence

tamegi wooden tool used to straighten heated bamboo

Tanabata festival of the Weaver Princess; celebrated in summer and includes tall, ornamented poles

Tanba-hanchiku another bamboo with a natural cloudlike pattern

tatami woven straw mats; basis of measuring traditional rooms (e.g., "6-mat room")

tessen a strong, open-weave pattern associated with Beppu basketry trays

"tiger bamboo" popular term applied to bamboo with cloudlike pattern; in Japanese known as *torafudake*

tojingasa Chinese-style umbrellas

Tokkaido the old road that linked Tokyo (Edo) with Kyoto

tokobashira vertical post in *tokonoma* alcove; often bamboo

tokonoma alcove in traditional Japanese house

tokusa-gaki fence style used at the entry to the Katsura Villa in Kyoto

torafudake literally means "tiger bamboo"; term applied to bamboo with cloud-like pattern

tori-no-ichi festival of the rooster held in November; ornamented bamboo rakes are purchased in order to ensure prosperity in the new year

Tosa one of the great papermaking centers in Japan; located in Kochi Prefecture

Tosa torafudake "tiger bamboo from Tosa"; *Phyllostachys nigra* variant found in Kochi Prefecture

Toyohashi region of Japan known for beautiful brushes used in painting and calligraphy, located in Aichi Prefecture

Toyotomi Hideyoshi (1537-98) low-ranking soldier who rose to lead Japan during the Momoyama period; often identified with tea ceremony and Rikyu, his tea master

tsugi zao jointed bamboo fishing rod

tsukubai low water basin used in Japanese gardens; usually made of stone

uchiwa flat, round fan

Ueda Koichiro (1898-1991) a Japanese scholar; internationally recognized botanist who devoted his life to bamboo

ukiyo-e Japanese woodblock prints

Urasenke a popular tea-ceremony school

wa (1) harmony; (2) one of four objectives in the tea ceremony (*wa, kei, sei, jaku*)

wabi aesthetic term that connotes the beauty of a rustic naturalness; as in *wabi-sabi*

wagasa most general word for traditional Japanese paper-and-bamboo umbrellas

wara rice straw; used in Japan for many crafts and household tasks (i.e., wrapping foodstuffs, making hats and ceremonial objects)

washi handmade Japanese paper; term has now become somewhat generic

ya arrow

yabusame mounted, ceremonial archery with military history; now limited to festivals and tournaments

yadake common name for *Pseudosasa japonica*, sometimes called "arrow" bamboo or *metake*

yahazu makibuchi elaborate lashing pattern used to secure the rim on large trays made in Beppu

Yanagi Soetsu (1889-1961) champion of the Japanese folk arts; with friends, coined the term *mingei* and founded the Nihon Mingei-kan (Japan Folk Crafts Museum) in Tokyo. Also known as Yanagi Muneyoshi

yukata thin summer kimono still worn by both men and women in Japan

yumi bow used in traditional archery (*kyudo*); in Japan most often made of bamboo

yuzarashi technique using a chemical solution to remove oil from bamboo

zaru the simple woven bamboo tray; basket used in kitchens throughout Japan

zenga paintings by Zen monks for personal expression

zumen-chiku bamboo that has been patterned by chemicals; technique often used on bamboo artificially shaped into square pole for interior design use

Zusetsu Take Kogei major technical text used by most bamboo companies for processing information. See Sato in bibliography

BIBLIOGRAPHY

Adachi, Barbara. *The Living Treasures of Japan*. Tokyo: Kodansha International, Ltd., 1973.

———. "Preserving the Intangible; Japan's Living National Treasures." *Craft Horizons* (Vol. XXXVIII, No. 5): 41–45.

Addiss, Stephen. *The Art of Zen: Paintings and Calligraphy by Japanese Monks 1600–1925*. New York: Harry N. Abrams, Inc., 1989.

———. *How to Look at Japanese Art*. New York: Harry N. Abrams, Inc., 1996.

Administration for Protection of Cultural Properties in Japan. Tokyo: National Commission for Protection of Cultural Properties, 1962.

Akiyama, Aisaburo. *The Jidai Matsuri or Festival*. Kyoto: Shotaro Sato, 1929.

Allen, Jeanne. *Designer's Guide to Japanese Patterns*. San Francisco: Chronicle Books, 1988.

———. *Designer's Guide to Samurai Patterns*. San Francisco: Chronicle Books, 1990.

American Bamboo Society. "Bamboo Species." Website. 1999.

———. *The Journal of the American Bamboo Society* (Vol. 8, No. 1–2, 1991).

———. "Species Source List," April 2000, No. 20.

Amstutz, Walter. *Japanese Emblems and Designs*. Toronto: University of Toronto Press, 1970.

Anderson, Charlotte, "Born to Fun." *The Imperial* (No. 249, Winter, 1995/96): 6–11.

Aoi Matsuri: Kamo-Sai (The Aoi Festival). Kyoto: Fujioka Mamoru, Kyoto Shoin Co., 1991.

Arakawa, Hirokazu and Hasebe Gakuji, Imanaga Seiji, Okumura Hideo. *Traditions in Japanese Design: Kacho: Bird and Flower Motifs*. Tokyo: Kodansha International Ltd., 1967.

The Art of Chanoyu: The Urasenke Tradition of Tea. Los Angeles: The Urasenke Foundation, 1986.

The Art of Netsuke Carving by Masatoshi as told to Raymond Bushell. Tokyo: Kodansha International Ltd., 1981.

"The Art of the Sword." *The East* (Vol. III, No. 3, 1967): 29–33.

Asano, Jiro and Yoshiro Isa. *Takegaki to Ikegaki: Bamboo Fence & Hedge*. "5th ed.," Tamana-shi, Kumamoto Prefecture: World Green Shuppan, 1996.

Ashkenazi, Michael. *Matsuri: Festivals of a Japanese Town*. Honolulu: University of Hawaii Press, 1993.

Ashton, Dore. *The Delicate Thread: Teshigahara's Life in Art*. Tokyo/New York: Kodansha International Ltd., 1997.

Asobi: Play in the Arts of Japan. In conjunction with an exhibition. Katonah, New York: Katonah Museum of Art, 1992.

Austin, Robert and Ueda Koichiro. *Bamboo*. Photo. by Dana Levy. New York: Weatherhill, 1972.

Bahan. Vol. 20, Issue 24. *Take no Zukan* ("An Illustrated Book on Bamboo"), 1993.

Bamboo and Its Use. International Symposium on Industrial Use of Bamboo. International Tropical Timber Organization, Chinese Academy of Forestry. Beijing, 1992.

Bamboo and the Chinese Scholar: Selections from the Lutz Bamboo Collection (pamphlet). Denver: Denver Art Museum, 1981.

Bamboo Craft Design. Conceived and Edited by A. G. Rao and Madhavi Koli. Industrial Design Centre, Indian Institute of Technology. Bombay: Industrial Design Center, 1994.

Bamboo, Flowers & Tea: Selections from the Lutz Bamboo Collection. Exhibition Catalogue. Denver: Denver Art Museum, 1982.

Bamboo in Kyoto Japan. Photo. by Yamamoto Kenzo. Kyoto: Mitsumura Suiko Shoin Co., Ltd., 1993.

Bamboo is Life and a Philosophy. Video. Not for sale. Produced by Zen Nihon Take Sangyo Rengokai, undated.

Bamboo Masterworks: Japanese Baskets from the Lloyd Cotsen Collection. Los Angeles: Cotsen Occasional Press, 1999.

Bamboo Masterworks in Form and Texture: Japanese Baskets from the Lloyd Cotsen Collection. (pamphlet). New York: Asia Society, 1999.

Bambou. No. 24. Marseilles, France: Association Europeenne du Bambou, March 4, 1997.

Barker, Richard and Lawrence Smith. *Netsuke: The Miniature Sculpture of Japan*. Catalogue for The British Museum. London: British Museum Publications Limited, 1976.

Barnet, Sylvan and William Burto. *Zen Ink Paintings*. Tokyo: Kodansha International Ltd., 1982.

Basho to Spun Steel. Video directed by Cristobal Zanartu. Written and produced by Rebecca Clark, 1998

Baten, Lea. *The Image and the Motif: Japanese Dolls*. Tokyo: Shufunotomo Co., Ltd., 1986.

———. *Japanese Folk Toys: The Playful Art*. Tokyo: Shufunotomo Co., Ltd., 1992.

———. *Playthings and Pastimes in Japanese Prints*. New York/Tokyo: Weatherhill, Inc./Shufunotomo Co., Ltd., 1995.

Bauer, Helen and Sherwin Carlquist. *Japanese Festivals*. Garden City, New York: Doubleday & Company, Inc., 1965.

Bennett, Anna Gray. *Unfolding Beauty: The Art of the Fan*. The Collection of Esther Oldham and the Museum of Fine Arts, Boston. In conjunction with the exhibition. Boston: Museum of Fine Arts, 1988.

Bestor, Theodore C. *Neighborhood Tokyo*. Stanford: Stanford University Press, 1989.

Blakemore, Frances. *Japanese Design: Through Textile Patterns*. New York: Weatherhill, 1978.

Bognar, Botond. *Contemporary Japanese Architecture: Its Development and Challenge*. New York: Van Nostrand Reinhold Company, 1985.

Booth, Alan. *Devils, Gods and Cameramen: Ten Japanese Festivals*. Tokyo: Kinseido, Ltd., 1982.

———. *Looking for the Lost: Journeys Through a Vanishing Japan*. New York/Tokyo: Kodansha International, Ltd., 1995.

Brandon, James, William P. Malm, and Donald H. Shively. *Studies in Kabuki: Its Acting, Music and Historical Context*. A Cultural Learning Institute Monograph, East-West Center. Honolulu/Michigan: The University Press of Hawaii/Center for Japanese Studies, 1978.

Brandon, Reiko Mochinaga. *Bright & Daring: Japanese Kimonos in the Taisho Mode from the Oka Nobutaka Collection of the Suzaka Classic Museum*. Published for the Honolulu Academy of Arts. Tokyo: Unsodo Publishing Co., 1996.

———. *Country Textiles of Japan: The Art of Tsutsugaki*. Honolulu: Honolulu Academy of Arts, 1986.

———and Barbara S. Stephan. *Spirit and Symbol: The Japanese New Year*. Honolulu: Honolulu Academy of Arts, 1986.

Buisson, Dominique. *The Art of Japanese Paper: Masks, Lanterns, Kites, Dolls, Origami*. Paris: S.A./Editions Pierre Terrail, 1992.

Bushell, Raymond. *Netsuke Masks*. New York/Tokyo: Weatherhill, Inc., 1985.

Carver, Norman F. Jr. *Form & Space in Japanese Architecture*. Kalamazoo, MI: Documan Press, Ltd. 1993.

———. *Japanese Folkhouses*. Kalamazoo, MI: Documan Press, Ltd. 1987.

Casal, U. A. *The Five Sacred Festivals of Japan: Their Symbolism & Historical Development*. Sophia University in Conjunction with Publisher. Rutland, Vermont and Tokyo/ Tokyo: Charles E. Tuttle Company, 1967.

Castile, Rand. "Tea." *Craft Horizons* (Vol. XXXVIII, No. 5): 21–22.

———. *The Way of Tea*. New York: Weatherhill, Inc., 1971.

Catalogue of the Imperial Treasures in the Shosoin: English Notes on Plates in Volume 1. Tokyo: Imperial Household Museum, 1929.

Ceremony and Ritual in Japan: Religious Practices in an Industrialized Society. Ed. by Jan van Bremen and D. P. Martinez. The Nissan Institute/Routledge Japanese Studies Series. London/New York: Routledge, 1995.

Chamberlain, Basil Hall. *Japanese Things: Being Notes on Various Subjects Connected with Japan*. 5th rev. ed., Rutland, Vermont and Tokyo: Charles E. Tuttle Company, 1971.

Chinese and Japanese Carvings from the Lutz Bamboo Collection (pamphlet). Denver: Denver Art Museum, 1980.

Chinese Teawares and Utensils. In conjunction with the Centenary Exhibition, "A Traditional Chinese Tea Shop." Singapore: National Museum, 1987.

"The Chirps of Insects and the Japanese Language." *The East* (Vol. XXVI, No. 5): 38–40.

Clarke, Rosy. "Baskets: Craft and Culture Entwined." *Imperial Magazine* (Winter, 1985-6): 19–21.

———. *Japanese Antique Furniture: A Guide to Evaluating & Restoring*. New York/ Tokyo, Weatherhill, Inc., 1988.

Coffland, Robert T. *Contemporary Japanese Bamboo Arts*. Chicago: Art Media Resources, 1999.

———. "Japanese Bamboo Arts." *Arts of Asia* (Vol. 29, No. 2, March/April 1999): 79–91.

Connor, Ian. Personal correspondence. May 27, 1998.

Cort, Louise Allison. "The Modern *Shokunin*." *Craft Horizons* (Vol. XXXVIII, No. 5): 38–39.

———and Nakamura Kenji: *A Basketmaker in Rural Japan*. In conjunction with an exhibition at the Arthur M. Sackler Gallery, Smithsonian Institute, Washington, D.C. New York/Tokyo: Weatherhill, 1994.

Crafts. Collection Catalogue. Tokyo: The National Museum of Modern Art. 1988.

Crafts 100: One Hundred Traditional Crafts of Japan Explained. Tokyo: The Society for the Promotion of Traditional Japanese Crafts, March 1990.

Crouzet, Yves. *Bamboos*. Photographs by Paul Starosta. Evergreen Edition. Koln: Benedikt Taschen Verlag GmbH, 1998.

———. *Bambous*. Photographs by Paul Starosta. Original French Edition. Editions du Chêne, 1996.

Dai hakkai Nihon dento kogei ten (The Eighth Exhibition of Japanese Traditional Industrial Arts). Tokyo: Asahi Shinbun, 1961.

Densho, Bushi ga Sodateta Gifu Gasa. (The Oral Tradition, Making Umbrellas Inherited from Bushi). Videocassette. In cooperation with Gifu-shi Wagasa Shinko Kai. Gifu: Dentsu Blocks Co.

Dento Kogei-hin, Shumi no Kasa (Craft Culture, Hobby Umbrellas). Pamphlet. Gifu: Fujisawa Shoten, Co.

Dento-teki Kogei-hin Sangyo Shinko Kyokai (Japan Traditional Craft Center). *Dento-teki Kogei hin Handobukku* (Traditional Crafts Handbook). Tokyo: Japan Traditional Craft Center, 1993.

Design and Craftsmanship of Japan: Stone. Metal. Fibers and Fabrics. Bamboo. Photo. by Iwamiya Takeji, Introd. Essay by Donald Richie. New York: Harry N. Abrams, Inc., (1964).

Design Diffusion News. No. 34. Milano, cover and 58–59.

The Design Heritage of Noren: Signs and Symbols in Japan. Photo. by Masuda Tadashi. Tokyo: Graphic-sha Publishing Company, Ltd., 1988.

The Design of the Japanese Folk House. Tokyo: Chuji Kawashima, 1986.

Dorrington-Ward, Carol, ed. *Fans from the East*. A Studio Book, first published by Debrett's Peerage Limited. New York: The Viking Press, 1978.

Dorson, Richard M. *Folk Legends of Japan*. Rutland, Vermont and Tokyo: Charles E. Tuttle, 1962.

Dower, John W. *The Elements of Japanese Design: A Handbook of Family Crest Heraldry & Symbolism*. New York: Weatherhill, 1971 (1991).

Duly, Colin. *The Houses of Mankind*. London: Thames and Hudson, 1979.

Dunkelberg, Klaus. *IL 31: Bambus Bamboo: Bamboo as a Building Material*. Information of the Institute for Lightweight Structures (IL) No. 31. Stuttgart: University of Stuttgart, 1985.

Dunn, Charles J. *Everyday Life in Imperial Japan*. Originally published as *Everyday Life in Traditional Japan*. London: Dorsett Press, 1969.

Durston, Diane. *Old Kyoto: A Guide to Traditional Shops, Restaurants, and Inns*. Tokyo: Kodansha International, 1986.

Earle, Joe. "The Fan in Japan," Chapter 2 in Dorrington-Ward, Ed. *Fans from the East*. New York: The Viking Press, 1978.

———, ed. *Japanese Art and Design*. The Toshiba Gallery, The Victoria and Albert Museum. London: V & A Publications, 1986.

Edo Beauties in Ukiyo-e: The James A. Michener Collection. Contributions by Kobayashi Tadashi, Howard A. Link, Juliann Wolfgram and Carol Shankel. Honolulu: Honolulu Academy of Arts, 1994.

Edo Shokunin Kyo-ka Awase (Comic Poems of Artisans of Edo).

Embree, John F. *Suye Mura: A Japanese Village*. Chicago: The University of Chicago Press, 1939.

Encounters with Living National Treasures of Japan. Tokyo: Mitsubishi Motors Corporation, 1985.

The Enduring Crafts of Japan: 33 Living National Treasures. Contri. by Ogawa Masataka. New York: Walker/Weatherhill, 1968.

Engel, Heinrich. *The Japanese House: A Tradition for Contemporary Architecture*. Rutland, Vermont and Tokyo: Charles E. Tuttle Company, 1964.

Fagone, Vittorio. *Art in Nature*. Milano: Edizione Gabriele Mazzotta, 1996.

Fairchild, David G. *Japanese Bamboos and Their Introduction into America*. U.S. Department of Agriculture, Bureau of Plant Industry, Bulletin No. 43. Washington: Government Printing Office, 1903. American Bamboo Society Reprint. 1996.

Farrelly, David. *The Book of Bamboo*. San Francisco: Sierra Club, 1984.

Faulkner, Rupert. *Japanese Studio Crafts: Tradition and Avant-Garde*. In conjunction with an exhibition at the Victoria and Albert Museum. London: Laurence King Publishing, 1995.

The Festival at Nishiure. Tokyo: Mirai-sha, Ltd., 1970.

"The Folding Fan." *The East* (Vol. XVIII, No. 9/10, 1982): 53–59.

Folk Beliefs in Modern Japan. Contemporary Papers on Japanese Religion, 3. Tokyo: Kokugakuin University, Institute for Japanese Culture and Classics, 1994.

Fontein, Jan and Money L. Hickman. *Zen Paintings & Calligraphy*. In conjunction with an exhibition. Boston: Museum of Fine Arts, 1970.

Forms, Textures, Images: Traditional Japanese Craftsmanship in Everyday Life. Ed. by Yoshida Mitsukuni. First published in Japanese. *Nihon no Katachi*. New York/Tokyo: Weatherhill/Tankosha, 1979.

Fox, Howard N. *A Primal Spirit: Ten Contemporary Japanese Sculptors*. Organized by the Hara Museum of Contemporary Art, Tokyo, and the Los Angeles County Museum of Art. Los Angeles: Los Angeles County Museum of Art, 1990.

Freeman-Mitford, A.B., C.B. *The Bamboo Garden*. 1896. American Bamboo Society Reprint, 1994.

Fude no Sato, Kumano: Fude Zukari Kote Shokai (Hometown of the Traditional Brush, Kumano). Video. Publisher: Hiroshima-ken, no date.

Fujikawa, Asako. *Cha-no-yu and Hideyoshi*. Tokyo: The Hokuseido Press, 1957.

Fujioka, Michio. *Kyoto Country Retreats: The Shugakuin and Katsura Palaces*. Tokyo: Kodansha International, Ltd., 1983.

Fujioka, Ryoichi. *Tea Ceremony Utensils*. Arts of Japan, 3. Originally published in Japanese in 1968, *Cha Dogu*, Vol. 22 in *Nihon no Bijutsu* (Arts of Japan). Trans. and adapt. by Louise Allison Cort. New York: Weatherhill/Shibundo, 1973.

Fujisawa, Kenichi. Personal interview. March 18, 1997.

Fukukita, Yasunosuke. *Cha-no-yu: Tea Cult of Japan*. Tokyo: The Hokuseido Press, 1938.

———. *Tea Cult of Japan*. Tourist Library: 4. Tokyo: Japan Travel Bureau, 1955.

Gribbin, Jill and David. *Japanese Antique Dolls*. New York: Weatherhill, 1984.

Grow Your Own House—Simon Velez and Bamboo Architecture. In German and English. Weil-am-Rhein, Germany: Vitra Design Museum, 2000.

Guide to the National Museum of Ethnology. Tokyo: Kodansha International, Ltd., 1991.

Gunsaulus, Helen C. *The Japanese New Year's Festival, Games and Pastimes*. Department of Anthropology, Leaflet Number 11. Chicago: Field Museum of Natural History, 1923.

Guth, Christine. *Art of Edo Japan: The Artist and the City, 1615–1868*. Perspectives. New York: Harry N. Abrams, Inc., Publishers, 1996.

———. *Art, Tea, and Industry*. Princeton, New Jersey: Princeton University Press, 1993.

Ha, Kuiming and Yigi Ha. *Chinese Artistic Kites*. (The Culture and Art of China Series). Ralph Kiggell, Trans. Originally published in Chinese. Hong Kong: China Books & Periodicals, Inc., 1990.

Hadamitzky, Wolfgang and Mark Spahn. *Kanji & Kana: A Handbook and Dictionary of the Japanese Writing System*. Rutland, Vermont and Tokyo: Charles E. Tuttle Company, 1981.

Haga, Hideo. *Japanese Festivals*. Hoikusha's Color Books Series, No. 13. Osaka: Hoikusha, 1968.

———. *Japanese Folk Festivals Illustrated*. Trans. by Fanny Hagin Mayer. Tokyo: Miura, 1970.

"Hakubundoh no Fude" ("Calligraphy Brush by Hakubundoh"). *The Long Time Best Seller*. In *Ima Shokunin-tachi wa* (Craftworkers Now). Tokyo: Shogakukan, (1995), 84–85.

"Hanamaru Market: Furuku te Atarashi Take no Miryoku Saihakken" ("Hanamaru Market: Discover Bamboo, It Is Old and New!") Japanese Television. TBS, July 7, 1998.

Hanley, Susan B. *Everyday Things in Premodern Japan: The Hidden Legacy of Material Culture*. Berkeley and Los Angeles: University of California Press, 1997.

Harada, Jiro. *The Shosoin: An Eighth Century Repository*. Tokyo: Mayuyama & Co., 1950.

Hauge, Victor and Takako. *Folk Traditions in Japanese Art*. In cooperation with the International Exhibitions Foundation/The Japan Foundation. Tokyo/New York: Kodansha International Ltd., 1978.

Hawley, W. M. *Japanese Crest Designs*. Hollywood, California: Hawley Publications, 1991.

Hayashiya, Seizo. *Chanoyu: Japanese Tea Ceremony*. Japan House Gallery. New York: Japan Society, 1979.

Hayashiya, Tatsusaburo and Nakamura Masao, Hayashiya Seizo. *Japanese Arts and the Tea Ceremony*. Trans. and adapt. by Joseph P. Macadam, The Heibonsha Survey of Japanese Art, Volume 15. New York: Weatherhill/Heibonsha, 1974.

Hearn, Lafcadio. *Exotics and Retrospectives*. Boston: Little, Brown, and Company, 1905.

———. *Kokoro: Hints and Echoes of Japanese Inner Life*. Rutland, Vermont and Tokyo: Charles E. Tuttle Company, 1972.

———. *Kwaidan: Stories and Studies of Strange Things*. Originally published by Shimbi Shoin in 1932. New York: Dover Publications, Inc., 1968.

Henderson, Paula. "The Bamboo Curtain." *The World of Interiors* (Sept. 1989): 108–115.

Herring, Ann. *Chiyogami: Hand-printed Patterned Papers of Japan*. Tokyo: Kodansha International, Ltd., 1987.

Hibi, Sadao. *Japanese Detail: Architecture*. San Francisco: Chronicle Books, 1989.

———. *Japanese Detail: Fashion*. Originally published in Japanese as *Nihon no Dento Iro to Katachi*. San Francisco: Chronicle Books, 1984.

———. *Japanese Tradition in Color and Form: Architecture*. Tokyo: Graphic-sha Publishing Co., Ltd., 1987.

———. *Japanese Tradition in Color and Form: Cuisine*. Tokyo: Graphic-sha Publishing Co., Ltd., 1987.

———. *Pastimes: Japanese Tradition in Color and Form*. Tokyo: Graphic-sha Publishing Co., Ltd., 1992.

Hickman, B. ed. *Japanese Crafts, Materials and Their Applications*. Selected Early Papers from the Japan Society of London. London/The Hague: East/West Publications, 1977.

Hickman, Money and Peter Fetchko. *Japan Day by Day*. An Exhibition Honoring Edward Sylvester Morse and Commemorating the Hundredth Anniversary of His Arrival in Japan in 1877. Exhibit from the Peabody Museum of Salem. Salem, MA: Peabody Museum of Salem. 1979.

Hiesinger, Kathryn B. and Felice Fischer. *Japanese Design: A Survey Since 1950*. In connection with an exhibition at the Philadelphia Museum of Art. New York: Harry N. Abrams, Inc., 1994.

Hillier, Jack. *The Art of Hokusai in Book Illustration*. Berkeley and Los Angeles: University of California Press, 1980.

Hirayama, Chuji. *Japanese Rural Dwellings*. Tokyo: Shokokusha Publishing Co., 1965.

Hiroshi Teshigahara. In conjunction with an exhibition. New York: 65 Thompson Street, 1990.

Holme, Charles. "The Uses of Bamboo in Japan." *Japanese Crafts: Materials and Their Applications*. B. Hickman, Ed. London: East-West Publications Limited, 1977, 33–58.

Homma, Kazuaki. *Take no Zokei* (Shapes in Bamboo). Kyoto: Futaba-shobo, 1991.

Honda, Isao. *Monsho: Family Crests for Symbolic Design*. Tsuzawa Masatsugu and Donald C. Mann, Trans. Rutland, Vermont and Tokyo: Japan Publications Trading Company, 1963.

Hori, Ichiro. *Folk Religion in Japan: Continuity and Change*. Ed. Joseph M. Kitagawa and Alan L. Miller. Haskell Lectures on History of Religions, New Series, No. 1. Chicago/London: The University of Chicago Press, 1968.

Hornung, Clarence, ed. *Traditional Japanese Stencil Designs*. New York: Dover Publications, Inc., 1985.

Hsiung, Wenyue. "Prospects for Bamboo Development in the World." *The Journal of the American Bamboo Sociey* (Vol. 8, No. 1–2, 1991).

Hutt, Julia and Helene Alexander. *Ogi: A History of the Japanese Fan*. London: Dauphin Publishing Limited, 1992.

Iannacci, Anthony. *Shoei Yoh: In Response to Natural Phenomena*. Milano: L'Arca Edizioni, 1997.

Iizuka Rokansai. In conjunction with an exhibition. Tochigi: Tochigi Prefectural Museum of Fine Arts, 1989.

Ikeda, Hyoa. "Appreciating Tea Scoops," *Chanoyu Quarterly*, No. 54, 10.

Inaji, Toshiro. *The Garden as Architecture: Form and Spirit in the Gardens of Japan, China, and Korea*. Trans. and adapt. by Pamela Virgilio. Tokyo: Kodansha International, Ltd., 1998.

Inoue, Yasumasa. "Profile of Master Craftsman As Cultural Asset." *Daily Yomiuri* (August 5, 1998)

Inoue, Yasushi, Ueda Koichiro, and Takama Shinji. *Nihon no Bi, Take* (Japanese Beauty, Bamboo). Tokyo: Tanko-sha, 1977.

The International Bamboo Association (brochure), July 1993.

International Bamboo Congress (IV). Scientific Programme & Summaries of Papers and Posters. Ubud, Bali: International Bamboo Congress, 1995.

Inumaru Tadashi and Yoshida Mitsukuni, ed. super. *The Traditional Crafts of Japan.* 8 volumes and 8 videos. Technical advisor, Japan Traditional Craft Center. Tokyo: Diamond, Inc., 1992.

——. *Brushes and Sumi Ink: Nara Writing Utensils.* Vol. 8 and video 8. Tokyo: Diamond, Inc., 1992

——. *Wood and Bamboo. The Traditional Crafts of Japan.* Vol. 5. Tokyo: Diamond, Inc., 1992.

——. *Paper and Dolls. The Traditional Crafts of Japan.* Vol. 7. Tokyo: Diamond, Inc., 1992.

Isozaki, Arata and Sato Osamu. *Katsura Villa: The Ambiguity of Its Space.* New York: Rizzoli International Publications, Inc., 1987.

Ito, Toshio and Komura Hirotsugu. *Kites: The Science and the Wonder.* Originally published in Japanese as *Tako no Kaguku.* Tokyo: Japan Publications, Inc. 1983.

Itoh, Teiji. *Kura: Design and Tradition of the Japanese Storehouse.* Tokyo: Kodansha International. Ltd., in cooperation with Tankosha Ltd., 1973.

——. *The Elegant Japanese House: Traditional Sukiya Architecture.* New York/ Tokyo: Walker/Weatherhill, in collaboration with Tankosha Ltd., 1969.

——. *The Gardens of Japan.* Tokyo: Kodansha International, Ltd., 1984.

——. *Traditional Domestic Architecture of Japan.* The Heibonsha Survey of Japanese Art. Trans. by Richard L. Gage. Originally published as *Minka.* New York: Weatherhill/Heibonsha, 1972.

——. *Traditional Japanese Homes.* Ed. and Photo. by Futagawa Yukio. Trans. Richard L. Gage. New York: Rizzoli International Publications, Inc., 1983.

——, Tanaka Ikko, and Tsune Sesoko, eds. *Wabi, Sabi, Suki: The Essence of Japanese Beauty.* Hiroshima: Mazda Motor Corporation, 1993.

Iwamiya, Takeji. *Forms, Textures, Images: Traditional Japanese Craftsmanship in Everyday Life.* Originally published in Japanese as *Nihon no Katachi.* New York/Tokyo: Weatherhill/Tankosha, 1979.

Jacknis, Ira. *Getemono: Collecting the Folk Crafts of Old Japan.* In conjunction with an exhibition entitled "Back Roads to Farm Towns: Folk Art of Rural Japan." Berkeley: University of California, 1994.

Janssen, Dr. Jules J. A. *Building with Bamboo: A Handbook.* London: Intermediate Technology Publications, Ltd., 1995.

Japan: An Illustrated Encyclopedia. 2 volumes. Tokyo: Kodansha, Ltd., 1993.

Japan Craft Forum. *Japanese Crafts: A Complete Guide to Today's Traditional Handmade Objects.* Previously, *Japan Crafts Sourcebook.* Introduction by Diane Durston. Tokyo: Kodansha International, Ltd. 2001.

Japan Craft Forum. *Japan Crafts Sourcebook: A Guide to Today's Traditional Handmade Objects.* Introduction by Diane Durston. Tokyo: Kodansha International, Ltd., 1996.

Japan Days. Rutland, Vermont and Tokyo: Charles E. Tuttle Company, 1959.

Japan Traditional Craft Center (pamphlet). Tokyo: Japan Traditional Craft Center, undated.

"Japanese Archery: An Exercise in Concentration." *The East* (Vol. XIX, No. 5/6, 1983: 68-71)

Japanese Bamboo Flutes: Tai Hei Shakuhachi. Updated 1995 Sourcebook. Willets, California: Monty H. Levenson, 1995.

Japanese Brushes. Form and Function Series. Tokyo/New York: Kodansha International, Ltd., 1979.

Japanese Courtyard Gardens. Photo. by Ohashi Haruzo. Tokyo: Graphic-sha Publishing Co., Ltd., 1997.

Japanese Design Motifs: 4260 Illustrations of Japanese Crests. Compiled by the Matsuya Piece Goods Store. Adachi Fumie, Trans. Originally published in Japanese. New York: Dover Publications, Inc., 1972.

Japanese Folk Art: A Triumph of Simplicity. In conjunction with an exhibition. New York: Japan Society Inc., 1992.

Japanese Folk Dolls & Toys. The Doll: Dolls of Japan and the World, Vol. 3. Kyoto: Kyoto Shoin Co., Ltd. 1986.

Japanese Garden Research Association. *Create Your Own Japanese Garden.* Tokyo: Graphic-sha Publishing Co., Ltd., 1995.

Japanese Theater in the World. Catalog for exhibition of the same name, at the Japan Society, 1997/98. Essays edited by Samuel Leiter. New York: Japan Society, 1997.

Japanesque: Series Nihon ga Mieru, Tsutsumu (Japanesque, Look at Japan Again, Wrapping). Video. Tokyo: Dentsu Video, Inc., 1994.

Jones, Alan. "Master of the Dance." *Contemporanea* (September 1960): 56-61.

Judge, Thomas F. *Edo Craftsmen: Master Artisans of Old Tokyo.* New York/Tokyo: Weatherhill, 1994.

Judziewicz, Emmet J. with Lynn G. Clark, Ximena Londono and Margaret J. Stern. *American Bamboos.* Washington/London: Smithsonian Institute Press, 1999.

Kaemmerer, Eric A. *Trades and Crafts of Old Japan: Leaves from a Contemporary Album.* Rutland, Vermont and Tokyo: Charles E. Tuttle Company, 1961.

Kahlenberg, Mary Hunt and Mark Schwartz. *A Book About Grass: Its Beauty and Uses.* New York: E. P. Dutton, 1983.

Kami. Contemporary Papers on Japanese Religion, 4. Tokyo: Kokugakuin University, Institute for Japanese Culture and Classics, 1998.

Katachi: Japanese Pattern and Design in Wood, Paper, and Clay. New York: Harry N. Abrams, Inc., 1963.

Kato, Shuichi. *Japan: Spirit & Form.* Trans. and adapt. by Abe Junko and Leza Lowitz. Originally published in Japanese. Rutland, Vermont and Tokyo: Charles E. Tuttle Company, 1994.

Katoh, Amy Sylvester. *Blue and White Japan.* Rutland, Vermont and Tokyo: Charles E. Tuttle Company, 1996.

——. *Japan: The Art of Living.* Rutland, Vermont and Tokyo: Charles E. Tuttle Company, 1990.

——. *Japan Country Living: Spirit, Tradition, Style.* Rutland, Vermont and Tokyo: Charles E. Tuttle Company, 1993.

Kawai, Hayao. *Dreams, Myths & Fairy Tales in Japan.* James Gerald Donat, ed. Einsiedeln, Switzerland: 1995.

Kawashima, Chuji. *Minka: Traditional Houses of Rural Japan.* Retitled as *Japan's Folk Architecture: Traditional Thatched Farmhouses.* Trans. by Lynne E. Riggs. Tokyo/New York: Kodansha International, Ltd., 1986.

Kazuya, Inaba and Shigenobu Nakayama. *Japanese Homes and Lifestyles: An Illustrated Journey Through History.* Originally published by Shokokusha Publishing Co., as *Nihonjin sumai: jukyo to seikatsu no rekishi.* Tokyo and New York: Kodansha International, 2000.

Keane, Marc P. *Japanese Garden Design.* Rutland, Vermont and Tokyo: Charles E. Tuttle, 1996.

Keene, Donald. *Japanese Literature: An Introduction for Western Readers.* Evergreen Book. New York: Grove Press, 1955.

——. *No and Bunraku: Two Forms of Japanese Theatre.* Originally published by Kodansha International Ltd. New York: Columbia University/Morningside Edition, 1990

Kenichi Nagakura. In conjunction with an exhibition. Santa Fe: TAI Gallery, 1999.

Kenrick, Doug. *The Book of Sumo: Sport, Spectacle and Ritual.* New York/Tokyo: Walker/Weatherhill, 1969.

Kikuchi, Yuko. "The Myth of Yanagi's Originality: The Formation of *Mingei* Theory in Its Social and Historical Context." *Journal of Design History* (Vol. 7 No. 4, 1994): 247-266.

Kinoshita, Masao. *Japanese Architecture: Sukiya.* Tokyo: Shokokusha Publishing Co., 1964.

Kirby, John B. Jr. *From Castle to Teahouse: Japanese Architecture of the Momoyama Period.* Rutland, Vermont and Tokyo: Charles E. Tuttle Company, 1962.

Kishibe, Shigeo. *The Traditional Music of Japan.* New York: The Japan Foundation, 1966.

Kitao, Harumichi. *Formation of Bamboo*. Tokyo: Shokokusha Publishing Co., 1958.

Kiyato, Minoru. *Kendo: Its Philosophy, History and Means to Personal Growth*. London: Kegan Paul International, 1995.

Kodansha Encyclopedia of Japan. 9 volumes. Tokyo: Kodansha Ltd., 1983.

Koizumi, Kazuko. *Traditional Japanese Furniture*. Trans. by Alfred Birnbaum. Tokyo: Kodansha International Ltd., 1986.

Koplos, Janet. *Contemporary Japanese Sculpture*. New York/London: Abbeville Press, 1991.

Koren, Leonard. *Wabi-Sabi for Artists, Designers, Poets & Philosophers*. Berkeley: Stone Bridge Press, 1994.

"Kosuge Shochikudo: The Language of Bamboo," *American Craft* (June/July 1982): 10.

Kudo, Kazuyoshi. *Japanese Bamboo Baskets*. Form and Function Series. Tokyo/New York: Kodansha International, Ltd., 1980.

———. *Kurashi no Naka no Take to Wara* (Bamboo and Rice Straw in Everyday Life). *Nihonjin no Seikatsu to Bunka*, 6 (Japanese Culture Series, 6). Tokyo: Gyosei, 1982.

Kumakura, Isao. "Yanagi and the Folk Movement." *Craft Horizons* (Vol. XXXVIII, No. 5): 60 and 75.

Kunst in de Lucht: Kunstvliegers (Art in the Air: Kites). In conjunction with a traveling exhibition in Germany. Osaka: Goethe Institut Osaka, 1991.

Kurokawa, Kisho. *Intercultural Architecture: The Philosophy of Symbiosis*. London: Academy Editions, 1991.

"*Kyudo*: Unique Art of Japanese Archery." *The East* (Vol. III, No. 4, May-June 1967): 40-45.

Kyushu no Dento-teki Kogei-hin (Kyushu's Traditional Crafts). Fukuoka City: Kyushu-denryoku Kabushikigaisha Jigyokaihatsubu, 1996.

Lane, Richard. *Images from the Floating World: The Japanese Print*. New York: G. P. Putnam & Sons, 1978.

Lawton, Thomas and Linda Merrill. *Freer: A Legacy of Art*. Freer Gallery of Art, Smithsonian Institute. New York: In association with Harry N. Abrams, Inc., Publishers, 1993.

Lee, O-Young. *The Compact Culture: The Japanese Tradition of "Smaller is Better."* Robert N. Huey, Trans. Originally published in Japanese as *Chijimi Shiko no Nihonjin*. Tokyo: Kodansha International, Ltd., 1984.

Lee, Sherman E. *Tea Taste in Japanese Art*. New York: The Asia Society, Inc., 1963.

Liese, Walter, "Anatomy and Utilization of Bamboos." *European Bamboo Society Journal* (May 6, 1995).

———. *The Anatomy of Bamboo Culms*. INBAR Technical Report 18. Beijing/Eindhoven: International Network for Bamboo and Rattan, 1998.

Linhart, Sepp and Sabine Fruhstuck, eds. *The Culture of Japan as Seen through Its Leisure*. SUNY Series, Japan in Transition. Albany, New York: State University of New York Press, 1998.

Link, Howard A. *The Art of Shibata Zeshin: The Mr. and Mrs. James E. O'Brien Collection at the Honolulu Academy of Arts*. Honolulu: Robert G. Sawers Publishing in association with the Honolulu Academy of Arts, 1979.

Living National Treasures of Japan. In conjunction with an exhibition. Boston: Museum of Fine Arts, 1982.

The Living Treasures of Japan. Inter. and text, Barbara Adachi. Intro. by Bernard Leach. London: Wildwood House, 1973.

Lopez, Oscar Hidalgo. *Manual de Construcción con Bambú* (*Manual for Constructing with Bamboo*). Estudios Técnicos Colombianos Ltda. *Construcción rural - 1*. Colombia: Universidad Nacional de Colombia, 1981.

Lowe, John. *Japanese Crafts*. London: John Murray Ltd., 1983.

Lutz, Walter E. "Bamboo Brushpots." *Arts of Asia*. (Vol. 5, No. 5, Sept./Oct. 1975): 23-33.

———. "Miniatures of Japanese Bamboo Art." *Arts of Asia*. (Vol. 15, No. 2, Mar./Apr. 1985): 81-97.

Maeda, Mana. *Ji: Signs and Symbols of Japan*. Tokyo: Kodansha International, Ltd., 1975.

Malm, William P. *Edo Festival Music and Pantomime*. Program. New York: Performing Arts Program of the Asia Society.

———. *Japanese Music & Musical Instruments*. Rutland, Vermont and Tokyo: Charles E. Tuttle Company, 1959.

———. *Six Hidden Views of Japanese Music*. Berkeley: University of California Press, 1986.

Marden, Luis, "Bamboo: The Giant Grass." *National Geographic* (October 1980, Vol. 158, No. 4): 502-528.

Massy, Patricia. *Sketches of Japanese Crafts and the People Who Make Them*. Tokyo: The Japan Times, Ltd., 1980.

Masterpieces of Contemporary Japanese Crafts. Commemorative Exhibition. Tokyo: The National Museum of Modern Art, 1977.

Matsubara, Hisako. *The Tale of the Shining Princess*. Tokyo: Kodansha International, Ltd., 1966.

Matsumoto, Takeshi. "On this car, carry-on a must." *The Daily Yomiuri* (1998).

Matsuo, Basho. *The Narrow Road to the Deep North*. New York: Viking Press, 1967.

Matsuri: Festival and Rite in Japanese Life. Contemporary Papers on Japanese Religion. Kokugakuin University, Institute for Japanese Culture and Classics, 1988.

Matsuzaki, Meizi. *Angling in Japan*. R. Okada, Trans. Tokyo: Board of Tourist Industry/Japanese Government Railways, 1940.

McAlpine, Helen and William. *Japanese Tales and Legends*. 1st American edition. New York: Henry Z. Walck, Inc., 1959.

McCallum, Toshiko M. *Containing Beauty: Japanese Bamboo Flower Baskets*. In conjunction with an exhibition at UCLA Museum of Cultural History. Los Angeles: Museum of Cultural History, 1988.

McCarty, Cara and Matilda McQuaid. *Structure and Surface: Contemporary Japanese Textiles*. In conjunction with an exhibition. New York: The Museum of Modern Art, 1998.

McCarthy, Ralph F. *The Moon Princess*. Tokyo: Kodansha International, 1993.

McClure, F. A. *The Bamboos: A Fresh Perspective*. Cambridge, MA: Harvard University Press, 1966.

———. *Bamboo as a Building Material*. Housing and Home Finance Agency, Office of International Housing Reprint Nov. 1964. Washington, DC: U.S. Department of Agriculture, Foreign Agricultural Service, 1953.

———. *Bamboos of the Genus Phyllostachys*. Agriculture Handbook No. 114. Washington: U.S. Government Printing Office, 1957. American Bamboo Society Reprint, 1994.

Meech, Julia. *Rain and Snow: The Umbrella in Japanese Art*. In conjunction with an exhibition. New York: Japan Society, 1993.

Meichiku (Special Bamboo). Video. Not for sale. Produced by Kyoto-fu Norinsuisan-bu Rinmu-ka, October 1993.

Mingei. Special issue devoted to *miki no kuchi*. Tokyo: *Nihon Mingei Kyokai*, Feb. 1980.

Mingei: Masterpieces of Japanese Folk Art. Tokyo: Kodansha International, Ltd., 1991.

Mingei: Two Centuries of Japanese Folk Art. In conjunction with an exhibition. Tokyo: The Japan Folk Crafts Museum, 1995.

Minka no Design (Designs of Japanese Folkhouses). Tokyo: Sagami Shobo, 1986.

"*Miyawaki-baisen-an no Sensu.*" ("Folding Fan by Miyawaki-baisen-an"). In *Ima Shokunin-tachi wa*. (Craftspeople Now). Tokyo: Shogakukan, 1995, 52-53.

Mizoguchi, Saburo. *Design Motifs*. (Arts of Japan 1). Originally published in Japanese as *Monyo (Design Motifs) (Nihon no Bijutsu 29)*. New York/Tokyo: Weatherhill/Shibundo, 1973.

Modern Bamboo Craft (Take no Kogei). With contributions by Kaneko Kenji and Moroyama Masanori. Tokyo: Crafts Gallery/The National Museum of Modern Art, 1985.

Moeran, Brian. *Folk Art Potters of Japan*. Honolulu: University of Hawaii Press, 1997.

———. *Language and Popular Culture in Japan*. Manchester/New York: Manchester University Press, 1989.

———. *Lost Innocence: Folk Craft Potters of Onta, Japan*. Berkeley/Los Angeles: University of California Press, 1984.

Moes, Robert, *Mingei: Japanese Folk Art*. Comm. by Robert Moes, Amanda Mayer Stinchecum, and William B. Hauser. Alexandria, Virginia: Art Services International, 1995.

———. *Mingei: Japanese Folk Art*. (From The Brooklyn Museum Collection). New York: The Brooklyn Museum, 1985.

Mono to Ningen no Bunka shi (Cultural History of Objects and People). No. 10, *Take* (Bamboo). Tokyo: Hosei Daigaku Shuppan Kyoku, 1983.

Morse, Edward S. *Japan Day by Day: 1877, 1878–79, 1882–83*. Vols. 1 and 2, Originally published in 1917. Atlanta: Cherokee Publishing Company, 1990.

———. *Japanese Homes and Their Surroundings*. Rutland, Vermont and Tokyo: Charles E. Tuttle Company, 1972.

Muraoka, Kageo and Okamura Kichiemon. *Folk Arts and Crafts of Japan*. Trans. by Daphne D. Stegmaier. The Heibonsha Survey of Japanese Art, Vol. 26. New York/Tokyo: Weatherhill/Heibonsha, 1973.

Muroi, Hiroshi and Okamura Hata. *Take to Sasa* (Bamboo and Sasa). Color Books, 236. (Tokyo): Hoikusha, 1971.

Musical Instruments in the Shosoin. Edited by Shosoin Office. Tokyo: Nihon Keizei Shimbun-sha, 1967.

Mutual Influences between Japanese and Western Arts. In conjunction with an exhibition. Tokyo: The National Museum of Modern Art, 1968.

Naito, Akira. *Katsura: A Princely Retreat*. Tokyo/New York: Kodansha International, Ltd. 1977.

Nakahara, Yasuo. *Japanese Joinery: A Handbook for Joiners and Carpenters*. Originally published in Japanese. Cloudburst Press Book. Point Roberts, WA: Hartley and Marks, Publishers, 1983.

Nakamura, Katsuya. *Tokonoma*. Tokyo: Johnan Shoin, 1958.

National Museum of Ethnology. Osaka: National Museum of Ethnology.

The Netsuke Handbook of Ueda Reikichi. Adapted from the Japanese by Raymond Bushnell. Rutland, Vermont and Tokyo: Charles E. Tuttle Company, 1961.

Nihon no Dento Kogei: Chikko-hin. (Japanese Traditional Craftworks, Bamboo Craftworks), Vol. 10. Tokyo: Libio-Shuppan, 1986.

Nihon no Dento Tako Shishi tachi. (Japanese Traditions: Kites). Video. Tokyo: Dentsu, 1994.

Nihon no Isho (Japanese Design in Art). 17 vols. Kyoto: Kyoto Shoin, 1984.

Nihon no Macchi Raberu (Japanese Match Labels). Kyoto Shoin Arts Collection, 82. Kyoto: Kyoto Shoin, 1998.

Nihon no Monyo (Japanese Design). *Take*, 6 (Bamboo, 6). Kyoto: Shogakkan, 1987.

Nihon no Tezukuri Kogei. (Japanese Crafts). Tokyo: Yomiuri Shimbunsha, 1982.

Nishi, Kazuo and Hozumi Kazuo. *What is Japanese Architecture?* Originally published as *Nihon Kenchiku no Katachi: Seikatsu to Kenchiku-zokei no Rekishi*. Trans. and adapt. by H. Mack Horton. Tokyo/New York: Kodansha International, Ltd., 1983.

Nishimoto, Keisuke. *Japanese Fairy Tales, Vol. 3*. Originally published in Japan by Kodansha Ltd. Torrance, California: Heian International, Inc., 2000.

Nishizawa, Tekiho. *Japanese Folk Toys*. S. Sakabe, Trans. Tokyo: Board of Tourist Industry, Japanese Government Railways, 1939.

The Official Museum Directory 2001, 31st edition. Washington, D.C.: American Association of Museums, 2000.

Ogawa, Masataka. *The Enduring Crafts of Japan: 33 Living National Treasures*. Originally published in Japanese as *Ningen Kokuho Dento Kogei*. New York/Tokyo: Walker/Weatherhill, 1968.

Ohrnberger, D. ed. *The Bamboos of the World: Annotated Nomenclature and Literature of the Species and the Higher and Lower Taxa*. Amsterdam/Lausanne: Elsevier Science B. V., 1999.

——— and J. Goerrings, eds. *The Bamboos of the World*. Series. Odenthal, Germany, 1983–1990.

Oka, Hideyuki. *Tsutsumu: The Art of Packaging*. Tokyo: The Mainichi Newspapers, 1972.

Okakura, Kakuzo. *The Book of Tea*. Originally published in Japanese. Tokyo/New York: Kodansha International Ltd., 1989.

———. *The Book of Tea: A Japanese Harmony of Art, Culture & the Simple Life*. Edinburgh: T. N. Foulis, 1919.

Okamura, Hata and Tanaka Yukio. *The Horticultural Bamboo Species in Japan*. Kobe: Hata Okamura, 1986.

———, Konishi Mieko, and Kashiwagi Harutsugu. *Illustrated Horticultural Bamboo Species in Japan*. Haato, 1991.

Okiura, Kazumitsu. *Take no Minzokushi* (Ethnological Encyclopedia of Bamboo). Tokyo: Iwanami Shinsho, 1992.

Oliver, Paul. *Dwellings: The House across the World*. Austin: The University of Texas Press, 1987.

Opincar, Abe. "Quail Gardens Spectacular Collection," *ABS Newsletter*, Vol. 17, No. 1, 10–13.

Oriental Gardening. With Kate Jerome. The American Garden Guides. The Japanese Garden Society of Oregon. New York: Pantheon Books, Knopf Publishing Group, 1996.

Oster, Maggie. *Bamboo Baskets: Japanese Art and Culture Interwoven with the Beauty of Ikebana*. New York: Viking Studio Books, 1995.

———. *Reflections of the Spirit: Japanese Gardens in America*. Dutton Studio Books. New York: Penguin Books USA Inc., 1993.

Ota, Yuzo. *Basil Hall Chamberlain: Portrait of a Japanologist*. Meiji Series: 4. Japan Library. London: Curzon Press Ltd., 1998.

Otsuka, Ronald Y. *Selections from the Lutz Bamboo Collection*. In conjunction with an exhibition. Denver: Denver Art Museum, 1979.

Ozawa, Hiroyuki. *Spectacle and Spirit: The Great Festivals of Japan*. Tokyo and New York: Kodansha International Ltd., 1999.

Pacific Northwest Bamboo Newsletter, Vol. 11, Issue, 4.

Paine, Robert Treat and Alexander Soper. *The Art and Architecture of Japan*. Pelican History of Art. New Haven/London: Yale University Press, 1985.

Philip, Leila. *The Road Through Miyama*. New York: Random House, 1989.

Picken, Stuart D. B. *Shinto: Japan's Spiritual Roots*. Tokyo: Kodansha International Ltd., 1980.

Piggott, Juliet. *Japanese Mythology*. London: Paul Hamlyn, 1969.

Piggott, Sir Francis. *The Music and Musical Instruments of Japan*. DaCapo Press Music, 1909. Reprint Series, Vassar College. New York: DaCapo Press, 1971.

Piper, Jacqueline M. *Bamboo and Rattan: Traditional Uses and Beliefs*. Images of Asia. Singapore/London: Oxford University Press, 1992.

Plutschow, Herbert. *Matsuri: The Festivals of Japan*. Surrey: Japan Library, 1996.

Pomeroy, Charles A. *Traditional Crafts of Japan: Illustrated with the Eighteenth-Century Artisan Prints of Tachibana Minko*. A Weathermark Edition. New York/Tokyo: Walker/Weatherhill, 1967.

Puro ni Manabu, Take-gaki zukuri (Learning from Professionals How to Make Bamboo Gates). Tokyo: Graphic-sha, 1997.

Putting a Bamboo Bridge Across the World: Abstracts, Oral & Poster Presentations. Minamata-City: The 3rd International Bamboo Congress & The 33rd National Bamboo Convention, 1992.

Rakugo in English! Starring Katsura Shijaku. Kennedy Stage. University of Hawaii. Honolulu, HI. June 2, 1996.

Ranjan, M. P. with Nilam Iyer and Ghanshyam Pandya. *Bamboo and Cane Crafts of Northeast India*. National Institute of Design. New Delhi: The Development Commissioner of Handicrafts, 1986.

Rao, Peggy Landers and Jean Mahoney. *Nature on View: Homes and Gardens Inspired by Japan*. Tokyo/New York: Shufunotomo/Weatherhill, 1993.

Rathbun, William Jay. *Yo no Bi: The Beauty of Japanese Folk Art*. Seattle: Seattle Art Museum and University of Washington Press, 1983.

Richie, Donald. "A Vocabulary of Taste." *House & Garden*, April 17, 1956, 20–22.

Roberts, Laurance P. *Roberts Guide to Japanese Museums*. In collaboration with the International House of Japan. Tokyo/New York: Kodansha International Ltd., 1978.

Ryan, Lisa Gail. *Insect Musicians & Cricket Champions: A Cultural History of Singing Insects in China and Japan*. San Francisco: China Books & Periodicals, Inc., 1996.

Ryerson, Egerton. *The Netsuke of Japan: Legends, History, Folklore and Customs*. New York: Castle Books, 1958.

Ryokan: The Japanese Inn, A Gateway to Traditional Japan. Tokyo: Shufunotomo Co., Ltd. 1985.

Sadler, A. L. *Cha-no-yu: The Japanese Tea Ceremony*. Rutland, Vermont and Tokyo: Charles E. Tuttle Company, 1962.

Saint-Gilles, Amaury. *Mingei: Japan's Enduring Folk Arts*. South San Francisco, Heian International, Inc., 1983.

"*Sakaida Eikichi no Janome-gasa*." (Oiled Paper Umbrella Designed by Eikichi Sakaida"). *Ima Shokunin Tachi wa* (Craftworkers Now). Tokyo: Shogakukan, 1995, 54–55.

Sakamoto, Kazuya. *Japanese toys: Playing with History*. Charles A. Pomeroy, Trans., Tokyo/Rutland, Vermont and Tokyo: Bijutsu Shuppan-sha/Charles E. Tuttle Co. Inc., 1962.

Salmon, Patricia. *Japanese Antiques: With a Guide to Shops*. Tokyo: Art International Publishers, 1975.

Salwey, Charlotte M. nee Birch. *Fans of Japan*. London: Keagan Paul, Trench, Trubner, & Co. Ltd., 1894.

Sasamori, Junzo and Gordon Warner. *This Is Kendo: The Art of Japanese Fencing*. Rutland, Vermont and Tokyo: Charles E. Tuttle Co., 1964.

Sato, Koseki. *Japanese Angler*. Tokyo: Foreign Affairs Association of Japan, undated.

Sato, Shogoro. *Chikko Nyumon* (Small Edition about Bamboo). Tokyo: Kyoritsu Shuppan, 1994.

———. *Zusetsu Take Kogei* (Illustrations of Bamboo Craft). Kyoto: Kyoritsu Shuppan, 1974.

Sato, Shozo. *The Art of Sumi-e*. Tokyo/New York: Kodansha International, Ltd., 1984.

Satow, Sir Ernest, K.C.M.G., *The Cultivation of Bamboos in Japan*. 1899. American Bamboo Reprint. 1995.

Schiffman, Maurice K. *Japan: The Land of Fans*. Tokyo: Foreign Affairs Associates of Japan, 1950.

Schilling, Mark. *Sumo: A Fans' Guide*. Tokyo: The Japan Times, 1994.

Sebastian-Peplow, Evelyn. "A Heritage of Bamboo Carvings." *Orientations* (Vol. 10, No. 1, Jan. 1979): 33–41.

Seike, Kiyoshi, Kudo Masanobu, and David H. Engel. *A Japanese Touch for Your Garden*. Based on Sakutei no Jiten. Tokyo: Kodansha International, Ltd., 1980.

Sekijima, Hisako. *Basketry*. Tokyo: Kodansha International, Ltd., 1986.

Sen, Soshitsu. *Chado: The Japanese Way of Tea*. New York/Tokyo: Weatherhill/Tankosha, 1979.

———. *Tea Life, Tea Mind*. Kyoto: The Urasenke Foundation, 1979.

Sen'o, Tanaka. *The Tea Ceremony*. Tokyo: Kodansha International, Ltd., 1973.

Seo, Audrey Yoshiko with Stephen Addiss. *The Art of Twentieth Century Zen: Paintings and Calligraphy by Japanese Masters*. Boston/London: Shambhala, 1998.

Shadows and Reflections: Japanese Lacquer Art from the Collection of Edmund J. Lewis. Honolulu: Honolulu Academy of Arts, 1996.

Shigaken Dentoteki Kogeihin. (Shiga Prefecture Crafts). Pamphlet. Shigaken: Shiga Shoko Rodobu Kanko Bussanka, 1995.

Shiraishi, Masami. *Mokuchiku—Dento Kogei* (Wood, Bamboo Craft). No. 303. *Nihon no Bijutsu, 8* (Japanese Beauty, 8). Tokyo: Shibundo, August 1991.

"*Shishi-odoshi*: Silence Born of Sound." *The East* (Vol. XXX No. 6, 1995): 42.

The Shitamachi Museum. Tokyo: Shitamachi Museum, 1983.

"*Shodo*" *Yogu to Kaki-kata, Sho-kyu Giho Kouza* ("Calligraphy" Tools and Technique for Beginners). Tokyo: Bijutsu Shuppan-sha, 1995.

Shono Shounsai-Chiku gei. (Shono Shounsai-Bamboo Craft). *Ningen Kokuho Series—34* (National Treasure Series, 34). Tokyo: Kodansha, 1977.

Simmons, Doreen. "Strong Men of the Sacred Circle." *Asian Art* (Winter, 1991): 47–70.

Skinner, Scott and Fujino Ali, eds. *Kites: Paper Wings over Japan*. London: Thames and Hudson Ltd., 1997.

Smith, Lawrence and Victor Harris. *Japanese Decorative Arts from the 17th to the 19th Centuries*. London: British Museum Publications Ltd., 1982.

Smith, Robert J. *Ancestor Worship in Contemporary Japan*. Stanford, California: Stanford University Press, 1974.

Sollier, Andre and Zsolt Gyorbiro. *Japanese Archery: Zen in Action*. New York: Walker/Weatherhill, 1969.

Statler, Oliver. *Japanese Inn: A Reconstruction of the Past*. New York: Random House, Inc., 1961.

Stevenson, John. *Yoshitoshi's Women: The Woodblock Series Fuzoku Sanjuniso*. rev. ed., Seattle: University of Washington Press in association with Avery Press, 1995.

Straiton, Kenneth. *A Collection: Japanese Design*. New York/Tokyo: Weatherhill, Inc., 1999.

Streeter, Tal. "Heavenly Humors: The Modern Kite." *American Craft* (Vol. 39, No. 4, 1979): 37–43.

———. *The Art of the Japanese Kite*. New York, Weatherhill, Inc., 1974.

Studies on the Physiology of Bamboo with Reference to Practical Application. Resources Bureau Reference Data. No. 34. Tokyo: Resources Bureau, Science and Technics Agency. Prime Minister's Office, 1960.

Suke Suke: The Emperor's New Fabrics. Tokyo: The Nuno Corporation, 1997.

Sullivan, M. J. *Japanese Calligraphy*. Kyoto: Nihon Shuji Kyoiku Zaidan, 1989.

The Sun. "100 Key Words for Understanding Japan. Special Issue" (No. 386, August, 1993).

Suzuki, Dr. Sadao. *Index to Japanese Bambusaceae*. Tokyo: Gakken Co., Ltd., 1978.

The Taiheiki: A Chronicle of Medieval Japan. Trans. Helen Craig McCullough. New York: Columbia University Press, 1959.

Tai Hei Shakuhachi. Website, December 1997.

Tai Hei Shakuhachi: Japanese Bamboo Flutes. 1999 sourcebook. Willits, California: Monty H. Levenson, 1999.

Taiyo, Bessatsu (*The Sun, Special Issue*). "*Nihon no Kokoyo 36, Wagashi Saijiki*" ("Japanese Spirit 36, The Collections of *Wagashi* Sweets"). 2nd ed., Tokyo: Heibonsha, 1997.

Takama, Shinji. *Take wo Kataru* (Talking About Bamboo). Tokyo: Sekai Bunka Sha, 1991.

———. *The World of Bamboo*. Includes essays by Ueda Koichiro and Yoshida Mitsukuni. San Francisco: Heian International, 1981.

Takashina, Shuji, J. Thomas Rimer with Gerald D. Bolas. *Paris in Japan: The Japanese Encounter with European Painting*. In conjunction with a traveling exhibition. Tokyo and St. Louis: The Japan Foundation and Washington University, 1987.

Takazawa, Fumio. Personal interview, Spring 1995.

Take (Bamboo). Tokyo: Shoshin Sha, 1940.

Take: Chikurin no Kairyo to Shitatekata (Bamboo: How to Improve and Process Bamboo). Tokyo: Noson Gyoson Bunka Kyokai, 1979.

Take: Ecological na Sozai to Gendai no Sekatsu, Human Renaissance Series (Bamboo: As a Natural Material and for New Usage in Living Life, Human Renaissance Series). Tokyo: Human Renaissance Kenkyusho, 1995.

Take: Kurashi ni Ikiru Take-Bunka. (Bamboo: Bamboo Culture in Daily Life. Tanko Special Issue. No. 13). Kyoto: Tanko-sha, Inc. 1995.

Take Asobi no Kenkyu (The Study of Bamboo Play). Yokohama: Ryokusei-kyoku Suishinka, 1994.

Take Dake (pamphlet). In conjunction with an exhibition. Notes by John Kaizan Neptune. Chiba: Miyoshimura Kyoiku Iinkai, 1997.

Take no Hakubutsushi (A Natural History of Bamboo). Graphic Bunka-shi Series. Tokyo: Asahi Shinbun-sha, 1985.

Take no Inochi ga Yumi ni Naru—Miyakojyo Yumi Zukuri. (The Spirit of Bamboo Becomes Bows—Making Bamboo Bows in Miyakojyo). Videocassette. Miyazaki: NHK.

Take no Kogei (Bamboo Crafts). In conjunction with an exhibition. Tokyo: The National Museum of Modern Art, 1985.

Take no Sekai: Part 2 (World of Bamboo: Part 2). Tokyo: Chizin Shokan, 1994.

Take no Shugei (Bamboo Craft). Tokyo: Fujingaho-sha, 1978.

Takeami no Tewaza: Kieru Kago-shokunin (Skill of Weaving with Bamboo: Disappearing Basket Craftsmen). Tokyo: Tamagawa Daigaku Shuppan, 1995.

Takeami: Bamboo Constructions. (Nihon no Zokei–Japanese Forms, Vol. 2). Kyoto: Tankosha, 1970.

Tanahashi, Kazuaki. *Japanese Design Motifs.* Tokyo: Hozan-sha, 1968.

Tanaka, Ikko and Koike Kazuko, eds. *Japan Design: The Four Seasons in Design.* San Francisco: Chronicle Books, 1984.

Taniguchi, Kichiro, Inoue Mitsuharu, and Okada Jo. *Nihon no Kogei* (Japanese Crafts), *8, Ki, Take* (8, Wood, Bamboo). Kyoto: Tanko Shinsha, 1966.

Tanko, Special Issue, "*Kyogashi*" ("Kyogashi Sweets"; February 1998, No. 25).

——, Special Issue, "*Wagashi*" ("Wagashi Sweets"; June 1993, No. 7).

Taut, Bruno. *Houses and People of Japan.* Tokyo: Sanseido Co., Ltd., 1937.

Teshigahara Hiroshi Ten: Take—Kokyu Suru Kukan (Teshigahara Hiroshi Exhibit: Bamboo—A Space to Breathe). Miura Insatsu Kabushikigaisha: Zaidan Hojin Sogetsu Kai, 1987.

Textile Magicians: Japan. Video by Cristo Zanartu. Produced by Rebecca Clark, 1996.

Thornbury, Barbara E. *Folk Performing Arts: Traditional Culture in Contemporary Japan.* Albany, New York: State University of New York Press, 1997.

Thrasher, William. *Kindred Spirits: The Eloquence of Function in American Shaker and Japanese Arts of Daily Life.* In conjunction with an exhibition. San Diego: Mingei International Museum, 1995.

Tobacco and Salt Museum. Tokyo: Japan Tobacco Foundation, 1985.

Tokubetsu-ten, Ukiyo-e no Bi—Ame to Yuki to Kasa. (Special Exhibition "The Beauty of Ukiyo-e—Rain, Snow and Umbrella"). Gifu, Japan: The Gifu City History Museum, 1994.

Tokubetsu-ten, Zuroku: Kago—Tama Chiiki wo Chushin to Shite (Exhibition Catalogue: Baskets—In Tama Region). Tokyo: Hachioji-shi Kyodo Shiryo kan, 1985.

Traditional Crafts of Japan (pamphlet). Tokyo: Japanese Traditional Crafts Center, 1995.

Traditional Handicrafts of Japan: An Exhibition of Contemporary Works. (Exhibition at Museum Voor Land-En Volkenkunde, Rotterdam, Netherlands, November 1963–January 1964). Tokyo: Nippon Kogei Kai, 1963.

Treasures from Nature. In Connection with an exhibition of the same name. London: Katie Jones and Brian Harkins, 1996.

Treasures of the Shosoin. Edited by Shosoin Office. Tokyo: Asahi Shinbun Publishing Co., 1965.

Tsutsumu. Kyoto: Tankosha Publisher, Inc., 1995.

Tsutsumu: The Art of Japanese Packaging. Japanese Video Series. Tokyo: Detsu Inc., 1994.

Tuer, Andrew W., FSA. *Japanese Stencil Designs.* New York: Dover Publications, Inc., 1967.

Ueda, Atsushi. *The Inner Harmony of the Japanese House.* Tokyo/New York: Kodansha International, Ltd., 1990.

Ueda, Koichiro. *Studies on the Physiology of Bamboo with References to Practical Application.* Resources Bureau, Reference Data No. 34. Tokyo: Resources Bureau, Science and Technology Agency, Prime Minister's Office, July 1960.

——. *Take no Hanashi* (Bamboo Talking). Tokyo: PHP Kenkyujo, 1985.

——. *Take no Kansho to Saibai* (Observing and Cultivating Bamboo). Tokyo: Hokuryukan, 1981.

——. *Take to Jinsei* (Bamboo and Life). 14th edition. Tokyo: Mengei Shobo, 1985.

——. *Take to Jinsei* (Bamboo and Life). Tokyo: Meigen Shobo, Ltd., 1970.

Uenoda, Setsuo. *Calendar of Annual Events in Japan.* Tokyo: Tokyo News Service, Ltd., 1951.

Urasenke. *The Art of Chanoyu: The Urasenke Tradition of Tea.* Los Angeles: The Urasenke Foundation, 1986.

——. *The Urasenke Tradition of Tea* (pamphlet). Kyoto: The Urasenke Foundation, undated.

Usui, Hakugetsu. *Shin Take Kogei: Hitofushibori* (New Bamboo Crafts). Tokyo: High Business, Inc., 1995.

Utamaro and Hiroshige: In a Survey of Japanese prints from the James A. Michener Collection of the Honolulu Academy of Arts. Honolulu: Honolulu Academy of Arts, 1976.

Van Bremen and Martinez, D. P. eds. *Ceremony and Ritual in Japan: Religious Practices in an Industrialized Society.* London: Routledge, 1995.

Varley, Paul and Kumakura Isao, eds. *Tea in Japan: Essays on the History of Chanoyu.* Honolulu: University of Hawaii Press, 1989.

Vilhar, Gorazd and Charlotte Anderson. *Gracious Gifts: Japan's Sacred Offerings.* Tokyo: Shufunotomo Co., Ltd., 1999.

——. *Matsuri: World of Japanese Festivals.* Tokyo: Shufunotomo Co., Ltd., 1994.

Village of Dreams. Dir. Higashi Yoichi. Video. 116 min.

Walking, Gillian. *Antique Bamboo Furniture.* London: Bell & Hyman, 1978.

Wang, Hongxum. *Chinese Kites: Traditional Chinese Arts and Culture.* Beijing: Foreign Language Press, 1989.

Warner, Langdon. *The Enduring Art of Japan.* New York: Grove Press, Inc., 1952.

Wichmann, Siegfried. *Japonisme: The Japanese Influence on Western Art in the 19th and 20th Centuries.* Originally published in German. New York: Park Lane, 1985.

Williams, Marjorie. *In the Nature of Materials: Japanese Decorative Arts.* Cleveland: The Cleveland Museum of Art, 1977.

The World of Bamboo. Photo. by Takama Shinji. In conjunction with an exhibition. San Francisco: Heian International, Inc., 1981.

Yabushita, Hiroshi. "History and Production of the Japanese Umbrella" in Meech, Julia. *Rain and Snow: The Umbrella in Japanese Art.* New York: Japan Society, 1993.

Yagi, Koji. *A Japanese Touch for Your Home.* Tokyo/New York: Kodansha International, Ltd., 1982.

Yamaguchi, H. S. K. *We Japanese,* Vol. I and II. Hakone: Fujiya Hotel, Ltd., 1937.

Yamaguchi, K. *We Japanese, Being descriptions of many of the customs, manners ceremonies, festivals, arts and crafts of the Japanese, besides numerous other subjects.* Miyanoshita: Fujiya Hotel, Ltd., 1934 (reprint 1950).

Yanagi, Soetsu. *Folk Crafts in Japan.* Tokyo: Rokusai Bunka Shinkokai (The Society for International Cultural Relations), 1956.

——. *Nihon Mingei-kan* (Japanese Folk Art Museum). Tokyo: Mingei-kan, 1956.

——. *The Unknown Craftsman: A Japanese Insight into Beauty.* Adapt. by Bernard Leach. Tokyo: Kodansha, International Ltd., 1972.

——. *The Way of Tea.* Honolulu: Honolulu Academy of Arts, 1953.

Yanagi, Sori. *Matoi: The Symbols of Firemen in the Edo Period.* Mingei Series, Vol. 2 Tokyo: Geiso do Co., 1987.

Yoshiaki, Shimizu, ed. *Japan: The Shaping of Daimyo Culture 1185–1868.* In conjunction with an exhibitiion at The National Gallery of Art. New York: George Braziller, Inc., 1988.

Yoshida, Mitsukuni, ed. *Forms, Textures, Images: Traditional Japanese Craftsmanship in Everyday Life.* First published in 1978 in Japanese, *Nihon no Tachi.* New York/Tokyo: Weatherhill/Tankosha, 1979.

——. *Harmony with Nature: A Heritage of Craftsmanship.* Hiroshima: Mazda Motor Corporation, 1986.

———. *Tsukuru: Aesthetics at Work*. Hiroshima: Mazda Motor Corporation, 1990.

Yoshida Mitsukuni, Tanaka Ikko, and Tsune Sesoko, eds. *Asobi: The Sensibilities at Play*. Hiroshima: Mazda Motor Corporation, 1987.

———. *The Culture of Anima: Supernature in Japanese Life*. Hiroshima: Mazda Motor Corporation, 1985.

———. *The People's Culture from Kyoto to Edo*. Hiroshima: Mazda Motor Corporation, 1986.

Yoshikawa, Isao. *The Bamboo Fences of Japan*. Tokyo: Graphic-sha, 1988.

———. *Japanese Gardening in Small Spaces*. Trans. by Ishiguro Yoko. Photo. by Kato Junnichi and Koshizuka Yoshihiko. Tokyo: Joie, Inc., 1996.

Young, Robert A. and Joseph R. Haun. *Bamboo in the United States: Description, Culture, and Utilization*. Crops Research Division, Agricultural Research Series. Agriculture Handbook No. 193. Washington, DC: United States Department of Agriculture, 1961.

Your Guide to Japan. Tokyo: Japan National Tourist Organization, 1999.

Yuzen-giho ni Yoru, Kyo Zome shi (Yuzen-Dyed Japanese Paper). Kyoto Shoin Arts Collection, 110. Kyoto: Kyoto Shoin, 1998.

Zhang, Yiguo. *Brushed Voices: Calligraphy in Contemporary China*. New York: Columbia University, 1998.

Zukai Iroha Biki—Hyojun Moncho (Standard Family Crests/Mon Designs in Alphabetical Order). Tokyo: Yoshino Takejiro/Kin En Sha, 1961.

INDEX

Numbers in *italics* refer to illustrations.

PHOTO CREDITS

PUBLICATIONS

The Genius of Japanese Design page 57.

Hokusai Manga pages 49, 50, 51.

Iwagumi Sonou Yaegakiden pages 93 (center & bottom), 95 (center & bottom).

Japanese Spoons & Ladles, from the series *Form and Function* page 127 (all).

Kaishien Gaden page 85.

Koetsu, Utai-bon page 1.

Tale of the Shining Princess page 16.

Traditional Japanese Furniture page 117.

Zukai Iroha Biki—Hyojun Moncho page 22.

ASSISTANCE

Mr. Joke Tasuku	Forestry Division, Department of Agriculture, Forestry & Fisheries, Kyoto Prefecture
Mr. Kotani Kimito	Beppu Industrial Art Research Division
Nihon Kogeikai	
Mr. Sato Keiji	Kyoto Municipal Institute of Industrial Research
Mrs. Utsumi Teiko	Japan Folk Crafts Museum
Mr. Watanabe Masatoshi	

PERMISSIONS

Asakura Choso-kan, Tokyo

Daikakuji, Kyoto

Domyoji Tenmangu, Osaka

Imperial Household Agency

Japan Folk Crafts Museum, Tokyo

Kawai Kanjiro Memorial Museum, Kyoto

Koenji, Kyoto

Kumano Hayatama Shrine, Wakayama

Kuroda Shogen

Matsubara Naoko (author of the illustrated woodblook-print book, *Tale of the Shining Princess*)

Matsui Bunko, Kumamoto

Musashino Art University, Museum and Library

Nagai Sokei

Nango-mura Kyoiku Iinkai (Educational Committee), Fukushima

National Museum of Modern Art

Shono Shounsai (family)

Taiko-an, Kyoto

Tokyo National Museum

Uraku-en, Aichi